HOW TO READ PAINTINGS

HOW TO READ PAINTINGS

Nadeije
LANEYRIE-DAGEN

CHAMBERS

For the English-language edition:

Translator
Richard Elliott

Art consultant
Dr Patricia Campbell, University of Edinburgh

Series editor
Patrick White

Editor
Camilla Rockwood

Proofreaders
Harry Campbell
Stuart Fortey
Ingalo Thomson

Prepress
Vienna Leigh

Originally published by Larousse as *Lire la Peinture* by Nadeije Laneyrie-Dagen

© Larousse/VUEF 2002

English-language edition
© Chambers Harrap Publishers Ltd 2004
Reprinted 2007

ISBN 978 0550 10122 8

Cover image: Edgar Degas, *La Loge*, c.1870 (Musée d'Orsay, Paris). Photo © Archives Larbor.

Typeset by Chambers Harrap Publishers Ltd, Edinburgh
Printed in France by I.M.E.

Contents

Foreword

The aim of this book is to help the reader understand how artists create paintings powerful enough to elicit the emotion and pleasure experienced in a gallery or an exhibition, without at the same time undermining the experience of that initial encounter.

Painting, like literature and music, is a language. It employs subtle methods to make what may have been a difficult process appear simple. Art lovers, quite understandably, may let themselves be drawn into this deception and enjoy the apparent facility with which line and colour combine to reproduce or create form. Just as one might avidly read a good poem or novel and gain immediate pleasure from it, painting appeals directly to the eye and provokes feelings in the viewer in which reason initially plays no part. This pleasure is the pleasure of discovery. It may be enough in itself; powerful emotions do not always need to be explained.

Occasionally, however, a work of art makes no impact on us, or we want to understand why one painting in particular appeals to us rather than another. The object of *How to Read Paintings* is to help the reader gain a better understanding of the works themselves. The viewer will be brought closer to the painter, enter the artist's studio and follow the creative process step by step. Readers with little in-depth knowledge of the history of art and those who love attractive art books will be initiated into the secret world of paintings and discover how artists perform the miracle of creating works of enduring power able to move millions, whereas so many other images glimpsed just as fleetingly are instantly forgotten and have nothing to say once they are removed from the context in which they were produced.

This is not meant as a scholarly work. It sets out to provide readers with a key — not one that will completely unlock a painting's secrets, for paintings will always preserve some desirable element of mystery, but one that will identify those elements that distinguish a masterpiece from a more mediocre work and that are indicative of the carefully considered creative process involved in any painting of merit. In this way, we believe, the pleasure of looking at paintings will be enhanced and increased.

Introduction

Our perception of a work of art is not something that is fixed. It depends as much, if not more, on the period in which the work is being viewed and on our expectations of it as it does on the period in which it was created. We should take particular care not to trap a painting inside a network of meanings that are alien to the culture that pro-

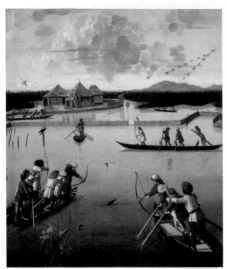

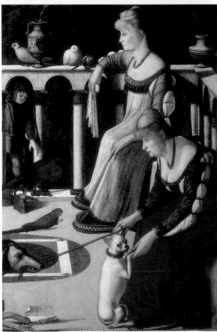

Vittore Carpaccio, *The Wait*: reconstruction of *Hunting on the Lagoon* and *Two Venetian Ladies*, c.1495, oil and tempera on wood, 78 x 63cm and 94 x 63.5cm respectively, Malibu, J. Paul Getty Museum and Venice, Museo Correr.

duced it. A notable example of misinterpretation of this kind is provided by a panel or fragment of panel preserved in the Museo Correr in Venice since the 19th century and known for a long time by the title *Two Courtesans*. It depicts two ladies with vacant expressions seated on a terrace in an attitude of boredom, their hands resting or absent-mindedly playing with dogs. Praised by 19th-century aesthetes, notably John Ruskin, who described it in 1877 as the best picture ever painted, it became famous at the beginning of the 20th century when historians, inveighing against the 'softness' of the two women and the 'sensuality of their faces', decided they were prostitutes relaxing and waiting for clients. This hypothesis was entirely fictional; but it suited an age in which writers and artists, including Toulouse-Lautrec, were inspired by the theme of the brothel. It was an interpretation that was embraced enthusiastically by Proust and D'Annunzio.

In actual fact, the Museo Correr's painting TWO COURTESANS is merely part of a larger painting that has been split in two at some time. In 1963, two specialists (Ragghianti and Robertson) matched up the panel and a fragment of painting in the J Paul Getty Museum in Malibu, Los Angeles. This fragment, whose size is roughly the same as that of the painting in the Museo Correr, shows a lagoon on which men in small, flat-bottomed boats are hunting ducks. The relationship between the two fragments is proven beyond doubt by the stem of a lily that extends from the bottom into the top panel, ending in a flower. On the back of the Malibu panel, a trompe-l'oeil image depicts letters attached to a grille. It is possible to make out the faded outlines of family names (Mozenigo) and honorifics (*honorando*). This is enough information to exclude the possibility that

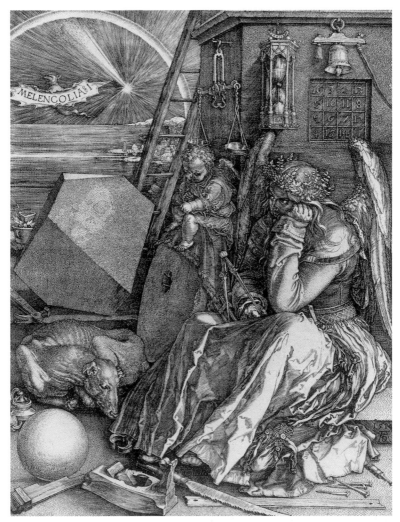

Albrecht Dürer, *Melancholia I*, 1514, copperplate engraving, 23.9 x 16.8cm.

the women depicted were prostitutes, and leads us to view the dismembered painting as a celebration of Venetian patrician family life, in particular of some of its innocent pleasures: hunting for the men and relaxation in the cool of a terrace for the somewhat bored women. It is essential to interpret paintings from an iconological standpoint – not on the basis of vague intuition, as in the case of the so-called *Two Courtesans*, but on the basis of solid argument. In this way we will see that paintings convey a message, that they are representations of thought in the form of images just as a text is a representation of thought in the form of words. The historian and art theoretician Erwin Panofsky (1892–1968), a specialist in the Middle Ages and the European Renaissance who lived and worked in Germany before moving to the United States in 1933, demonstrated in a series of acclaimed books that the works of this period were heavy with philosophical and moral meaning. Thanks to Panofsky, Dürer's *MELANCHOLIA I*, an engraving from 1514, has become legendary as a symbol of both the morbid depression to which mankind is vulnerable and the anguish of the creative mind incapable of capturing beauty. Panofsky's interpretation was only possible thanks to his scrupulous observation of the different elements that make up this image of just

a few dozen square centimetres: the measuring and counting instruments (scales, sandglass, magic square etc); the shape and arrangement or rather 'disorder', as Panofsky has it, of the stereometric objects (the sphere, the rhomboid, the polyhedron etc); the animals (the sleeping dog, the bat); the astronomical and optical themes (comet, rainbow); the landscape (a partly submerged bay); the appearance of the woman (her wings, the objects she holds, the wreath on her head), the attitude of codified abandon conveyed by her slumped seated posture and her face resting on her folded arm.

Taken to any great length, however, research into the artist's intellectual intentions alone can lead if not to misinterpretation, then certainly to a partial and ultimately disappointing understanding of a work of art. In a book entitled *Problems in Titian, Mostly Iconographic*, Panofsky deciphers a celebrated painting by the Venetian painter, SACRED AND PROFANE LOVE (a 'modern' title first used in 1693), which hangs in the Galleria Borghese in Rome. In this learned analysis Panofsky concentrates on the symbolism of the contrast between the two women. One of the women, sumptuously dressed in white, evokes Earthly love and its virtuous (because sanctified by marriage) but ephemeral joys. The other, naked and holding a vase in which a flame burns, embodies the heavenly love that seeks its happiness in God. The landscape is organized so as to reinforce this symbolism. Behind the Earthly Venus, our eye is led up to a fortress (the wife's castle); behind the Celestial Venus we see a church tower. The sarcophagus on which the women are seated is decorated with a relief. The first image we see is that of a horse without a bridle. Panofsky informs us that this is the emblem of brutish love, an interpretation confirmed by the scene behind it of a man pulling a woman by the hair prior, no doubt, to raping her. It is impossible to find fault with this reading of *Sacred and Profane Love*. It explains and justifies the details, even going so

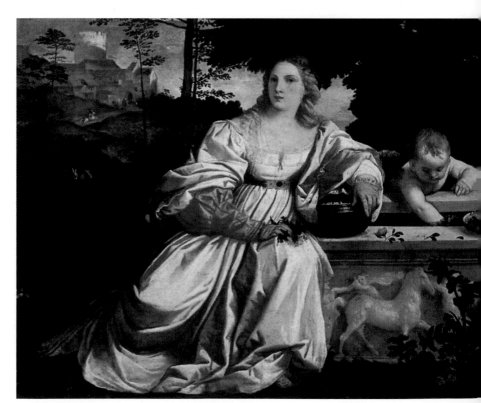

Titian, *Sacred and Profane Love*, 1515–16, oil on canvas, 118 x 270cm, Rome, Galleria Borghese.

far as to reveal a number of ingenious devices that we might otherwise have judged trivial. Our attention is drawn to a pair of rabbits frolicking behind the clothed Venus while to the rear of the Celestial Venus another rabbit is chased by a couple of horsemen who will soon put an end to any lustful ideas it might have ... It is not certain whether the painting emerges enhanced in any way from this last revelation, assuming we can agree with the art historian's interpretation of the motif. Taken to such an extreme, thematic decoding distracts our attention from what is as much a part of the painting's greatness as its symbolism: its form and style.

As has been repeatedly asserted by many people, from the theoretician Alberti in the 15th century to the painter Maurice Denis in the 20th, a painting is first and foremost the result of the play of lines and combination of colours. These lines and colours produce physical effects calculated by the artist. He has chosen and arranged them in order to please the eye, in order to 'calm and refresh it [...] like a finger touching ice' or to 'excite' it like the effect produced by 'a spiced dish on the palate', as Wassily Kandinsky put it. The combining of these lines and colours into shapes that divide up the painting constitutes a language. We have to examine the rules and procedures on which this language is based in the same way that we might analyse the words and rhymes of a poem or the notes and rhythm of a piece of music.

As with the examination of motif, this focus on colour and form assumes that we have learned to look attentively enough to understand each of the different elements of a work of art. This takes time. The importance of taking time, the awareness that pictures reveal themselves gradually and need to be appreciated during a slow process of discovery or exploration — these are the realizations that this book hopes to instil in the reader.

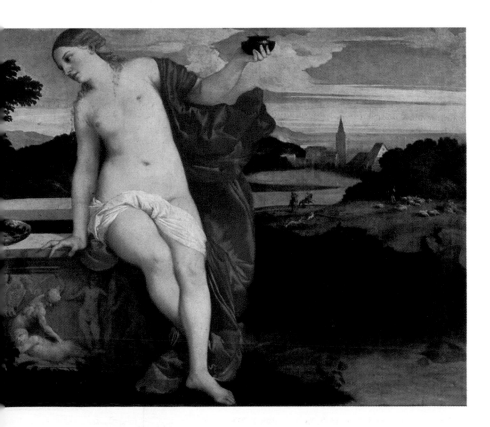

Identification

Every painting is first and foremost an object. It is an object that has been made by a person or group of persons; that uses techniques which say a lot about the era in which it was made and sometimes about the unusual decisions taken by the artist; and that possesses a history whose complexity increases with the age of the work.

Our initial approach to paintings should therefore be to examine them as the objects they are: in other words to look at the people who made them (attribution), the manner in which they have been made (technique), and their past (history).

ATTRIBUTION AND DATE

Today, works of art are signed. The importance attached to the notion of the individual from the 14th century onwards and the idea that masterpieces are the product of the unique imagination of individuals of genius contributed to popularizing the practice of signing work and indeed made it all but obligatory. The role played by the art market has meant that a work that cannot be authenticated by an artist's name, and ideally a great artist's name, forfeits a significant proportion of its value. Recent debates concerning attribution within the studios of old masters — Rembrandt for example — have shown how the value of a painting increases or decreases not as a function of its intrinsic qualities, but according to the degree of certainty as to whether a particular master painted it in its entirety or whether it was worked on by an assistant. Normally, but not always, paintings from the end of the Middle Ages (if not earlier) display the signature of the artist either on the viewing side or on the reverse, and often the date of execution as well. Any description of a work should start with these details.

Contemporary signatures

The artist's signature has to be discreet if it is on the painted surface of the picture. It needs to be integrated into the work in such a way that it does not interfere with the viewer's appreciation of the painting.

In contemporary works, the signature is normally positioned at the bottom of the painting, usually in the right-hand corner. This is not the case for engravings, where the draughtsman and the engraver are not usually the same person. Here, the name of the artist who has created the work appears in the bottom left-hand corner, traditionally accompanied by the term *delin.* (short for *delineavit*, 'drew'), while the name of the engraver who is responsible for transferring the work onto the printing plate appears in the bottom right-hand corner with the term *sculps.* (short for *sculpsit*, 'engraved').

Over the last hundred years, works have been signed in a simple manner which makes reliable identification straightforward. Signatures are generally limited to the surname, sometimes with first name, and should ideally be the same on each work in order to avoid doubts about authenticity. However, painters rarely stick to one signature throughout their career. Often the particular form taken by a signature will indicate that a work was produced during certain years, providing a chronological clue in the absence of a date. Thus Picasso signed his early works (up to 1900-01) Pablo Ruiz Picasso, P Ruiz Picasso or P R Picasso. Afterwards, during his Blue and Rose periods, he simply signed himself Picasso, often slanting his signature slightly and underlining it. Sometimes his signature is accompanied by the date in the form of the year written in full or just the last two digits. Painters occasionally use original systems of dating. Rather than using the calendar year, the French artist Camille Saint-Jacques bases his dates on the number of years and days that have elapsed in his life. Born in 1957, he dated a 1991 painting 'XXXIV, 175'.

More rarely, artists sometimes use wordplay in their signatures as a provocation or an act of faith. In the 1980s, Jean-Michel Alberola signed 'Acteon fecit' ('made by Actaeon') on a series of paintings on the theme of classical mythology. This was a way of declaring that like the hunter Actaeon, who surprised Diana as she was bathing and was punished with death, the painter reveals things that ordinary men cannot or dare not see. Another French painter, Louis Cane, made his signature the main motif and subject of his pictures.

During the 1970s, at the time of the Supports-Surfaces movement (see p. 65), he used a stamp to cover his works with the words 'Louis Cane artiste peintre' ('Louis Cane fine-art painter'), an affirmation, at a time when the Maoist movement was in full swing, that being a painter was no different from being an artisan or workman.

Apart from these special cases, it is only on works executed on paper and using more intimate techniques such as gouache, watercolour, pastels, drawing or engraving that inscriptions other than name and date are sometimes found, for example a dedication on a donated work.

Signatures on the backs of paintings are usually fuller. Sometimes the season, month or more rarely the day are mentioned. For example, 'Paris, winter' (or autumn, summer etc) is to be found on the back of many of Picasso's sketches and paintings dating from his Cubist period. These indications are valuable for studying the evolution of a style over the course of a particular year. The reverse of a painting is also where artists sometimes specify the title they want the work to have. On the unprimed canvas on the back of a recent series, for example, the painter Vincent Bioulès wrote 'BIOULES, Intérieur, fév. 98' ('BIOULES, Interior, Feb. 98') with a black brush. PIERRE SOULAGES provides more complete information. On the back of one of his canvases (below and p.263) he has added an instruction for those hanging the work (an arrow on the vertical strut of the stretcher with the word 'HAUT' ['TOP']), his signature (SOULAGES), a title ('titre: Peinture 63cm x 102cm' ['title: Painting 63cm x 102cm']) and a precise date ('7-12-1990').

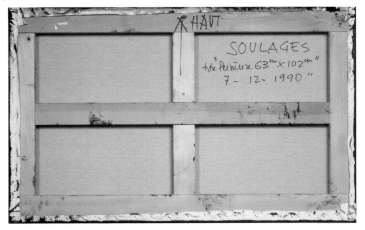

The signature... before the signature

This basic way of signing works started to become widespread around the beginning of the 17th century. Medieval artists appended their signatures more rarely, but also more visibly, adding an entire inscription in their own honour or even including a self-portrait. In the 12th century, for example, the Bohemian miniaturist Hildebert depicted himself holding the tools of his trade — a brush and a bowl containing the paints — on a page of the missal he was illuminating. Above his head, furthermore, he added the words 'H. Pictor' ('H[ildebert] painter'). This work is in the collection of the Kungliga Bibliothek in Stockholm.

This method of displaying oneself for the admiration of viewers had far from disappeared by the 15th century. In a decorative cycle executed in Perugia in 1496, Perugino, the teacher of Raphael, places his self-portrait in a trompe-l'oeil frame beneath which is the inscription: 'If the art of painting had disappeared, / He has revived it. / If it had never been invented anywhere, / He has brought it forth.' Pintoricchio did something similar five years later in the church of Santa Maria Maggiore in Spello, but contented himself with inscribing his name beneath his portrait. More often, artists would paint themselves into their works without identifying these portraits by name. It is suspected that much earlier, Giotto had depicted himself among the righteous in the Last Judgement in Padua (Cappella

Scrovegni, also known as the Arena Chapel, c.1305). In the following century, Andrea Mantegna can be made out as a young man in a *Presentation in the Temple in Berlin* and as an older man in a fresco in the bridal chamber of the Ducal Palace in Mantua, and the Florentine painter Sandro Botticelli, a contemporary of Mantegna, added his own portrait to his *Adoration of the Magi* in the Uffizi Gallery in Florence.

The identification of these self-portraits is an entertaining game initiated by the artists themselves. Often, tradition spares the viewer any effort at all as knowledge of an artist's self-portrait can date back to the painter's own lifetime, when it would have been recognized and commented on. Where this is not the case, the distinctiveness of a particular figure in a group often allows us to suspect the truth behind it: its physical features may have been rendered with exceptional individuality or else the angle from which it is depicted — a three-quarter profile, for example, observing the viewer while the other faces are seen from the side — may in itself be sufficient evidence.

Even signatures that by current standards are the most simple — a patronymic some-times accompanied by the date — often assumed extraordinary forms in 15th-century Italy. On a panel depicting his *The Virgin and Child with St George and St Anthony Abbot* (1445, London, National Gallery), Pisanello has added his signature, PISANUS, to the bot-tom of the picture. The flamboyant Gothic letters forming the word are the same colour as the vegetation and twist and bend like blades of grass in the wind, making the signa-ture extremely difficult to read. In later years, a number of artists in northern Italy inscribed their names on a slab of stone or a leaf that seemed to have been added as an afterthought to the composition. These trompe-l'oeil objects, positioned on the spot in

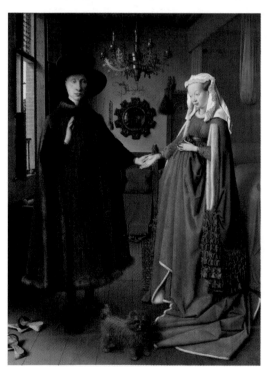

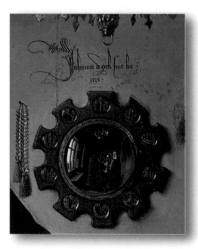

Jan van Eyck, *Portrait of Giovanni Arnolfini and His Wife*, oil on wood, 82 x 59.5cm, 1434, London, National Gallery. Whole and detail.

which the artist wanted his patronymic to appear, are known as *cartellinos* and are illu-sionistic feats of skill whose purpose was to allow the painter to show off his virtuosity.

But northern Europe was not outdone in the invention of attention-grabbing signatures in the 15th and 16th centuries. One of the best known is the inscription added by Jan van Eyck to his small *PORTRAIT OF GIOVANNI ARNOLFINI AND HIS WIFE.* At the centre of the paint-ing, a circular mirror is fixed to the back wall of the room above the joined hands of the young married couple. In it are reflected the backs of Giovanni Arnolfini and Giovanna Cenami as well as two minuscule figures seen from the front, one in blue and the other

Albrecht Dürer, *The Martyrdom of the Ten Thousand*, 1508, oil on canvas applied to wood, 99 x 87cm, Vienna, Kunsthistorisches Museum. Whole and detail.

in red, who are standing in the doorway. Two lines of calligraphy above the mirror read: 'Johannes de Eyck fuit hic. 1434' ('Jan van Eyck was here. 1434'). In this case the signature is not a signature in the true sense, but rather an act of witness, a form of visual protocol that turns the image (the portrait of a married couple) into an official deed or certificate.

In Germany at the start of the following century, the engraver and painter ALBRECHT DÜRER also took care to sign his work in a highly visible fashion. His engravings and paintings bear a monogram, a harmonious graphic device featuring the initials of his surname and Christian name (a small 'D' contained within, and positioned beneath the bar of, a larger 'A'). He also frequently added an inscription indicating the date of the painting and commenting on its subject and the conditions under which it was executed (as in the self-portrait of 1498 in the Museo Nacional del Prado in Madrid). Finally, in *The Martyrdom of the Ten Thousand*, he included a full-length portrait of himself near the centre of the painting. He stands there proudly, holding up a sign bearing an inscription and his monogram. During the 17th and 18th centuries the tendency for painters to include themselves in their works died out, though without signatures dwindling to the minimal form they have on present-day works. Name and date alone began to appear, but they were often positioned in such a way as to merge with the composition, the viewer being required to make some small effort to discover where the signature was hidden: carved into the bark of a tree, incorporated into part of the architecture and so on.

TITLE

Before the Salons were established in France at the end of the 17th century and during the 18th, paintings did not have titles in the modern sense. However, the exhibitions and catalogues which emerged with the developing art market made it necessary for works to be identified by title.

The title, a later addition

The names by which we refer to ancient works are modern. They derive from a succinct definition of the subject or a concise description of what can be seen in the painting. Religious paintings, for example, are relatively easy to name: an Annunciation (the Angel Gabriel announcing to the Virgin Mary that she will conceive and bear Christ) is quite distinct from a Pietà (in which the Virgin Mary is seated on the ground with the dead Christ in her arms). By convention, designations vary depending on how a theme has been treated by the artist. A half-length representation of the Virgin alone with

the Child is known as a Madonna; the Virgin with the Child becomes an enthroned Virgin (or *Maestà* in Italy) when she is seated on a throne surrounded by angels and saints; seated on the ground with the Infant Jesus on her knees she is known as the Virgin of Humility. Titles are also easily given to historical and mythological subjects: Jacques Louis David's *The Consecration of the Emperor and the Coronation of the Empress* depicts the coronation of Napoleon; and Titian's *The Flaying of Marsyas* depicts the flaying alive of the satyr who dared challenge Apollo. A landscape might be known by the simple title *Landscape* or named after one of the main characteristics depicted by the painter: *Seaport at Sunset* by Claude Lorraine, for example. In the case of older paintings that predate the creation of catalogues, titles sometimes correspond to an oral designation for which some written evidence exists. Titian's *Sacred and Profane Love* falls into this category. Paintings are also sometimes named by their owners, thus Georges de La Tour's *Repentant Magdalen*, today part of the collection of the National Gallery of Art in Washington, was known until it left France in 1974 by the title *Madeleine Fabius*. Finally, a portrait might be given the simple title *Portrait* without any further details, either out of discretion or because the sitter is unknown. Alternatively, the name of the sitter might be given, and always is if the subject is well known: Raphael's *Baldassare Castiglione*, for instance. Even if the sitter is well known and is mentioned in initial references to the painting, his or her name can end up being replaced by a description of the salient characteristics of the painting. Henri Matisse's *Portrait of Madame Matisse* (1905), for example, soon became known as *The Green Line*. However useful they may be, titles are therefore also volatile, created and adapted over time. Yet how paintings are named is not a trivial matter. Words affect our perception of works of art, as we have seen with Carpaccio's so-called *Two Courtesans*. Other titles pose similarly delicate problems: Giorgione's THE TEMPEST depicts a near-naked woman breastfeeding an infant in the countryside and a young man, clothed, on the opposite riverbank in the foreground; between them extends a verdant landscape featuring ruins (including two broken columns), a bridge and a small town. The heavy

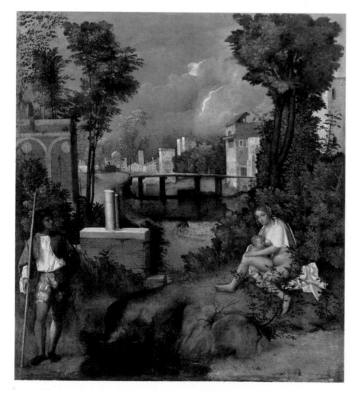

Giorgione, *The Tempest,* c.1506–8?, oil on canvas, 83 x 73cm, Venice, Galleria dell'Accademia.

sky is streaked with lightning. This motif, a new one at the beginning of the 16th century, provided the painting with its conventional title without, however, explaining either its subject or its meaning.

The meaningful title

The reverse can also be true: that a title supplies precious information, its choice of words relating to considerations of which we have completely lost sight. During the 17th and 18th centuries in France, painters who worked in the genres regarded as 'inferior' — landscape and still life — were held in low esteem. In order to gain admission to the Academy (originally the Académie Royale de Peinture et de Sculpture, founded by Louis XIV, later known as the Académie des Beaux-Arts), enjoy success at the Salons (the periodic official art exhibitions) and win lucrative commissions, those who wanted to paint the countryside or still lifes sometimes chose to disguise their subject matter. By depicting not just the sea but also a port, Claude was able to include architecture (an exercise in perspective that attracted great admiration) and people (the noble human figure) in the same painting, and by placing the minuscule figures of Adam and Eve in a natural setting, Poussin turned a landscape into a religious painting. The title commonly used for this work, *The Spring. Adam and Eve in Paradise* (see p.48), does not misrepresent the painting, yet it reveals the constraints placed upon the artist.

The choice of title or its rejection

Artists today like to have control of how their works are named and many painters continue to use the traditional system of titling. They provide titles by talking about their works, by naming them or having them named in catalogues or articles, by writing the title on the back of a picture or by adding it to lists of their work that they themselves maintain. Certain artists exercise this control more assiduously than others. Picasso, relatively indifferent to the process, gave titles to his great political paintings *Guernica* and *Massacre in Korea*. But *Les Demoiselles d'Avignon* was named by his friends, who were the first to see the work. If we hear the title without knowing to what it refers, we view the painting's tall figures — twisted and dislocated by the artist's early experimentation with the Cubist treatment of volume — differently from how we perceive them if we recall that these 'young ladies' were originally prostitutes in a Barcelona brothel.

Other artists use titles to provoke, shock or surprise. Marcel Duchamp's *Nude Descending a Staircase No. 2* of 1912 was designed to produce the first of these effects. The words describe the figure's motion, a fundamental feature of the painting and of Duchamp's experimentation during this period, but the term 'nude' evokes the idea of a human figure treated in an academic manner – evidently not the case here. Over the following years, Duchamp used combinations of letters and phrases that relate in a playful and paradoxical manner to what is on view. *L.H.O.O.Q.* (a title designed to be pronounced letter by letter in French, yielding 'elle a chaud au cul', a slang expression meaning 'she's a bit of a nympho') was Duchamp's title for his version of the Mona Lisa with added moustache (1919, Paris, private collection) and *THE BRIDE STRIPPED BARE BY HER BACHELORS, EVEN* was the title he gave to a major work of the years 1915–23 that is also referred to by art historians, because of the distinctiveness of its technique, as the *Great Glass*.

Certain artists, on the other hand, choose to dispense with titles altogether. In doing so they are guarding against their work being understood in any way that is not the result of visual perception alone. Thus the American abstract artist Mark Rothko gave his paintings numbers (*Number 10*, 1950, New York, MOMA, for example) accompanied sometimes by a description of their colours (*Dark Over Brown No. 14*, 1963, Musée National d'Art Modern, Paris). These are not titles in the traditional sense, but rather

technical descriptions relating to a classification of the work within the artist's overall output.

The choice facing artists of whether or not to give their work a title does not depend on whether the work is figurative or abstract. The abstract painter Jackson Pollock gave the large canvases he produced with his splattering technique simple numerical titles (such as *One*, New York, MOMA), but also in certain cases distinctly poetic ones: *Lavender Mist No. 1* (1950, New York, Ossorio-Dragon Collection); *Autumn Rhythm* (1950, New York, Metropolitan Museum). The decision depends therefore on whether or not the artist wishes to call into play the evocative power of words.

TECHNIQUE

A description of the technical aspects of painting needs to take into account both the support (the surface on which the painting is executed) and the medium that is applied to it.

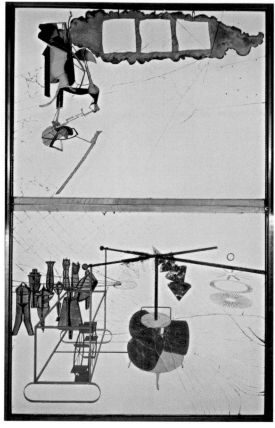

Marcel Duchamp, *The Great Glass*, also known as *The Bride Stripped Bare by Her Bachelors, Even*, 1923, oil, lead foil, dust, varnish, glass plates, 272.5 x 175.8cm, Philadelphia Museum of Art, The Louis and Walter Arensberg Collection.

Works may be painted on a wall (this technique will be referred to here generically as mural painting), on wood (panel painting), on canvas or – depending on the period – on parchment or paper. Other supports have been used too, particularly in the 20th century, but those mentioned above are the main ones.

The pigments used are mineral, vegetable, animal or artificial (chemical) in origin. Apart from the special case of 20th-century paints manufactured by chemical processes, they generally occur in the form of dry powder. The image of an assistant grinding pigment into smaller particles that the painter will be able to use appears relatively frequently in ancient depictions of artists' studios. The binding medium that enables this powder to be transformed into a smooth and usable paste is the essential component that distinguishes one technique from another.

Supports

In mural painting, the picture is not painted directly onto the wall, but onto an intermediate prepared base. In the case of fresco, this is plaster composed of a coarse roughcast *(arriccio)* covered by a thinner layer of fine sand and lime *(intonaco)*. One method of applying the pigment to the plaster is to use a binding medium that is heated and then sets as it cools: – namely wax. This wax technique is known as encaustic painting and was used by the Romans, most notably in the paintings at Pompeii. After the Middle Ages, and predominantly in southern Europe, the main technique employed was that of true fresco *(buon fresco)*. The pigment (which had to be mineral-based) was diluted with water

and applied to a layer of fresh, in other words damp *(fresco)*, lime. This method differs from the dry technique *(a secco)*, which involved the application of pigment that had not been diluted in water to plaster that was also dry. The different binders that can be used for this include egg, glue and gum (made from the exudation of trees such as cherry, peach and acacia).

The encaustic technique can be recognized from its satin-like finish. The main advantage of true fresco is that it preserves the original brightness of the paint. By combining with the damp lime used in the *intonaco*, the mineral pigments are trapped in a transparent layer of calcium carbonate, which prevents them from fading. The overall effect is characterized by a matt finish. True fresco can also be recognized by the cracks that mark the boundary of each expanse of wall successively worked on by the painter or painters.

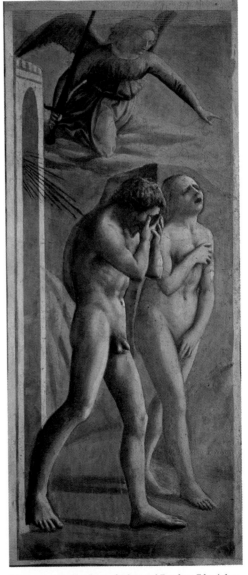

As the pigment can only be applied to wet lime, artists determined on a daily basis the area of *arriccio* that could be physically covered in the time available. The smooth, wet plaster would then be spread over this area (known as the *giornata* [day], plural *giornate*), ready to be painted on. However much care was put into concealing the joins, they often remain easy to spot. In the Brancacci Chapel in the church of Santa Maria del Carmine in Florence, it is easy to identify the day's work devoted by MASACCIO to painting Adam, and a thin crack in the layer of paint above Eve reveals that the Florentine painter devoted another day to her. The dark lines emanating from the doorway in the same fresco were previously covered with gold. The fact that these lines have deteriorated demonstrates that they were painted using the *a secco* technique, in other words applied to the already painted, dry surface using a pigment (or in this case, gold) mixed with a binding medium such as egg, oil or glue. This procedure proved to be fragile: additions made *a secco*, as here, rarely withstand the passage of time.

Masaccio, *The Expulsion of Adam and Eve from Eden* (after restoration), 1426–8, fresco, 214 x 90cm, Florence, Brancacci Chapel, Santa Maria del Carmine.

Wood

Wood is another commonly found type of painting support. It was used widely during

ALTARPIECES: FROM THE RETABLE TO THE PALA – THREE CENTURIES OF EVOLUTION

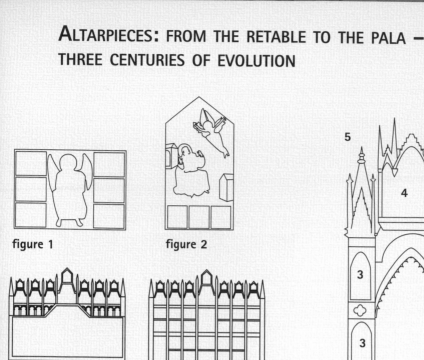

figure 1

figure 2

figure 3

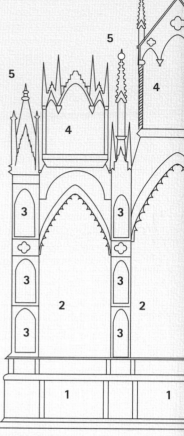

figure 4

The Romanesque retable

13th-century altarpieces were compact objects in the form of a single rectangular panel known as a retable. Its central portion would be occupied by the image of a saint, while scenes from that saint's life would be depicted on a number of smaller rectangular panels to the left and right (fig.1). In some cases these scenes were placed side by side at the bottom of the panel, anticipating what came to be known as the predella (fig.2). In other cases, the retable was painted on both sides (fig.3). One side would be decorated with a large image with narrative subjects painted above and below, and the other side would have rectangular compartments divided into rows (tiers) one above the other. An example of this type of retable is the *Maestà* (1308–11, Sienna, Museo dell'Opera del Duomo) by the Siennese painter Duccio. On the front is displayed the *Virgin and Child Enthroned with Saints and Angels* and on the back, *Scenes from the Life of Christ*. In the early 14th century, those altarpieces composed of a single panel are often surmounted by a triangular pediment known as a 'mitre arch'. *The Stigmatization of St Francis* by Giotto is one such example (fig.2).

The Gothic retable

During the 14th century in Italy, and on into the 15th century and later in Flanders, the retable was composed of a number of panels set within a wooden framework. This type of altarpiece, known generically as a polyptych (fig.4), can take the form of a diptych (two panels) or triptych (three panels, the most common form in Italy). The side panels are called wings if they can be folded over the central panel, as was common in northern Europe. Where this is the case they are painted on both sides.

1. Predella: the bottom part of the retable. This is composed of small panels placed side by side, each of which is dedicated to an episode from the life of the saint depicted above. If the saint in the main panel is John the Baptist, for example, the predella beneath him will feature his decapitation. Some retables have not one, but two predelle, one above the other.

2. Main panel: this is the area in which painters would depict important saints, frequently showing them in hieratic poses. With the exception of particularly holy subjects,

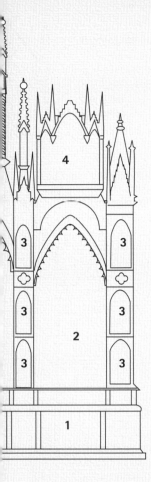

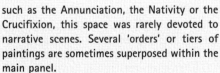

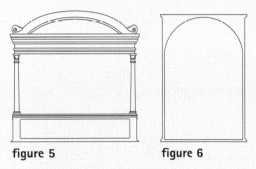

figure 5 figure 6

Evolution towards the pala or altar panel

The altarpiece became more compact in 15th-century Italy. A single panel, in other words a single painting rather than a number of different images, came to occupy the whole of the central portion, and even the predella was sometimes reduced to a single long compartment. The cymatium, occasionally separated from the main panel by a cornice (fig.5), gave way to a classical element that was either semicircular (known as a lunette) or triangular (pediment) in shape. By the end of the 15th century, both predella and cymatium had disappeared, along with all traces of any subdivision within what now constituted the sole tier of the altarpiece (fig.6). The retable had thus been replaced by the *pala*, or altar panel. Raphael's *Marriage of the Virgin* (1504) represents the high point of this development (see p.85).

such as the Annunciation, the Nativity or the Crucifixion, this space was rarely devoted to narrative scenes. Several 'orders' or tiers of paintings are sometimes superposed within the main panel.

3. Pilasters: the uprights that separate or frame the different panels were decorated with pictures of angels or saints contained within small vertical rectangles or 'medallions', or within circular or quatrefoil-shaped (four-leaved) compartments.

4. Cymatium: this area above the main panel is composed of small paintings that usually feature angels and sometimes busts of the angel Raphael and the Virgin Mary, representing the various elements of an Annunciation on either side of the retable.

5. Pinnacles or (more rarely) gables: these pyramid-shaped decorative elements ending in finials or triangles surmount the wooden framework of the retable, which is sculpted or worked to varying degrees and often covered with gold leaf.

the Middle Ages, but was also relatively common during the 16th and even 17th centuries. For a long time, wood was perceived to be a more solid and durable material than canvas. It was used for the fabrication of day-to-day objects, the decoration of which was entrusted to artists (such as wedding chests), and objects that were complex in shape such as crucifixes, which were painted in large quantities throughout the 13th and early 14th centuries. Wood was also indispensable as the material used for the elaborate framing of paintings, which were not autonomous items at this period: painted surfaces were simply a constituent part of the heavy and bulky altarpieces that represented a form of sculptural decoration. Their subjects were always religious; their intended place of use was the church.

Paintings executed on wood are characterized by their perfectly smooth appearance. The panels, joined together by wooden pegs (metal was avoided as it would rust), were polished and then covered with a coating or ground that was impermeable to water (*gesso*). The pigment was applied to this ground in the form of distemper, which used a binding medium of glue or gum, or tempera, which used egg, an emulsion of egg and oil, or varnish. Neither of these media allows the superimposition of one layer of paint over another or the creation of an impasto effect. A painting on wood using either of these methods is characterized by a visibly thin and uniform layer of paint. Its surface is generally matt unless the painter has added oil (so-called fat tempera) or a varnish to the egg binder. The only relief effect obtainable, other than that which results from the way in which the wood has been worked, is achieved through an accumulation of *gesso*, which is then covered as finely as the other parts of the painting with gold (applied as gold leaf) or pigment. This technique was used by Gentile da Fabriano for the crown and halo of the standing king, as well as for other areas of relief covered with gold leaf, in his *Adoration of the Magi*.

Canvas

The transition to canvas represented a genuine revolution. Paintings changed from being heavy, complicated objects to being easily transportable, generally self-contained works. While it was possible to combine several canvases on a wall in order to form an ensemble, it became rare and more difficult to integrate them into complex, fixed objects. Except when applied to a solid support, canvases are nailed to a wooden framework known as a stretcher, which is reinforced at its centre by two struts forming a cross (see p.3). This stretcher gives the canvas its shape, which is usually simple: a rectangle hung either horizontally (referred to in relation to contemporary works as landscape format) or vertically (portrait format).

There are just a few rare examples of canvas being used in the Middle Ages (one such being the altar frontal known as the *Parement de Narbonne*), but during the 15th century it became more widespread, becoming particularly popular in Venice at the beginning of the 16th century. In a city whose winter humidity caused frescoes to deteriorate rapidly, it was important to find an alternative to painting on walls. Canvases which covered walls but were not applied directly onto them were called *tele*, and proved to be reasonably long-lasting. In other parts of Europe, canvas prevailed for commercial reasons. Rolled up, paintings could be sold in places far away from where they were produced. Poussin, who was based in Rome almost continuously from 1624 up to his death in 1665, was thus able to sell work to collectors in France. This would have been impossible had he painted on wood.

The specific characteristics of all textile surfaces — the relative fragility of the fabric and the texture that results from the interweaving of warp and weft — help to determine the final appearance of the paintings executed on them. The addition of areas of relief, which would stretch and thus deform the canvas, was no longer possible, but the paint surface was in any case less uniform than on other supports. As with paintings executed on walls and on wood, a ground is first of all applied to the surface of the canvas. This preparation, generally white but occasionally coloured, forms a fine film. Providing the layer of paint on top of it remains thin, this film allows the structure of the canvas below to show

through. Fifteenth-century painters such as Mantegna, Hugo van der Goes and Dürer used a finely woven canvas known as *tela rensa*. The artists of the 16th century on the other hand, particularly the Venetians, preferred a twill-type canvas that displays chevrons or fish bones in its structure. The surface of their paintings thus appears coarse and prominently textured.

Attention should therefore be paid to whether the artist has chosen a fine or a coarse canvas. The characteristics of the pigment used by painters to cover their canvases is another, essential element affecting the appearance of their works.

Paint as a medium

Oil

The switch from wood to canvas happened at the same time that distemper and *tempera* were abandoned in favour of oil. While continuing to paint on wood in Flanders in the

1430s, the brothers Jan and Hubert van Eyck perfected (although did not invent) the use of a binding medium based on a quick-drying oil. This new procedure of theirs opened up significant possibilities. Mixed with oil but also diluted with a quick-evaporating spirit or resin, the paint used by the van Eyck brothers enabled them to depict minute details, something that had not been possible with the dense paint that had been used until then. An example of such fine details are the figures reflected in the mirror in the PORTRAIT OF GIOVANNI ARNOLFINI AND HIS WIFE.

The use of oils also allows painters to add subsequent layers of paint without impairing or covering up the layer below. Extremely fine and transparent surface layers are known as 'glazes'. Application of a glaze gently modifies the colour over which it is laid, allowing backgrounds to be shaded off or nuances of

Jan van Eyck, *Portrait of Giovanni Arnolfini and His Wife*, 1434, detail, oil on wood, 82 x 59.5cm. See also p.4.

flesh tone to be achieved. It also allows subtler colour combinations to be created than can be achieved by simply mixing colours on the palette. Furthermore, even if a picture has not been given a final coat of varnish, the oil that has been added to the pigment gives the end result a glossy quality that distinguishes it from paintings made using tempera.

All of these properties can be seen in oil paintings from the time of the van Eyck brothers, when the support used was still wood. The transition to canvas gave rise to other effects that were experimented with in Venice by Titian (towards the end of his career) and most importantly by Tintoretto. Thick paint, in other words pigment mixed with oil and only sparingly thinned, catches on the protrusions in the canvas. The relief obtained in this way can be light or emphatic, depending on how much paint the artist applies to the canvas: its effect is to create hollows and protuberances that will be played on by the light. In the 17th century, Rubens and Rembrandt used this technique, known as impasto, enthusiastically — it has been said of some of the latter's portraits that they can be 'grasped by the nose' — while Vermeer and Poussin remained true to a much thinner style of painting. Courbet and the Impressionists in the 19th century, and Jean Fautrier, Jean Dubuffet, OLIVIER DEBRÉ and Eugène Leroy (in France) and de Kooning (in the United States) in the 20th century have all made systematic use of thick brushstrokes or thick layers of paint.

Pigments

The kind of pigment used is another element worthy of consideration, regardless of the particular technique employed by the painter. For as long as paint was made by hand, deriving from natural elements processed in various ways (sometimes baked or dried and

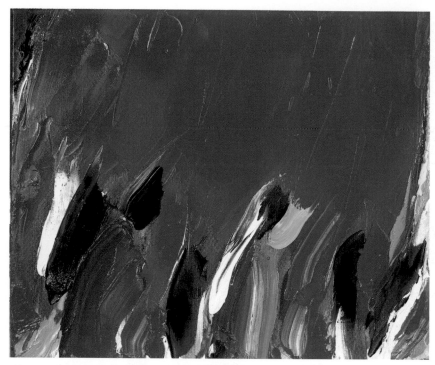

Olivier Debré, *Surgissement*, 1987, oil on canvas, 130 x 180cm, private collection.

generally ground), the range of colours available was limited. In *Il Libro dell'Arte* (*The Craftsman's Handbook*), which he wrote at the end of the 14th century, the Italian painter Cennino Cennini mentions twenty colours. This number increased gradually over the following centuries until the mid 1850s, when organic chemistry made a variety of artificial pigments available to artists. The packaging of ready-made paints in tin tubes (first produced in Great Britain in 1840), which relieved artists of the need to prepare their pig-

ments at the time of use or transport them ready-mixed in unwieldy bladders, was another major revolution. Tubes allowed painters to leave their studios. By taking with them the relatively little they now needed in a small case, artists were able to work and indeed complete whole paintings on the spot rather than make do with sketches or watercolour studies which they would then have to paint up in the studio, as had previously been the case. The Impressionists' technique was entirely dependent upon mass-produced tubes of paint.

Walls, wood and canvas are not the only supports, just as fresco, distemper, tempera and oil are not the only techniques. Parchment is the natural painting surface for egg tempera (using the yolk, white or a combination of both), used by the illuminators of the Middle Ages. Paper, which can either be smooth or

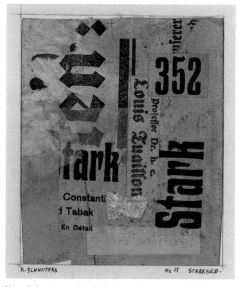

Kurt Schwitters, *Starkbild (Mz 11)*, 1921, 36 x 24cm, Houston, Menil Collection.

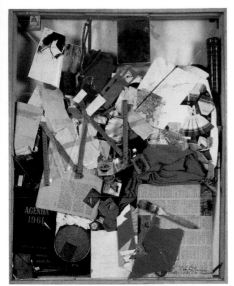

Arman, *Jacques de la Villeglé's Rubbish Bin,* 1965, collage, 24 x 16.5cm, Nîmes, Musée d'Art Contemporain, Carré d'Art.

textured, white or coloured, is the usual support for drawing (pencil, charcoal etc), pastels (Leonardo da Vinci's 'dry-colouring method') and the various water-based painting techniques: gouache (which, like a form of distemper, uses pigment bound with a type of gum), watercolour (which uses a similar pigment but in solution, in other words generously diluted in water) or water-based ink wash. Contemporary painters use acrylic as much as oil. Works are also produced not by applying pigment to a support, but by creating collages from cut paper (*STARKBILD* by Kurt Schwitters, *The Sadness of the King* by Henri Matisse) or by shredding posters collected in the street (Raymond Hains). Using a process which is halfway between painting and sculpture, and which resembles a form of coloured relief, artists such as *ARMAN* — one of the founders of the Nouveaux Réalistes (New Realists) group in France — gather together disparate objects, rubbish from urban and everyday life, on a two-dimensional support.

DIMENSIONS

The dimensions of a work — height first, then width — constitute an essential piece of information. Detailed measurements, to the nearest millimetre for smaller formats and to the nearest centimetre for very large works, represent a further element in the identification of a work. In the absence of a title or when the title is vague or generic (*Landscape*, *Composition*, for example), the size of the painting allows it to be distinguished from others in a large series. This is especially true of older paintings. The formats of contemporary canvases are often standard sizes, and therefore less indicative of a work's individuality.

Apart from the question of identification, a consideration of dimensions helps us form an accurate idea of the appearance of a work and of the choices made by the artist. In an age in which the public's main means of discovering art is through photography (reproductions in books or on CD-ROMs, slides etc), small-format paintings are almost always shown the same size as frescoes. Artists have always employed different methods, however, depending on whether they are working on small or large pictures. In the case of an illumination, a predella panel or more generally a drawing or very small painting, an artist would expect the viewer to examine the work from close up. Rather than sacrificing detail, he or she would be tempted to increase the amount of detail, secure in the knowledge that the art lover will be able to see it all. Very large works, by contrast, are generally placed a long way from the viewer, and Michelangelo's frescoes on the ceiling of the Sistine Chapel in the Vatican look down on the public from a height of more than 20 metres (see p.60). Given these conditions, it would be pointless to include too much detail as it would not be seen and would muddy the composition. The same applies to colour: gradation of tone and an extensive colour range are easy to appreciate in a work viewed from close up while a simpler use of colour is preferable for works designed to be viewed from a distance.

The reverse is also true. If a reproduction does not supply the dimensions of a work, an examination of its forms and colours should allow us if not to guess the exact size of the original, at least to gain an approximate idea of it. The habit of painting in one format in particular, whether large or small, influences the way in which an artist works. In Italy, where mural painting was commonly practised, composition is highly coherent or synthetic. Forms are treated in terms of carefully structured ensembles without artists feel-

ing the need to overload them with detail. In the north, where illumination and paint-
ing on wood held sway, and where engraving originated, painting methods were more
analytical. The van Eyck brothers, who were illuminators before turning to wood, owed
much of their prestige to their ability to depict minute detail — the splashes from a
fountain in *The Adoration of the Mystic Lamb* from the Ghent Altarpiece, for example,
or the multiple reflections of the Virgin on a suit of armour in *The Madonna with
Canon Van der Paele*.

When they turn to new formats, artists who enjoy painting detail find it difficult to
break the habit. Dürer, an engraver by trade and therefore accustomed to expressing
himself in small formats, tried his hand in Venice at considerably larger paintings fea-

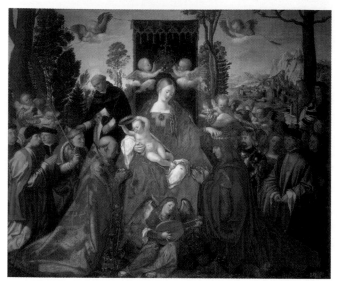

Albrecht Dürer, *Festival of the Rosary*, 1506, oil on wood, 162 x 194.5cm, Prague, Národní Gallery.

turing vivid colours. His *FESTIVAL OF THE ROSARY*, painted in the city of the Doges in
1505–6, was designed to rival the Holy Conversations (the Virgin with the Child sur-
rounded by saints and angels) painted by the artists of northern Italy. An example of this
type of work is the *SAN GIOBBE ALTARPIECE* by Giovanni Bellini, the major Venetian painter
of the day. Whereas Bellini distributed nine figures harmoniously around the Virgin, and
gave the scene an architectural setting, specifically a chapel ending in a blind wall, Dürer
set it outdoors, adding a complex landscape of mountains and forests. He also introduced
a feast of colour that is absent from Bellini's picture, making use of delicate transitions
between browns, oranges and reds in order to emphasize the motifs and textures of the
costumes of the pope (on the left) and the emperor (on the right).

BACKGROUND HISTORY AS AN AID TO UNDERSTANDING

Familiarity with the history of a painting — following its varied journey from commis-
sioning to present whereabouts — enables us to establish once more its authenticity
and to gain a better understanding of it. The history of a work of art is often also a
reflection of wider historical events: its neglect or rediscovery are the result of chang-
ing taste; the dangers it is exposed to, its prohibition or even its deportation are the
consequence of religious and political events.

Documenting the work

The information available about a work can sometimes be very complete, but it can
also be full of gaps. Contracts dating from the end of the Middle Ages, correspondence
from the time of a work's execution, court records relating to any disputes that may

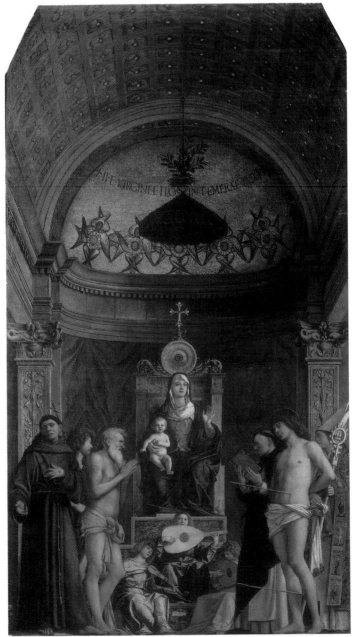

Giovanni Bellini, *San Giobbe Altarpiece*, c.1470–5, oil on wood, 471 x 258cm, Venice, Galleria dell'Accademia.

have arisen – all these documents, where they exist, allow us to follow both the chronology of the painting and the conditions under which the painter worked. These include not only material facts such as the number of figures an artist had to include in a work and the pigments he had to use, but also the cultural conditions, since records of this kind tell us about the period and the personality of the individuals who commissioned the work.

This situation changed with the gradual emergence of an art market from around the beginning of the 18th century. Whereas previously painters had produced work to order, executing subjects chosen by someone else in a format also chosen by that per-

son, they were now free to paint whatever they wanted. They entrusted their finished work to an art dealer — the term 'gallery' came into use at the end of the 19th century – who organized periodic exhibitions during which the major sales would take place. This does not mean that commissions have completely disappeared today, but those that are awarded comprise only a small proportion of artists' overall output and are mainly official commissions (for the decoration of public monuments, for example). Documentation of works was now to be found elsewhere. Letters between patron and painter were replaced by those between dealer and painter; more and more painters started to keep journals in which they recorded their work; and gallery owners would retain visitors' books, exhibition catalogues, sales invoices, photographs and so on.

The neglect and re-emergence of works

The inclusion of a painting in ancient collections or references to it in old documents are valuable clues that allow historians to authenticate a work or identify its author. It is not unknown, however, for paintings that have been completely or virtually forgotten to reappear in the marketplace without a great deal being known about their origins. This is often the case when an artist who was once famous is subsequently forgotten and not rediscovered until several centuries later. This is true of the painter Georges de La Tour. Celebrated during his lifetime, he disappeared more or less completely from 18th- and 19th-century histories of painting and his work was only rehabilitated by experts in the interwar years of the 20th century. Long-neglected canvases by him that had become anonymous in obscure collections subsequently reappeared at auction and top prices were paid for them by the world's major museums, particularly the American galleries.

As a result of years of neglect, certain pictures can reveal a new aspect of a painter's work when they are exhibited again and can exert a considerable influence on the art of the age in which they are rediscovered. Ingres's *Turkish Bath* was bought by the ambassador to Paris of the Sublime Porte, Khalil Bey, after Napoleon III had previously bought it and then returned it to the artist. The painting was started in 1859, but was not exhibited publicly until 1905, at a retrospective dedicated to the artist held at the Salon d'Automne. Markedly erotic by early 20th-century standards, the canvas caused great astonishment. Quotations from or direct allusions to the painting can be found in works by young painters of the day, including Matisse in *The Joy of Life*, on which he started work in the winter of 1905–6 (Barnes Collection, Meryon, Pennsylvania), Derain in *The Golden Age* (Museum of Fine Arts, Teheran) and Picasso in *The Harem* (Cleveland Museum of Art, Hanna Collection), a work dating from summer 1906 that paved the way for *Les Demoiselles d'Avignon*.

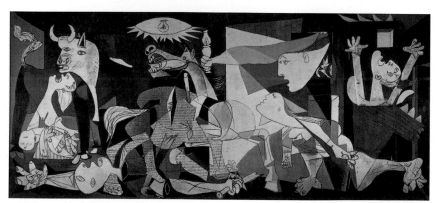

Pablo Picasso, *Guernica*, 1937, oil on canvas, 349.3 x 766.6cm, Madrid, Centro de Arte Reina Sofia.

Adventures and misadventures

The 'pedigree' of a work may also be worth mentioning, perhaps because of the prominence of its successive owners or because of the richness of its history. The GHENT ALTARPIECE, painted by the brothers Hubert and Jan van Eyck between 1425 and 1436 and now in a chapel of the Cathedral of St Bavon in Ghent in Belgium, is one example of a work with a turbulent past. During the upheavals of the Reformation, the altarpiece was hidden from iconoclasts firstly in the cathedral's tower and subsequently in the town hall. Two hundred years later, the paintings of *Adam* and *Eve* were denounced as indecent and removed from the polyptych. In 1794, French Republicans confiscated the four central panels and transported them to Paris. They were restored to the altarpiece in 1816. During the 20th century, the work suffered further mishaps. In 1934, two panels from its lower tier were stolen: *St John the Baptist* was found in the left-luggage office of a railway station, but the *Just Judges* disappeared for good and was replaced by a copy. Finally, during World War II, the polyptych was removed by the Germans from Pau, where it had been taken for safekeeping, and was rediscovered in 1945 ... in a salt mine in Pomerania.

Many 20th-century works have also had a hard time of it. In an age of totalitarian regimes of both right and left, paintings disappeared either because they were critical of the regime or quite simply because they were judged to be too modern. In Germany, the Nazis burned pictures after publicly condemning them in the 'Degenerate Art' exhibition in Munich in 1937. Works denouncing the horrors of war, such as *The Trench* and *War Cripples* (depicting a procession of blind war veterans) by Otto Dix are now known only from photographs. Instead of destroying avant-garde works, the Soviet regime, similarly mistrustful of modern art, relegated them to the storerooms of its museums, from where they have finally been re-emerging over recent years. As a result of this policy, the paintings of Kasimir Malevich, for example, became far better known in the West than they were in the Soviet Union. Conscious of the hostility of the authorities, in 1927 the artist decided to send a number of his works to Germany and left them there. For other, obvious reasons, Picasso's famous painting GUERNICA, a gift from the artist to his country, remained outside Spain for many years. Painted in the weeks following the bombing of the Basque town of the same name and exhibited in the pavilion of the Republic of Spain at the Paris World Fair of 1937, it was sent at the artist's request to the United States and deposited with MOMA (Museum of Modern Art) in New York with the proviso that it be returned to the Spanish government on the restoration of democracy. This duly happened in 1981. Today the work is on show at the Centro de Arte Reina Sofia in Madrid.

Jan van Eyck, *Eve*, c.1432–6, panel from the Ghent Altarpiece, oil on wood, 213.5 x 36.1cm, Ghent, Cathedral of St Bavon.

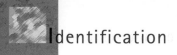

Original setting and current location

While it is customary to give the current whereabouts of a painting, in general this is only relevant for the purposes of documentation. It is more important to reconstruct mentally, or to attempt to reconstitute, the original conditions under which the work was displayed.

This process of reconstitution is essential in the case of a dismantled altarpiece. The iconography of paintings which we consider today to be separate works, as well as their choice of colours and composition, can in part be explained by the relative position of these paintings within a group. Thus a triptych that includes portraits of the donors will often feature the Virgin or a holy scene in its central panel, with the male donor and his sons, if any, on the left wing (viewed from the front) and the wife and any daughters on the right. A man and a woman contemplating the central figure or scene are thus depicted symmetrically, in profile or three-quarter profile. The richest colours – in particular an expensive type of intense blue – were reserved for the central panel. All of this needs to be taken into account even if we are viewing only a single panel on its own in a gallery.

It is also useful, even if the painted object is exhibited in its entirety, to try to imagine it in the location for which it was made. For example, Giovanni Bellini designed the San Giobbe Altarpiece (the altarpiece that Dürer measured himself against) for the particular position it was to occupy on the altar of a church in Cannaregio. He devised the architectonic framework of the painting in such a way as to create the illusion that it was a chapel opening into the wall behind the altar. In the plain room of the Galleria dell'Academia in which the altarpiece now hangs, the trompe-l'oeil effect is completely lost. Lighting effects and iconographic devices can also be explained by the specific characteristics of the work's initial location.

Finally, when studying a painting from photographs of individual details, it is important to take account of the precise position of these details within the work and of the position of the work in space. The Florentine painter Giotto, for example, gave the faces of the figures in his frescoes brown outlines, large, elongated eyes and deep fur-

Michelangelo, detail of the ceiling of the Sistine Chapel, 1508–12, before restoration.

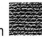

rows at the temple and on the forehead. Viewed from close up, either from scaffolding or from detailed photographs, this technique seems heavy-handed. When such detail is returned to the context of the image as a whole, in other words when the faces are viewed from a distance of several metres, this detail can be seen for what it is: a device that enables the facial expressions of the figures to be seen and understood by the viewer.

STATE OF CONSERVATION AND RESTORATION

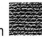

When we view old works of art today, they no longer look as they did when first painted. In the best cases, the deterioration will be superficial: cracks in the painting and a more or less noticeable alteration of the colours and therefore of their relative values do not fundamentally damage the work. They do not destroy its emotional power, which can even increase as a result of the character and patina of history acquired by objects over a period of time. In other cases, however, the damage can be far greater. Variations in temperature and humidity, natural disasters (such as floods and fires), war, vandalism or simply the negligence of successive owners often cause irreparable damage. Cut into pieces and stripped of their skin of pigment to varying degrees, paintings can often be reduced to islands of form separated from each other by empty spaces. Providing it is not already too late, cases such as these require the intervention of a restorer. The restoration of a painting is always a delicate operation, however. It needs to be discreet and it also needs to be reversible, in other words it must be possible to undo the restoration without damaging the painting. This calls for a considerable amount of scientific and technical research to be performed before any work is actually carried out on the painting. The knowledge acquired during this process is of great value to art historians. It allows them to identify the type of pigment used and sometimes as a consequence to pinpoint the workshop involved, to date works accurately or even to uncover fakes. It can also give them the opportunity to gain a better understanding of the gestation of a painting. Photographs taken using low-angled light and X-ray photography – techniques used in the preliminary

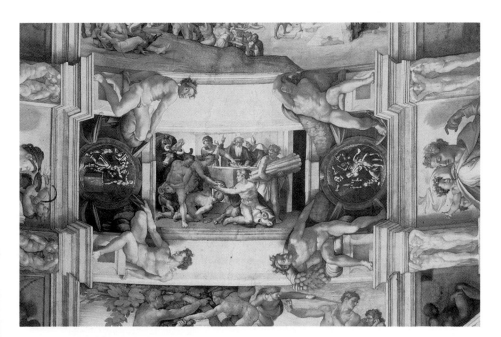

Michelangelo, detail of the ceiling of the Sistine Chapel, 1508–12, after restoration.

stages of a well-conducted restoration – have revealed, for example, that during initial work on *The Tempest* (see p.6), Giorgione had painted not a page or a shepherd, but another naked young woman. This discovery has not helped art historians explain the theme of the work, but it has at least allowed them to eliminate simplistic interpretations.

Restoring and undoing restoration work

When looking at a work of art we need to be aware of the transformations wrought by time. We also need to be able to spot the work of successive restorers and to assess the condition of the painting in order to gauge the need for future restoration work or to appraise it once it has been carried out.

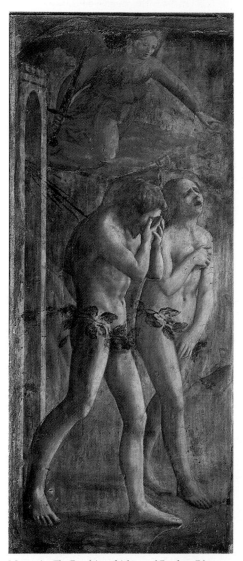

Masaccio, *The Expulsion of Adam and Eve from Eden* (before restoration), 1426–8, fresco, 214 x 90cm, Florence, Brancacci Chapel, Santa Maria del Carmine. See also p.9.

The simple cleaning of a painting is the basic remedial procedure of restoration, although this is always a delicate operation in which care has to be taken not to remove any of the pigment. Cleaning consists of removing varnish that has yellowed over the course of time, or more straightforwardly of removing any dirt that has accumulated on the surface of the paint. This process can lead to surprises. After nine years of restoration (1985–94) the brilliant, even violent colours of Michelangelo's frescoes on the ceiling of the SISTINE CHAPEL, which had been hidden for centuries beneath a dark film from the smoke of candles lit by the faithful, re-emerged in all their glory. While some people cried out in indignation, others praised the process of rejuvenation that had led to the rediscovery of Michelangelo's qualities as a bold colourist.

Another element of the restorer's job is the removal of poor work left behind by previous restoration. This process can be drastic. In the 1950s, restorers removed 19th-century retouching from frescoes by Giotto in the Bardi Chapel in Santa Croce in Florence without being able to salvage the artist's own work. The yawning gaps that resulted completely ruin Giotto's composition.

The decision whether or not to remove retouched areas of painting does not depend solely on the possibility of rediscovering the original layer of paint beneath the additions, but also on the historical desirability of such an intervention. Having undergone careful cleaning, the two figures in THE EXPULSION OF ADAM AND EVE FROM EDEN in the Brancacci Chapel, for example, were stripped of the 'fig leaves' they had been forced to wear during the more prudish 17th century. During restoration of the *Last Judgement* in the Sistine

Chapel (see p.67), the decision was taken on the other hand not to 'undress' the figures. In painting them naked, Michelangelo had provoked a scandal (alluded to in famous texts including a letter written by Pietro Aretino) that resulted in a decision by the Council of Trent (which was primarily concerned with the reform of the Roman Catholic church) to hire an artist to 'cover up' the areas considered to be 'obscene'. (The chosen artist, Daniele da Volterra, earned himself the nickname Braghettone, the 'maker of breeches'.) This episode is so well known, and reveals so much about the issues of censorship that artists are faced with, that it was decided to retain the *braghette*, or at least a number of them, as historical documents.

Restoration is not solely concerned with removing material. When a painting has irreparable gaps, a decision is sometimes taken to fill in the spaces by adding pigment in order to restore an appearance of completeness to the painted surface. In such cases restorers take care to ensure that even a casual inspection of the painting will allow the viewer to distinguish between the restorer's additions and the original work of the painter. Instead of applying paint in a continuous layer, the restorer will fill in the gaps with a dense network of dotted lines, for example. Sometimes, however, a restorer will refrain on principle from completing the work, either because there is too much missing material or because it is still meaningful in its existing state. A large part of Rembrandt's THE ANATOMY LESSON OF DR JOAN DEYMAN — less well known than his *Anatomy Lesson of Dr Nicolaes Tulp*, which has been preserved in its original format (see p.42) – was destroyed in a fire. By recentring the composition on the cadaver on which the autopsy is being carried out, on the hands exploring its brain, on the abdomen that has been opened up and on the top of the skull being held like a dish, the accident has concentrated the meaning of the painting, perhaps rendering its lugubrious message even more shocking for modern sensibilities than if the picture had remained intact.

Rembrandt, *The Anatomy Lesson of Dr Joan Deyman*, 1656, oil on canvas, 100 x 134cm (in its current state), Amsterdam, Rijksmuseum.

Subject

Until the beginning of the 20th century, all painting was figurative: it depicted forms that resembled real objects and beings. The degree of realism, or in other words the degree of resemblance to the physical world, varied from period to period and according to the aims of the painter. The range of subjects represented during this time was diverse. Throughout the Middle Ages, however, all subject matter was religious. Paintings depicted holy figures, recounted their stories or legends and gave the faithful a glimpse of the hereafter (heaven or hell). Secular subjects started to appear in the 14th century, when a greater number of ancient texts began to be copied, illustrated and, a little later, printed. These non-religious narratives were put into pictures by illuminators and engravers, and in turn were the inspiration for the decoration of palaces. The same period also witnessed the emergence of a preoccupation with naturalism: nature crept into paintings in the form of plants and animals; architecture and objects from everyday life followed soon after. Individuals — great princes and patrons — demanded that painters portray them in a recognizable manner. Different 'genres' developed, and it became common to divide works up by subject matter: 'history paintings', 'genre paintings' (scenes of everyday life), 'portraits', 'landscapes' and 'still lifes'.

HISTORY PAINTING

The term 'history painting' was used to refer to all works depicting in narrative or symbolic form 'serious' subjects designed to be spiritually uplifting and to educate the viewer. In a development that began in France, from the 17th century onwards paintings with religious subjects, mythological subjects, allegorical subjects and historical subjects in the strict sense were all described as 'history paintings'. For French critics of the time, starting with the scholar Félibien (1617–95), the purpose of art was not only to delight the eye, but also to elevate the soul. A hierarchy of genres was established that regarded history painting (known in France as 'le grand genre' and in England as 'the Grand Manner') as the only genre truly worthy of being practised. In addition to human history (often in reality that of kings and battles), this genre included religious history (episodes from the Old Testament, the life of Jesus and the saints), mythology (subjects taken from the great classical authors) and certain modern tales (such as Dante's *Divine Comedy* and Tasso's *Jerusalem Delivered*). History painting depicted figures that were expected to resemble their real-life counterparts (if the scene involved real people) in plausible settings, which also had to be historically convincing if the scene was set in bygone days. History painting was therefore regarded not only as the most noble of genres from a moral point of view, but also the most technically difficult (artist having to be simultaneously portrait painter, landscape painter etc) and intellectually demanding (presupposing learning and a feeling for history).

'Le grand genre'

Having been closely connected to the absolute monarchy's control over artistic creation in France, the doctrine of the hierarchy of genres (the division of painting into genres also corresponded to a distinction among the different poetic categories of literature) and the primacy of history painting survived well beyond the reign of Louis XIV. The dream of every artist up to the end of the 19th century was to become established as a

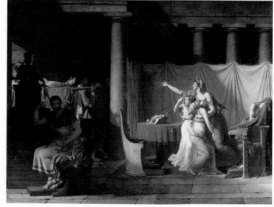

Jacques Louis David, *The Lictors Returning to Brutus the Bodies of His Sons*, 1789, oil on canvas, 323 x 422cm, Paris, Musée du Louvre.

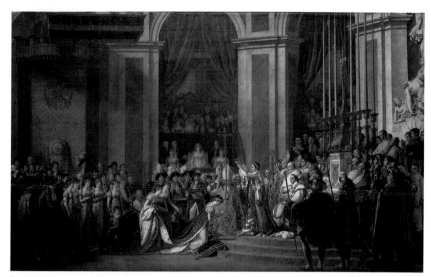

Jacques Louis David, *The Consecration of the Emperor Napoleon I and the Coronation of the Empress Josephine in the Cathedral of Notre-Dame de Paris on 2nd December 1804*, 1805–7, oil on canvas, 629 x 979cm, Paris, Musée du Louvre.

history painter. This was the key to success and to winning the Prix de Rome, a highly competitive prize awarded by the Académie Royale des Beaux-Arts and accompanied by a bursary to study in Rome. Winning the prize also meant a coveted place for the laureate's work at the Salons, a precondition for securing important commissions.

If Charles Le Brun, the predominant artist during the reign of Louis XIV, is regarded as the most accomplished of history painters, Jacques Louis David, a century later, was a worthy successor. From the eve of the French Revolution to the last days of the First Empire, David personified the desire to paint an epic account of the French people and to commemorate their moments of triumph in the form of great moral lessons accessible to the ordinary person. Prior to 1789, David revived the image of heroic Roman soldiers in paintings such as *Belisarius Begging for Alms* (1781), *The Oath of the Horatii* and THE LICTORS RETURNING TO BRUTUS THE BODIES OF HIS SONS. These canvases feature a small number of figures (the 'grand genre' is not necessarily overblown), the colours are sober, the scenery is restricted to colonnades and classical architecture, the composition is simple, characterized by a rigorous geometry, and the dimensions are large: over three metres by four in the case of *The Oath of the Horatii*.

The paintings that followed over subsequent years were even more ambitious. In his unfinished *The Tennis Court Oath* (1790), David attempted to transform a recent political event — the gathering of the Third Estate and the clergy in the National Assembly in order to promulgate the first constitution — into a 'sublime' image. A sketch for a fragment of the composition (part of the collection of the Palace of Versailles) is 648cm wide, giving an idea of how big the final work would have been. The *Intervention of the Sabine Women*, completed nine years later, takes an episode from Roman history and uses it to deliver a pacifist message.

THE CONSECRATION OF THE EMPEROR AND THE CORONATION OF THE EMPRESS (1805–7) is even larger (629 x 979cm), and deals with the transformation of Napoleon Bonaparte's rule into a monarchy. In his commemoration of the event, David does not this time idealize what happened. He was present at the ceremony and depicted it as he saw it — or at least created the illusion of doing so. The framework for the consecration (the choir of Notre-Dame), those present, their dress, their gestures — including that of Napoleon crowning Josephine — all are recognizable. On the instructions of Napoleon, however, David has included the emperor's mother (who was not present) among those seated in the main rostrum; and despite the realistic positioning of dignitaries on either side of the choir, he

THE INTERVENTION OF THE SABINE WOMEN

In *The Intervention of the Sabine Women*, David has depicted a well-known subject from Roman history, one documented by a number of renowned writers, notably Livy in his *Histories* (I, 12) and Plutarch in his *Life of Romulus*. However, instead of depicting the rape of the Sabines by the Romans (who had come in search of wives with whom to found a new people), he has chosen to depict the moment several months or several years later when the Sabines come to avenge their honour and take back their women. The Sabine women call for peace from their position between the combatants (their original families on one side, and their husbands and the fathers of their children on the other). In the context of the France of 1799, which was seeking reconciliation at home and peace in Europe, this episode of history had clear resonances. Its treatment here, rich in secondary incident, has turned it into a complex and dramatic story.

Small figures on the ramparts of Rome continue to fight.

A mother holds her child above the spears of the Sabines.

An officer on horseback holds back the Sabine soldiers.

Tatius is the Sabine leader. The hero's nudity (discreetly concealed by the sheath of his sword) was justified by David, who invoked the 'custom among ancient painters, sculptors and poets to depict naked the gods and heroes and in general all men to whom they wished to lend distinction.'

Hersilia, whom historical sources name as the wife of Romulus, separates the combatants. Plutarch has her say: '...Restore to us [...] we entreat you [...] our fathers and brothers, but rob us not of our husbands and infants among the Romans.'

Oblivious to the drama unfolding around them, young children are playing and a newborn baby is daydreaming apparently unconcerned. Some of them nevertheless look towards the viewer, whom they invoke as a witness.

26

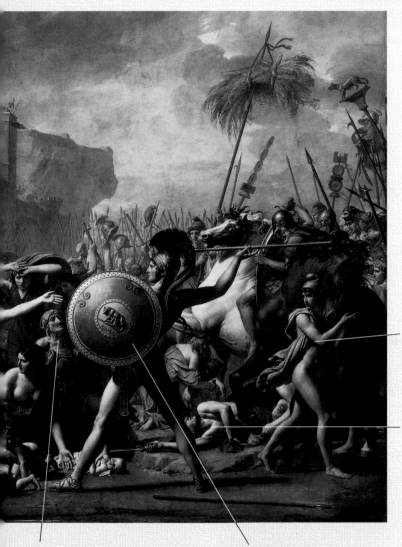

Jacques Louis David, *The Intervention of the Sabine Women*, 1799, oil on canvas, 385 x 522cm, Paris, Musée du Louvre.

A groom holds back a horse. His body frames the composition.

The dead body of a soldier testifies to the violence of the fight that has already begun.

An old woman rends her garment in a gesture of anguish. Behind her, a young woman hurls herself forward from the background. Their red and green dresses bring together complementary colours, a traditional method of attracting the viewer's eye. In front of them a bare-breasted Sabine woman gestures towards her children, indicating that they would be the real victims of any combat in which their fathers or uncles died.

Romulus, identifiable from the she-wolf on his round shield, is shown in a posture almost identical to that of Tatius. David is in effect moving around their bodies, showing them from the front and the back in the manner of a sculptor.

has cleared the foreground of spectators who might have been there in order to give viewers the impression of being present at the scene themselves.

The development and transformation of history painting

It was not only in France that history painting thrived. It flourished particularly in those countries in which strong monarchical power favoured the commissioning of large works celebrating the glory of the monarchy. In Spain, for example, this type of painting was encouraged by royal patronage. Diego Vclázquez, appointed court painter to King Philip IV in 1623, gradually gave up painting humble tavern and kitchen scenes, subjects he had been painting since his youth in Seville. THE SURRENDER OF BREDA (also known as *The Lances*), which he painted at the beginning of the 1630s, celebrates the capitulation of this city in the southern Netherlands to Spanish forces commanded by General Spinola in June 1625. Using a lighter palette than that used in the paintings we have just looked at (the events took place outside, in winter), this painting displays many of the most common characteristics of history painting: its large format (307 x 367cm), its concentration on a small number of important figures in the midst of others who merge into a barely recognizable crowd, its sober and eloquent gestures that lend the episode a certain humanity, and a setting that is simultaneously realistic (the landscape in the background resembles a military map) and idealized in order to achieve epic grandeur (the blue background blurring the natural features behind the line of lances). Although history painting was connected to the 'grand genre', to the nobility of the classical style characterized by dignity and restraint, it did not by any means die with it. Around 1810, during the Spanish war of liberation against the French occupation, Francisco de Goya worked on a series of engravings called *The Disasters of War* which denounced the horrors perpetrated during war. In 1814 he completed two large pictures, *The Second of May, 1808* and THE THIRD OF MAY, 1808 (Madrid, Museo Nacional del Prado). The second of these, which features a stark contrast between black and yellow and between areas of intense light and extreme darkness, is treated without the addition of any decorative element glorifying the scene, and the lamp in the picture is a mere stable lamp of simple design. This is far removed from the

Diego Velázquez, *The Surrender of Breda* or *The Lances*, 1634–5, oil on canvas, 307 x 367cm, Madrid, Museo Nacional del Prado.

Francisco de Goya, *The Third of May, 1808*, 1814, oil on canvas, 268 x 347cm, Madrid, Museo Nacional del Prado.

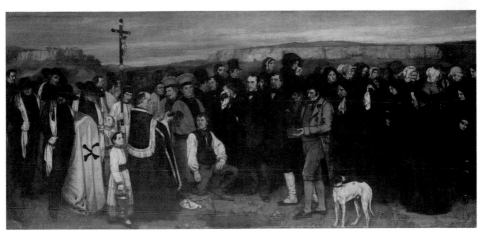

Gustave Courbet, *A Burial at Ornans*, 1849, oil on canvas, 313 x 664cm, Paris, Musée d'Orsay.

traditional reserve and pomp of earlier historical paintings, and serves to make the final, harrowing appeal of the condemned man all the more potent and distressing. An even greater shift can be seen in paintings produced during the following decades. Courbet's *A BURIAL AT ORNANS,* painted during the summer of 1849, is an immense work in which the painter tackles a solemn subject: death. He has arranged the full-length figures in a solemn cortege converging on the empty grave at the centre of the composition. Eschewing all pathos and setting his figures against a real landscape in the eastern French countryside of Franche-Comté, he has chosen to make the heroes of this painting anonymous middle-class individuals who have gathered for the burial of a person whose identity is also unknown to us. In short, he has opened up history painting to the trivial events of everyday life. Thirty-five years later, Seurat was to do a similar thing with *Bathers at Asnières* (see p.64), whose format (201 x 300cm) again links it to history painting. This painting, moreover, was designed by its young artist to be exhibited at the Salon, but was refused by the jury in early spring 1884, no doubt because the depiction of members of the Parisian working class at leisure on a canvas of such monumental proportions was found too shocking.

This 19th-century revival of history painting enabled it subsequently to find a place in the art of the 20th century. Indeed, it could be claimed that the genre was given fresh impetus during the 20th century by further tragedies of the type found throughout history. *Guernica*, dating from 1937 (see p.18), is a history painting. Basing it on distorted, sectioned and fragmented forms (reminiscent of the Cubism he abandoned after 1915), Picasso wanted to perpetuate in it the memory of the aerial bombardment that claimed 800 victims among the population of the small Basque town. The painting tells of humanity's suffering, the oppressor's lack of restraint, and the cries of innocent civilians, victims of wars they do not understand. From left to right loom a bull (a symbol of brutality), a mother mourning her dead child, the dismembered corpse of a soldier, a panic-stricken horse (representing suffering) and a woman shrieking with terror.

From narrative to allegory

Another, specialized class of painting belonging to the genre of history painting is the allegory. Allegories depict deeds in symbolic, rather than narrative, form. In the words of the 18th-century French author of a dictionary of iconology, the allegory allows for 'the communication of a simple idea in an agreeable manner that pleases the imagination'. Whereas a narrative might require a series of individual accounts, allegory delivers a message in a synthetic or all-encompassing way: 'An artist charged with the task of depicting the capture of several towns, for example, could not accomplish this with historical accuracy in a single painting [...]; to do so he would have to enter into a degree of detail that the available space would not allow. If, however, he summoned Allegory to his aid, nothing would be easier. He could then depict Victory with her customary attributes, holding the coats of arms of the captured cities, or show this

allegorical figure inscribing the names of these towns or fortresses on a shield.'

Using a code

The painting of allegories assumes a level of learning on the part of the public that will allow them to distinguish allegorical figures from real individuals and to recognize the symbols enabling those figures to be identified. During the Middle Ages, religious sculpture and painting had taught the faithful to identify the saints from their emblems: keys denoted St Peter, a lamb St John the Baptist, flayed skin St Bartholomew and intestines St Erasmus. From the Renaissance onwards, illustrated dictionaries taught a more limited public of art lovers the language of symbols. From then on, at least during the 17th and 18th centuries, when this type of publication was particularly widespread, artists could expect their public to recognize the gods: Saturn as an old man armed with a scythe, Jupiter as a bearded man armed with a thunderbolt and accompanied by an eagle, or Neptune as a male figure holding a trident. They could also assume that viewers of the painting would be able to interpret the personification of concepts immediately and accurately: Prudence as a woman with a mirror surrounded by snakes, Justice as a female figure holding up scales and a sword, the Rivers as recumbent old men wearing garlands of reeds and clasping urns. Today we have largely forgotten this language of metaphor and many of the allegories have become obscure. It is essential when confronted with such paintings to consult either old dictionaries or modern reference works that provide a key.

Even without reference works, however, a small amount of careful observation can help the viewer identify a figure as an allegory and work out the intentions of the artist. During the Classical period of the 17th century, artists adopted the techniques of history painting to portray allegorical subjects: dimensions were often large, allegorical figures were partially naked (their bodies appear idealized rather than made of real flesh and blood)

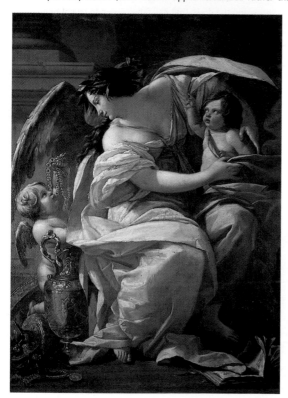

and their dress was timeless, consisting not of clothing that could be accurately dated, but of drapery. This is true of *ALLEGORY OF WEALTH*, one of the most beautiful canvases by Louis XIII's favourite artist, Simon Vouet. In this large-format work, the female figure personifying wealth has been painted larger than life-size. The scenery has been reduced to plinths of columns supplemented only by the gold and silver vessels and pearl and diamond necklaces that unambiguously illustrate the theme of the painting. The female figure is swathed in white and yellow drapery that nevertheless leaves areas of pale, flawless flesh uncovered. The wings on her back help the viewer to establish that this is unquestionably a metaphorical creature and not the portrait of a real woman.

Simon Vouet, *Allegory of Wealth*, undated, oil on canvas, 170 x 124cm, Paris, Musée du Louvre.

History as allegory

Occasionally, allegories are combined with historical narrative. This blending of genres is usually found in works that do not belong to the French Classical period. In his cycle of paintings celebrating the life of Marie de Médicis (Musée du Louvre, Paris), the Flemish painter Peter Paul Rubens devoted a large canvas, dating from sometime after 1621, to the queen's arrival in Marseilles (see p.211). This well-documented scene, accurately reconstructed by the painter, shows Marie advancing down the gangplank accompanied by her ladies-in-waiting while a Knight of the Order of Malta remains on the galley that has brought her to port. In the sky, Rubens has added a winged female allegorical figure blowing trumpets. The distinguished citizens of Provence who came to welcome the young wife of Henri IV have been replaced by allegorical figures personifying the French monarchy and the city of Marseilles. Finally, three powerfully built and completely naked Sirens, some Tritons and the god Neptune cavort in the water while commenting on the event.

The inclusion of allegorical elements is sometimes rather more discreet than this. In Delacroix's famous painting LIBERTY GUIDING THE PEOPLE, which commemorates the Trois Glorieuses, the three-day revolution of 1830, a barricade occupies the centre of the canvas. In the background, a glimpse of the towers of Notre-Dame de Paris and a tiny tricolour make the context clear: on the second day of the revolution (28 July 1830), the three-colour flag was raised on the cathedral and the reactionary monarchy of Charles X was overthrown for good with the capture of the Hôtel de Ville. The figures in this painting have been chosen for their symbolic value. The child brandishing the pistols is the type of Parisian urchin later immortalized by Victor Hugo in Les Misérables. The young man in frock coat and top hat represents the archetypal bourgeois. The sabre-holding man and the boy wearing the red scarf on his head at the feet of Liberty recall the participation of the workers in the July Revolution. Liberty herself does not symbolize any single class or group. She is taller than the other figures, and the dress that has fallen down to reveal her chest and her classical profile turn her into an idealized type, an eternal figure — even if her powerful bust and underarm hair lend her an immediate reality that transforms this allegorical figure into a 'fishwife', as a number of hostile critics wrote at the time.

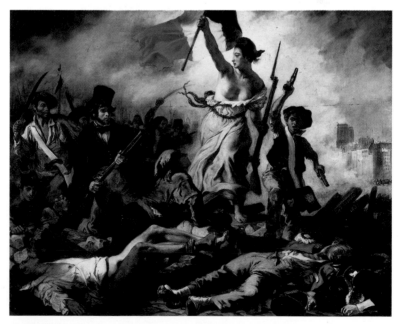

Eugène Delacroix, *Liberty Guiding the People*, 1830, oil on canvas, 259 x 325cm, Paris, Musée du Louvre.

Subject

THE PORTRAIT

The portrait occupies an ambiguous place in the hierarchy of genres. Because its subject is man, a creature made in God's image, it ought to occupy second place after history painting, which glorifies man's moral greatness. However, the celebration of individuals known to no one outside the family circle or forgotten after a limited period of time offended the moral sense of critics who saw in this genre only the glorification of personal vanity. Yet these reservations did not prevent the portrait from enjoying a phenomenal success.

The birth of the portrait

The realistic portrait was not unknown in the ancient world. Sculptors in Etruscan and subsequently Roman Italy and the Fayum painters of late Egypt produced numerous works depicting strikingly naturalistic bodies and faces. By exhorting the faithful to turn their attention to the hereafter, however, the Christian revolution broke with this tradition. In the art of the early Christian era and the first centuries of the Middle Ages, there are no depictions of individuals in which a faithful resemblance can be discerned. It was not until the 14th century, and more importantly the 15th century, that — thanks to the advance of naturalism and a renewal of interest in the individual — the production of images of unique personalities, painted in a manner that made them recognizable, was revived.

Dating from the end of the Middle Ages, the first 'pure' portraits — in other words depic-

Anonymous (French school), *Jean II Le Bon, King of France*, c.1360, tempera and gold leaf on wood, 60 x 44.5cm, Paris, Musée du Louvre.

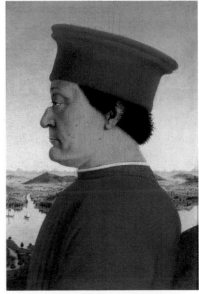

Piero della Francesca, *Double Portrait of the Duke and Duchess of Urbino (Frederico da Montefeltro and Battista Sforza)*, c.1465–70, two wings of a diptych, tempera on wood, each 47 x 33cm, Florence, Galleria degli Uffizi.

tions of solitary sitters in paintings containing no other subject – were those of monarchs. It would have been unthinkable at that time for the image of an ordinary individual to be the main subject of a work. These portraits were modelled on antique medals. Painters concentrated on the face, rendering it in profile, and of the rest of the body showed only the shoulders, as in the portrait of JEAN LE BON, painted in the middle of the 14th century. This type of portrait – just shoulders and profile – was predominant in Italy throughout the 15th century. Quattrocento painters would place their subjects in front of a background of decorative motifs or a landscape painted in light colours, as in Piero della Francesca's DOUBLE PORTRAIT OF THE DUKE AND DUCHESS OF URBINO.

In 15th-century Italy, this choice of pose was accompanied by an attempt to idealize the subject without, however, spoiling the resemblance. Thus Frederico da Montefeltro, the Duke of Urbino, who had lost an eye and part of his nose in battle, is portrayed by Piero from his 'good side'. His duchess, Battista Sforza, a mature woman at the time of the portrait, has an impeccable white complexion without a single wrinkle, like that of a young girl or a wax figure.

Flemish portraits, which began to emerge between 1420 and 1440 during the time of Robert Campin and Jan van Eyck, are immediately recognizable because of the contrast they present with this type. Portraying their subject in three-quarter profile, these artists depicted more of the upper body, including hands clasped in prayer or holding some object. They also unfailingly reproduced any defects in the skin including lines, scars, warts, spots and protruding veins. The realistic effect is striking, all the more so since instead of avoiding confrontation with the viewer by directing their gaze into the painting, the subjects seem to be looking directly at the viewer. Flemish artists took care to add a small patch of white to their sitters' pupils in order to suggest a reflection, thus indicating brilliance, moisture and life in the eyes of their subjects. These features are evident in PORTRAIT OF A MAN WITH CARNATION,

a copy of a work by van Eyck rather than an original, but nonetheless an old copy of remarkable quality. By the end of the 15th century, this early model of the portrait was still adhered to, but with modifications to the background. Flemish portraits from the period of van Eyck and his immediate successors can be identified by their dark, monochrome backgrounds, while those dating from the last third of the 15th century feature invented settings, often an interior with an open window, and also take in more of the body, showing the subject almost as far down as the waist. The portraits of Hans Memling, for example, painted between 1470 and 1490, conform to this mode of framing and type of setting.

In the 16th century, Italy again took the initiative in matters of portraiture. Leonardo, Raphael and Titian, brilliant portraitists by any standards, adopted larger

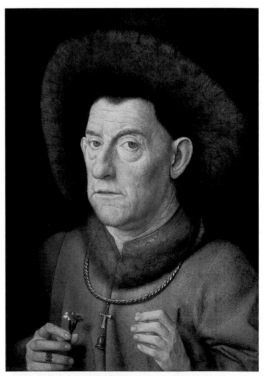

School of Jan van Eyck, *Portrait of a Man with Carnation*, c.1420–30?, oil on wood, 41.5 x 31.5cm, Berlin, Staatliche Museen, Preußischer Kulturbesitz.

formats in order to paint half-length portraits of men and women in serene poses and sober attire. The *MONA LISA* depicts a young woman — anonymous or at least inconclusively identified — taking the air on a terrace in front of a deep landscape of high, rocky outcrops and flooded valleys. The subject's pose is characterized by restraint: her hands are crossed as stipulated for ladies by the manuals of decorum; her dress is simple and chaste, even if it does not completely conceal the fine shape of her bust; her face, featuring that famous smile, reveals the presence of private feelings that are deliberately withheld and thus difficult to define — lascivious come-on or chaste love, irony or tenderness?

A few years later, Raphael chose a similar format and an almost identical pose for the portrait of his friend, the writer *BALDASSARE CASTIGLIONE.* While his subject has been painted indoors, the palette used by the painter is the same, consisting of gentle tonalities tending towards the monochrome, its brown-greens and greys relieved only by the radiant blue of the sitter's eyes. The reserve inherent in the pose, the simplicity of the attire and the restraint of the colours are all indicative, in this as in the previous painting, of an ideal expressed by Castiglione in his book *Il Libro del Cortigiano* (*The Book of the Courtier*), that of the *gentiluomo* or *gentildonna*, the gentleman and lady of the court, characterized by a refined, dignified and restrained demeanour and a generosity of feeling discreetly expressed.

Psychological portrait and ceremonial portrait

The portrait came of age during the 16th century. Subjects (who were becoming more numerous as increasing numbers of people were

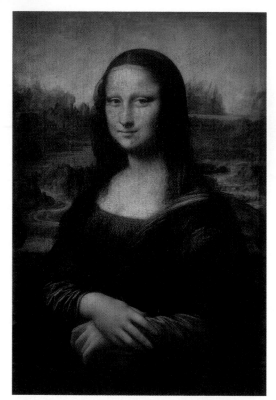

Leonardo da Vinci, *Mona Lisa*, 1503–5, oil on wood, 77 x 53cm, Paris, Musée du Louvre.

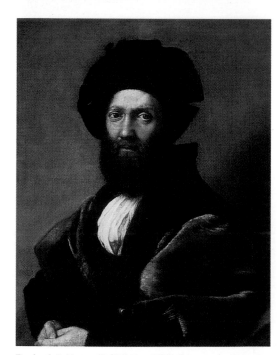

Raphael, *Baldassare Castiglione*, c.1515, oil on canvas, 82 x 67cm, Paris, Musée du Louvre.

asking to be painted) were portrayed in an increasingly diverse range of formats, both in full-length and in more modest half-length poses. The techniques, supports and formal aspects of these portraits varied considerably according to the importance of the subject and the purpose of the work. The main division was between psychological portraits, usually for private use, and ceremonial portraits destined for public display.

These two different functions can be seen clearly in French portraiture of the 16th century. Jean and François Clouet, for example, painted a clearly political portrait of 'great King Francis' (FRANÇOIS I). On a large wooden panel, the king, wearing a magnificent tunic with leg-of-mutton sleeves, his torso facing forward and his face at a slight angle, occupies the entire width of the painting. The tapestry behind him features a crown motif. A medal of the Order of St Michael, the patron saint of France, adorns the king's chest. In his right hand he holds a glove, a symbol of aristocratic elegance, and in his left a sword, an emblem of command. François Clouet, the son of Jean, chose a more modest solution for his painting of one of François I's successors, FRANÇOIS II. This portrait of the frail and short-lived king of France at the age of 15 was sketched on a piece of paper barely a third of the size of the portrait of his grandfather. Colour has been used for his face alone and no emblems have been included to indicate his status.

The psychological portraits painted over subsequent centuries are of a similar character. Often executed in small format, they confine themselves to the head and shoulders or just the head of the subject, thus concentrating on the face, seen as the window of the soul. They were often execut-

Jean and François Clouet, *Portrait of François I*, c.1525, oil on wood, 96 x 74cm, Paris, Musée du Louvre.

François Clouet, *François II*, 1560, black and red chalk on paper, 33.5 x 23.4cm, Paris, Bibliothèque Nationale de France.

Subject

ed in oil, but also sometimes in pencil, and during the 18th century, at the time of Jean-Étienne Liotard, Maurice Quentin de La Tour and Jean Baptiste Siméon Chardin, in pastel too. The subtle charm of these faces is present too in Chardin's oil paintings. These kinds of images — of individuals enjoying a game or a snack, or taking pleasure in the business of everyday life — have modest titles such as *A Lady Taking Tea* and *Boy with a Top* and are only rarely of prominent figures. Possibly Chardin shared the conviction of his friend the philosopher Denis Diderot, a great admirer of his work, that painting was an inappropriate medium for conveying the complexity of great minds. He excelled, however, in capturing the intimate moments of anonymous individuals who enjoy such a strong relationship with their environment that they seem to be defined by it. The bond we feel with these sitters, whose images do not fall within the category of the portrait in any formal sense, is often more immediate and more real than that with many figures whose names are familiar to us. In a quite different style, the 'fantasy figure' portraits painted by Jean Honoré Fragonard around 1770 are also of unknown models (other than a small number of people such as Diderot and Abbé de Saint-Non). These powerful half-length likenesses — brought alive by the twisting motion of the subject's pose — no longer sought to capture the personal history or social position of an individual, but the vitality of passionate beings who seem to impose their personalities on us out of nowhere.

J A D Ingres, *The Comtesse d'Haussonville*, 1845, oil on canvas, 131.8 x 92cm, New York, Frick Collection.

Diego Velázquez, *Philip IV on Horseback*, c.1635, oil on canvas, 301 x 317cm, Madrid, Museo Nacional del Prado.

In the ceremonial portrait, from the Mannerist period in Italy (roughly 1520 to 1600) to the Neoclassical canvases dating from the end of the 18th century and the start of the 19th century (those of David and Ingres, for example), the finish is smooth and the draughtsmanship impeccable. The often large format of these paintings allowed the subject to be portrayed full or three-quarter length. The poses suggest a long period of immobility and the attitudes adopted display a high degree of affectation. The sitters' features are stylized and generally

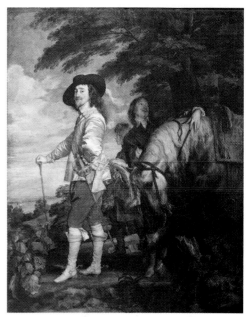

Hyacinthe Rigaud, *Louis XIV*, 1701–2, oil on canvas, 279 x 190cm, Paris, Musée du Louvre.

AnthonyVan Dyck, *Charles I at the Hunt*, undated (1632–41), oil on canvas, 266 x 207cm, Paris, Musée du Louvre.

enhanced. No imperfections are allowed to disfigure their pale skin. Their faces express nothing except occasional mild boredom. Their attire is splendid and ornate. The decorative accessories have a symbolic function: a book signifies learning; a statue points to an interest in the arts; trinkets and delicate flowers indicate the luxury in which the sitter lives as well as a refined temperament: hence the tulips, roses and precious porcelain in Ingres's *THE COMTESSE D'HAUSSONVILLE*.

The quintessential ceremonial portrait is clearly that of the sovereign. Taking their inspiration from statues of Roman emperors, a number of painters portrayed their subjects on horseback. Titian's *Charles V at the Battle of Mühlberg* (Madrid, Museo Nacional del Prado) and Velázquez's *PHILIP IV ON HORSEBACK* belong to this tradition. The indoor equivalent of these equestrian portraits (which were necessarily set outside) was the full-length standing portrait. *LOUIS XIV* by Hyacinthe Rigaud, painted between 1701 and 1702, without doubt represents the pinnacle of this style. It is a large work, measuring 279 x 190cm. The king, shown full-length, wears a wig and a long, flowing cloak that is turned back on the viewer's side. It features a Bourbon fleur-de-lis pattern on a blue background and has an ermine lining. He is standing on a platform in front of the throne next to a table covered with the same lily-patterned material. His crown sits on a cushion on the table. Behind him is a column with a high plinth and a curtain of red velvet embroidered with gold. The pose is studied: the king is looking in the direction of the viewer – his subject – below him. His right hand rests on the sceptre and his left is propped against his hip above a sword set with precious stones. The king exposes his legs, which are sheathed in white stockings. His shoes sport red heels, a badge of the aristocracy, and he traces a dance step as he used to as a young man during magnificent entertainments at Versailles.

Some artists attempted to introduce a degree of flexibility into the ceremonial portrait. Sir Anthony Van Dyck, who settled in London in 1632, painted *CHARLES I* a few years later. The English king, who was beheaded in 1649 after attempting to impose absolutism on his country, has been caught in a nonchalant pose. There is no obvious sign of his royal status: he is wearing a hunting outfit of aristocratic elegance and has stopped for a moment at the edge of the forest, no doubt to admire the countryside. Examining the painting carefully, however, it can be seen that the motifs introduced by the artist

THE FRONTAL PORTRAIT AND ITS SUBVERSION

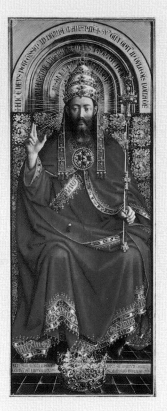

During the early centuries of Christianity and throughout the Middle Ages, frontal portraits were reserved for holy figures or, at the very least, individuals of exceptionally high rank: God the Father or Son, the Virgin, heroes from Christian history, the pope, the emperor, kings. Either seated on a throne or standing, in a pose suggesting perfect immobility, such figures were designed to inspire awe in the faithful or a ruler's subjects through their hieratic appearance. This form of representation (known as 'in majesty') was to exert an enduring influence on paintings — both religious pictures and more importantly portraits.

Jan van Eyck
God (the Father or the Son), 1426–32, central panel of the upper tier of the Ghent Altarpiece, oil on wood, 212.2 x 83.1cm (open), Ghent, Cathedral of St Bavon.

Absolutely full-frontal as regards the positioning of the upper abdomen and face, the Lord's body has been integrated into the axis of symmetry of the painting, which runs from the S of MAIESTATE to the main lancet of the crown via the vertically aligned pearls and precious stones on his three-tiered tiara (representing the Trinity), the gold plaque on his chest and the knot joining the strings on his robe. The lavishness of the clothes and accessories, the fullness of the body emphasized by the flare of the red fabric, and the hieratic nature of the pose — one hand giving the blessing and the other holding the crystal sceptre decorated with rings of gold, gems and a golden flower — all has been designed to make this personification of God a figure of glory and eternity.

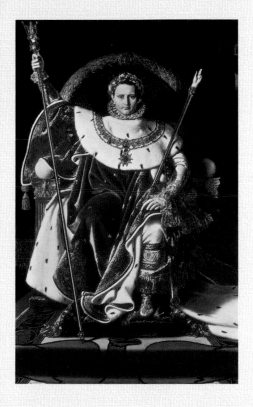

J A D Ingres

Napoleon I on the Imperial Throne, 1806, oil on canvas, 259 x 162cm, Paris, Musée de l'Armée.

Described as 'extraordinary' (in the pejorative sense) when exhibited at the 1806 Salon, this portrait displays the same 'Byzantine', in other words hieratic and luxurious, character as that of Christ in the preceding image. The power of the new French emperor is manifested here in the magnificence of his trappings (displaying an abundance of gold, velvet and ermine) and in the fullness of his robes, whose great folds seem to swamp the little man and make him a prisoner of the pomp he himself has invented. His body has been depicted from the front and its axis of symmetry coincides with that of the canvas, from the circular medallion adorning the top of the throne down to another embroidered on the cushion. The pose subtly reflects that of God in van Eyck's painting: Napoleon's right hand is raised to support the sceptre (his folded fingers reflect the gesture of blessing that the ivory hand on the rod of command actually performs) and his other hand rests on his knee as does God's in the Cathedral of St Bavon. Behind Napoleon's head, which is crowned with a laurel wreath, the circular back of the throne forms a golden halo, again echoing the composition of van Eyck's painting.

Paul Cézanne

Portrait of Achille Emperaire, 1869–70, oil on canvas, 200 x 120cm, Paris, Musée d'Orsay.

Seated in an armchair covered with a sheet featuring a large flower pattern, its back reproducing the circular shape of the thrones in the paintings by van Eyck and Ingres, Achille Emperaire seems even smaller than he actually was. This painter, ten years older than Cézanne and a compatriot from Aix, was a dwarf. He sits slightly askew, his feet positioned diagonally on the footrest. His head, with its large forehead, longish hair and Louis XIII-style goatee beard – the face of a musketeer – is too wide for his narrow body. His hands with their long, bony fingers hang down. The brushstrokes are wide and flat and the palette limited. Unlike in the preceding works with their clarity of line and smooth finish, Cézanne has used a medium – oily but not thick – which muddies the lines. The subversion of the genre, right down to the dressing gown that replaces Napoleon's magnificent robes, is evident and undoubtedly deliberate. The painter has played on the words Emperaire and Empereur, and during the final year of the reign of 'little Napoleon' (Louis Napoleon) he has transformed the image of the emperor 'in majesty' into a caricature that is both pitiful and ridiculous.

correspond to a code: the hand resting on the hip is a gesture of authority (the same one adopted by Louis XIV in Rigaud's painting sixty years later), and the sword and rod of command are also present, as in Rigaud's portrait. Here too is the glove, a symbol of elegance we have noted already in *Portrait of François I* by Jean and François Clouet. The horse standing behind him also has symbolic significance, referring to the tradition of the equestrian portrait. This portrait conveys the image, an incorrect one as we now know, of a monarchy ruling benevolently and without undue arrogance.

From donor portrait to group portrait

Well before the appearance of individual, autonomous portraits, it had become the custom for artists to integrate a portrait of the donor — that is, the person financing the picture in question — into paintings of religious subjects. The insertion of portraits started to become more commonplace in the 14th century and its character changed. On the one hand the donors acquired a more important position within the composition and on the other their faces and figures became more individualized to the point where the notion of resemblance became established. One of the most famous donor portraits from the beginning of the trecento in Italy is that of the merchant and banker Enrico Scrovegni in the *Last Judgement in the Arena Chapel* in Padua, the cost of whose construction and decoration he paid for. Giotto has depicted him at the bottom of the fresco, kneeling before the Virgin and holding out the model of the building to her. He is shown in profile (in keeping with the Italian style of individual portraits), is dressed in the attire of his day, and is comparable in size to Mary, although his posture, with one knee on the ground, is that of humility. A century later, in Flanders, donors were usually included in altarpieces. There they were depicted in three-quarter profile as in individual portraits. In triptychs — since

the central section is occupied by the main subject — the donors are relegated to the side panels, the man on the left wing and the woman on the right. As was mentioned in the first chapter, they are often accompanied by their issue, including any deceased children (whose heads are shown with a small cross above them). They are depicted kneeling in prayer, often with their patron saints standing by their sides. The inclusion of patron saints provides an interesting piece of information in the absence of any documentation relating to the commission as it allows us to guess the first names of the donors.

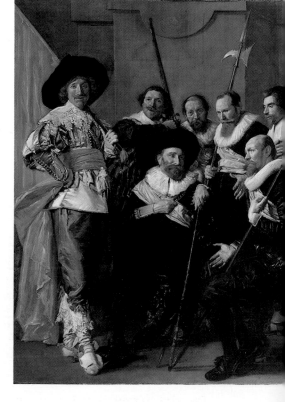

By the second third of the 15th century, donors had even started to become integrated into sacred paintings. In van Eyck's *Madonna with Chancellor Rolin* and *Madonna with Canon van der Paele* (c.1430 and 1436 respectively, Bruges, Groeningenmuseum), Chancellor Rolin and Canon van der Paele, both powerful men, can be seen kneeling in the same room as the Virgin. The same thing occurs in the *Adoration of the Child* (Bladelin Triptych) by Rogier van der Weyden (between 1450 and 1460), in

the *Pietà* by the French painter Enguerrand Quarton from around the same time, and, in Italy at a considerably later date, in Raphael's *Madonna of Foligno* (Rome, Pinacoteca Vaticana, 1511–12).

All of these elements — the relative size of the donors, their posture, their proximity to or remoteness from the holy figures — are of considerable importance, and encourage a sociological rather than aesthetic interpretation of the work. At the end of the Middle Ages, trade was flourishing in the towns and cities of the West. For the prosperous middle classes, self-confident and anxious to assert their principles, having their portraits displayed next to saints in altar paintings allowed them to immortalize their own images while underlining the fact that their lives conformed to Christian ideals.

Reserved originally for a very rich urban elite (important citizens wealthy enough to pay the full cost of an altarpiece or fresco) the inclusion of portraits in holy scenes was extended during the 15th century to far more people. As members of guilds or brotherhoods, citizens who were no more than comfortably off could band together to finance a votive image in which each participant appeared as a recognizable individual among his peers. The Florentine frescoes of Ghirlandaio, the Venetian *tele* (or canvases applied to walls) of Gentile Bellini and Carpaccio, and the retables (often bordered by ornate sculpted frames) of northern Europe all provide examples of such images in which crowds of people with individual faces that are clearly portraits stand close to the Virgin or on either side of a holy scene. It was not unusual for the painter to depict himself among them. Two centuries later, in northern Europe at least, the middle classes had become the dominant social group both economically and politically. In the Netherlands, the bourgeoisie were Protestant, or more precisely Calvinist. Calvinism was opposed to religious painting, but looked favourably on the depiction of individuals in painting,

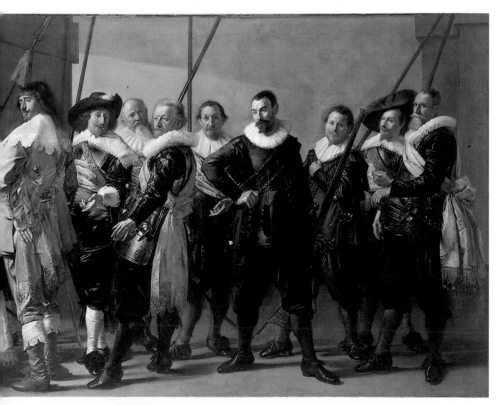

Frans Hals and Pieter Codde, *The Meagre Company*, 1633–7, oil on canvas, 207.2 x 427.5cm. Group portrait, Amsterdam, Rijksmuseum.

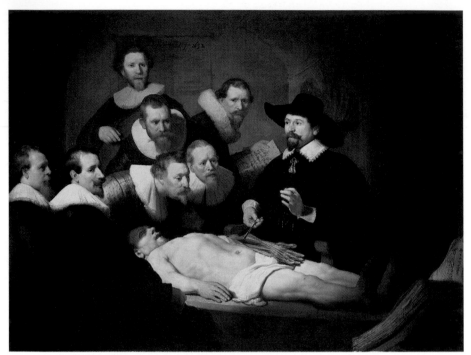

Rembrandt, *The Anatomy Lesson of Dr Nicolaes Tulp*, 1632, oil on canvas, 169.5 x 216.5cm, The Hague, Mauritshuis.

particularly if this took place within the frameworks that provided society with its structure: the family and the various community organizations. The GROUP PORTRAIT, which became autonomous around this time (in other words began to constitute a self-sufficient image like the portraits of individuals), began to prosper. Frans Hals, from Haarlem, was the champion of this type of portrait (see p.40), and gathered together either men or women, but never a mixed-sex group, in vague street settings, around tables laden with food or in the offices in which they performed their duties. Using a dark, almost monochrome palette, faces are rendered with great realism, creating an often cruel vision of the effects of the ravages of time on the body and features. Dutch painters did not lie and did not disguise reality. Their faith prevented them from doing so and, besides, their public wanted to be able to recognize themselves in their work.

Among Protestant artists, Rembrandt (a contemporary of Frans Hals, but based in Amsterdam) was the only one who sought to transcend the reality of his times. In his *Anatomy Lesson of Dr Joan Deyman* (see p.23), the ANATOMY LESSON OF DR NICOLAES TULP and the *Night Watch* (Amsterdam, Rijksmuseum), he moved the portrait closer to what would have been called history painting in France. In addition to immortalizing the physical appearance of the city's leading doctors of medicine, the first two paintings also tell of the drama inherent in a confrontation with death on the dissecting table. The *Night Watch* (in reality the daytime group portrait of the company of Captain Frans Banning Cocq) depicts the civic guard preparing to move out in a radiant golden light with a degree of animation and movement that makes the painting seem like an allegory of action and determination.

A genre within a genre: the self-portrait

Already in evidence in medieval painting as a variant of the signature, the self-portrait (portrait of the painter by himself) really took off during the 15th and especially the 16th centuries. Its development followed the general historical development of the portrait, as

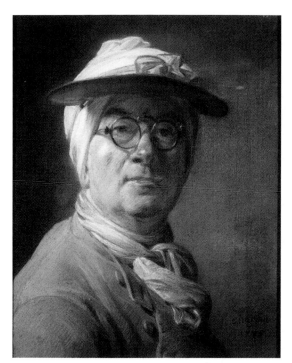

Jean-Baptiste-Siméon Chardin, *Self-portrait with Visor*, 1775, pastel, 46 x 38cm, Paris, Prints and Drawings Department, Musée du Louvre.

the progress of social mores gave those outside the narrow circle of the powerful the right to see their images in paint.

What is distinctive about self-portraits is that they are a means by which artists can study themselves. In studying themselves in this way, they have two main concerns that may overlap but usually remain separate. On the one hand they examine their faces and bodies in the mirror as all men and women do, and are aware, with an anxiety that increases over the years, of the ravages of time. On the other hand, they are professional artists, in other words public figures. They know their paintings are going to be commented on and so want them to be both a demonstration of their talent and an indication of how they view their profession. In the self-portrait, scarcely different in form, we see the same distinction that is found within the portrait generally. Corresponding to the intimate psychological portrait is the physical and physiognomical likeness in which there is nothing or almost nothing to indicate that the subject is a painter. This type of portrait can be described as 'personal'. Corresponding to the other (ceremonial) type of portrait is the 'professional' portrait, in which the artist portrays himself in the process of painting, or at least includes various elements that denote his profession.

To all intents and purposes, personal self-portraits are painted in the same way as psychological portraits. Thus Chardin's SELF-PORTRAIT WITH VISOR, a 'portrait of the artist as an old man' to paraphrase James Joyce, is a pastel measuring just 46 x 38cm. In it, the painter gazes at the viewer from behind steel spectacles (in reality, of course, he is looking into the mirror in which his image is reflected). On his head he wears a white cloth forming a bonnet. Around this is tied a pink scarf to which an enormous blue eyeshade is attached. This strange get-up, necessary to protect his tired eyes, is completed by a light-brown jacket with its collar left casually open. The background is monochrome. Chardin creates an image of himself intended to be demystifying and truthful.

'Professional' self-portraits are larger and generally painted in oil. Poussin, who never consented to paint portraits and was reluctant to produce an image of himself, complet-

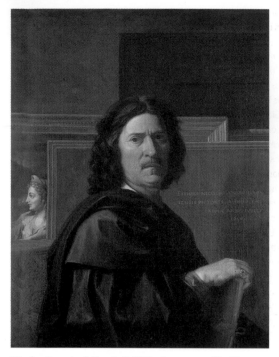

Nicolas Poussin, *Self-portrait*, 1650, oil on canvas, 98 x 74cm, Paris, Musée du Louvre.

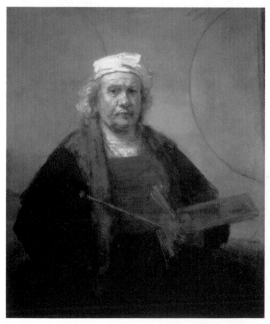

Rembrandt, *Self-portrait*, 1665–9, oil on canvas, 114.3 x 94cm, London, Kenwood House, The Iveagh Bequest.

ed two self-portraits at the end of his life under intense pressure from collectors and friends. These are the Berlin *Self-portrait* (78 x 65cm, Staatliche Museen, Bode-museum) and the Louvre *SELF-PORTRAIT*, 98 x 74cm, both painted in oil on canvas. The Paris self-portrait shows the artist half-length with his face seen almost directly from the front (in a position of authority if not majesty). He is dressed in a cloak of black silk that resembles the gown of a professor or magistrate – a noble and sober garment. His right hand, wearing a ring, rests on a portfolio which probably contains prints or drawings. However, part of a framed canvas visible on the left shows a female figure against a blue background wearing a diadem decorated with an eye (an allegory of Painting). She is being embraced by an unseen person (an allegory of Friendship). At almost the same time (between 1665 and 1669), Rembrandt was painting an even larger self-portrait in oil (114.3 x 94cm) in which he too portrays himself half-length from the front and in which he uses a colour range not that different from Poussin's.

Rembrandt's *SELF-PORTRAIT* is one of a very full series of self-portraits begun by the artist back in his youth. Rembrandt makes no concessions to vanity in portraying his thickset figure and puffy face with its sagging skin and thinning white hair. His clothes are also as careless as Chardin's in the pastel – the latter executed a century later, and consist of a white linen scarf, a loose lined coat — to guard against the cold of the studio during the Amsterdam winter — and a shirt-front that serves as an apron while at the same time keeping his stomach warm. The technique he has employed here differs considerably from

Poussin's. The brush strokes are rapid and blur the lines. The black paint has spilled over the outline of the shoulder, whereas in Poussin's portrait it forms a perfect line at the same spot. Holding a rectangular palette, a mahlstick, brushes and what is possibly a cloth, Rembrandt's hand is reduced to no more than a claw. He emphasizes the artisanal side to being a painter, which involves the 'messy business' of handling pigment that dribbles and soils. Nevertheless, he does not miss the opportunity of asserting his great artistic ability and even superiority, not least in the field of drawing. In the background, fragments of two circles refer to an anecdote about Giotto that was well known at the time: when the Pope asked the Italian master for a demonstration of his skill, Giotto responded by drawing a simple circle in a single, fluid movement.

Depictions of the painter at work sometimes involve an elaborate amount of staging. A dozen or so years before this self-portrait by Rembrandt, Velázquez's immense canvas *The Family of Philip IV*, better known under the title *Las Meninas* (see p.90), included a full-length self-portrait of the Spanish painter holding his palette and gazing in an attentive and mildly amused way at either the viewer or his subject. Velázquez has positioned himself to one side of the composition, but above the other figures, and with his face fully lit. He is in the same room as the Infanta and her attendants (*menina* means 'maid of honour'), but also as the King and Queen of Spain, his probable sitters, whose images (they are outside the picture, in the space occupied by the viewer) are reflected in the mirror on the back wall. This magnificent precedent was recalled by Goya at the beginning of the 19th century when he included himself in his *FAMILY OF CHARLES IV*, albeit with a little more modesty, as he remains in the background with the royal figures lined up in front of him and his face is shadowy in the half-light.

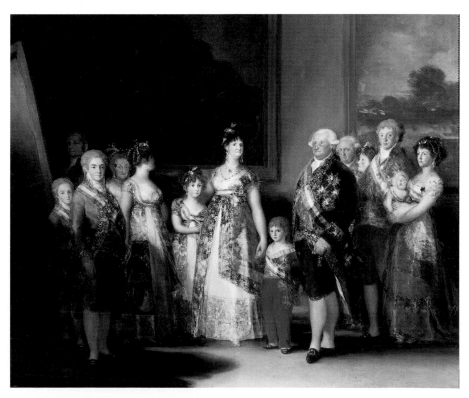

Francisco de Goya, *The Family of Charles IV*, 1800–1, oil on canvas, 280 x 336cm, Madrid, Museo Nacional del Prado.

 ubject

LANDSCAPE

Landscape as an autonomous genre developed very gradually from the 16th century onwards. From the end of the Middle Ages, artists had started to increase the number of naturalistic details in their work so as to provide their subjects with a setting that resembled the natural world. Following centuries in which painting had restricted itself to archetypal symbols — wavy lines to denote water, festoons to represent clouds, and so on — artists gradually had to invent a vocabulary of forms to signify the real world. Around 1300, Giotto was still painting rocks set with near-identical tiny trees as a way of representing the countryside (see p.70). Just a century later, trees had become varied and were painted on the same scale as the human figure. In his *Baptism of Christ* (c.1450?, London, National Gallery), Piero della Francesa painted a tree so tall that – for the first time ever – not all of it fitted into the picture. It is highly instructive to examine how painters grew progressively closer to nature in works executed between the 13th and 15th centuries. Rocks, inherited from Byzantine icons, became softer and were transformed into hills, valleys and plains; the ground, initially sterile, was gradually covered with grass, (identifiable) flowers, crops and forests; the decorative backgrounds inherited from the early Middle Ages gave way to realistic skies, including the night sky illuminated by the moon and the stars or the ambiguous light of dawn, dusk or storm, as in Giorgione's *The Tempest* (see p.6).

A certain reticence remained with regard to landscape painting, however. Representations of nature served for a long time as settings rather than as the main subjects for works. The landscape proper originated in Venice. In the city of the Doges — the city too of Vittore Carpaccio, Giovanni Bellini and Giorgione — at the end of the 15th and the beginning of the 16th centuries, painters created admirable views of the lagoon and its hinterland, the rural 'terra firma' beyond. These views, it should be noted, formed the framework for subjects that were not themselves landscapes. They accommodated the depiction of a duck hunt (Carpaccio), a crucifixion or some other holy scene (Bellini) or the mysterious encounter between a young, clothed man and a naked woman (Giorgione). The same is true, at least in Italy, of the other great masters. The flooded valleys behind the Mona Lisa represent a 'chosen landscape', to borrow Verlaine's phrase — a mental landscape, in fact, conceived by Leonardo to serve as a powerful echo of the mystery of his model. Leonardo never went so far as to paint a 'pure' landscape.

Development into a genre

The landscape seems to have taken off as an autonomous genre in the north rather than the south of Europe, more precisely in the Germanic regions and especially around the Danube, where nature survived in a virgin state into the 16th century. In the work of Lucas Cranach the Younger and Albrecht Altdorfer, figures so small they are sometimes difficult to make out seem to be under assault from extremely dense forests of immense trees. These landscapes in German paintings are both unsettling and attractive. At this dawn of the modern age, when nations were just starting to come into existence, the representation of landscapes played a role in the formation of what later, perhaps dangerously, came to be called the 'German soul': a passion for the earth (*der Boden*), for the wild landscape that had been described centuries earlier by the writer Tacitus in his *Germania*.

In fact, if we outline the character of the landscapes in the different regions in which the landscape started to flourish in the 16th century, we see obvious contrasts. The painters of central Europe depicted immense landscapes in which man seems lost: high mountains, steep slopes opening onto vertiginous distant planes, vast skies and foliage on almost the same scale. Dürer, who crossed the Alps several times during the early years of the 16th century, Adam Elsheimer around 1600 and Caspar David Friedrich in the first half of the 19th century all embodied this tendency, which could perhaps be described as 'cosmic' and 'sublime'. Following the example of Joachim Patenier in the first

quarter of the 16th century, Flemish artists also painted vast horizons, often featuring rocks and mountains: Pieter Bruegel the Elder executed numerous Alpine landscapes when he travelled to Italy in the 1550s. However, the Flemish painters populated these lonely expanses with very visible people, adding houses and a network of tracks. Meticulously painted and often engraved, their landscapes create the impression of an inhabited world in which nature has been tamed. Finally, the Italians depicted nature in a very different way: instead of mountains and wild valleys they preferred rolling coun-tryside colonized by man — in other words a cultivated landscape densely dotted with buildings, featuring valleys and plains in which villages, farms, villas and even ruins were scattered.

In the 17th century, landscape painting still varied markedly from region to region. In the Netherlands, paintings that embraced the genre for its own sake, in other words without using some other subject as a pretext, became more and more common. Bought by a middle-class clientele, they were the chief means of decorating a home alongside family portraits and genre scenes. The majority of these landscapes were representations of the local countryside. They often included stormy or calm seas, either as the main sub-ject (seascape) or as a secondary motif. Dutch merchant ships, which ruled the seas and were the basis of the Low Countries' wealth, featured frequently in them. The low hori-zons of a countryside criss-crossed by rivers and covered with vegetation stretch out beneath cloudy skies, punctuated by the occasional well-placed windmill. Artists such as Hendrick Avercamp painted frozen lakes on which the citizens of the Dutch Republic skated, all the different social classes mingling together. Others devoted themselves to views of towns, painting brick houses, crow-step gables and Gothic churches with tall spires. Jan van der Heyden and Carel Fabritius painted townscapes of this kind, the supreme example of which, however, is Vermeer's VIEW OF DELFT. This was regarded by

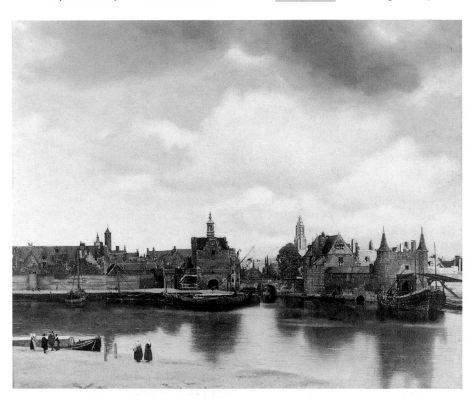

Jan Vermeer, *View of Delft*, c.1660–1, oil on canvas, 98.5 x 117.5cm, The Hague, Mauritshuis.

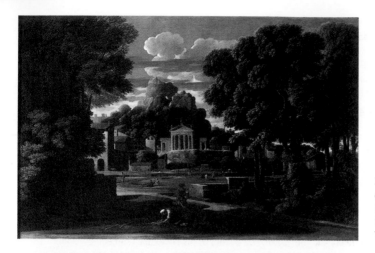

Nicolas Poussin, *The Ashes of Phocion Collected by His Widow*, 1648, oil on canvas, 116 x 176cm, Liverpool, Walker Art Gallery.

Nicolas Poussin, *Winter (The Deluge)*, 1660–4, oil on canvas, 118 x 160cm, Paris, Musée du Louvre.

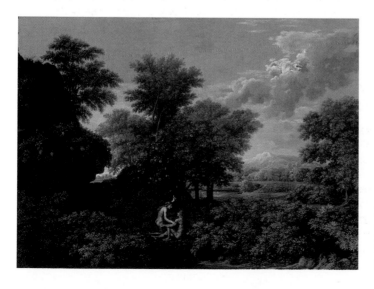

Nicolas Poussin, *The Spring. Adam and Eve in Paradise*, 1660–4, oil on canvas, 117 x 160cm, Paris, Musée du Louvre.

Marcel Proust, who made it famous in his *À la Recherche du Temps Perdu*, as 'the most beautiful painting in the world'.

The landscapes of southern Europe contrast strongly with these pictures steeped in local colour and expressing the love of the citizens of the United Provinces for their country. In the work of Italian painters such as Annibale Carracci and then Domenichino in the first half of the 17th century, and the French artists Philippe de Champaigne, Claude Lorraine and particularly POUSSIN during the years 1640–60, successive horizontal planes are marked out by tall trees, fields, roads, slopes, rocks, calm waters and architectural follies, often beneath clear, bright blue skies with scudding clouds. Humans are always present in the foreground of these landscapes, but they are often also visible well into the depths of the painting.

When viewing landscapes of this type, which came to be described generically as 'idealized' or 'classical', we must look for what is distinctive about each one. Describing the tonality he wanted for his paintings, Poussin distinguished between the following modes: the 'solemn and severe', the 'wild and tempestuous', that which displays 'a certain mellowness and sweetness', and the 'joyful'. The poetics of his landscapes sometimes reflect these theoretical categories too. His solemn mode — the 18th-century theoretician Roger de Piles preferred the term 'heroic landscape' — can be seen for example in *The Ashes of Phocion Collected by His Widow*, whose spacious and severe composition features distinct planes closed off by classical buildings; *Winter (The Deluge)*, with its darkness and water everywhere, its threatening rocks, the panic-stricken gestures of the figures and its great diagonal thunderbolt, belongs to the 'tempestuous', or tragic, category. Others, such as *Spring. Adam and Eve in Paradise*, are more difficult to classify. The brighter light, the peaceful though wild character of the vegetation and the diagonal movement of the clouds in a calm sky do not lend themselves to a single interpretation. We might describe such scenes as 'pastoral' or insist that they are Romantic before their time; but it is not always essential to attempt to categorize paintings, to subordinate feeling to theory.

It is not our intention here to provide a history, even in outline, of landscape painting as a genre, but simply to point out that modes of representation vary significantly depending on the time and place in which the artist lived. Thus history — the history of technology and economics as well as the history of travel and tourism — has also played its part in the development of the genre. The 'natural' destination of artists was for a long time Italy, whose humanized countryside, bright light, gentle hills and plentiful ruins were given a privileged position in their art. The discovery of the Orient — in fact Greece and Northern Africa to begin with — inspired works in which the light is harsher, the natural world (including deserts and oases) drier and the architecture very different. Thanks to the railway, 19th-century painters were able to travel more often and more easily, either making brief trips into the countryside around their cities or embarking on longer journeys. To take an example from French painting, the Seine landscapes that became common at the end of the 19th century would have been unthinkable without the fashion for spending Sunday in the country. This is equally true of views of Brittany and of seascapes more generally: the sea around the train stations of Normandy, and then the Mediterranean and Provence when the railway suddenly brought them within striking distance of Paris. But quite apart from these opportunities for travel, the way in which painters have looked at landscape has always varied according to their particular sensibility and that of the period in which they lived. Working in one and the same Italian countryside, Poussin painted ancient structures that were extremely well preserved (or rather reconstructed in an idealized way), while a century later Hubert Robert and Jean Honoré Fragonard cultivated a specific interest in ruins. In the 19th century, John Constable painted skies filled with stupendous clouds, Jean-Baptiste Corot painted the forests and villages of Normandy in a Neoclassical Italianate style, while others such as Édouard Manet set himself the task of capturing the world in all its modernity, taking his inspiration from photographs of the city with its tiers of roofs, its chimneys, its bridges and its railways.

Subject

THE GENRE SCENE

Like history painting, genre painting depicts men and women and tells their stories. However, it deals with everyday subjects such as street scenes or domestic scenes inspired by contemporary manners, subjects that often provoke laughter. Genre painting — which acquired its label by default in the 18th century as it depicted neither history in the noble sense of the word nor allegory, landscape or still life — was a 'low genre', a form of painting that critics judged to be good enough only for entertaining the bourgeoisie.

History painting's younger cousin

The first genre scenes were produced by the northern schools, which were more inclined than those in the south to examine and depict real life without seeking to idealize it. In the 15th century, these scenes were often connected with money, featuring merciless depictions of moneylenders and tax collectors. In the 16th century, 'merry gatherings' in drinking dens and bawdy houses (Jan van Hemessen, the Brunswick Monogrammist) and scenes of the market and of food preparation (Pieter Aertsen and his nephew Joachim Beuckelaer) provided a whole repertoire of images.

The genre scenes of the Flemish painter Pieter Bruegel the Elder have a different quality. He portrayed the poor, usually peasants, and his pictures are at the same time ethnographic (though painted before the invention of the term) and allegorical. As its full modern title suggests, the blind men heading for a fall in *The Parable of the Blind Leading the Blind* (Naples, Museo Nazionale di Capodimonte) seem to symbolize human destiny, which leads inescapably to disaster and death.

Although designed to amuse, or occasionally to educate in an entertaining manner, genre scenes nevertheless have certain features in common with history painting. In order to express the emotions of their characters, they employ the same language of gesture and 'passions' (see p.146) as history painting, often in an exaggerated manner. Genre painters also had to invent costumes and provide a setting in the manner of history painting. Contemporary clothing was generally favoured over timeless costume and was always preferred to the nudity of Grand Manner heroes. Their settings eschewed bombastic elements such as cornices, columns, temples and generally anything that evoked antiquity. Genre paintings showed their subjects either half-length or full-length. The large number of figures in the painting and/or the importance of the setting often led to relatively large works. Aertsen's THE COOK IN FRONT OF THE STOVE is more than 1.25m high and Pieter Bruegel's *The Parable of the Blind* more than 1.5m wide. The range of colour varies from work to work, by and large following the tendencies evident in other paintings of the day. Where the palette shows a bias towards darker colours, and lower-class characters (raised in genre painting to the status of heroes) are therefore required to dress soberly, the monochrome nature of the work is relieved by vivid colours and eye-catching patches of bright paintwork.

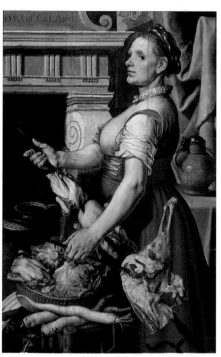

Pieter Aertsen, *The Cook in Front of the Stove*, 1559, oil on wood, 127.5 x 82cm, Brussels, Musées Royaux des Beaux-Arts.

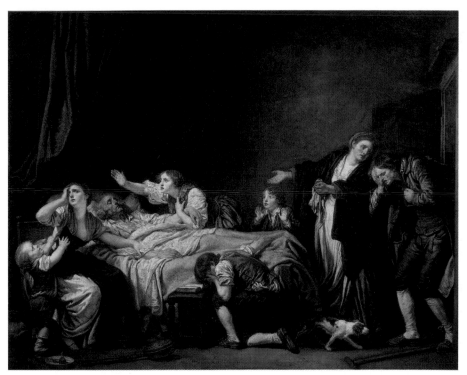

Jean-Baptiste Greuze, *The Son Punished*, 1778, oil on canvas, 130 x 163cm, Paris, Musée du Louvre.

Didactic intent

One of the challenges of understanding genre painting is trying to assess to what extent it provides simple entertainment and to what extent it conceals a moral or social truth. In the 18th century, painters such as William Hogarth in Great Britain and Jean-Baptiste Greuze in France sought to give genre painting a new dignity by bring-ing it closer to the fashionable literary forms of the day: bourgeois comedy and drama. Hogarth, from the 1730s to the middle of the 1750s, used irony to denounce the aris-tocratic and political vices of his time. His three series – *The Rake's Progress*, *Marriage à la Mode* and *The Humours of an Election* – are each organized in a clear chronolog-ical sequence. The images in these series of paintings, which were made widely avail-able as engravings, follow on from each other like theatrical scenes, recounting the lives of the characters from their initial pleasure-seeking to their ultimate undoing. In the years that followed, Greuze took a moralizing approach where Hogarth had been satirical. Paintings like THE SON PUNISHED, *The Village Bride* or *Dead Bird* earned praise from the Enlightenment writer and thinker Denis Diderot, who invented art criticism in his *Salons*. Greuze has an eloquent style: he takes us into peasant or bourgeois milieux where large casts of characters act out touching scenes – with ample use of gesture – and shows evil or mere negligence being punished while good triumphs.

From *bambocciata* to a celebration of the private

During the first half of the 17th century the tradition of painting tavern scenes (which had begun to be known as *bambocciate* after the nickname of genre painter Pieter van Laer) was transformed by Georges de La Tour, from Lorraine, into a series of parables on the fate of foolish children. *The Fortune Teller* (see p.63), *The Cheat with the Ace of Diamonds* (see p.62) and *The Cheat with the Ace of Clubs* (Fort Worth, United States) tell, with great economy of gesture, the unfortunate story of a naïve young man who allows himself to be cheated and robbed. During the same period, 1630–40, the French

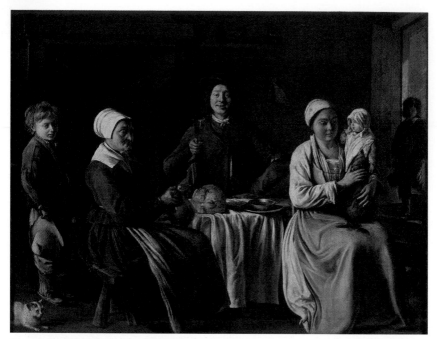

Louis Le Nain, *Peasant Family*, also known as *Return from the Baptism*, 1642, oil on canvas, 61 x 78cm, Paris, Musée du Louvre.

brothers Antoine, Louis and Mathieu *LE NAIN* breathed new life into the 'peasant scene'. Using smaller formats than La Tour, they showed peasants sitting or standing motionlessly in dark interiors lit by a hearth fire, outside in front of their crumbling houses or on endless smooth grey plains. These figures display great dignity in their restrained poses and coarse but decent clothes. In the Netherlands, the genre scene developed

in a similar way. While painters like Jan Steen, Gerrit Dou and Gabriel Metsu continued to paint scenes of buffoonery, depicting charlatans (itinerant salesmen or quack doctors), dissolute gatherings, peasant celebrations at which the guests are relieving themselves or schoolrooms where naughty pupils are being spanked, *VERMEER* — in 'genre paintings' from which narrative is completely absent — devoted his life to celebrating the subtle mysteries of domestic life in immaculate dwellings in which dreamy, well-dressed young women slowly and carefully perform daily rituals that thereby assume a sacred character.

Jan Vermeer, *The Lacemaker*, c.1669–70, oil on canvas, 23.9 x 20.5cm, Paris, Musée du Louvre.

STILL LIFE

Occupying the lowest rung in the hierarchy of genres since it does not depict man and indeed hardly ever includes any living creature, the still life — known in 17th-century France as the *vie coye* or *coyte* (quiet) — enthrals us today as a genre that reveals the metaphysical meaning of things.

A motif within larger paintings

As with landscapes and portraits, objects were at first introduced discreetly into paintings of religious subjects. For example, Giotto depicted the interior of the house of St Anne, the mother of Mary, in two frescoes in the Cappella Scrovegni (Arena Chapel) in Padua. In this interior, a pair of bellows, a spinning wheel, a set of shelves fixed to the wall, a red wooden chest with black fittings, a curtain round the bed and a striped blanket on the mattress are some of the humble items — later termed 'minor objects' (*Mindereien*) by Dürer — painted by the Italian master with a degree of care and love that had not been seen in Western art since Roman times. It is important to look for objects like these, on which the artist has lavished so much attention, in history, religious and mythological paintings, in the background of portraits and in genre paintings. They often give the picture its meaning and can even justify its title, as is the case with *Slippers* by the Dutch painter Samuel van Hoogstraten (Paris, Musée du Louvre) in which two mule slippers are lying on a mat at the centre of an interior. But sometimes it may not be easy to relate the objects to the story in the picture and their surprising inclusion can be seen as a celebration of pure painting in pictures dominated by narrative. This is true of the workbasket that sits on a table in David's THE LICTORS, in a prominent light area set against the red and green of the tablecloth and curtain. This motif serves little purpose in terms of narrative structure. Instead it suggests that the drama has interrupted a peaceful domestic existence, and above all it is a piece of skilful painting of pure virtuosity.

Jacques Louis David, *The Lictors Returning to Brutus the Bodies of His Sons*, 1789, oil on canvas, 323 x 422cm, Paris, Musée du Louvre. Detail. See also p.24.

From *vanitas* to virtuosity

Having emerged as an independent genre at the beginning of the 17th century (after the other genres had already achieved autonomy), the still life wavered for a long time between stylistic exercise and philosophy lesson. In strongly Catholic countries, where there persisted a reluctance to depict objects for their own sake — in other words for pure visual 'delectation' (Poussin) — still lifes were justified in religious or moral terms. In 1638, FRANCISCO DE ZURBARÁN painted a dead sheep. This is clearly not a trophy, still less a beloved animal mourned by an adolescent girl (as in Greuze's *Dead Bird*), but a sacred symbol, the Agnus Dei or Lamb of God, which the painter has crowned with a delicate halo. JUAN SÁNCHEZ COTÁN (who became a Carthusian monk) was also primarily concerned with metaphysical meaning when he painted still lifes. Painting humble vegetables and fruit suspended on threads within an abstract space enclosed by a frame represented in perspective, Sánchez Cotán contributed during the first thirty years of the 17th century to the development of the specifically Spanish type of still life known as a *bodegon*: a celebration of the simple things created by God and at the same time a 'vanitas' (a reminder of the ephemeral

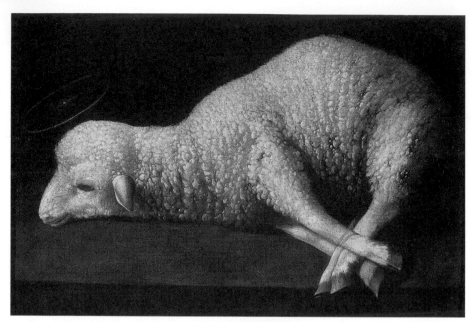

Francisco de Zurbarán, *Agnus Dei*, 1638, oil on canvas, 35 x 52cm, San Diego, Museum of Art.

Juan Sánchez Cotán, *Still Life with Birds, Vegetables and Fruit*, 1602, oil on canvas, 68 x 89cm, Madrid, Museo Nacional del Prado.

nature of all that lives and grows on this earth). The paradox of these still lifes that aim for a purity free from worldly preoccupations is that their formal perfection ultimately contradicts the message of humility they are designed to deliver. Beautifully painted, protruding in trompe-l'oeil effect out of their framing masonry, Sánchez Cotán's carrots, turnips and celery demonstrate the permanence of painting in contrast to the precariousness of life. Supposedly the most modest of artists, still-life painters can actually be regarded as the most ambitious of all, for in creating their art they dispense with any techniques that do not strictly belong to pictorial art, such as the interest provided by a narrative, or the curiosity aroused by a particular face. Seen in this light, it is no surprise that the genre has given rise to exercises in which painters have attempted to dazzle rather than enlighten the viewer. Their feats of skill have taken the form of subtle

Albrecht Dürer, *Dead Duck*, 1515, watercolour and gouache with gold highlights on parchment, 23.3 x 12.7cm, Lisbon, Gulbenkian Foundation.

and delightful games: a dead duck that seems to be actually hanging on the wall (*DÜRER*); a painting imitating an engraving covered by a piece of broken glass (*FRANÇOIS VISPRÉ*); envelopes, trompe-l'oeil letters and other pieces of paper 'fixed' to a support that imitates a piece of panelling, and so forth.

The undisputed mastery of the Flemish and Dutch painters

Flemish and Dutch painting was more diligent than that of other countries not only in capturing ephemeral objects in a wonderful way but also in increasing their sensual effect (to counterbalance the fleeting nature of the pleasure they provide). In the work of the Antwerp painter Jan Brueghel (known as 'Velvet' Brueghel) at the beginning of the 17th century, Pieter Claesz and Willem Claesz Heda (both from Haarlem), Willem Kalf and Jan Davidsz de Heem a little later, and in the canvases of painters from other countries influenced by northern art, such as the Frenchmen Jacques Samuel Berbard and Sebastian Stoskopff, we find bouquets, laid tables, overturned vessels, sideboards covered with gold or silver plate, exotic shells and precious jewels. The palette they used varies from a brown or grey tonality (the expression 'monochrome breakfast piece' is used in connection with the work of *CLAESZ HEDA* and others) to a range of bright colours set against a dark background as in the still lifes of *BERBARD*. Objects were chosen that evoked the pleasures

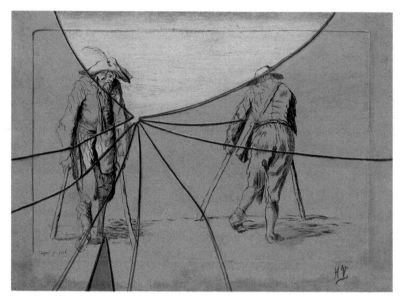

François Vispré, *Grisaille*, 1746, oil on wood, 24 x 32.5cm, Houston, Menil Collection.

of the senses. Thus, in the still life by Berbard shown here, taste is represented by food and drink, sight and smell by flowers, touch by the soft material of the carpet, and hearing by the music of the violin. The delicate materials (such as the glass that has been knocked over and possibly broken in Claesz Heda's painting), the dishes that have been started, the overripe fruit and the flowers that are beginning to fade — all act as reminders of the fragility of these all too earthly pleasures. Soap bubbles, hourglasses, skulls and anatomical drawings are also part of this stock of accessories symbolizing the transience of existence. Other recurring motifs are half-peeled lemons and knife handles or plates projecting over the edge of the table: shapes that stand out sharply, providing an excuse for painters to show off their skill in perspective and in creating a wide variety of textures, from the downy softness of the pith on a lemon skin to the shining moistness of the peeled fruit.

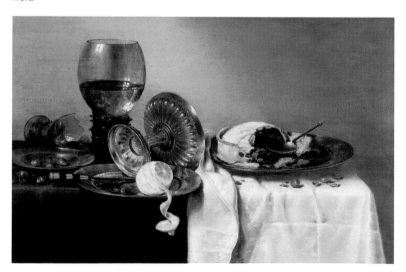

Willem Claesz Heda, *Still Life*, 1634, oil on wood, 43.5 x 68cm, Madrid, Fundaciòn Thyssen-Bornemisza.

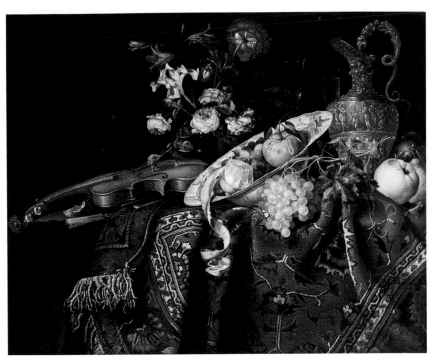

Jacques Samuel Berbard, *Still Life with Violin, Ewer and Bouquet of Flowers*, oil on canvas, 79 x 94.5cm, New York, private collection.

The genres today

Since the 19th century, it has no longer been appropriate to categorize painting into separate genres. Of course, some artists continue to paint mythological scenes, some are commissioned to decorate churches and others respond to contemporary events by producing work that follows in the tradition of history painting. Others continue to produce portraits of their contemporaries or, like David Hockney, create vast landscapes or paint bathers around a swimming pool (which could pass for a genre scene). The term 'genre', however, implies a hierarchy of subject matter that no longer pertains today. It relates to a precise historical context in which painting and sculpture were the only forms of visual art that existed. Today, when figurative and abstract painting coexist, when 'installations' gather different objects together in order to create a meaningful whole, when nature is used by artists as a medium (Process Art and Earth Art) and when even the body — sometimes that of a model (Yves Klein's imprints), sometimes that of the artist (for example Jackson Pollock's paint-dripping technique, see p.262) — lies at the heart of the creative process, rather than classifying works by genre it is more appropriate to treat each one as a unique form of artistic expression by examining what it presents and how it presents it.

Composition

The term 'composition' refers to the various means, graphic rather than chromatic, used by painters to organize or order their work. The notion of compositio with regard to painting was developed by the Italian theoretician Leon Battista Alberti, who wrote *De Pictura* (*On Painting*) in 1435. Its main thesis was that a picture was like a sentence composed of different parts arranged in a hierarchical system and aiming to achieve the grace of oratory. Composition highlights certain figures and motifs and plays down others. Through perspective, it allows a distinction to be made between background and foreground and introduces the possibility of symmetry and asymmetry, thus creating harmony or, its opposite, tension and instability.

 ## Composition and context of a work

Composition depends on the choices made by the artist. It can also, however, be imposed on the artist by the way in which a work fits into the space it is destined for and its relationship with other works in the vicinity (particularly where the work is not an easel painting, but part of a cycle or decorative ensemble).

The setting, or the shape of the space to be painted

The spaces artists are required to paint are not always the ones that would allow them the greatest freedom. The wooden uprights separating the various panels within an altarpiece, for example, contain small compartments, either vertical and very narrow or in the shape of a quatrefoil (a four-lobed decorative motif), and these also had to be decorated. In the case of buildings, they encounter greater difficulties: they have to adapt to the

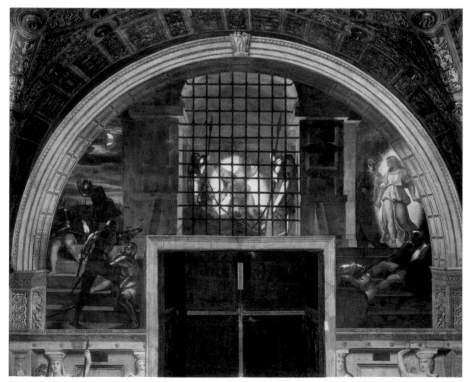

Raphael, *The Liberation of St Peter*, c.1512, fresco, base 660cm, Rome, Stanza d'Eliodoro, Vatican Palace.

Studio of Raphael,
pilaster decoration:
grotesques, detail of a
fresco, c.1516–19,
Rome, Loggias,
Vatican Palace.

architecture, take account of openings and the curvature or slant of the upper areas and so on. In the Stanze of the Vatican (the 'chambers' within the papal apartments), Raphael had no quadrilateral spaces at his disposal. The walls end in lunettes (semicircular spaces). The lower portion of each fresco is either encroached on by a door-frame on one side (*The School of Athens*, see p.82) or extends down on either side of a window (THE LIBERATION OF ST PETER). His decisions concerning composition were determined by these structures. At the top of *The School of Athens*, semicircular vaults painted in the fresco create an echo that enhances the arch of the lunette, while in *The Liberation of St Peter*, painted flights of steps allow the figures to be arranged on different levels.

In the Loggias, a long gallery or portico on the second floor of the Vatican Palace, the spatial constraints were even more formidable. Raphael and his assistants had to paint PILASTERS, high, narrow supports on which any form of storytelling was impossible. In this instance they adapted not only the composition, but the subject too, reinventing (or at least reusing on a scale not seen since ancient times) 'grotesques' — playful decorative elements (sphinxes, harpies, small temples, animals of all kinds, *putti* and shells) distributed among the tracery and infinitely superposable. The Vatican Loggias are a series of arcades surmounted by groined vaults. The design of these arcades resulted in vaulted ceilings divided into quarter sections, in other words sloping concave triangles. Raphael gave up the idea of decorating these as single blocks, creating instead smaller rectangles on which he painted individual scenes (episodes from the Old Testament). Examining the composition of a work in a case such as this involves not only looking at the distribution of forms within the frame, but also in analysing the solution the artist has adopted in order to create a usable surface within a difficult environment.

Positioning of Paintings Within a Complex Space: The Ceiling of the Sistine Chapel.

The ceiling of the Sistine Chapel, painted by Michelangelo between 1508 and 1512, provides a perfect example of the complex problem facing painters required to decorate a space with a difficult layout.

Extremely large (more than 40 metres long), the ceiling takes the form of a barrel vault supported against the sides of the walls by triangular springings ('spandrels' or arch segments) and in the corners by other, larger triangles ('pendentives'). The tops of the walls, the decoration of which was also entrusted to Michelangelo, are divided into lunettes.

Rather than treating the ceiling as a single unit, the artist divided it into separate compartments. By introducing similar iconographical elements into architectural spaces of the same type, he gave the ceiling a regularity and logic while still creating great variety.

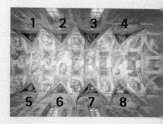

Michelangelo, general view of the ceiling of the Sistine Chapel, 1508–12, fresco, 40.23 x 13.41m, Rome, Vatican City, Sistine Chapel.

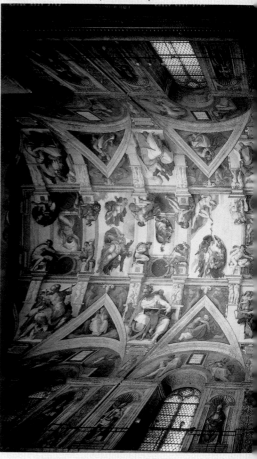

Episodes from Genesis ▲

Michelangelo divided the centre of the ceiling, its flattest part, into nine alternating large and small rectangles on which he painted episodes from Genesis. Ignoring strict chronology when he considered it necessary, he reserved the largest rectangles for the Bible's most important or most spectacular episodes. *The Creation of Adam* and *The Fall of Man* occupy the two large rectangles at the centre; *The Creation of Eve* has been allocated only a small space; *The Sacrifice of Noah*, which took place when the floods receded, comes before *The Flood*, a chronological absurdity that allowed Michelangelo to devote a large space to the drama of the flood itself.

1. The Separation of Light and Darkness, 2. The Creation of the Sun, the Moon and the Planets, 3. The Separation of the Land from the Waters, 4. The Creation of Adam, 5. The Creation of Eve, 6. The Fall of Man, 7. The Sacrifice of Noah, 8. The Flood, 9. The Drunkenness of Noah

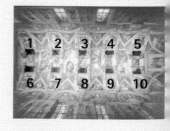

The Ancestors of Christ (I: Spandrel series)

Arranged in groups of three people, the first series of Christ's ancestors provided the opportunity for some beautiful variations on the theme of a mother with her children. The bucrania (sculptured ornaments representing ox-skulls) below the spandrels may be an allusion to death, and the bronze nudes may represent the rebel and fallen angels. *1. Salmon as a child with his mother and Boaz, 2. Roboam as a child with his mother and Solomon, 3. Ozias as a child with his mother, father Joram and one of his brothers, 4. Zorobabel as a child with his mother and father Salathiel, 5. The parents of the future king, Jesse, 6. Asa as a child with his father, 7. Ezechias as a child with his mother and father, 8. Josias as a child with his mother and father*

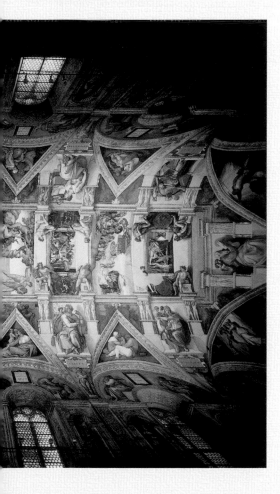

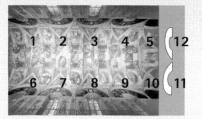

▲ The Ancestors of Christ (II: Lunette series)

This time the figures are isolated, have wild-eyed expressions and assume abandoned poses. They are despondent figures, symbolizing the sadness of the human condition between the Fall of Man and the coming of the Messiah. They form a counterpoint to the prophets and Sibyls, whose energy is born of their knowledge of the Redemption. *1. Salmon, Boaz, Obed, 2. Roboam, Abias, 3. Ozias, Joatham, Achaz, 4. Zorobabel, Abiud, Eliachim, 5. Achim, Eliud, 6. Jesse, David, Solomon, 7. Asa, Josaphat, Joram, 8. Ezechias, Manasses, Amon, 9. Josias, Iechonias, Salathiel, 10. Azor, Sadoc, 11. (not shown) Eleazar, Matthan, 12. (not shown) Jacob, Joseph*

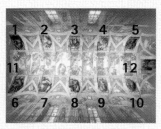

▲ The prophets and Sibyls

The prophets and Sibyls are positioned alternately just above the false cornice. They are seated on large thrones bounded by pillars, five along each of the long walls and one (a prophet in each case) at each end. Michelangelo took pains to avoid any monotony by systematically varying their poses. The prophets and Sibyls represent the peoples who awaited and in certain cases (thanks to their gift of divination) foresaw the coming of the Messiah. *1. The Prophet Jeremiah, 2. The Persian Sibyl, 3. The Prophet Ezekiel, 4. The Erythrean Sibyl, 5. The Prophet Joel, 6. The Libyan Sibyl, 7. The Prophet Daniel, 8. The Cumaean Sibyl, 9. The Prophet Isaiah, 10. The Delphic Sibyl, 11. (not shown) The Prophet Jonah, 12. The Prophet Zechariah*

◀ Ignudi (nudes) and medallions

On either side of the scenes from Genesis, wingless angels (in effect, nude youths) support gilt bronze medallions containing well-known scenes from the Old Testament.

1. The Ascension of Elias, 2. unknown subject, 3. The Death of Nicanor, 4. Mattathias Destroying the Altar at Modin, 5. The Fall of Antiochus Epiphanus, 6. The Sacrifice of Isaac, 7. The Death of Absalom, 8. Alexander the Great Worshipping the Name of God, 9. The Punishment of Heliodorus, 10. The Murder of Abner

▲ Four episodes in the salvation of Israel

On the four pendentives, Michelangelo has depicted four occasions on which the Hebrew people were saved by divine intervention.

1. David and Goliath, 2. Judith and Holofernes, 3. (not shown) The Punishment of Haman, 4. (not shown) The Brazen Serpent

Choice of format: the prestigious golden section

While the height and width of the squares or rectangles marked out by a painter on the surface of a wall are determined by the wall's size and the number of scenes that have to be painted on it, the choice of format for a wood, canvas or paper support, unless governed by the need to fill a given space (such as a commission to paint a picture of precise dimensions, to decorate an altar perhaps), depends on considerations that are to some extent abstract.

The golden section — a mathematical fantasy of harmony inherited from Pythagorean philosophy — has kept artists (and even more so art theoreticians and critics) speculating for a very long time. Some of these speculations have influenced the choice of dimensions for works and the internal organization of form. To put it simply, the term 'golden section' refers to a ratio (whose exact value is: [root of 5 + 1] divided by 2, in other words 1.618) derived from shapes considered by Pythagoreans to be perfect: the square and the circle.

Today, the dimensions of the most common format of commercially available paper are determined by the golden section. Let us take the example of a sheet of standard printer paper. It is rectangular and measures 21 x 29.7cm. We will call its corners A, B, C and D. If we fold up each of the two short sides (first AB and then DC) to meet the long side AD and then fold them down to meet the other long side, BC, we get two squares, ABA'B' and DCD'C' of which AA' and BB' are the diagonals of one square and DD' and CC' are the diagonals of the golden rectangle deriving from a shape regarded as perfect, the square.

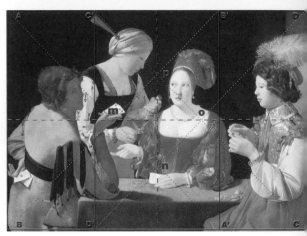

Georges de La Tour, *The Cheat with the Ace of Diamonds*, c.1630, oil on canvas, 106 x 146cm, Paris, Musée du Louvre.

The Golden Rectangle: an illustration of the ratios between a rectangle measuring 21 x 29.7cm (such as a sheet of A4 paper) and the squares contained within it.

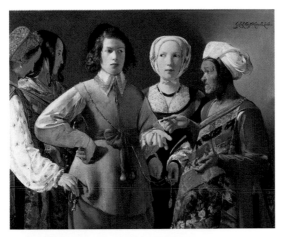

Illustration of composition:
Georges de La Tour,
The Fortune Teller, c.1632–5, oil on canvas,
102 x 123cm, New York, Metropolitan
Museum of Art.

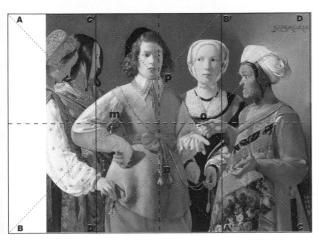

Visually it divides into three vertical rectangles, a wide one in the middle (C'D'A'B') and two narrower ones of identical size to the right and left (ABD'C' and DCA'B'). The central axes of the sheet of paper are formed by the straight lines that pass through the meeting points of the diagonals of the squares, points p and n in the case of the vertical axis and points m and o in the case of the horizontal axis. Painters both past and present have used this essentially very simple formula as the structural basis for their paintings. In Georges de La Tour's *CHEAT WITH THE ACE OF DIAMONDS,* this structure is easy to spot thanks to a strip added at some time to the top of the picture. By applying the same letters as before to the corners of this painting and to the points at which the folded diagonals would meet the edges, we can see that the painting has been divided into three rectangles that could be described as 'harmonious': the one in the centre containing the two women (the courtesan playing cards and the servant bringing her wine), the one on the left in which the cheat hides his ace from the others while revealing it to the viewer, and the one on the right containing the simpleton. The heads of the four protagonists are all placed above the horizontal axis m-o, and the figures have been arranged symmetrically around the central axis p-n with two characters on either side.

The Fortune Teller is another painting whose initial format — which can be graphically reconstructed — was a golden rectangle. At an unknown date and for an unknown reason, the canvas was cut along the side on which the gypsy stealing the adolescent's purse now only appears in part. By folding over the short side of the canvas (DC) to the left to meet each of the two long sides in turn, we would obtain a square (DCD'C') on the basis of which it is a simple matter to reconstruct the original plan. The central vertical section consists of the adolescent and his companion — again a courtesan, elegantly dressed. The right-hand rectangle contains the old gypsy woman, who is in the process of reading the boy's future. The left-hand rectangle takes in the two 'Egyptian women' (the term used in Lorraine to refer to female gypsies), though now only incompletely. The vertical axis p-n passes through the face of the naive boy and follows the seam and then the bow of his

Composition

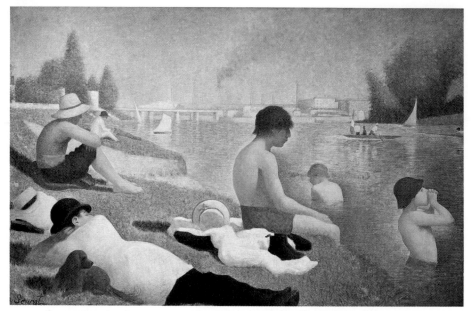

Georges Seurat, *Bathers at Asnières*, 1884, oil on canvas, 201 x 300cm, London, National Gallery.

tunic. All the heads are positioned above the horizontal m-o, and the young man fails completely to notice what is happening beneath it: hands are cutting his golden chain and grabbing his purse.

Painters continued to be interested in the golden section well after the 17th century. Georges Seurat and Paul Sérusier made use of it at the end of the 19th century, and the first Cubist exhibition, in October 1912, was held under the title 'Section d'Or' (Golden Section). Looking beyond these associations (sometimes more nominal than real), the idea of an aesthetic founded on mathematics — in other words one with scientific legitimacy — has seduced a great many artists. One of the directions taken by aspirations of this kind has been experimentation with simple spatial relationships within the rectangle of the painting. *Bathers at Asnières* and *Sunday Afternoon on the Island of La Grande Jatte* (see p.107) by SEURAT, for example, reveal a division of the surface based on eighths (rhythmic scansion in two, four and eight) that can also be found in another painting by the same artist, *Circus Parade* (New York, MOMA). The choice of round or square formats is another aspect of this type of experimentation, particularly in the case of painters who see geometry as a means of achieving some sort of conception of the cosmos. One such is Piet Mondrian, who began using the square (which he preferred to call the 'diamond') in 1917, positioned either on its base or as a lozenge on one of its corners.

THE INTERIOR OF THE PAINTING: ORGANIZATION OF THE PLANE

Because it consists of colour and line on a flat surface, painting should be studied as a plane, in other words as a surface featuring different zones (top, bottom, right, left, centre, edges) and that takes its structure from geometrical elements: points, lines, surfaces. Leon Battista Alberti called this the 'rudiments' of the art.

From the beginning of the Christian era to the start of the Gothic age, artists took the flatness of the support as a given and even emphasized it by constructing their images in terms of horizontal or vertical planes rather than by introducing a sense of orthogonal direction to create the illusion of depth. Much more recently, in 1970s France, a group of artists adopted the name 'Supports-Surfaces' as a way of indicat-

ing their interest in the physical reality of paintings, in other words paintings as surfaces. Their experimentation resulted in stretcherless canvases cut up and fixed partly to the wall and partly to the floor (Louis Cane) or marked with horizontal and vertical stripes (Marc Devade), and in nets, ropes and stencilled parasols (bearing the flexible-rectangle, or 'bean-shaped', motifs of Claude Viallat).

But even those painters from centuries past who regarded their art as 'the hollowing-out of a surface' (to borrow Seurat's definition) never neglected the organization of the surface of their paintings.

Centre and sides

Paintings of the Middle Ages had a simple layout that took account of the physiology of human vision and satisfied a demand for symbolism. Let us consider the ALTARPIECE OF THE LAST JUDGEMENT, a polyptych painted by Rogier van der Weyden shortly before the middle of the 15th century. When open, it reveals nine panels. The central panel is the first to attract the eye. The viewer stands in front of it before moving to each of the wings; this is made necessary by the large size of the altarpiece (it is 560cm wide in all). Van der Weyden has made the central panel, the most prominent, taller than the others (215cm compared to 130cm for the bottom wings and 74cm for the top wings). He has also emphasized the central axis, placing Christ the Judge and the terrestrial globe directly above Archangel Michael, the weigher of souls, at the very middle of the altarpiece. The wings are organized in strict symmetry, with three panels on either side at the bottom level and a single panel on either side at the top. The holy figures depicted in them are all turned towards the centre of the altarpiece.

Direction of reading

The gaze of a right-handed viewer will naturally move to the right before exploring the area on the left. This fact is well known to layout artists, who prefer to place illustrations on the right-hand page, or 'good side', of a book. Medieval logic, however, took account of God's point of view. To sit 'at the right hand of God' is a privilege reserved for the elect, so paradise is on the left of the painting as seen by the viewer. It is unfortunate if this half of the altarpiece is less carefully scrutinized: the painter knew full well that the torment and terror of the damned is literally a more 'picturesque' (and thus easier) subject matter. Hell is therefore on the viewer's right.

It is also common for the horizontal composition of a painting to be influenced by

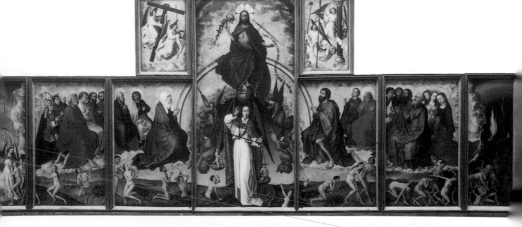

Rogier van der Weyden, *Altarpiece of the Last Judgement,* c.1445–8, oil and gold leaf on wood, 215 x 560cm (open), Beaune, Musée de l'Hôtel-Dieu.

the direction of reading as practised in the West (left to right). When several scenes are depicted within a work (as was frequently the case up to the beginning of the 16th century), the events with which the narrative starts are painted on the left and those with which it ends on the right. In his *The Liberation of St Peter*, Raphael positioned the conversation between the angel and the imprisoned saint at the centre and painted St Peter's miraculous escape immediately to the right of this scene (see p.58). In the case of a cycle, the order in which the paintings are presented still depends on reading habits, but it also depends on the direction of traffic flow and particular logic of the gallery or other exhibition space. Giotto's cycle of the lives of Mary and Jesus in Padua (Arena Chapel) is organized into three tiers (registers) positioned one on top of the other. The oldest stories (The Virgin's youth) occupy the top tier, those concerning the life of Jesus are in the middle and the Passion and Resurrection are at the bottom. Visually, the narrative reads from top to bottom like a written text. In the Sistine Chapel (see p.60), the stories from Genesis start above the altar. *The Separation of Light and Darkness*, the first episode of the Creation, is at the point furthest away from where the congregation gathers (it is also the most distant event in time) and directly above where the Eucharist is celebrated, in other words where God is present at the moment when bread and wine are transformed into the body and blood of Christ.

High and low

Christian morality — as well as popular attitudes, at least in the West — favour the high (representing the good, noble and beautiful) over the low (representing all that is base and ugly). ROGIER VAN DER WEYDEN'S altarpiece, to use the same example, conforms to this hierarchy. It places Christ above all the other figures, positions the angels above the saints (the heavenly Church against the background of a golden cloud) and the saints above the dead who are returning to life. The elect ascend to paradise (the steps have been drawn with remarkable precision) while the damned topple into the pit of hell. This predilection for the 'high' influences the physical image of the Judgement, the weighing of souls, represented by a tiny naked man. On the scales held by the Archangel Michael, the dish near his right hand is the higher of the two (and therefore the lighter) and contains the righteous soul; the dish directly below his left hand is lower (and therefore heavier) and contains a damned soul who is wailing. Similarly, within the general organization of an altarpiece, the placing of the various paintings conforms to the symbolism of this system of orientation. The holier figures occupy the central and top parts rather than the bottom, while the minor saints occupy the edges. No donor would dare to occupy the exact centre of an altarpiece. Conversely, when painters broke with this system (which had a life extending well beyond the Middle Ages), they did so in a deliberate manner and

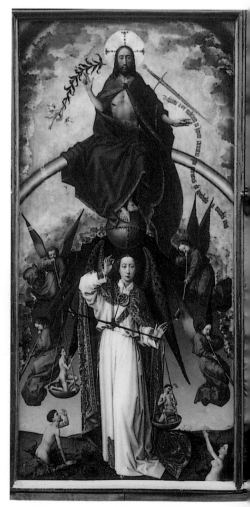

Rogier van der Weyden, *The Last Judgement*, central panel.

with specific intent. Michelangelo's fresco of the LAST JUDGEMENT (1536–41) in the Sistine Chapel caused a scandal not only because it depicted nakedness. The unambiguous organization of the normal iconography of this scene — which left no room for doubt among the faithful with regard to the fate of good and bad Christians — is dangerously confused here. A clear division into right and left, top and bottom, has been replaced by a terrifying whirlwind that sweeps up the dead emerging from the ground along with the holy saints, the righteous and the damned. As a result it is difficult to be certain who is ascending to heaven and who is descending into hell.

Symmetry and asymmetry

While remaining essentially faithful to traditional forms of organization, particularly where symmetrical distribution around the centre was concerned, many painters took subtle liberties.

In the Italian Holy Conversations (see p.16), figures and motifs were evenly distributed between the left and right sides. On either side of the axis formed by the baldachin, the cross, the Virgin Mary and the central angel in Giovanni Bellini's SAN GIOBBE ALTARPIECE (see p.17), there are three standing saints and another seated angel (facing

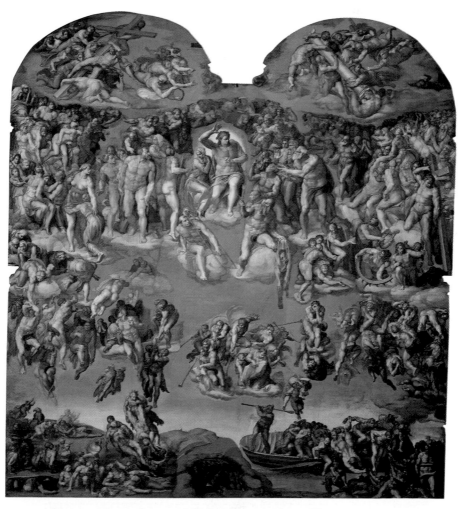

Michelangelo, *The Last Judgement*, 1536–41, fresco, 13.7 x 12.2m, Rome, Sistine Chapel, Vatican Palace.

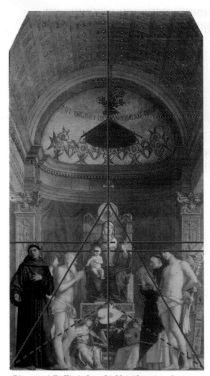

Giovanni Bellini, *San Giobbe Altarpiece* (see p.17).

towards the central axis). The architecture is identical on either side, but one small variation is that instead of looking at the Virgin and Child, St Francis on the left (recognizable from his brown habit and triple-knotted girdle) is looking towards the viewer: he has been given the role of 'admonisher' (Alberti), the figure who appeals to the viewer to devote their attention to the scene before them. In Titian's *Sacred and Profane Love* (p.XIV, Introduction), which dates from a few years later, the central axis passes just to the right of the bent elbow of the child (*putto*) who is moving his hand through the water in the sarcophagus, thereby introducing a subtle decentralization. This reinforces the isolation of the figure representing Sacred Love, the woman who turns towards God rather than the world. To take a final example, from the 17th century: in Louis Le Nain's PEASANT FAMILY, often called Return from the Baptism, the vertical p-n passes through the middle of the face and body of the man seated behind the table. Compositional balance is achieved by positioning the two women in the foreground to the right and left. There are only two figures in the left half of the painting, however, as opposed to three in the other half: the mother and baby plus a small boy who has been left in semi-darkness by the painter. Furthermore, the two women are not both looking towards the centre; the woman on the right is looking beyond the edge of the painting.

These subtle deviations from the rule of symmetry result from a desire not to bore the viewer, which would happen were the image to be constructed strictly according to the rules and without any surprising variations. This is the principle of 'variety' (*varietas*), first formulated, yet again, by Alberti. For him, this variety was essential if a work was to 'hold the viewer's eye for any length of time'. We will see that this principle has important consequences that go beyond the mere construction of the surface of a picture.

Pyramid and frieze

Bellini's *San Giobbe Altarpiece* and Le Nain's *Return from the Baptism* demonstrate that the positioning of elements above and next to one another is not sufficient in itself as a means of organizing paintings. Often, artists base their composition on simple geometric shapes and adhere faithfully to the straightforward solutions which they offer. The above-mentioned works by Bellini and Le Nain are based on a pyramid (or triangular) structure. In Bellini's altarpiece, the pyramid rises from the bottom two corners of the work and comes to a point at the Virgin's head. In Le Nain's painting it rises from the same bottom corners and comes to a point at the head of the man behind the table. Relative to the apex of the triangle, the other figures are arranged in a frieze, in other words next to one another, all the heads on the same level within each picture ('isocephaly'), a level distinctly below that of Mary or the peasant father. In addition to its simplicity, this arrangement has the merit of establishing a clear hierarchy, stressing the pre-eminence of Mary and Jesus in the Bellini altarpiece and that of the head of the family in Le Nain's genre scene while at the same time establishing perfect equality among the other figures.

The composition of Nicolas Poussin's JUDGEMENT OF SOLOMON is organized along the same simple principles. The subject is well known: the appearance of two women

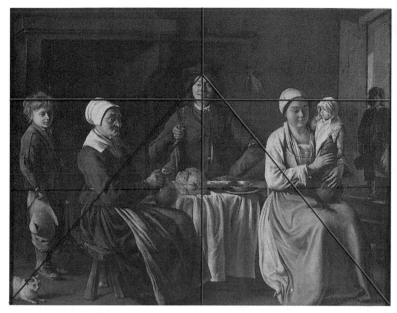

Louis Le Nain, *Peasant Family,* also known as *Return from the Baptism,* 1642, oil on canvas, 61 x 78cm, Paris, Musée du Louvre.

before Solomon following the death of an infant, and the ruse employed by the king of the Jews to discover who is the mother of the surviving child. Solomon orders the little boy to be cut into two. The false mother accepts and the real mother pleads for the child to be spared. The horizontal and vertical symmetry is clear, with the figure of Solomon isolated in the upper half of the picture, the two pleading women positioned in the lower half and the other figures distributed like pieces of scenery on either side of the king, through whom the vertical axis passes. A triangle rising from corners B and C of the picture, with its apex at the king's head, takes in the two women, while outside it the two groups of onlookers are arranged in a frieze formation. The only head that rises above the group is that of the executioner, on the left, who is about to divide the child in two. This is a method of making him stand out.

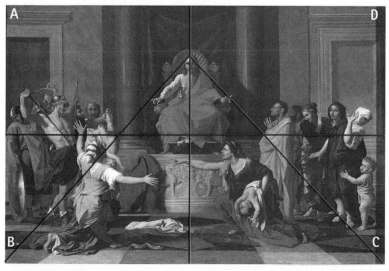

Nicolas Poussin, *The Judgement of Solomon* (see p. 98).

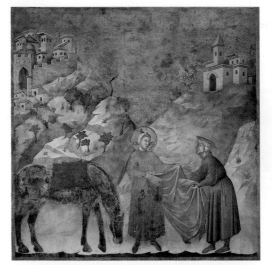

Shapes other than the pyramid are also used to organize paintings. The structure of Giotto's fresco *THE GIFT OF THE MANTLE* is based on two triangles, ABC and BCD. The slopes of the hills behind the St Francis lie on the diagonals A-C and B-D, meeting almost exactly at his head. On other occasions, circles or ovals are chosen in preference to the triangle. In the Paris version of Poussin's *SHEPHERDS OF ARCADIA,* the shepherds are arranged around the tomb in an almost perfect circle.

Horizontals, verticals and diagonals

The choice of lines on which painters base the organization of their work is as important as the choice of geometric shapes that assist them in the arrangement of their motifs. Straight or curved, following the same or different directions, lines are used by painters according to their supposed formal qualities and varying degrees of simplicity or complexity. While Giotto and Rembrandt appreciated the purity of curves, as we saw in the previous chapter (Rembrandt to the extent that he added fragments of circles to the background of his self-portrait, see p.44), William Hogarth, in the 18th century, preferred diversity — which, like Alberti, he called 'variety' — achieved through the com-

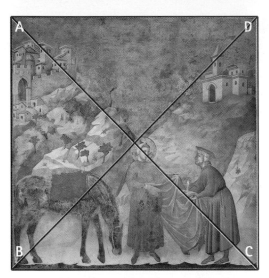

Giotto, *The Gift of the Mantle*, 1297–9, fresco, 270 x 230cm, Assisi, Upper Basilica, Basilica of St Francis.

bining of 'curved and straight lines blended together'. In his *Analysis of Beauty* (1753), Hogarth, who was not only a painter but also the first British art theoretician, praised the 'waving line' (which he also called the 'line of beauty'), made up of 'two curves contrasted', and especially the 'serpentine line' or 'line of grace', with 'its waving and winding at the same time different ways'. This aesthetic is related to the new style initially known as *rocaille* (rococo) that began to spread throughout Europe in the 1730s, a style that favoured surface ornamentation based on the delicate grace and vigour of the arabesque over the heavy straight lines inspired by the noble columns and cornices of classical architecture.

Horizontal, vertical, diagonal, parallel or diverging — lines in paintings express contrasting feelings, giving the works in which they feature an atmosphere which can be either solemn or cheerful, peaceful or tense, feminine or masculine. This, at least, is how art theoreticians since the Renaissance have understood it. In 1890, Seurat wrote in a letter to a friend that 'conflicting lines' are 'those that form a right angle'; 'gaiety' of line is conveyed by 'lines above the horizontal'; calm is expressed by horizontality and sadness by 'downward-sloping lines'.

This type of contrast can be seen in the choices Poussin made in his two versions of the same subject with identical titles, THE SHEPHERDS OF ARCADIA, also known as *Et in Arcadia Ego*. These paintings depict the harsh discovery of death, as represented by a tomb, by shepherds who had hitherto lived in blissful ignorance of it. The older version, which dates from the end of the 1620s, is vertical in format. Its dominant lines are diagonal. Thus the upper body of the old god at the bottom of the picture, who personifies a spring, is bent forward in a diagonal that is extended to the top of the painting by a large tree trunk. On the other side, two shepherds and a shepherdess rush forward in a movement that tips their bodies towards the right in order to read the inscription on the tomb, which also tilts upwards. The instability of the composition is meant as a graphic reflection of the emotional turmoil in which the shepherds find themselves.

For THE SHEPHERDS OF ARCADIA in the Louvre, painted ten years later, the painter chose a symmetrical composition in which the four figures are positioned around a tomb which is almost parallel to the picture plane. The agitation of the shepherds at the centre of the painting is emphasized by the right angles formed by their knees and arms (Seurat's 'conflicting lines'), but this emotion is alleviated by a

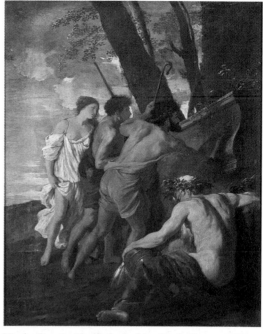

Nicolas Poussin, *The Shepherds of Arcadia*, also known as *Et in Arcadia Ego*, c.1628–30, oil on canvas, 101 x 82cm, Chatsworth (Derbyshire), The Trustees of Chatsworth Settlement.

Nicolas Poussin, *The Shepherds of Arcadia*, also known as *Et in Arcadia Ego*, c.1638–40, oil on canvas, 85 x 121cm, Paris, Musée du Louvre.

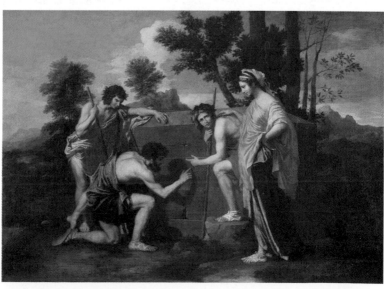

calmer, almost elegiac quality resulting from the arrangement of the figures in a harmonious circle, as previously mentioned, and through the repetition of horizontal lines ('calm horizontality', to quote Seurat again).

Poussin's judicious use or almost complete exclusion of diagonals shows his preference for a pictorial language that favours restraint even where the expression of suffering or emotion is concerned. Other painters in other times have made the opposite choice and used diagonals (lines that suggest imbalance) to convey tense situations. At the beginning of the Romantic era, Théodore Géricault, for example, based his works on a diagonal structure. In 1812 he depicted the mount of his *Officer of the Imperial Guard* rearing up (see p.228). Its powerful body extends across the canvas from the bottom left-hand to the top right-hand corner, offering a complete contrast to the well-behaved charger in Velázquez's *Philip IV on Horseback* (see p.36). Seven years later, Géricault structured his painting THE RAFT OF THE 'MEDUSA' on two intersecting diagonals, which can be described as an 'X'-style composition. One of the diagonals of the 'X' runs down from the top left of the picture to the opposite corner, following one of the retaining ropes of the makeshift sail and the line of the corpse stretched out in the foreground; and the other diagonal runs from the bottom left,

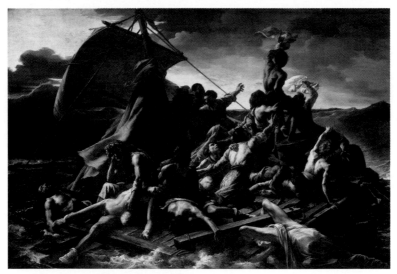

Théodore Géricault, *The Raft of the 'Medusa'*, 1819, oil on canvas, 491 x 716cm, Paris, Musée du Louvre.

along the body of another dead or dying man, and ends at the front of the raft, where the men are waving towards the tiny sailing boat coming to their rescue.

Empty and full composition

The number of figures or motifs and the sequence of densely filled zones and less densely filled zones in a picture are also the result of compositional choices. In many works, empty or near-empty areas are as important as areas filled with motifs. Their function is to set off the other areas and also to function like 'rests' in music, enabling the eye to pause and enjoy a moment of calm contemplation. The paintings of Chardin (sometimes) and the paintings of Vermeer (often) create an impression of 'celestial calm' (to cite one of Vermeer's biographers), which comes not only from the almost complete immobility of the figures, but also from the space around them: subtly lit walls or uniformly dark backgrounds.

Other painters fill their pictures to a greater extent. Most take care to leave a space around each figure in order to show it off to its best advantage, however. This custom has its roots in medieval art: in altarpieces, saints were often isolated to the extent

that each one was placed in an individual compartment. In the work of some artists, this separation takes on a metaphysical dimension. In the best paintings by the Le Nain brothers, for example, the peasants are separate from each other, have no physical contact and do not exchange glances. Here the space around them does not show off the figures so much as express human solitude. More often, painters simply try to ensure that the entire body of each of their figures, or in any case of their principle heroes, can be seen. In *The Lictors Returning to Brutus the Bodies of His Sons* (see p.24), the protagonists, or at least groups of protagonists, are so clearly visible that their full outlines can be traced: on the left, the fierce figure of Brutus, the father who condemned his sons to death for conspiracy; on the right, the mother and her two daughters, who helped the boys and who now express their despair. In this instance, the distance separating the man from the women symbolizes the conflict between political duty (which Brutus has obeyed) and love of family.

In the case of subjects involving a large number of people and requiring movement, painters find other solutions to avoid overloading their pictures. Alberti, who did not mean 'variety' to be synonymous with disarray, advocated a maximum number of figures per picture: 'In my opinion, there can be no story filled with such a great variety of actions that nine or ten men will not be enough to do it justice.' In battle scenes, entire armies come face to face with each other. Uccello in his three versions of *The Battle of San Romano* (Galleria degli Uffizi, National Gallery and Musée du Louvre), Velázquez in *The Surrender of Breda* (see p.28) and David in *The Intervention of the Sabine Women* (see p.26) all isolate a small number of protagonists (no more than a dozen) in the foreground and make do with hats, lances and indistinct outlines as a way of suggesting the crowds of soldiers behind them.

On the other hand, artists choose dense, complex forms of composition when they want to emphasize the tumultuous nature of an event. The Mannerist painters of the 16th century frequently adopted this approach. Michelangelo, as we have seen, rejected a simple method of organization for his *Last Judgement* (see p.67), filling it instead with a vast number of human forms. Containing over three hundred figures, of which either the entire body or just the face is visible, this is far removed from the judicious restraint advocated by Alberti. Other artists around the time of Michelangelo also liked to paint a multitude of figures. In 1508, Dürer filled his painting *The Martyrdom of the Ten Thousand* (see p.5) with a profusion of small characters (clearly the subject matter lent itself to this treatment). El Greco also succumbed to this temptation in his *Martyrdom of St Maurice and the Theban Legion* (Madrid, El Escorial) and other paintings.

Even with fewer figures, certain types of composition can be highly complex. There are a number of works by the Florentine Rosso Fiorentino, for example, that contain few empty spaces. In *Moses Defending the Daughters of Jethro* (Florence, Galleria degli Uffizi), not only do the figures fill the canvas from the centre to the edges, they also press up against one another and overlap, resulting in an inextricable visual tangle. The viewer has to study the painting carefully in order to re-establish the contours of each body and work out which arms and legs belong to which figure. The picture forms a compact mass into which it is difficult to enter. Replacing the ideal of harmony sought by the majority of painters, at least until the end of the 19th century, this approach is designed to surprise, shock and stun the eye in order to provoke reflection.

Open and closed composition

The organization of empty and full spaces can be interpreted in terms of open and closed composition. The terms 'closed' form and 'open' form were used at the beginning of the 20th century by the art historian Heinrich Wölfflin to describe types of painting in which figures and motifs are either grouped together in ensembles that are closed in on themselves (closed form) or else give the impression of being fragments of a world that continues beyond the painting (open form). The majority of paintings up to the end of the 19th century, with the exception of certain works from the Mannerist period, correspond to the ideal of closed composition. The main elements of

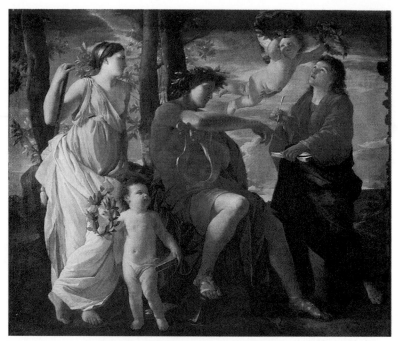

Nicolas Poussin, *The Inspiration of the Poet*,
1624–33, oil on canvas, 182.5 x 213cm, Paris, Musée
du Louvre.

Edgar Degas, *La Loge*, c.1870, oil on canvas, 56.5 x
46.2cm, Paris, Musée d'Orsay.

the subject are placed in the centre of the picture. In particular, all the human figures are contained within this sector, and are surrounded by a space – an empty zone in which the motifs are less dense – between them and the edges of the canvas. This was very often exactly the case in Classical-style paintings of the 17th century such as THE INSPIRATION OF THE POET by Poussin, the Paris version of *The Shepherds of Arcadia* (see p.71) or, a little later (around 1655), the *Portrait of Chancellor Séguier* by Charles Le Brun (see p.213).

From the end of the 19th century on the other hand, artists started becoming far more interested in opening composition up, leading to its almost systematic decentralization. Edgar Degas made this revitalization of the 'point of view' one of his main areas of experimentation during the 1870s. His pastels and oils of dancers (either in rehearsal or on stage) capture the subject from unusual angles that systematically cut figures off at the top, bottom or sides. In a number of works, including *The Orchestra of the Opera*, dating from around 1870,

or *La Loge* from 15 years later, this procedure is all the more disconcerting as he shifts the main interest from what in a traditional painting would normally constitute the main subject (the ballet) to motifs that one would expect to find in subordinate roles, such as the orchestra pit in the first painting and a female member of the audience in the second.

The size of figures relative to the size of the painting

Logically, the rule of closed composition that prevailed until a relatively late date would lead one to assume that figures were always depicted full-length, in such a way that their bodies were fully visible. Different ways of centring or framing a subject, however, could also mean that only part of a figure was captured. This might be the head and shoulders, as is often the case in portraits, or the whole of the trunk, in other words the upper part of the body without the legs, otherwise known as half-length composition.

The choice of whether to depict a figure full-length or half-length in history paintings and genre scenes depended on a variety of considerations. Half-length figures create an illusion of great proximity. If the picture is sufficiently large, the characters can be painted life-size or nearly life-size, creating the impression that the viewer is standing before a real-life scene. Being aware of these illusionistic possibilities, the 17th-century painters described as 'realist painters' — those faithful to Caravaggesque methods as opposed to the supporters of the classical tradition — frequently adopted this form of representation. It was employed by Velázquez in one of his very first masterpieces, OLD WOMAN COOKING EGGS. Georges de La Tour used it more or less systematically (see p.62–3) and, before him, Valentin de Boulogne used it in the tavern scenes he made his speciality.

On the other hand, depicting figures full-length and setting them further back, thus making them a lot smaller relative to the size of the picture, also offered certain advantages. It allowed painters to establish a setting, essential at times for ensuring that the subject of a painting was understood. This style was popular both with painters of the Grand Manner, who were fond of settings full of pomp, and with

Diego Velázquez, *Old Woman Cooking Eggs*, 1618, oil on canvas, 100.5 x 119.5cm, Edinburgh, National Gallery of Scotland.

Antoine Watteau, *The Pilgrimage to Cythera*, 1717, oil on canvas, 129 x 194cm, Paris, Musée du Louvre.

painters of genre or exotic scenes, who were attached to the picturesque element inherent in settings featuring strong 'local colour'.

Moving figures into the background of the painting also allowed them to be integrated into panoramas with which they could harmonize. The art of Antoine Watteau, dating from the beginning of the 18th century, is based on this fusion of setting and human figures. His 'fêtes galantes', the most famous of which is THE PILGRIMAGE TO CYTHERA, his reception piece for the Academy, depict elegant, leafy parks through which glide delicate puppet-sized figures. The distance at which these figures are placed from the viewer serves to locate them in a dream world that is all the more enchanting since we know it is not real. In works such as these, Watteau no longer sought to create a realistic effect but an unreal or 'surnatural' one, to borrow a term invented by the Goncourt brothers, the great 19th-century champions of this painter.

In the case of very large paintings, full-length depiction can lend human figures a striking presence. And when portrayed life-size, a figure can be more impressive still. Portraits of monarchs exploit this, and allow a king to be present in effigy, if not in person, throughout his kingdom. Sometimes etiquette even demands that homage is paid to his image as if it were the actual monarch. Watteau also recognized the potency of this technique and used it in his painting *Gilles as Pierrot* (Paris, Musée du Louvre). This tall figure dressed in white, standing in a painting that seems too low for him, has become synonymous with the dreamer who feels out of place in the real world. His helplessness is conveyed by the awkwardness of his arms, which he holds stiffly against the sides of his immaculate costume. In the previous century, Georges de La Tour had

Veronese (Paolo Caliari), *The Feast in the House of Levi*, 1573, oil on canvas, 555 x 310cm, Venice, Galleria dell'Academia.

already exploited this 'law of framing' (an expression used by the art historian Henri Focillon in connection with Romanesque sculpture) to more radical effect. This 'law' refers to the pictorial situation in which a figure seems to bend to fit a tight space, rather than the frame being adjusted to accommodate the figure. In *Job Mocked by his Wife* (see p.122), the arrogant wife of this man being tested by God seems all the more menacing as a result of her tall figure having to arch over in order to fit into the painting.

The integration of full-length figures into compositions far larger than the two works mentioned here creates an even greater sense of illusion. This is the direct result of a relationship between viewpoint and size with respect to the viewer and the painting. Veronese's large decorative murals — feast scenes with titles such as *Wedding Feast at Cana* and THE FEAST IN THE HOUSE OF LEVI, which were designed to adorn the refectories of Venetian convents — contain large numbers of figures in vast architectural settings. As they were intended to be viewed from relatively far away, viewers are given the sensation — helped by the equivalence of scale — that these paintings are a continuation of the viewers' own space and that they could actually enter them. Watteau, again, used this technique in *Gersaint's Shop Sign* (see p.82), a large canvas that invites the viewer to peer inside an art dealer's. And David used it in *The Consecration of the Emperor and the Coronation of the Empress* (see p.25), a painting that features 'more than two hundred life-size figures', according to an early description of it, and of which Napoleon, astounded by its realism, is said to have exclaimed: 'this is not a painting, one can walk into it'.

THE ILLUSION OF DEPTH: CREATING PERSPECTIVE

The illusion of reality produced by certain paintings, such as Veronese's *Wedding Feast at Cana*, Watteau's *Gersaint's Shop Sign*, or David's *Consecration*, does not depend solely upon the size of the figures. It also depends upon a use of perspective that creates an illusion of depth. In order to examine how perspective is achieved, it is essential that we look at what it is in paintings that draws the eye towards apparently distant planes. For six

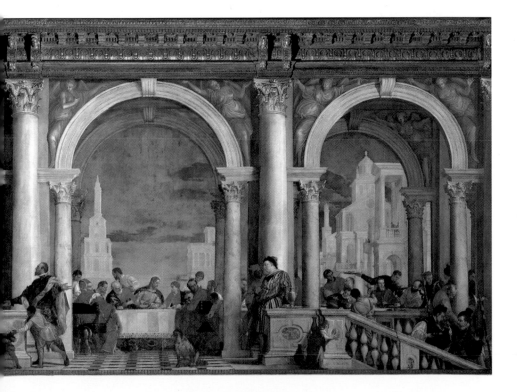

centuries, from the 14th century to the beginning of the 20th century, paintings have been designed as exercises in trompe l'oeil, the aim of which is to create the illusion of three-dimensional representation in spite of being painted on two-dimensional surfaces. Again it is *On Painting* by the indispensable Leon Battista Alberti that supports this view, comparing pictures to 'open windows' through which we are permitted to gaze.

Perspective or perspectives?

Painters use many different procedures to create perspective. The most self-evident, and one that we will not go into in detail here, is the progressive reduction in size of figures and motifs. This is called 'diminishing perspective'.

Alongside this particular graphic device there are others relating to the treatment of zones in the extreme distance, known collectively by the term 'aerial perspective'. One form of aerial perspective is the use of a chromatic range in which primary colours are placed in the foreground along with the strongest contrasts in terms of intensity of light (very dark colours alongside very light ones). This is called 'colour perspective'. Another form uses shading off in order to produce blurred contours in the distance. The most perfect expression of this technique can be found in the *sfumato* effects (the gradual transition from light to dark shades) used by Leonardo in many of his paintings (in the background of the MONA LISA, for example, see p.34). Leonardo explains the theory behind this in his notebooks. Sfumato, which literally means 'smoky', is allied to the practice of depicting differences in the colour of the sky, which is paler on the horizon than it is at the

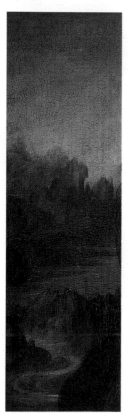

zenith, and of giving the landscape in the far distance that blue tinge which results from the greater density of air that separates the observer from the object observed. These effects are known as 'atmospheric perspective' and were neatly defined by Diderot in the 18th century as 'a manner of shrouding contours in a light haze'.

Unlike distant planes, which are rendered using aerial perspective, near and intermediate planes obey the laws of 'linear perspective' (at least when they contain architectural motifs). This technique, which is also known by its Italian names *costruzione legittima* (legitimate construction) or very rarely *quadratura* (not to be confused with the other meaning of this term explained on p.95), involves laying down a set of lines that in reality are perpendicular to the plane of vision, but which appear to continue in the same direction (at an oblique angle as a result of perspective distortion), converging on a single point just as railway lines, which are really parallel, also appear to meet in the distance. These receding parallel lines are known as 'orthogonals' and the point on which they converge as the 'vanishing point'.

It should be remembered that these various means of representing depth were not invented all at once. For the most part, they were elaborated during the 15th century: in Flanders, where painters (in particular Jan van Eyck from the 1430s onwards) practised various methods of geometric, colour and atmospheric perspective before they had been defined theoretically; and in Italy, where the architect and sculptor Brunelleschi conducted the first experiments with *costruzione legittima* and Leonardo da Vinci developed his ideas on the relationship between the illusion of depth and the treatment of colour and light.

Leonardo da Vinci,
Mona Lisa, detail, 1503–5,
oil on wood, 77 x 53cm,
Paris, Musée du Louvre.

The rejection of perspective in the Middle Ages

It would be wrong, however, to believe that artists had waited all this time to find ways of representing depth. Ancient Greek texts tell of scenographers who painted backdrops for the theatre and who certainly employed all kinds of visual tricks to deceive the audience. Roman homes in Pompeii and Boscoreale show that decorative trompe-l'oeil architectural scenes were frequently used to break up the monotony of the walls. This knowledge of perspective disappeared only during the Christian era, not because its painters were less skilful than their pagan predecessors, but because the new religion was reluctant to encourage the individualism inherent in any painting using perspective techniques.

Painting the world in perspective involves depicting it as it is seen from an individual's specific position in the universe. The notion of 'point of view', essential to any discussion of these techniques, clearly expresses the subjectivity of perspective: it is not a way of representing objects as one knows them to be, but as they are seen by a particular observer from a given spot. This approach, favouring perception over objective reality, was not acceptable to the theologians of the Middle Ages. It also had the disadvantage of seeming to create a hierarchy where the church did not want one. It would have been inconceivable at that time, for example, to depict Jesus smaller than a mere mortal simply because he was positioned further away from the viewer. From the early Christian days of the Roman era, artists therefore eschewed trompe l'oeil or the illusion of depth. They placed figures and motifs at different levels within the image that did not actually signify anything in terms of their relative positions in space, they filled backgrounds with horizontal bands, and they were ambiguous as regards the location of figures, of whom it is often impossible to say whether they are indoors or outdoors (St Mark the Evangelist, see p.132). By the time this reluctance to take account of human vision diminished – from the 13th century onwards, as a result of the curiosity aroused by learned Arab treatises on optics which had arrived in Europe – painters had to relearn the laws of 'visual realism' which had been completely forgotten.

The 'empirical perspective' of the trecento

The history of Italian painting during the 14th century is largely one of continual experimentation by artists as they seek to rediscover these laws. Their methods varied from workshop to workshop. This was the age of 'empirical perspective'. It was not yet a matter of constructing an entire image on the basis of some coherent spatial logic, but of finding partial solutions that effectively created perspective illusion. Around 1311, the Siennese painter DUCCIO juxtaposed a gold background – apparently enough in itself to exclude any attempt at realism – with various motifs that are on a tiny scale compared to the human figures. A path leads to a bridge with low walls and then into an urban enclosure. Houses project above the city walls and extend across the picture in diagonal lines, creating the effect of progressive distancing. At the same time, Giotto was experimenting more systematically with spatial construction. In his *Stigmatization of St Francis* (see p.183), he positioned two chapels (still much smaller than the figures) in such a way that they are at a very pronounced angle to the picture plane. The technical name for this system, which presents two foreshortened walls to the view, is 'two-point' or 'angular' perspective.

When painting interiors, Giotto presents the viewer with a house seen from the outside. This is either, as above, at an angle to the picture plane (for example, *St Francis and the Crucifix at St Damian's*, in Assisi) or else one wall is shown parallel to the surface of the mural and another is foreshortened. This latter solution, used in *The Angel Appearing to St Anne* and *The Nativity of Mary in Padua*, offers the advantage of being less 'aggressive' (John White) than angular perspective. It is known as 'artificial perspective' because its logic is clearly impossible unless we imagine that the walls of the building do not meet at right angles. One of the sides of the house is removed so that the viewer can see inside. These architectural representations are like doll's houses with removable walls, and have been referred to as such by the art historian Erwin Panowsky.

Duccio di Buoninsegna, *Christ and the Samaritan*, 1305–11, tempera and gold on wood, 43.5 x 46cm, Madrid, Fundaciòn Thyssen-Bornemisza.

In yet other works, Giotto uses part of a building to stand for the whole. This type of perspective, which could be called 'metonymic', is used by the painter in *The Institution of the Crib at Greccio* and *The Verification of the Stigmata* in the Basilica at Assisi. In both of these paintings, all that can be seen of the church in which the action takes place is the rood screen (from a viewpoint in the choir in the case of the first fresco and in the nave in the second). These scenes gain in terms of size — the architectural elements are on the same scale as the figures — but lose out in terms of intelligibility as it is not easy to see that the action is taking place indoors.

The solution for interiors adopted most commonly by Giotto also happens to be the one that pointed most strongly towards the future. Within the interior of the four-sided painted compartment, Giotto traced a virtual cube whose two sides as well as its top and bottom planes each meet the edges of the painting. The only missing side is the front. The effect of this is to transform the wall on which a work is painted into a window. Already used in *The Confirmation of the Rule in Assisi* and in *Christ among the Doctors* and *Christ before Caiphas* in Padua, Giotto employed the perspective cube again in *INNOCENT III APPROVING THE RULE OF ST FRANCIS*, a predella compartment in the altarpiece *THE STIGMATIZATION OF ST FRANCIS* (see p.183). A simple diagram allows us to follow the orthogonals in the top part of the interior — formed by the beams of the ceiling and the red cornices at the tops of the walls — and also (somewhat less easily) those in the lower part of the room, which run along the bottom of the left-hand wall and the meeting points of the hexagonal floor tiles. The first group of lines meets in a tight knot of points above the central window, while the others converge on the area slightly behind and above the head of St Francis. There are separate vanishing points for the orthogonals of each window. The few pieces of furniture visible (the bases of the thrones) are organized without regard to the laws of perspective. Relative to the walls of the room, they are positioned at a slant, and

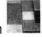

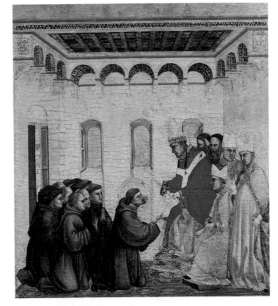

the lines formed by the edges of the steps are parallel to each other and do not converge.

The golden age of centralized perspective

This perspective cube — in which all the orthogonals were made to converge on a single vanishing point (in reality they do not converge quite so perfectly) — became the most commonly used method of depicting interiors from the 15th century onwards. By convention, and in order to create a situation as close as possible to actual visual conditions, this single vanishing point is located on what is called the 'horizon line'. This is situated at the eye-level of a standing person, in other words that of the painter standing in front of his subject.

Sometimes one or both side walls are not shown, creating the impression that the room continues to the side. The impression of space is thereby greatly increased. This is true of van Eyck's *Madonna with Chancellor Rolin* and Velázquez's *Las Meninas* (see p.90). The rear of the cube can also be removed, either completely or in part, in order to reveal more distant planes, as the same paintings demonstrate. Painters may also shift the room further back from the front of the picture. In GERSAINT'S SHOP SIGN, Watteau's

Frontal perspective (a single wall visible from the front)

Angular perspective (two slanting, or foreshortened, walls)

Artificial perspective (one wall visible from the front, one wall foreshortened)

Attenuated two-point perspective (two walls somewhat foreshortened)

Different types of perspective

Composition

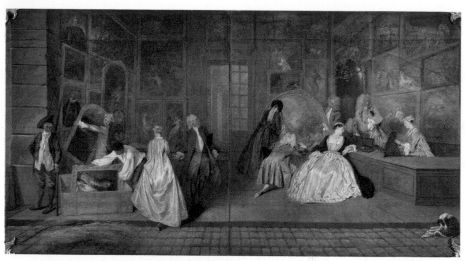

Antoine Watteau, *Gersaint's Shop Sign*, 1721, oil on canvas (cut down the middle), present size 166 x 306cm, Berlin, Charlottenburg Palace.

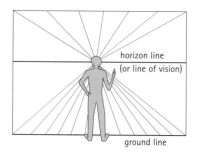

horizon line
(or line of vision)

ground line

Convergence of orthogonals: the vanishing point is located in the centre of the picture on the line of vision of a standing viewer.

composition opens with the cobblestones of the street at the front. Their grid-like arrangement leads the eye into the interior of the shop towards a vanishing point located in the centre of the picture, on the jamb of the open glass half-door that leads into a second room at the rear. The artist has chosen not to depict the ceiling, producing a remarkable effect of spatial expansion.

Centralized perspective was also used for exterior scenes set in towns or cities. Indeed, the geometry of the orthogonals lends itself far less well to the representation of nature than it does to the representation of buildings, which are essentially simple volumes that can be reduced to rectangular surfaces either shown from the front or foreshortened. Very often, as we have seen in the case of *Gersaint's Shop Sign*, the eye is led back first of all by a tiled 'chessboard' floor and then by the sloping walls of buildings whose architectural lines converge on a vanishing point located in the centre of the picture or slightly to one side. Spaces are created between buildings arranged in this way, and these streets or avenues create a rhythm that reinforces the impression of gradual distancing. This also allows for the addition of decorative elements to façades that are shown from the front or with almost imperceptible foreshortening. During the 16th and 17th centuries this decoration was generally classical in style, featuring statues, cornices, pilasters and such like. This can be seen in Raphael's THE SCHOOL OF ATHENS.

Raphael, *The School of Athens*, 1509–10, fresco, base 770cm, Rome, Stanza della Signatura, Vatican Palace.

Perspective and virtuosity: anamorphic images

The triumph of linear perspective in painting from the 15th century onwards corresponded to a desire to replace an intuitive conception of the world with an approach based — according to Luca Pacioli, the first theoretician of perspective along with Alberti — on *certezze*, or scientific certainties. This method suited an age that was becoming more and more infatuated with rationality, and between the 15th and 18th centuries it appealed to those painters in particular who wanted to make their art a *cosa mentale* (intellectual discipline) based on knowledge rather than empirical practice.

From the 1400s onwards, this quest for rationality led to the painting of pictures without a subject, townscapes constructed according to perfect perspective logic — such as the Ideal Cities or *prospettive* (architectonic views) inspired by works of contemporary marquetry and attributed to Piero della Francesca — and paintings and engravings of complex volumes: for example, the *mazocchi* or headgear in the form of a mulit-faceted circle in the different versions of Paolo Uccello's *The Battle of San Romano* (see p.139), or the block of stone fashioned into a polyhedron in Dürer's *Melancholia I* (see p.XIII, Introduction). A few years later, at the start of the 16th century, experiments with space took the form of a sophisticated game (not without metaphysical meaning) in the anamorphic images described by the art historian Jurgis Baltrusaitis as 'depraved perspectives'. These involved the total distortion of images of real objects through a special application of the laws of geometry. The distorted skull in the foreground of THE *AMBASSADORS* by Holbein is a prime example of an anamorphic image. Meaningless unless viewed from the correct angle, this curious shape lying at an angle across the inlaid floor between the two friends makes sense when viewed from the right-hand edge of the

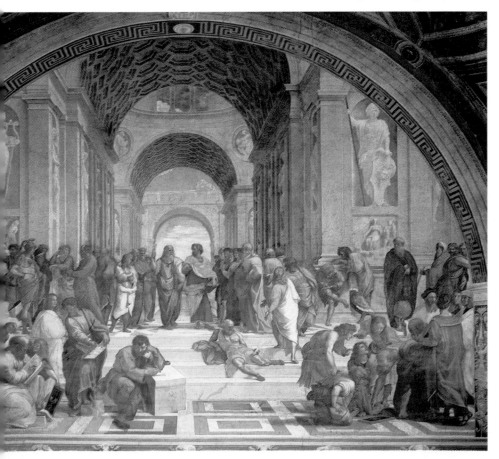

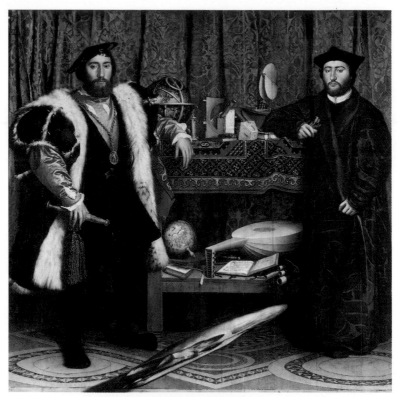

Hans Holbein the Younger, *Portrait of Jean de Dinteville and Georges de Selve,* known as *The Ambassadors,* 1533, oil on wood, 207 x 210cm, London, National Gallery. Whole and detail.

painting. The distortion tells us that we only notice the appearance of things. Observed 'correctly', reality reveals itself in the shape of a *memento mori*, a warning of the imminence of death.

Classical perspective and narrative

The success of linear perspective can also be explained by its effectiveness in enhancing narrative. The division into near and distant spaces allows a narrative to be clearly told by setting successive events in distinct zones. Events that occurred prior to the scene depicted in the foreground are shown behind, generally to the left, while those that occur afterwards are shown in the distance, often to the right. Perspective thus

Perspective as symbol: van Eyck, Raphael and centralized construction

Painters who shunned such complex virtuoso exercises as anamorphic images occasionally used deep perspective to symbolic effect. We can see this at work in van Eyck's *The Annunciation* from the Ghent Altarpiece and Raphael's *The Marriage of the Virgin*.

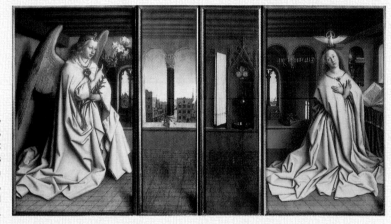

Jan van Eyck, *The Annunciation*, detail from The Ghent Altarpiece (with wings shut), 1425–36, oil on wood, c.120 x 260cm, Ghent, Cathedral of St Bavon.

When van Eyck's polyptych is closed, the rectangular wings of its upper tier form an *Annunciation* in which the Angel Gabriel and the Virgin, on the left and right respectively, are separated by a wide space. In an almost abstract solution, the central space is taken up by a highly conspicuous perspective grid. This leads the eye, on the left, to a wall containing an arched opening that looks out onto the sky and a townscape, and on the right to an almost blind wall into which is set a niche containing an aquamanile. Next to the niche a white cloth is draped over a pole that projects from the wall.

With the regular rhythm provided by the floor tiles and the beams, these panels are far from silent. They tell of the reality of space, the infinitely far and the infinitely near on which Pascal would later meditate.

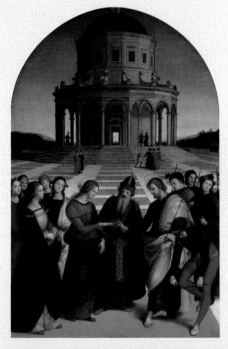

Raphael, *The Marriage of the Virgin*, also known as *Spozalizio*, 1504, oil on wood, 170 x 118cm, Milan, Pinacoteca di Brera.

In this *pala* inspired by a painting on the same subject by his teacher Perugino (Musée des Beaux-Arts, Caen), Raphael has depicted an impressive pavement in linear perspective behind the grand priest marrying the bride and groom.

The perspective lines in the centre of the painting lead to a door in the temple. The opening, which creates a luminous hole in the building (itself positioned on the central axis and drawn in perfect perspective), has a metaphorical meaning: at the same time as Mary (through her marriage) passes from childhood to a stage in life when as a woman she will conceive the Son of God, the door symbolizes the transition from the Old Testament to the New Testament.

refines and perfects the superficial chronological organization that we have already described.

The arrangement of figures on successive planes within a picture is also sometimes used to indicate a transition from reality to memory or commemoration. In THE FLAGELLATION OF CHRIST by Piero della Francesca, the unusual relegation of the main subject to the rear and the importance given to the three figures on the right have given rise to much debate. From the very beginning it always seemed clear that the shift in perspective, together with the very strong relationship between the two parts of the picture, indicated some sort of interaction between two periods and a comparison between two situations. Art historians of the past assumed that the young man in the foreground was the half-brother of Frederico da Montefeltro, the Duke of Urbino, who was 'morally flagellated' by two bad

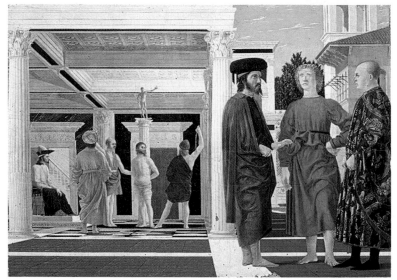

Piero della Francesca, *The Flagellation of Christ*, after 1459, tempera on wood, 59 x 81cm, Urbino, Galleria Nazionale delle Marche.

advisers who drove him to rebellion and death. Today, critics think the painting refers to the situation the Church found itself in at the time of the Council of Mantua in 1459. 'Flagellated' by the advance of the Turks six years after they had captured Constantinople, the Greek Orthodox Church had sought to draw closer to the Latin Church. In the background, the figure of Pilate bears a resemblance to the Byzantine emperor John VIII Palaeologus, who was powerless to prevent the persecution of the Christians in the East. And it is perhaps significant that the torturer facing Christ (but seen by the viewer from behind) is wearing a turban.

The treatment of space also determines what could be called the emotional key of the narrative. In the work of Tintoretto (see p.140), possibly the only genuinely Mannerist Venetian painter, the impetuousness of his compositions, filled with figures captured in frantic poses, is underlined by the construction of 'accelerated' or foreshortened perspective spaces — in other words perspectives in which the orthogonals ascend towards a spot located above the normal line of vision of a viewer looking straight ahead. The ground, or 'representational plane', therefore gives the impression of having been tipped up, and viewers find themselves drawn into a dramatic scene that seems to be rushing towards them or else they become dizzy as their eyes work their way up the picture towards distant planes.

Linear perspective and complex spatial games

In their desire to bring the world of the picture closer to that of the viewer, and thus encourage the viewer's emotional involvement, artists used other methods apart from

simply raising the representational plane. Subtle trompe-l'oeil effects, such as integrating the illusionistic image of a frame into the painting, make the viewer incapable of distinguishing where a painting starts and where it finishes, and make it seem as if the figures inside the painting are on the point of entering the viewer's own space.

Artists began to play this game — similar to what happens in the Woody Allen film *The Purple Rose of Cairo* (in which the actors escape from and later return to the screen) — from the 15th century onwards. In the GHENT ALTARPIECE, for example, Adam, cramped inside his narrow niche, has moved his right leg forward and part of his foot appears to project beyond the painting's frame. Twenty years later, in *The Assumption of the Virgin* in the Church of the Eremitani in Padua, Andrea Mantegna had the idea of painting one of the apostles with his arm apparently wrapped around a painted pilaster that forms one of the fresco's painted borders. And Paolo Uccello, in his *Virgin and Child* (Dublin, National Gallery of Ireland), painted an Infant Jesus who has escaped from his mother and seems to be bolting out of the picture. Instead of tricks like these, artists sometimes preferred to adopt an unusual angle of vision that places viewers above or beneath the scene depicted rather than making them see it from the perspective of someone looking straight ahead (which is relatively unusual in reality). At the end of the 19th century, Degas was fond of framing a scene in surprising ways, adopting high-angle or low-angle viewpoints. In *The Orchestra of the Opera, La Loge* (see p.74) and various other paintings (of women in the bathtub or dancers at rest, for example), he puts the viewer in a position looking down on the scene. In *Portraits in an Office* (New Orleans), also known as *A Cotton Office in New Orleans* (Pau, Musée des Beaux-Arts), he places the viewer on the edge of a space that rises with startling rapidity. During the same period (the 1870s and 1880s), Auguste Caillebotte was painting almost vertical views of Parisian squares seen from the upper storeys of the new Haussmann-style blocks or else pushing the 'low-angle' viewpoint to extremes. In *The Floor Scrapers*, painted in 1875 (see p.242), viewers observe the scene as if they themselves were kneeling down at a level hardly much higher than the workers busy scraping the wooden floor. Thrown by the bright light shining into their eyes, the viewers are trapped inside a dizzying space. The walls of the room, framed very low, and the perspective lines of the parquet floor, converging on an off-centre vanishing point beyond the painting, also contribute to the dramatic appearance of this work.

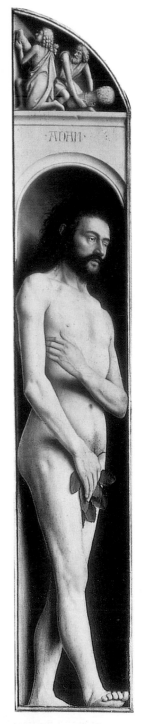

Jan van Eyck, *Adam*, c.1432-6, panel from the Ghent Altarpiece, oil on wood, 212.9 x 37.1cm, Ghent, Cathedral of St Bavon.

picture space | **viewer's space**

Da sotto in sù and Baroque illusionism

Painters had been experimenting with audacious viewpoints since well before the 19th century, however. Following on from Andrea Mantegna's work in the Bridal Chamber of the Ducal Palace in Mantua, artists such as Correggio in Parma at the beginning of the 16th century or Giulio Romano a little later decorated ceiling vaults with figures and architectural scenes designed to be appreciated by viewers looking up from the middle of the room, in other words 'from below', hence the name for this type of perspective: *da sotto in sù* ('from below upwards').

These dynamic scenes that seem to burst through the walls and lead the eye up into the clouds reached their peak during the Baroque era. Between 1597 and 1604, Annibale and Agostino Carracci used the *quadratura* technique (trompe-l'oeil mural with an architectural subject) for the first time on the ceiling vault of the Farnese Gallery in Rome, where it took the form of a portico that disguised the curvature of the wall. Between the simulated architectural lines, however, they painted framed frescoes designed to imitate canvases (*quadri riportati*), each of which features its own individual (frontal) perspective.

Over the following years (from 1620 onwards), artists opted more categorically for an 'open' form of perspective. They gave up compartmentalizing ceilings altogether, treating them instead as single units, and decorating them with subjects that seemed to belong more naturally to the space above one's head: skies filled with figures hanging in the air, darting upwards or plunging towards the viewer. The *quadratura* either made way for clouds or was retained in order to accentuate upward movement.

Until the beginning of the 17th century, Pietro da Cortona at the Barberini Palace, Giovanni Battista Gaulli (known as Il Baciccio) with his ceiling in the Gesù and Father ANDREA POZZO (author of the treatise *Perspectiva Pictorum et Architectorum*) at St Ignatius, all of whom worked in Rome, were the main exponents of these 'zenithal perspectives' that conformed so well to the piety of the Catholic Reformation, anxious as it was to reach out to the viewer emotionally rather than intellectually.

After the 17th century, which saw a general return to closed, compartmentalized and only partially illusionistic ceiling vaults, the Italian Giovanni Battista Tiepolo and Spätbarock (late Baroque) artists such as Johann Michael Rottmayr and Johann Jakob Zeiller in the German-speaking countries were to ensure that radiant skies filled with nimble flying figures triumphed once again in the 18th century.

Foreground and the construction of depth

While keeping the traditional viewpoint based on normal eye level, painters (particularly during the 19th century) explored the whole range of possibilities offered by linear spatial construction within the perspective cube.

Some chose to stress the foreground by placing a motif at the very front of the painting as a repoussoir — that is, it has the effect of accentuating the depth of the composition by seeming to push back all that is situated behind it.

Andrea Pozzo, *The Glorification of St Ignatius* or *The Triumph of St Ignatius and the Jesuit Mission*, 1685–94, fresco, Rome, ceiling of the nave, Church of St Ignatius.

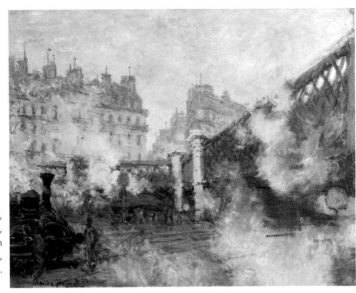

Claude Monet,
Saint-Lazare Station,
1877, sketch, oil on
canvas, 65 x 81cm,
private collection.

At the front of his famous *Las Meninas* (see p.90), Velázquez has depicted the stretcher
of a large canvas on which he shows himself working and a dog (on which a dwarf has
placed his foot) lying on the floor. Behind, in rational perspective, there extends the vast

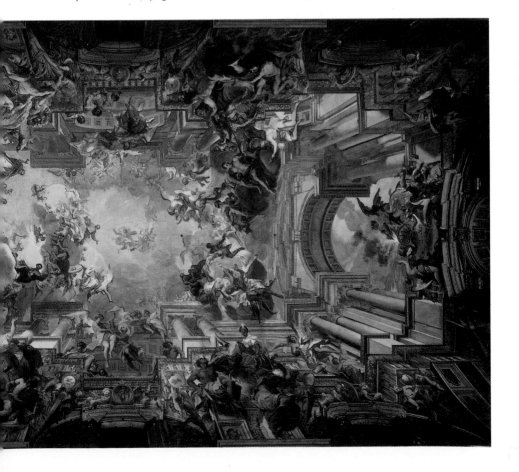

and austere setting of the 'gallery', as he called his own studio. Two centuries later, in his SAINT-LAZARE STATION series, Claude Monet highlighted the foreground more emphatically by painting enormous railway signals at the front of one of the paintings and at the top of another — merely a sketch — the steam from a locomotive that has just passed by.

Painting the viewer's space

One of the weaknesses of the perspective cube, and in fact of almost every painting, is that it depicts the space in front of the spectator (whether painter or viewer) but gives no hint of what surrounds the chosen motif.

In the 15th century, painters — and Flemish painters in particular — came up with the idea of using reflective surfaces to remedy this flaw and introduce into their paintings reflected images of the world. The mirror in van Eyck's *Portrait of Giovanni Arnolfini and His Wife* (see p.13) is clearly one important example of the use of such surfaces, revealing something of what the human figures in paintings might be looking at if they too were able to see. In LAS MENINAS again, Velázquez exploits the possibilities of this 'image-within-an-image' or 'double-view' (Anne-Marie Lecoq) composition in full. Hanging on a wall at the back of the room is a black-framed mirror that provides the key to the painting. In it are reflected the images of the painter's true subjects: the King and Queen of Spain, who have come to see their little daughter the Infanta, attended here by her maids of honour.

In the 19th century, the use of mirrors, which were now larger and relatively cheap as a result of industrialization, became less rare. Ingres introduced an enormous mirror into his

Portrait of Madame de Senonnes of around 1815 (Nantes, Musée des Beaux-Arts) and again thirty years later in the portraits of *Madame Moitessier* (London, National Gallery) and *The Comtesse d'Haussonville* (see p.36). These mirrors reflect the backs of his sitters, resulting in an image of their bodies that is almost as complete as that achieved by busts sculpted 'in the round'. They do not, however, afford any glimpses of the spectator's world.

Édouard Manet was more ambitious when he painted *A Bar at the Folies Bergère* (London, Courtauld Institute Gallery) in 1882. In it an even larger mirror reflects not only

Diego Velázquez, *Las Meninas*, 1656, oil on canvas, 318 x 276cm, Madrid, Museo Nacional del Prado. Whole and detail.

the back of the barmaid facing the viewer, but also the face of a customer who is not seen elsewhere in the painting (and who might be positioned where the viewer is standing) as well as the crowd of customers sitting at tables who also — at least topographically — belong to 'real' space, the space of the spectator rather than that of the picture.

Calling traditional perspective into question

The creation of depth using the methods we have described has sometimes been perceived by painters as repetitive, gratuitously virtuosic and liable to divert the viewer's attention away from the main subject and towards the less important decorative setting. Keen to focus the viewer's attention on his sitter, Raphael, for example, gave his portrait of *Baldassare Castiglione* an abstract background that provides no indication of depth. He has restored a certain sense of depth, however, by placing the author of *The Book of the Courtier* in an armchair whose only visible part is a foreshortened armrest (see p.34).

After 1600, the Caravaggisti broke more openly with the principle of the virtual cube. They set their figures in extremely shallow spaces against near-monochrome backdrops on which a change of hue to indicate the fall of the light at a different angle was all that conveyed any sense of physical space. La Tour used this method in his MUSICIANS' BRAWL, which depicts a frieze of beggars gesticulating in front of a brown rectangle. Part of the background on one side is more brightly lit, suggesting an angle in the room. Frans Hals used the same method, though giving greater emphasis to architectural line, in a number of his group portraits, including *The Meagre Company* (see p.40).

It was in the second half of the 19th century, however, that artists started experimenting systematically with different spatial solutions. When he painted his bedroom at Arles in 1888, VINCENT VAN GOGH used receding parallel lines in an obviously caricatural manner. The lines of the floor and bed climb up the surface of the picture to meet in improbable places. It is obvious that to Van Gogh the perspective cube had become a naive solution that could be used for nostalgic reasons, but which was no longer relevant to painting in the modern world.

This calling into question of the traditional treatment of space owes much to the discovery of Japanese prints some years earlier. These prints offered undreamt-of spatial

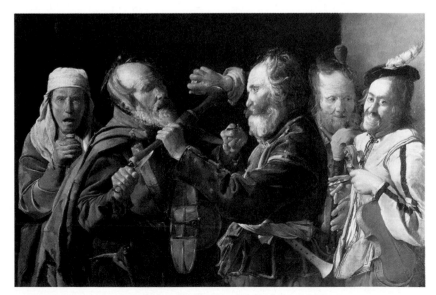

Georges de La Tour, *Musicians' Brawl*, 1625–30, oil on canvas, 86.5 x 142cm, Malibu, The J Paul Getty Museum.

Composition

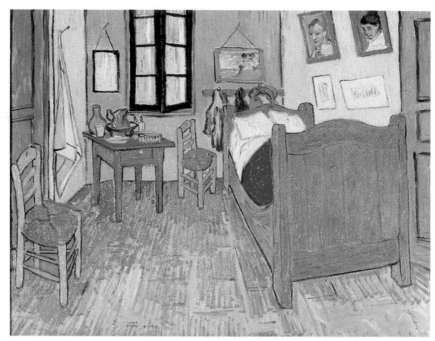

Vincent Van Gogh, *Vincent's Bedroom at Arles*, 1888, oil on canvas, 57.5 x 74cm, Paris, Musée d'Orsay.

solutions — notably the possibility of treating space as though it had no depth. In 1868, Édouard Manet used this flat style in his *Portrait of Émile Zola* (see p.124). His sitter has been pressed, as it were, against a wall parallel to the picture plane, and instead of opening the wall up, the artist has added areas of light in the form of a screen and a frame containing prints. A little over twenty years later, Paul Gauguin directly took over ideas from the Japanese treatment of space in *La Belle Angèle*, enclosing the portrait of his sitter in a circle and setting this against a decorative lilac-coloured background.

With Cubism, which developed in the early years of the 20th century, criticism of pictorial perspective assumed a philosophical character. Using quite different formal means, the Cubist treatment of space sought to return to what could be called the 'intellectual realism' of the Middle Ages. This offered a contrast to the reductive subjectivity of the single viewpoint that allows only one view of an object to be captured — a view that is distorted furthermore by the distance from which the object is observed.

Bearing in mind the example of Cézanne, who had attempted to restore solidity and density to objects that had lost these attributes as a result of the Impressionists' experimentation with colour and light, the Cubists returned to the very basics of how to depict volumes on a flat surface. During the key period 1907–11, the Pablo Picasso–Georges Braque 'partnership' experimented with an 'analytical' approach that attempted to capture all the different aspects of a motif from different points of view at the same time. Reduced by a simplified form of draughtsmanship to their basic shapes (polyhedron, cylinder, cone ... and cube), objects became fragmented and their contours lost their structure, but this dismantling process forced the eye to penetrate beyond superficial appearances.

Braque's STILL LIFE WITH VIOLIN is a good example of what the poet and critic Pierre Reverdy called the 'methodical adventure' of Cubism. Painted during the summer of 1911, which Braque and Picasso spent together at Céret in the south of France, it employs a visual language so elaborate that it borders on the obscure.

Some objects can be easily identified: part of a rectangular table top at the bottom of the picture, a small carafe seen almost in its entirety from above and, higher up, a stemmed glass (or perhaps a conical bowl) can all be identified with ease. The neck of the

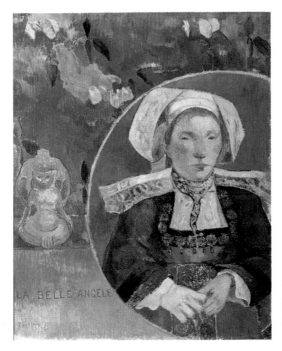

Paul Gauguin,
La Belle Angèle, 1889, oil on
canvas, 92 x 73cm, Paris,
Musée d'Orsay.

violin, from which the still life takes its name, can be seen on the right, while the scroll is repeated on the left. The shoulders of the instrument can also be made out, and possibly the strings, at an angle, somewhat lower down.

Perfectly satisfactory in themselves as elements in a pictorial structure, these shapes are enclosed in a network of lines that no longer represent their true positions relative to each other: they are no longer imitations of things, but have become 'pictorial objects'. Similarly, the space represented by the canvas no longer seeks to create the illusion of depth as it exists in the real world, but to restore to the exploded objects the density that the eye is not aware of when looking at them in reality.

Georges Braque, *Still Life with Violin*, 1911, oil on canvas,
130 x 89cm, Paris, Musée National d'Art Moderne.

Line and colour

The aim of this chapter is not to examine drawing as a separate genre or drawings as finished works designed to be hung on walls, but to consider the role of drawing as a preparatory technique in the creation of paintings: in the form of studies executed on paper or traced out on the support prior to the application of the paint medium. It will also be examined as a possible guiding principle that may or may not shape the work of a painter, whose tasks are the delineation of form, its organization in accordance with his judgement and imagination, and the bringing to life of coloured forms.

DRAWING

The act of drawing goes back to the origins of humanity. Rock and cave paintings offer many examples of engraved motifs, in other words motifs scratched onto a surface, or forms painted in such a way that only their contours, sometimes accentuated by a thick outline, are indicated: animals, human or anthropomorphic figures, and hands have been found. According to one tradition (mentioned by Pliny the Elder in his *Natural History*), the first work of art was created by a young girl in love, who traced the outline of her lover's shadow on the wall before he set off on a voyage.

Be that as it may, very few old drawings have survived. A squared-up image of the pharaoh Tuthmosis III is one of the items that have come down to us from the ancient world, but we have nothing from Greece or Rome. A small number of drawings survive from the Middle Ages, including the pen-and-ink drawings of the Utrecht Psalter, which dates from the Carolingian period (8th–10th centuries). We have a slightly greater number dating from the Gothic era onwards, in the form of model books (*taccuini*, singular *taccuino*) that provided artists with a source of inspiration and that were passed down from generation to generation. A famous book of such examples (*exempla*), which were later replaced by engravings (an even more effective way of disseminating pictorial models), was that of the architect Villard de Honnecourt, from Picardy, which dates from the first third of the 13th century.

The rarity of ancient drawings can be explained by the fragility of their supports. Initially papyrus was used, and later (from the end of the Classical period) parchment – from the Latin *pergamena*, describing sheep or goat skin from Pergamum (now Bergama in Turkey), a major centre of production – or vellum (made from calf skin). An even more important reason is the low value that was for a long time attached to drawings. They were regarded as a preliminary stage prior to the application of pigment rather than as an art form in themselves. It was only from the end of the 15th and the beginning of the 16th centuries that drawings started to be properly appreciated and therefore deliberately created and worked up into finished pieces of art. They were then carefully preserved, sold or given as valuable gifts. In the second half of the 15th century, for example, Jacopo Bellini's *taccuino*, inherited by his son Gentile, was taken by the latter on a journey to the Orient and given as a present to the Ottoman sultan (its 101 sheets are today preserved in the British Museum in London).

Sinopia or fresco underdrawing

All this goes to explain why the majority of drawings that have come down to us from the Medieval period are those that were executed on the surface to be painted, and that have therefore been preserved beneath the paint layer. They are referred to generically as 'preliminary drawings' or, in the case of modern underpainting on a wood or canvas support, as 'sketches' (the Italian term used is *abozzo*, plural *abozzi*).

In the case of works on wood or canvas, the drawn lines are best revealed by X-ray photography and other scientific techniques. In the case of frescoes, they sometimes reappear by chance, usually because the paint has been applied *a secco* rather than *a fresco* (see p.9) and has therefore not adhered to the support. Most often, however, they are exposed

deliberately by restorers who take great pains to separate the final layer of plaster (*intonaco*) — to which the pigment is applied — from the thicker coat of mortar (*arriccio*) that lines the wall directly and on which the drawing is sketched out. Since World War II, the development of the separation techniques known as *stacco* ('detaching') and *stappo* ('unblocking') has led to the creation of collections of *sinopie* which are now exhibited independently of the frescoes as entirely separate works.

Executed on the *arriccio* and covered at the time of painting by a fine layer of *intonaco* that does not completely conceal it, this underdrawing takes its name from the red pigment in which it used to be carried out: *sinopia*, plural *sinopie*. In reality, this pigment was only applied once the drawing was completely finished, covering preliminary markings in charcoal that were liable to be erased.

Drawings have also been discovered beneath frescoes that have simply been marked out by small holes made in the *arriccio*. This indicates that the composition was transferred by placing a sheet of paper on the surface of the wall and pricking through the sheet. Charcoal was then rubbed through the resulting holes so that the design remained clearly visible after the removal of the paper.

Benozzo Gozzoli, *Angel*, detail
from an *Annunciation*, 1468–84,
sinopia from beneath a fresco,
Pisa, Museo delle Sinopie.

The cartoon — paper equivalent of the *sinopia*

The existence of pricked lines is proof of the very ancient use of drawings that were independent of the painting support and executed on the same scale as the painting itself. These drawings, called 'cartoons' (from the Italian *cartone*, or French *carton*, referring originally to the designs on stout paper supplied by artists to tapestry makers), represent the final stage in the preparatory work for a painting. They reproduce all the various compositional elements including light and shade, curls of hair, facial expression and different values (or nuances of intensity) of light.

The cartoons that have been found pricked with holes were therefore executed on the same scale as the final work. When the projected painting was very large, however, artists preferred to work out their composition in a format that enabled them to take in the whole of it at a single glance. The small size of the available sheets of paper also prompted them to proceed in this manner, despite their having the option of joining a number of sheets together. Thus, when the drawing was smaller than the surface to be painted, the transfer was no longer carried out by placing the drawing over the support, but by a process of squaring up (also sometimes referred to, in a third meaning of the term, as *quadratura* or *quadrettatura*). This involved covering the original drawing with a grid of horizontal and vertical lines and then transferring it to a larger grid, sometimes made of threads (later removed by the painter), on the surface that was to be painted.

More modern techniques have now replaced the traditional *SQUARING UP* technique.

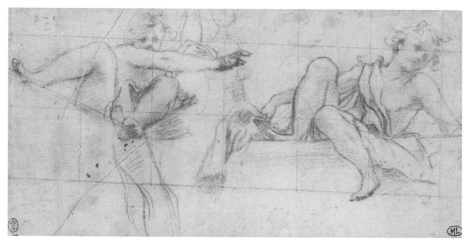

Correggio (Antonio Allegri), red chalk drawing, Paris, Musée du Louvre.

Painters either work out their composition in advance in a drawing which they then photograph and project onto their chosen support (and then simply trace the outlines of the projected image) or else they work directly from slides and draw the projected motif (which then becomes the model for their painting) on the canvas, paper or wall using the same procedure.

Drawing as preparatory study: from sketch to cartoon

Cartoons represented the ultimate stage in the preparatory work for a painting. These final drawings served as points of reference or templates during the application of paint, and thus played an especially important role when the execution of the work was entrusted to studio assistants.

Before arriving at this final drawing, however, painters will often have completed a large number of earlier sketches. Where these have been preserved, they constitute a valuable documentary record that allows us to follow the gestation of a given work and to understand the choices made by the artist.

These drawings have different names depending on the extent to which they have been worked up.The first quick sketch is known as a *macchia* or *schizzo.* These were generally fairly small and often executed on whatever material was to hand (the bottom of a commissioning contract, a page in a notebook, etc). They represent the initial formulation of an idea that would evolve considerably, but which essentially laid down the main forms underlying the structure of the final composition. A relatively large number of drawings more detailed than these initial sketches have survived from the second half of the 16th century and later. These are often referred to as *modelli* (singular *modello*) and establish lines of perspective (perspective drawings) and the position of figures and motifs within the picture (compositional drawings). Once the overall plan had been worked out in this way, artists would study the different elements of the composition using for the figures either small clay figurines (in the case of Poussin), jointed wooden mannequins, live models ('life drawing') or sometimes master drawings or casts of antique statues (especially during the Classical period of the 17th and 18th centuries).

During the period that extended from Raphael and Michelangelo in the early 16th century to the Neoclassical painters of the late 18th century, drawings assumed a special prominence in the creation of paintings, at least in parts of Italy (Rome and Tuscany) and among the French painters. In terms of the largest number of surviving sketches and studies, this phenomenon was at its peak in France from the end of the 1700s and beginning of the 1800s. For his *THE TENNIS COURT OATH,* David filled notebooks (there is one at

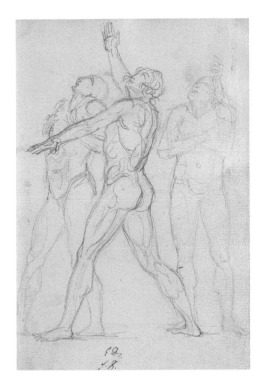

Jacques Louis David,
The Tennis Court Oath, 1791,
drawing, 19.2 x 12.5cm, folio 53r of
the album in the collection of the
Musée National du Château de
Versailles. Detail from a
preliminary drawing.

Versailles and another in the Louvre), executed a sketch on virgin canvas, and made draw-
ings on loose sheets of paper glued together. These include sketches of the empty room
with the floor and ceiling lines converging on a point in the centre, naked delegates per-
forming various gestures, the same delegates wearing clothes, studies of heads that were
then executed in watercolour and a number of drawings that unite all these figures and
add in various scenic elements. The same prolific and meticulous work went into the
preparations for *The Intervention of the Sabine Women* (see p.26) and *The Consecration of
the Emperor Napoleon* (see p.25). Copious drawing also played an integral role in the
design process of David's pupil Ingres, who at his death left a collection of 4,500 sheets
of drawings to the museum in Montauban, his native town. These preliminary studies are
frequently accompanied by notes specifying the name of the model (Ingres used female
models for his male figures too), the colours to be used, the tonality he wanted for the
light and shade, and so on.

Recognizing technique: the development of the draughtsman's tools

A knowledge of the tools available to painters and therefore of the choices they were able
to make is essential if we are to assess their intentions during these preliminary stages in
the creation of a painting.

Pen

From ancient times to the end of the Middle Ages, drawings were made either with a quill
dipped in ink or using a technique known as metal point. In both cases, the line obtained
is fine and lightly incised into the support surface (which was parchment during the peri-
od in question). In the case of metal point, the line is paler. Metal points were generally
made of silver (silver point) but also, occasionally, of lead (lead point). Drawing with these
implements results in a precise outline of the motif, producing works of an informative
nature and allowing great precision in the marking out of shapes. It is also a dry tech-
nique, however, and one lacking in sensuality.

POUSSIN AND PARMIGIANINO:
FROM PRELIMINARY DRAWING TO FINISHED PAINTING

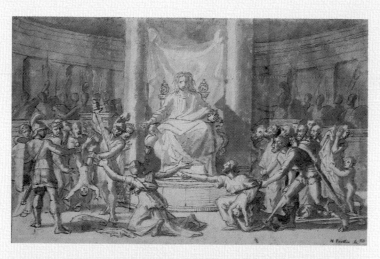

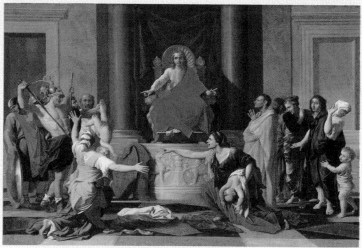

Nicolas Poussin, *The Judgement of Solomon*, 1649, preliminary drawing and oil on canvas, respectively 24.8 x 38.4cm and 101 x 150cm, Paris, École Nationale Supérieure des Beaux-Arts and Paris, Musée du Louvre.

The drawing was executed in pen and brown wash over black chalk. The use of pen and ink allowed Poussin to fix the contours of the figures and architectural elements precisely. He did not aim for beauty with his pen strokes, but efficiency. Solomon's head, for example, is surrounded by rudimentary wavy lines that give his hair a caricatural appearance and his robes are marked with lines that indicate its folds and accentuate the figure's breadth. Covering the lines made in chalk, which are less visible than those made in ink, the wash creates shadows and

therefore indicates the direction of the light, which illuminates the figures from the left. It plunges the background into semi-darkness, allowing the artist to focus attention on the action unfolding in the considerably lighter foreground.

Poussin's plans continued to evolve after he completed this *modello*. Some of the more obvious decisions revealed by the drawing have been retained in the final painting, such as the light falling from the left and the contrast between a brightly lit foreground and a darker background. On the other hand, Poussin has chosen ultimately

to move Solomon — who was far bigger (and therefore more important) in the study — further back. His hair is now plastered over his temples, but the shell-shaped decoration of the throne provides the king with a halo that emphasizes his head, giving him a holy appearance. The witnesses have also been moved further back, leaving the foreground entirely free for the mothers. Finally, the circular portico in the background of the drawing has been replaced by an even simpler solution consisting of doorways with heavy classical frames.

Parmigianino (Francesco Mazzola), *Madonna and Child with Saints John the Baptist and Jerome*, also known as *The Vision of St Jerome*, c.1526–7, preparatory drawing and oil on wood (349 x 149cm), London, National Gallery.

This altarpiece commissioned from Parmigianino for a church in Rome that no longer exists is of unusual dimensions, being extremely high for its width. These proportions presented the painter with a difficult problem in terms of composition, and a comparison between the preparatory drawing and the painting itself demonstrates how he gradually resolved it.

The subject is a Madonna in glory, which generally means a Virgin with Child appearing in the skies, relatively isolated, with adoring saints on the ground occupying the whole width of the painting. This solution, adopted by Raphael in his *Madonna of Foligno* (Rome, Pinacoteca Vaticana), results in a triangular arrangement that suits the formal logic of an altarpiece of normal dimensions, but not the narrow format required here. This drawing in the collection of the British Museum, a pen-and-ink sketch with wash highlights for the shadows, shows that the artist's first idea was to follow this traditional arrangement. At this stage, Parmigianino 'cheated' with the dimensions by using a format slightly larger than the panel was supposed to be, but still only managed to fit St John the Baptist and St Jerome on the same plane by drawing them on a smaller scale to the Madonna.

The form of composition adopted in the painting shows that the artist learnt from his experience with the drawing, and instead of placing a second figure in the foreground, he relegated St Jerome to an ambiguous and asymmetrical position in the middle ground. Given the difficulty of showing him standing up in this new arrangement, which would have assumed a change of scale that would have been hard on the eye, Parmigianino chose to depict the saint lying down as if asleep. Formal rather than religious considerations led therefore to a fundamental renewal of the theme of the Madonna in glory through the invention of the motif of a saint who appears to be in the throes of mystical ecstasy — hence the name given to the painting in the 19th century: *The Vision of St Jerome*.

Line and colour

Chalk

Black, red (sanguine) and white chalk started to become more and more widely used in the 15th century. It creates a precise but slightly greasy line that is softer than that made by pen. The word crayon (from the French for chalk, *craie*) came into use in the middle of the 17th century to refer to small sticks or pencils of chalk, charcoal or wax (consisting of a core wrapped in a wooden casing) coloured with pigment.

Charcoal

The use on paper of charcoal — wood semi-carbonized in a sealed vessel — goes back only as far as the 16th century, when the process of fixing drawings was discovered. The name was applied to the medium (and drawings made with it) at the end of the 17th century. Charcoal is a soft material that requires a lightly textured support in order to adhere. It produces broad lines, deep blacks and subtle greys, and can be extended over larger areas or shaded off using a 'stump' of rolled paper, cotton or hide with a blunted tip. It allows more sensual textures to be obtained than are possible with other drawing implements.

Graphite

Graphite (also known as plumbago) became the basic draughtsman's tool in the second half of the 17th century. It came from deposits discovered in Borrowdale in Cumberland, and after the French Revolution was mixed with clay and sold on the continent as the 'Conté pencil' (named after its inventor, Nicolas Jacques Conté). The friability of this new material was offset by its great qualities: the possibility of obtaining more or less sustained greys, of creating larger areas of shadow (with or without different degrees of shading) than was possible with pure graphite, and also of obtaining lines almost as fine as those achievable with pen or metal point.

Pastel

Made of bound, powdered pigment, sticks of pastel were regarded as painters' rather than draughtsmen's tools — a relatively artificial distinction, but one attested by the fact that during the 17th century in France, where the use of pastels was especially popular, those who practised this technique were known as 'pastel painters'. Either way, pastels had originally been used in France during the 15th century as a complement to traditional drawing methods and their use spread considerably throughout the 16th and 17th centuries.

Washes

Finally, washes created not with a pen, but with a very wet brush that is then dipped in ink, represent another intermediate technique between drawing and painting. They are used in conjunction with lines marked out by a pen or other instrument as a way of indicating tonality, and also as a means of creating entire works, in which case the ink is generally of a single colour, usually black.

Choice of implement and the intentions of the artist

The specific choice of implement determines the type of drawing that will be produced, revealing in turn the style and intentions of the artist. When artists found they had a whole range of instruments at their disposal, from the 17th century onwards, their preference for one implement over another acquired greater significance.

Pen and metal point were particularly well suited to drawing as practised by artists at the end of the Middle Ages. These implements allowed them to make perfect outlines of their chosen motifs, thereby conveying the maximum amount of information. This was the aim of the creators of the *taccuini*, who had educational concerns at heart. The preference of artists of the late Gothic period (International Gothic) for curved and broken lines was extremely well suited to their use of these same instruments. Equally, from the 14th century onwards, a new interest in conveying three-dimensionality led to novel ways of using pen or metal point. These included dotting, hatching and later cross-hatching (with short or long parallel lines) in order to explore the folds of a hanging drape or evoke the

plasticity of the human body. At the same time, as a way of rendering shadow, artists started going over the areas they wanted to be darkest with a discreet wash. In modern drawings from the 16th century onwards, the use of black chalk (along with more prominent hatching, the addition of a wash as described above and now highlights in white chalk as well) expressed more strongly the desire of artists to produce a sense of space and three-dimensionality. The new lightness of tone and the hazy quality made possible by graphite were particularly well suited to artists interested in drawing nature, to the extent that graphite

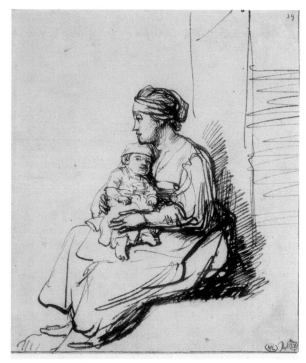

Rembrandt, *Woman Holding Her Child on Her Knees*, c.1646–7, pen and brown ink with a brown wash, 16.2 x 12.8cm, Paris, Frits Lugt Collection, Dutch Institute, Benesch 382.

became the preferred medium of Flemish and Dutch landscape artists of the 17th century such as David Teniers and Albert Cuyp. In addition to such choices as these for obtaining specific effects, a tendency to use this or that drawing implement also reveals choices of a far more fundamental nature. Artists who worked exclusively in black or brown on white paper, using fine lines and a light wash, attached particular importance to the definition of form. Their studies laid down perspective lines, defined secondary details and established their figures' gestures. Thus Poussin, David and Ingres (to return to several painters we have already considered) devised their works on the basis of precise drawings and only introduced colour once the drawing stage had been fully completed. Other painters, on the other hand, either dispensed with the drawing stage more or less entirely (Caravaggio, La Tour, the Le Nain brothers and Chardin, for example) or made drawings employing techniques that resemble the actual painting process: by using instruments that produce broad lines akin to brush strokes, by scratching the paper repeatedly and marking out dark shadows (*REMBRANDT*) or even by introducing colour at this early stage.

The use of charcoal by Titian and Tintoretto in Venice in the 16th century, and much later by Degas in the 19th century, reveals a similar tendency to visualize straight away the pictorial effect of the work to be completed. Rembrandt's use of an ink wash – either in forceful black lines or in more diluted layers to produce delicate greys with just a few added pen lines – is another expression of the desire to work from the very beginning in a medium similar to oil paint, in other words with pigment used in a more or less fluid state, but never dry. The technique which that skilled draughtsman Rubens employed is likewise inextricably linked to the overall pictorial effect. Rather than making black-and-white drawings, he worked with the three types of chalk, using black for the definition of form, red for flesh tones and white to indicate light. Instead of a white support, moreover, he chose a coloured paper: Venetian *carta tinta*.

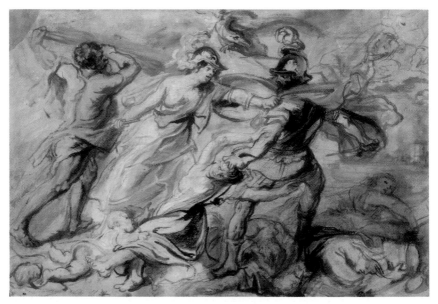

Peter Paul Rubens, *Hercules and Minerva Repelling Mars*, c.1635, oil and sanguine drawing over white chalk markings on coloured paper, 37 x 53.9cm, Paris, Cabinet des Dessins, Musée du Louvre.

Finally, having covered his canvas with a coloured preparation (*imprimatura*), RUBENS transferred his compositions onto the support to be painted by drawing them out with a brush, sometimes using the actual colours, as again the Venetian painters of the 16th century often did, and denoting light and shade in grey tints.

THE RIVALRY BETWEEN LINE AND COLOUR

An irreconcilable difference in temperament existed between those painters who attached paramount importance to drawing and those who preferred to translate their ideas straight into colour. This has been said by artists — 'Drawing embraces everything except colour' (David) — and written by philosophers — 'colour destroys the drawing' and 'drawing is always in conflict with colour' (Alain). Such dogmatic statements are exaggerated, but they highlight the fact that quite apart from the different methods (pen or brush) used for preliminary sketching out, the alternative routes taken by 'painters of line' and 'painters of colour' are very clearly differentiated in the finished works themselves. 'Design' and 'drawing': the two meanings of the Italian term *disegno* highlight the opposition between line and colour.

In Italy during the first half of the 15th century, painters such as Cennino Cennini and sculptors such as Lorenzo Ghiberti regarded drawing as the foundation of all the arts. A few decades later, Leonardo da Vinci attributed to it an essential role as a means of transmitting knowledge. Another hundred years later, in *L'Idea de' Scultori, Pittori ed Architetti*, published in 1607, the painter and art theoretician Federico Zuccaro praised *il disegno* as the instrument that allows us to capture the world and organize it according to our internal judgement (*ordo*). For this critic, *disegno* is simultaneously an analytical and a creative process. Zuccaro plays on the double meaning of the Italian term. Firstly it signifies the formulation of the idea (Zuccaro describes this as *disegno interno* — 'intention' or 'design', which turns the artist into a demiurge, in other words the equal of God, and secondly it signifies the act of projection that makes the form of this idea appear in the artist's own style (*disegno esterno* — 'drawing').

This double definition fuelled a dispute that initially, during the 16th century, opposed the Venetian school to the Roman school and in particular the art of Titian to that of

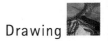

Michelangelo. Extolled in the middle of the cinquecento by writer Ludovico Dolce, himself Venetian, Titian was seen as the man who had introduced sensory and almost tactile qualities into painting by using colour in such a way that it radiated from the canvas and rendered living creatures, and flesh in particular, with an illusionistic perfection that none had achieved before him. Championed by Giorgio Vasari during the same period, Michelangelo, on the other hand, became the model for those who relied on drawing as a way of formulating 'clear and logical concepts' for their paintings.

In the following century, the upholders of the pre-eminence of 'line' found their champion in the figure of Nicolas Poussin. Represented by painters such as Philippe de Champaigne and most importantly Charles Le Brun, director of the Académie Royale de Peinture et de Sculpture, as well as by the writer André Félibien, from the end of the 1660s the Poussinists found themselves up against none other than Flemish painter Rubens. The Rubenists (the painters Gabriel Blanchard and Pierre Mignard and the theoreticians Charles Alphonse Du Fresnoy and Roger de Piles) defined 'chromatics', regarded for the first time as a genuine science, as 'the very soul and culmination of painting', the 'make-up' that alone could create an illusion capable of deluding the viewer and provide him with the sense of enchantment that can be felt when looking at paintings.

Colour and brushwork

Paradoxically, it was not so much the actual colours they used that placed artists on one side or the other — colourists or champions of line — as how they handled the pigment. Certain painters who were clearly supporters of line were also praised as subtle colourists. In his *THE INSPIRATION OF THE POET,* Poussin himself, who can be seen in his Berlin self-portrait holding a treatise on light and colour, pays great attention to both of these pictorial elements. The yellows, blues and reds of the foreground are resplendent in the warm, late-afternoon summer light, and the background is bathed in gold by the setting

Nicolas Poussin, *The Inspiration of the Poet*, 1624–33, oil on canvas, 182.5 x 213cm, Paris, Musée du Louvre (detail, see p.74).

sun. Poussin never, however, intensified colour for its own sake, unlike Rubens with the pinks and vermilions he used for female flesh (see *The Rape of the Daughters of Leucippus* on p.159) or Velázquez, who developed a range of silvers that can be seen, for example, in the dresses in *Las Meninas* (see p.90). And other than in certain youthful works perhaps, Poussin never exhibited any real joy in brushwork, in playing with vigorous or thick brush strokes or with highlights in intense or brilliant colours. Instead he set himself a goal of moderation where chromatic effects were concerned and of utmost discretion in the appearance of the painted surface, which he wanted to be smooth, revealing no trace of brush marks.

Smooth or 'untidy' finishes: the material qualities of paintings

By making the work of the painter seem considerably more intellectual than material, this pursuit of a smooth surface finish — erasing any hint of the 'messy business' of work in the studio — goes hand in hand with the notion of the pre-eminence of drawing. Today, we have lost sight of the wider implications of this question during the 16th and 17th centuries. At that time, painters were still considered by many as 'makers of images', as artisans belonging to guilds, whose status was no different from that of weavers, shoe-makers or even bakers. Making people forget the extent to which painting a picture depended on material processes (stretching and nailing canvases, preparing walls, grind-ing pigment, mixing it with a binder, getting one's fingers dirty holding the brush) became necessary for those who wished to convince the public that the artist was no hired hand performing manual work, but a creative artist who used his judgement, learning and imagination to produce works whose merit lay as much in the idea itself as in its execution.

An emphasis was placed on the material nature of painting by Venetian painters such as Giovanni Bellini and most importantly Giorgione and Titian at the beginning of the 16th century. The glorification of colour, which was thought to appeal directly to the viewers' senses, was expressed through their use of a varied palette, the introduction of hues obtained as a result of new combinations, experimentation with rare lighting effects (dawn and dusk, for example), gradated transitions from one colour to another and occa-sional experimentation with bold chromatic juxtapositions. It was also conveyed through methods of handling paint that gave pigment and brushwork a new personality. This was achieved by combining areas of impasto — areas made up of a visible, thick layer of paint, applied either uniformly or in alternating crests and hollows — with other areas covered merely by a glaze, in other words by a thin, perfectly uniform film of paint. In Titian's late works, not only is the medium used in the picture very prominent, but his brushwork is also visible, including grooves made by the brush in thick areas of paint, lines made by the end of the brush (which as an old man the painter sometimes used the 'wrong' way round) and occasionally fingerprints left when he dispensed with the brush altogether as a means of shaping the paint.

A little later in the 16th century, Tintoretto in Venice and El Greco in Spain (he had stopped off in Venice on his way from Crete to Toledo, where he settled) also painted in this style. In the 17th century, Rubens, Frans Hals and Rembrandt (one of whose pupils declared that a number of his paintings, featuring heavy impasto, could be 'grasped by the nose') all worked with visible brush strokes and an uneven paint surface. Watteau in the 18th century and Delacroix (nicknamed the 'drunken broom' by Ingres) and Courbet in the 19th century also made emphatic brush strokes a fundamental part of the act of painting.

REMBRANDT AND VELÁZQUEZ:
TWO EXAMPLES OF VISIBLE BRUSH STROKES IN CLOSE-UP

Rembrandt, detail of *Self-portrait*, London, Kenwood House (see also p.44).

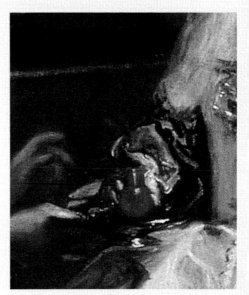

Diego Velázquez, Maria Agostina Sarmiento offering Infanta Margarita a little earthenware jug, detail from *Las Meninas* (see also p.90).

Just like the rest of this painting, the hand holding the artist's implements, the painter's chest and the top of his shirt have been treated in an extremely free manner. There is no impasto here, even though the pigment is thick enough for fine cracks to have appeared on the shirt front, but the whole picture has been painted in a schematic, sketch-like manner. In Italian, this method of painting is known as *alla prima* or *far presto* (to which the English translation 'done in a hurry' does little justice).

Indeed, if the circles marked out in the background (see p.44) are an indication of the artist's ability to draw, then the strictly pictorial qualities of this painting can be seen to far outweigh the presence of line. Far from defining the precise outline of the arm, as Raphael, for example, did in his portrait of *Baldassare Castiglione* (see p.34), a work Rembrandt knew and copied, the Dutch painter has applied the black pigment in broad strokes that reveal the marks made by the brush and without worrying about the brush overshooting onto the light brown of the wall.

Rembrandt has painted the fur trim of his coat in just as perfunctory a fashion. Again, there is a complete contrast with the fine lines that make up the soft fur in Castiglione's coat or with the even more delicate lines with which van Eyck rendered the mink or ermine in his *Portrait of Giovanni Arnolfini and His Wife* (see p.4).

Finally, Rembrandt has used white — a white mixed with yellow, a white he wanted to be 'dirty' — in rapid highlights in order to indicate the bristles of his paintbrushes and the reflection of the light on their wooden stems, applying it here in quick vertical and horizontal touches as well as along the edges of his shirt front. He has also used the pointed tip of the paintbrush to etch lines into the still wet paint in order to indicate the smocking of the shirt.

In *LAS MENINAS* (see p.90), the technique used by Velázquez displays an equally extraordinary freedom and fluidity. The detail reproduced here of a maid of honour offering the Infanta (the daughter of Philip IV) something to drink illustrates the artist's exceptionally effective use of colour in the light-coloured dresses executed in varying shades of silver with red and black highlights for their decorative elements. The virtuoso brushwork achieves its effect through addition — the accumulation of small highlights (the tiny points of white on the red bow of the little princess) — or through subtraction, giving the impression that Velázquez removed some of the pigment in order to expose the grain of the canvas and exploit its texture. This can be seen in the ray of sunlight that illuminates the floor leading to the luminous gap of the doorway. This is painted so thinly that it reveals the drawing below: vertical and horizontal lines that mark out the position of the steps.

While the sharpness of its forms is apparent when the painting is viewed from a distance (as required by its large format), when it is viewed from close up nothing is well defined. The figures' hands consist of simple patches of flesh-coloured paint, their hair has been painted in wet pigment without any effort to hide the reworking — the outline of the initially over-large bow in the hair of the maid of honour; a shorter trapezium, probably made of netting, which was initially supposed to form the Infanta's. The whole gives the impression of being a sketch, the largest and most masterly sketch ever created.

IMPRESSIONISTS AND NEO-IMPRESSIONISTS:
INDIVIDUAL BRUSH STROKES AND PICTORIAL EFFECTS

The French Impressionists revived the practice of using distinct brush strokes at the end of the 19th century. For them, this was a deliberate artistic choice essential to their experimentation with light rather than a means of emphasizing the material qualities of painting, as it had previously been.

Landscape painters first and foremost, the Impressionists were no longer interested in painting individual motifs, but in capturing 'the open air, the light and fleeting effects' (Claude Monet). The forms that made up the landscape interested them less than the air that circulated around them, the shadows that followed or preceded them and the moving reflections that deconstructed them when their images were projected onto the surface of water. Their outlook during the 1870s was dictated by the following preoccupations: to paint 'the calm and hazy impression' (Monet again) of a late afternoon in northern France, the play of muted shadows on snow warmed by a low sun, or the 'vibration of the air saturated with sunshine' (the critic Louis Edmond Duranty). The Impressionists' repetition of the same subject at different times of day, culminating in Monet's case in 'series' of paintings (for example of haystacks and of Rouen Cathedral), their predilection for subjects that demanded a blurring of form (such as landscapes under snow or landscapes featuring water) and their choice of parks and gardens with shimmering light and shade rather than vast, uniformly lit expanses — all these justified a technique based on broad brush strokes that enabled space to be opened out to maximum effect, on circular touches that allowed every fragment of colour and change in the light to be captured and on other methods of applying paint in a flat manner that split up colour tones into their component parts and broke up both volume and surface.

From the mid 1880s, the use of visible brush strokes and their separation one from another became so common that it no longer caused a scandal. The astonishment of the public was now provoked by the transformation of the free patches of colour of the older generation into the systematic 'tiny stippling' (as novelist Octave Mirbeau put it) of the 'Neo-Impressionists' Georges Seurat and later Paul Signac.

Seeking to break down rather than combine colour tones, the exponents of 'Divisionism' or 'Pointillism' — mockingly referred to by Gauguin as 'ripipoint' — abandoned flat colour completely and refused to draw lines in a single stroke, flecking their works instead with dots of pure colour.

In the work of Vincent Van Gogh, the brush stroke developed in an altogether different way. His brushwork dances with life, laying no claim to scientific rigour. Van Gogh's discovery of the emotional power of separate brush strokes and the pleasure that can be created when intense colours are brought together can be attributed to a combination of two influences: Impressionism and Japanese prints.

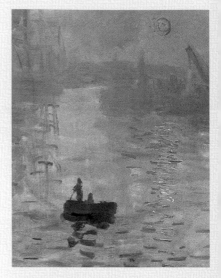

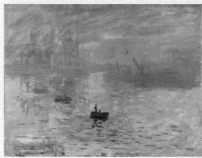

Claude Monet, *Impression: Sunrise*, 1872, oil on canvas, 48 x 63cm, Paris, Musée Marmottan.

Shown in the exhibition of 1874 (held in the studio of photographer Félix Nadar) that gave the group its name, *Impression: Sunrise* displays a particularly bold technique.

While its subject matter is ordinary — a view of the port of Le Havre in the early morning or, to put it another way, a seascape like those painted by Claude Lorraine two centuries earlier — the visible brush strokes, clearly separated from one another (the critic Louis Leroy described them, with reference to another of Monet's works, as 'black tongue-lickings'), were new. Applied quite distinctly, colour here simplifies the contours and reduces objects and silhouettes to synthetic shapes. The picture seems to have been abandoned at sketch stage: a momentary feeling or 'impression' of the scene has been favoured over careful observation, something the champions of 'rational' and 'noble' painting could not accept.

Writing in the magazine *Le Charivari* about the scandal aroused by the exhibition, Leroy compared the work to 'wallpaper in an embryonic state'.

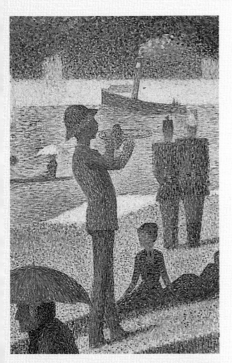

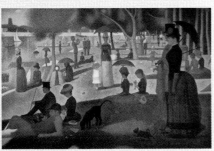

Georges Seurat, *Sunday Afternoon on the Island of La Grande Jatte*, 1881–6, oil on canvas, 207 x 308cm, Chicago, The Art Institute (Helen Birch Bartlett Memorial Collection).

Vincent Van Gogh, *The Siesta* (La Méridienne), 1889–90, oil on canvas, 73 x 91cm, Paris, Musée d'Orsay.

In *La Grande Jatte*, the manner in which the paint has been applied appears uniform from a distance, but varies considerably when we examine the picture from close up. The body of the standing trumpet player consists of long, vertical rectilinear strokes. For the water, Seurat has used even longer, horizontal brush strokes. Finally, for the grass, he has used a combination of small dots, squares and a number of longer, vertical or diagonal brush strokes.

The sunshine of the South of France finally convinced Van Gogh of the pleasures of painting outdoors and using light colours, but he did not give up painting distinct forms, and he even emphasized their contours by giving his shapes definite outlines rather than seeking to make them dissolve into the translucent atmosphere.

The artist has used long brush strokes in this painting. Where he has not given his forms an outline, he has 'drawn' them in colour with the brush. His brush strokes are also boldly stylized. In the hay on which the figures are sleeping, they are curved, scrolled or 'comma-shaped', while in the haystack above they form a dense network of diagonals. For the sky, Van Gogh has wielded his brush more firmly and broadened its strokes, and finally to convey the roughness of the dry grass he has used small brush strokes grouped together in a fan-like arrangement.

COLOUR THROUGH THE FILTER OF SCIENCE

Studying colour — whether in the work of a colourist or a devotee of drawing — requires the colours in question to be recognized and precisely described and the appropriate vocabulary correctly applied. The description of colours in such a way that someone who has not seen a painting can visualize it was of great importance during the very long period when paintings were known by their descriptions alone (Diderot's *Salons*, the first example of formal art criticism in history, were not illustrated). This remained essential throughout the 19th century and during the first half of the 20th century, when paintings were reproduced as engravings or black and white photographs. And even today, describing colour remains an excellent way of learning about the chromatic means employed by an artist.

Colours: the discovery of the colour wheel

In the first chapter we saw how the range of pigments available to painters gradually increased from a very limited palette during the Middle Ages to a wide choice in the industrial age. In addition to the evolution of the different types of pigment — knowledge of which is essential if we are to understand why this or that hue predominated during a given era — a visual and intellectual understanding of what actually constitutes colour is also of prime importance.

Prior to the beginning of the modern age, colour was regarded by those who attempted to analyse it as a material property. In the Middle Ages it was defined as brilliance and connected with light, not in terms of a reasoned physical relationship, but rather in a metaphorical sense. Thus, around the year 600, the encyclopedist Isidore of Seville compared it to 'imprisoned sunlight' and 'purified matter'. For their part, the painters who examined colour in technical manuals confined themselves to listing the materials (minerals and plants) from which pigments could be obtained.

From the 18th century onwards, a great conceptual revolution changed people's understanding of colour. Discoveries and experiments revealed that colour is a physical, or more accurately optical, and therefore at the same time physiological, reality. An object is not made of a given colour, but is perceived as being that colour by the human brain, which analyzes and measures the degree of reflectivity of its surface when illuminated by a light whose mean wavelength corresponds to light of that colour. A green object, for example, appears green because it reflects only those rays of light that make up green light and absorbs (or 'extinguishes') all others. White contains all the colours, and an object appears white when it reflects all the colours in the spectrum. Black is the absence of colour: objects that are perceived as black do not reflect any of the colours in the spectrum, but absorb them all. In 1666, the physicist Sir Isaac Newton was the first to split white light (in other words the visible spectrum) into bands or rays of different electromagnetic wavelengths, seen as different colours, by passing a beam of light through a prism. He distinguished seven colours this way (the same number as in a rainbow, which is produced by

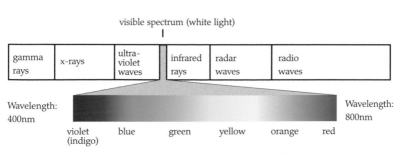

Diagram showing the sequence of colours in the solar spectrum (visible white light) and the position of the spectrum within the range of wavelengths.

a similar dispersion of light, in this case through drops of water present in the atmosphere): red, orange, yellow, green, blue, indigo (an arbitrary colour added in order to define a seventh colour) and violet.

During the 18th and 19th centuries, other scientists continued Newton's work. The first colour wheel (or colour circle), divided into coloured segments, was devised by Father

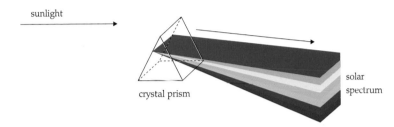

sunlight

crystal prism

solar spectrum

The sequence of colours in the solar spectrum

The colour wheel

primary colours:
blue
red
yellow

secondary colours:
green
orange
violet

Louis-Bertrand Castel in his *Optique des Couleurs* of 1740. This was followed by a series of more precise optical diagrams featuring the colours of the solar spectrum according to their visible sequence in the rainbow and the dispersion of light established by Newton. These diagrams were constructed by the chemist Eugène Chevreul between 1830 and 1860 and became increasingly widely known during the course of the 19th century. In parallel with Chevreul's work, other figures — such as the painter Philipp Otto Runge and the writer Johann Wolfgang von Goethe (whose *Theory of Colours*, widely read by painters, dates from 1810), the scientists Hermann von Helmholtz and Charles Henry and in the 20th century the philosopher Ludwig Wittgenstein — attempted to establish a psychology of colour that treated colour as a subjective phenomenon whose perception depends on the individual and on 'visual context' (time of day and proximity to other colours). The colour wheel and other diagrams of the colours of the spectrum have provided artists with a frame of reference that has allowed them to make better use of colour by defining the relationships among the different colours. They created a vocabulary whose terms have become part and parcel of the study of colour.

In the colour wheel, the three basic colours that cannot be produced by combining any of the others — in other words

Complementary colours

yellow, red and blue — are called the 'primary colours'. Violet, green and orange, composites because they result from mixing two of the primaries together, are known as the 'secondary colours'. White, an optical combination of all the light in the spectrum, and black, which results from the absorption of the whole range of light, are 'non-colours' and represent the two extremes of the colour scale.

The combining of two primaries to create a secondary inevitably leaves out one primary in each case. That primary is essential to the reconstitution of the spectrum in its entirety (in other words white light), and is known as the 'complementary' of the colour obtained through the combining of the other two. Thus blue is the complementary of orange (the result of mixing red and yellow); yellow is the complementary of violet (the result of mixing red and blue); and red is the complementary of green (the result of mixing blue and yellow). The reverse is also true (in other words orange can be described as the complementary of blue).

The light spectrum and use of pigment: 'simultaneous contrast' and 'achromatism'

The study of coloured light is one thing, but the use of pigment is quite another. This can be demonstrated by a simple experiment: mixing equal quantities of pigment of the three primary colours, or even of all the colours of the spectrum, produces not white, but grey.

In spite of this difference, a knowledge of the laws of physics governing colour provides insights that can be extremely useful to painters.

The most remarkable of the optical laws concerning colour is what Chevreul called the 'law of simultaneous contrast': the juxtaposition of a given colour and its complementary leads to a heightening of both, displaying them at their greatest degree of visual intensity. A green and a red placed side by side will therefore enhance each other, an orange will set off a blue and vice versa and a violet and a yellow will both appear more

Example of the use of complementary colours, in this case red and green.
Claude Monet, *Poppies*, 1873, oil on canvas, 50 x 65cm, Paris, Musée d'Orsay.

brilliant when used in conjunction with each other.

The reciprocal rule is that of achromatism (absence of colour). The same colours that appear more intense when they are placed side by side cancel each other when mixed together. Mixing red and green, orange and blue or violet and yellow on the palette will therefore produce a shade of grey. This is inevitable as each complementary pair unites all the basic colours in the spectrum, the combining of which, as we have already seen, produces white in the case of light and grey in the case of pigment. This property can be used to positive effect by painters. When the quantities are measured out carefully, this mixing process can be used to tone down a hue judged to be too bright, to moderate its brilliance. A little red mixed with green, for example, will lessen its impact. The effect of this can be appreciable in a landscape.

These two rules — knowledge of which is clearly of fundamental importance — were brilliantly summarized in a book entitled *La Grammaire des Arts du Dessin* (*Grammar of the Art of Drawing*) by Charles Blanc, which enjoyed enormous success at the end of the 19th century: 'Complementaries fight side by side to victory or against each other to the death.'

'Warm' and 'cold' colours

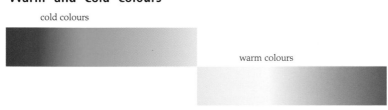

cold colours

warm colours

Logically, use of the terms 'primary', 'secondary' and 'complementary' should be reserved for the analysis of paintings that postdate the discovery of the spectrum. In reality, however, even Classical authors recognized the principle of three generative colours, yellow, red and blue, and in the 15th century Leonado da Vinci wrote that 'white is not a colour in itself; it is the container of all the colours'. Furthermore, numerous paintings dating from before the 19th century testify to the fact that complementary colours were used together as a means of intensifying or highlighting a motif positioned in the area where they met. It is therefore not entirely inappropriate to use the contemporary language of colour in connection with works painted in earlier centuries, as long as this is done with care.

It is also advisable to use the adjectives 'warm' and 'cold' with caution when discussing colour. In terms of assumed 'temperature', colour is indeed classified according to the sequence of the spectrum: from yellow via orange to red in the case of the 'warm' colours and from blue-violet to green for the 'cold' colours. It is nevertheless true that these qualities of coldness or warmth are related to very old commonplaces of Western thought: the 'warm' colours resemble the colour of flames and are said to give rise to 'a captivating, pleasing feeling when looked at' (Larousse dictionary). They are also the colours of danger and prohibition: the colour of the flames of hell and that of traffic lights directing vehicles to slow down or stop. As for the 'cold' colours, they evoke the hues of water and are deemed to arouse 'no feeling [...] of life or liveliness' or 'sensuality' (Larousse dictionary again). They also evoke the sky, and call forth images of open spaces, calmness and infinity. The theory of the humours, so prominent in ancient medicine (it was thought, for example, that 'fiery' or 'irascible' characters could be spotted from their red complexions), and the four elements, which remained an important concept right up to the beginning of the modern age (Earth, Fire, Air and Water, divided into cold and hot and represented respectively by black/brown, red/orange, blue/white and green), are also related to this classification by temperature, which has now been eclipsed by the modern science of colour.

Line and colour

Description of colour and choice of terminology

The language used to describe colour needs to be both structured and precise. Terms that refer to non-pictorial concerns should be avoided. The word 'beige', for example, belongs to the lexicon of fashion; so, in order to describe this hue in painting, we must seek a definition closer to the physiological code of colours and talk of a very light brown bordering on yellow. 'Navy blue' is avoided for a similar reason, and should not be used to describe the dark blue used by artists.

The terminology used to discuss paintings sometimes takes on a historical aspect and considers colour from a material point of view, in other words in terms of how the pigments are produced. Thanks to a tradition inherited from 19th-century literary criticism, this is enriched by metaphors taken from the language of flowers. Finally, it also has a tendency to borrow the nomenclature established by those physicists who described the dispersion of light.

Colour described in terms of material

Colour can be considered from a material point of view, and terms can be used that were or still are employed by artists to describe the different pigments. These terms often relate to how the pigments were or are obtained. In *Il Libro dell'Arte* (*The Craftsman's Handbook*), Cennino Cennini distinguishes two grades of blue (Ultramarine and German Azure), four reds (Cinabrese, Sanguine, Dragon's Blood, Lac), six yellows (Masticote, Ochre, Orpiment, Realgar, Saffron, Arzica), and so on for green, white and black. Each name is followed by a paragraph on the constituents of the pigment, whether pure or mixed. During the industrial age, the names given to pigments also specified their chemical composition. The following could be found at dealers and identified in paintings: in the case of green, an 'Emerald Green' (hydrated chromium oxide) and a 'Chromium Oxide Green' (of similar origin, but using a non-hydrated oxide); in the case of blue, a 'Prussian Blue' (ferric ferrocyanide), a 'Phtalocyanine Blue' (made from tar), and so on.

The pigments to which these totally objective (and thus to be recommended) terms refer can only, in the majority of cases, be identified from the paintings themselves, rather than from photographs, and their identification often presupposes chemical analysis. In short, the use of these words is only conceivable, other than in exceptional cases, in highly technical commentaries.

Floral hues

In the works of 19th-century writers, a blue might be called 'lilac', a yellow 'daffodil' and so on. The use of these terms seems rather outmoded today. It can be justified when we are examining older paintings whose object was to please the eye, but it does not have a place in the analysis of pictures whose object is not to delight viewers but to surprise or shock them, to give them food for thought. It is difficult to imagine admiring the 'beautiful lavender hue' at the centre of *Les Demoiselles d'Avignon*, for example.

The light spectrum and its shades

Generally, the most satisfactory solution is the adoption of the terminology used to describe the spectrum, although it is not entirely unambiguous. Even with the addition of 'indigo', a colour identified somewhat arbitrarily by Newton among the dispersed rays of light, the colours of the colour wheel far from exhaust the capacity of the eye to distinguish between different hues. It is impossible, however, to find a word that everyone agrees on to identify each of the shades that can be produced through the mixing of light or pigment.

From Chevreul to Charles Blanc, theoreticians became used to distinguishing twelve colours (about whose names there is not universal consensus) around the colour wheel. The lexically most neutral way of describing the colours is to confine the terms we use more or less to the primary and secondary colours (the colours in the six-colour wheel) and to combine them to give as exact an idea as possible of the shade. Clockwise from

yellow this gives: yellow, yellow-orange, orange, red-orange, red, red-violet (purple), violet, blue-violet, blue, blue-green, green, yellow-green.

The colour wheel and its developments

Instead of arbitrarily distinguishing a set number of colours and naming them once and for all, it can be useful to consider the colours as running in a continuous band around the colour wheel and then to specify a hue by its relation to the other hues.

Colour charts drawn up for each family of colours by professionals for industrial or artistic purposes allow this rather dry list of names to be somewhat enlivened and refined, and, with practice, it is easy to distinguish a vermilion from a magenta or a crimson, an emerald green from a brilliant green, an ultramarine from a cobalt blue, and so on. These colours are also frequently called by the names of the materials from which they are made, hence the terms 'burnt sienna' (a ferric oxide obtained by means of the calcination of raw sienna earth) or 'umber' (a hydrate of iron and manganese, its name referring to Umbria in Italy).

Identification of colours in relation to the six colours of the colour wheel: continuous sequence.

The ring of twelve colours distributed around the colour wheel.

THE HISTORY OF COLOURS

The way colours have been used — linked as this is to the production methods and the knowledge of physics at the time — constitutes a history of its own. The works themselves can help us to reconstruct this history.

The 'gold and glitter' aesthetic of the Middle Ages

The world of the Middle Ages was a world without colour. Until the 13th century, the dying of fabric was rare and clothing was uniformly brown or ochre. St Louis, King of France, provoked astonishment by being the first to wear a beautiful ultramarine cloak. Light was also a thing of rarity: people of modest means went to bed early to save candles. Colour and light aroused a joy and wonder that is hard for us to imagine today. In the 13th century, the triumph of stained-glass windows in northern Europe (with its cold light and infrequent sunshine) can to some extent be explained by the delight congregations felt when they found themselves in churches bathed in light made up of multi-coloured reflections. Abbot Thomas de Verceuil, in around 1250, talks of the *delectatio et dulcoratio* (delectation and delight) such iridescence conferred upon the soul.

In order to provide this pleasure, medieval art objects were all brightly coloured. Reliquaries and other items of plate sparkled with gold and precious stones or glass. And illuminated manuscripts shone just as brightly: the word 'miniature' (in the sense of illuminated letter) in fact comes from the Latin *miniare*, meaning to employ bright colours such as minium (a red-orange pigment derived from the oxidization of melted lead).

Line and colour

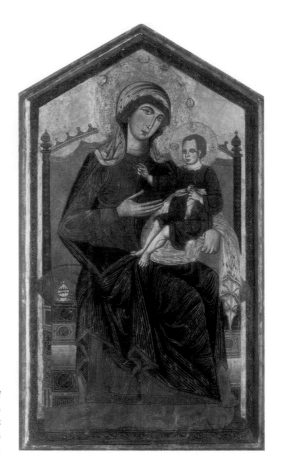

Guido da Siena, *Virgin and Child*, 1265–75, tempera on wood and gold leaf, 125 x 73cm, Florence, Galleria dell'Accademia.

Paintings on wood, in gilt frames sometimes incrusted with polished but unfaceted gems known as 'cabochons' (as in Guido da Siena's VIRGIN AND CHILD), featured a similar richness of colour. This aesthetic has been described as 'gold and glitter'. It granted an important place to strong colours in the body of the painting too: gold (applied in the form of gold leaf to backgrounds, haloes and various other details), and blue and red, two of the colours we now call primary colours, but not yellow, which is too close to gold to stand out against it.

During the same period, economic considerations also favoured the use of gold and certain expensive colours. If works were valued for *peritia*, the skill of the artist, they were valued just as highly for the costliness of the materials that went into them. Offered to God or the saints, a painting had to be luxurious. This was another argument in favour of the application of large quantities of gold to the surface of paintings and the use of precious pigments in them. Lapis lazuli, obtained by grinding a mineral (sodalite) imported from Afghanistan (the Badakshan region, to be precise), was valued for its beautiful azure colour and its remarkable stability, but was also used for reasons of ostentation. Because of this, its usage was confined to the most prominent areas of the painting.

Finally, the way colours were used was also influenced by the symbolic value attached to them by the medieval mind. Reminiscent of imperial purple, red was the colour of glory, and was used for God's cloak in van Eyck's Ghent Altarpiece (see p.115). It is also the colour of spilt blood and therefore of sacrifice: in Duccio's *Maestà*, Jesus is always shown wearing a red robe. Blue, which evokes a clear sky, is the colour of the Virgin: Mary's cloak is invariably blue, as here in van Eyck's painting. She wears it over a red garment because

114

Upper tier of the main part of the Ghent Altarpiece by van Eyck, 1432: The Virgin Mary, God and St John the Baptist (see also p.38).

she shares in the sacrifice and majesty of the Son of God through her nobility and mother's sorrow.

Apparently for moral reasons, composite colours did not have such a good reputation: duality and the mixing of elements conveyed overtones of sin and impurity to the medieval mind. While the Flemish were happy to use green (and van Eyck used it for John the Baptist's cape, again in the Ghent Altarpiece), the Italians were not. They did not reject green completely, but avoided using it for the clothing of the major saints. For less obvious reasons, yellow also had a bad reputation. It was sometimes used for the coats of traitors: Judas, for example, wears a large yellow cloak in Giotto's fresco *The Kiss of Judas* (see p.132). Finally, as art historian Michel Pastoureau has demonstrated, the use of stripes — two colours used in conjunction with one another in the same space — was also used as a way of stigmatizing evil characters: traitors, torturers and those who repudiate Christ's message.

The sobriety of the early Renaissance

In 15th-century Italy, with the Middle Ages drawing to a close, this taste for colour underwent a radical reversal. The desire to compete with works surviving from ancient times — limestone and marble statuary and reliefs that had lost their coating of colour with the passage of time — led artists to be wary of bright hues. The ideal pursued by painters such as Andrea Mantegna in northern Italy during the second half of the quattrocento was almost monochrome. In his frescoes in the Church of the Eremitani in Padua, he attempted to imitate the effect of sculpted stone using a limited palette

Line and colour

Andrea Mantegna, *Dead Christ*, c.1475–90, tempera on canvas, 68 x 81cm, Milan, Pinacoteca di Brera.

dominated by grey, brown and pink. His paintings on both wood and canvas sometimes aspire to a cameo effect: figures and motifs painted in a single colour contrast with a background painted in another. The term *camaïeu* is used to describe paintings of this type executed in different shades of a single colour. Mantegna's DEAD CHRIST is a perfect example of this technique.

This monochrome aesthetic was sometimes backed up by morality. During an era when rigorist concerns were a reality — the end of the 15th century witnessed the Savonarolan revolution in Florence — colour, or at least an excess of colour, was denounced by certain theologians as an irrelevance that diverted the soul from God rather than leading it to him. Most importantly, however, since painters (supported by theoreticians) were striving to establish the idea that the value of a work of art depended on their talent rather than on the worth of the materials, the use of gold found itself discredited. In *De Pictura*, Leon Battista Alberti had these words to say on the subject: 'If I wanted to paint Virgil's Dido, resplendent in gold [...], I would attempt to render her with colour rather than gold [...]. If one applies gold to a flat panel, most of the surfaces that should have been made light and bright appear dark to the spectator, and certain others, which should perhaps have been more muted, appear more radiant.'

At the time the Italian theoretician was writing these words, the approach to colour in northern Europe was determined not by a concern to revive the art of Classical antiquity, but by an economy of image which took into account the conditions under which the work would be viewed as well as liturgical considerations. The economy of the Flemish altarpiece involved positioning its more brightly coloured sections on the inside and its darker brown and grey motifs on the outside of the wings. Inspired by the large altarpieces that had become a feature of the churches, the smaller diptychs executed by HANS MEM-LING — more intimate devotional images (*imagines pietatis*) — also frequently display this type of organization. Except during the major religious festivals, and particularly during

Lent, the altarpieces remained closed. The relatively colourless universe displayed in the paintings that were visible when the altarpieces were closed was a symbolic evocation of the base world, a world of poverty, illness and death, to which man had been condemned as a result of Eve's sin. The opening of the altarpiece was an act of theatre: by revealing to the faithful a universe full of colour, the priest could reassure them of the promise of a better world, one they could dream of and one in which they had to earn their place.

The 16th century and the return of colour

Colour triumphed again in the 16th century. Glorified in Venice, it also became highly stylized, and its harmonies were completely reformulated — in Florence and Rome by Michelangelo, and then in Tuscany and throughout Europe by the Mannerists.

The restoration of Michelangelo's paintings has allowed us to rediscover the boldness of the chromatic effects he experimented with (he nevertheless described himself as more a sculptor than a painter). Unlike the artists of the Middle Ages or even Raphael, Michelangelo made restrained use of the primary colours, rarely used saturated hues, and tried out daring and totally new combinations. In his *Tondo Doni*, a youthful work depicting the *Holy Family* (Florence, Galleria degli Uffizi), the Virgin's cloak is not pure azure but a blue mixed with a large quantity of white, and her dress is pink rather than red. On the ceiling of the Sistine Chapel, yellows, oranges, greens and light violets are far more in evidence than they had been in earlier paintings, and sometimes their juxtaposition results in strange sonorities. In the

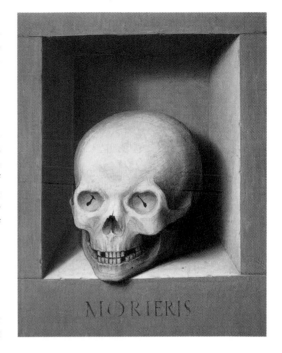

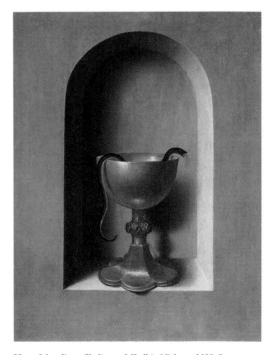

Hans Memling, *Chalice and Skull in Niches,* c.1480–3, reverse of the left and right wings of the diptych of St John the Baptist and St Veronica, 31.2 x 24.4cm and 31.6 x 24.4cm, Munich, Alte Pinakothek (left wing) and Washington, Samuel H. Kress Collection, National Gallery of Art (right wing).

Line and colour

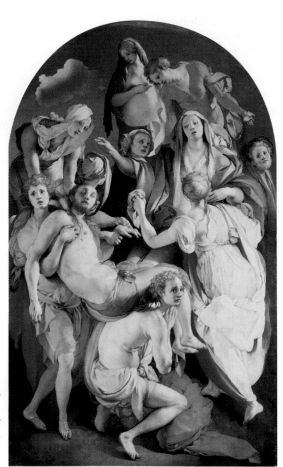

Pontormo (Jacopo
Carucci),
*The Deposition from the
Cross,* 1526–7, oil on
wood, 313 x 192cm,
Florence, Santa Felicità.

lower parts of the ceiling, which were executed last (the work on the fresco proceeded from top to bottom), the chromatic innovations are even more obvious: pale yellows and violets proliferate, greens mutate into pink and pinks into indigo.

In *The Punishment of Haman* (see p.155), the grand vizir who was the enemy of the Jews is crucified on the yellow-green trunk of a tree in front of an orange cloth.

In the years 1510–20, the Tuscan Mannerists began taking these experiments with colour even further. Rosso and Pontormo, two Florentine painters, adopted a palette based on that of Michelangelo and made systematic use of the juxtaposition of discordant hues. In his THE DEPOSITION FROM THE CROSS, for example, Pontormo, who worked with the most subdued palette of all the Mannerist painters, has made abundant use of pale pinks, light blues, delicate orangey yellows and very light violets against an indigo background. At the top of the painting he has created a daring combination of colours in the clothing of St John the Baptist, who leans over the Virgin: his green-bronze tunic stands out against a loose red cloak which veers between vermilion and orange. At the bottom of the picture, the yellow robes of one of the holy women, rushing towards Mary, likewise turn orange and vermilion where they are in shadow; and in the foreground Nicodemus, the young man supporting Christ's feet, also wears a tight-fitting tunic, this time blue where the light falls on it and pink where it does not.

Colour and light: chiaroscuro and coloured shadows

The metamorphosis of yellow into red or pink into blue in Pontormo's painting is used to

indicate the transition of a garment from an illuminated zone to an area in shadow. The change of colour conveys the three-dimensionality of both clothing and body. In the 16th century, this was a completely new way of treating this phenomenon.

The technique of rendering three-dimensionality through the depiction of light and shade originated during the trecento in Italy when painters, primarily Giotto, began to concern themselves with the problem of how to convey an impression of the density of bodies (animate and inanimate), or in other words their physical thickness. Technically, this was achieved by adding white or black to the colour being used, a procedure that allowed different gradations of brightness to be achieved. From the 15th century onwards, painters no longer confined themselves to rendering shaded areas (those areas of a body less exposed to the light); they also started painting the shadows cast by objects (Italian *sbattimenti*, singular *sbattimento*), varying the intensity of the shadow according to the lighting conditions and the greater or lesser opacity of the body being depicted and adjusting the length of the shadows according to the position of the light source. Shadows and shading have many important functions: they reinforce a feeling of space (by making the distance that separates different objects seem real); they provide an indication of the time of day (shadows are much longer at dawn and dusk); and they can have great expressive power, looming up behind figures like the Commander in Molière's play *Don Juan* — as in the colour engraving reproduced here of an anatomical figure by *DAGOTY*.

Chiaroscuro (light and shade) is determined by the variations of tone of a colour (the terms 'intensity' and 'value' are also used in this context). These variations depend on whether white or black have been added to the colour and in what quantities. Around 1400, Cennino Cennini advised painters to use three different tonal values to treat a motif in light and shade (*adombrare*): light, medium (*mezz'ombra*) and dark. Over time, painters adopted the practice of employing a far greater number of different values to achieve a gradation of colour, adding varying amounts of black to darken or white to lighten a pure (also known as a 'saturated') hue.

Chiaroscuro remained the most widespread means of depicting the progressive transformation of a colour affected by increasing or decreasing amounts of light until well after the 14th century, until the dawning of the modern age in fact. However, it has sometimes been the case — and particularly so since the end of the 19th century — that painters have preferred to depict objects without taking into account any modification by light and shade. This has led to attempts to depict objects in a 'neutral' or mid tone, corresponding to the colour of the object when subjected to neither excessively bright nor excessively weak light.

Arnaud-Éloi Gautier Dagoty, *Écorché from the front, showing the superficial muscles*, 1773, colour engraving, 55 x 39.8cm, Paris, private collection.

Michelangelo, *The Drunkenness of Noah*, 1508–12, fresco, Rome, ceiling of the Sistine Chapel.

Pontormo's painting demonstrates, however, that light and shade was not the only means artists had at their disposal for depicting modulations of colour caused by lighting conditions. At the beginning of the 16th century, artists who did not want to forgo any intensity of colour sought an alternative to adding black to their hues. On the ceiling of the Sistine Chapel, Michelangelo experimented with painting relief using colour alone. In *The Drunkenness of Noah*, the green blanket on which the patriarch is sleeping has not been shaded using black and white; instead those areas on which the light falls have been heightened with saffron and bright yellow. Pontormo's subtle changes of colour can be seen as a continuation of this experiment.

Light and dark painting: the tenebrist revolution

While the Mannerist painters broke with tradition in many ways, most of them did not go so far as to question the then rigid principle of painting in light colours. With the exception of the Siennese painter Domenico Beccafumi, who experimented with contrasts of light so extreme that they bordered on the fantastic, 16th-century artists painted a world in which daylight illuminated all of the motifs in their paintings more or less uniformly and allowed the smallest details of their elaborate compositions to be seen and enjoyed.

Around 1600, Michelangelo Merisi, known as CARAVAGGIO, led what amounted to an all-out offensive on this 'light' style of painting. As his biographer Giovan Pietro Bellori wrote in 1672, he painted 'in colours dense with robust shadows, using abundant blacks in order to add relief to the body' and refrained from 'exposing his models to broad daylight [...], positioning them instead in dark rooms where they are exposed to a high source of light that strikes the prominent parts of their bodies and leaves the rest of them in darkness, resulting in violent contrasts between light and shade.'

This new style of painting – with which Caravaggio experimented in two large churches in Rome (San Luigi dei Francesi and Santa Maria del Popolo) and which he pur-

sued in numerous other works — provoked the wrath of traditionalist painters, who claimed that Caravaggio 'could paint only cellars, that he had no conception of the dignity of art, composition or the science of gradation' (Bellori again).

In reality, Caravaggio's 'black painting' established a model. The after-effects of his radical revolution spread throughout the whole of Europe during the remainder of the 17th century: from Rome to Naples; to Spain, where the Velázquez of *Old Woman Cooking Eggs* (see p.75) adopted Caravaggio's dark palette; to Lorraine, where his techniques were adopted by Georges de La Tour; and to the Netherlands where he influenced Frans Hals and above all Rembrandt.

Caravaggio's success can be explained in part by the appeal of this new dark palette after centuries in which the virtues of light colours had been exploited and perhaps exhausted by the great masters. But more fundamentally, painters were attracted by the emotional power that could be conveyed by the contrasts of light and colour within the predominant darkness. The popularity today of *LA TOUR*'s nocturnal images — in which a small number of figures hold a night-time vigil over a wax taper or a 'fine, bright candle'

Caravaggio (Michelangelo Merisi), *The Death of the Virgin*, c.1606, oil on canvas, 369 x 245cm, Paris, Musée du Louvre.

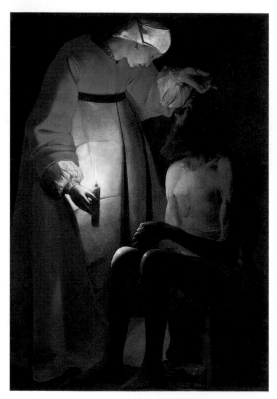

Georges de La Tour, *Job Mocked by His Wife*, date unknown, oil on canvas, 145 x 97cm, Épinal, Musée Départemental des Vosges.

(to quote a line of French 16th-century verse) — helps us to understand the seductive power that these night-time scenes, illuminated by a local, simple source of light, must have had.

Even stronger contrasts of light provided a chromatic means of underlining the harrowing narratives that painters sometimes chose to depict. Up to then, pagan or Christian martyrs had been put to death on bright summer days which seemed to inspire joy rather than terror, but from the time of Caravaggio they met their ends bathed in an appropriately grim light. The invention of a palette of great emotional power was one obvious reason for the success of scenes of execution or torture (as common as their tavern scenes) in the work of Caravaggio and his followers: Caravaggio's *The Martyrdom of St Matthew* in Santa Maria del Popolo and *The Crucifixion of St Peter* in San Luigi dei Francesi were followed by Artemisia Gentileschi's *Judith Slaying Holofernes*, José Ribera's scenes of martyrdom, and so on.

One of Rembrandt's most violent paintings, THE BLINDING OF SAMSON, uses the same chromatic tools. The image is almost unbearable: a soldier plunges his dagger into the eye-socket of the floored giant, the eye bursts and blood spurts out. The scene is set in the dark hollow of a cave whose shadows are rendered using intense blacks. The light flooding in through the mouth of the cave prevents viewers from clearly distinguishing the figures and objects in the painting: by dazzling us, it makes us share in the brutal blinding of Samson.

From Baroque luminarism to Romantic darkness

In chromatic terms, Caravaggio's tenebrism, relieved by flashes of light and colour, inaugurated the Baroque age, which sought out theatrical effects designed to make a strong impact on the senses and revelled in grandiloquence. Classical painting, however, remained faithful to a range of light colours moderated only by restrained shadow. From the time of Louis XIII — or more precisely Simon Vouet's return from Rome to Paris in 1627 — to the Neoclassicism of the end of the 18th and beginning of the 19th centuries, the palette of French painters (Georges de La Tour was from Lorraine, which was an independent duchy at the time) remained predominantly bright. Even in the work of artists such as Le Nain and Philippe de Champaigne, who used browns a great deal, no part of the picture was plunged into a darkness so obscure that it was impenetrable to the eye.

It was not until the Romantic era that painting grew darker again, or more precisely started once more to combine a predominant darkness with sharp contrasts of light and

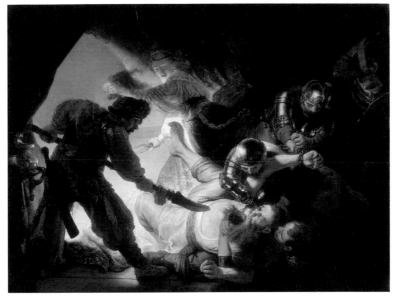

Rembrandt, *The Blinding of Samson*, also known as *The Triumph of Delilah*, 1636, oil on canvas, 205 x 272cm, Frankfurt, Städelsches Kunstinstitut.

colour. Was it simply chance that one of the most influential books in terms of the shaping of the Romantic sensibility was called *Le Rouge et le Noir* (*The Red and the Black*)? Stendhal's novel was published in 1830, just three years after the painting that announced the ultimate triumph of the Romantic school in painting, THE DEATH OF SARDANAPALUS by Eugène Delacroix — a torrent of brown and red pigment from which little by little lighter colours emerge: the whites of the fabrics, the toga and the horse's coat; the yellows and oranges of the women's bodies.

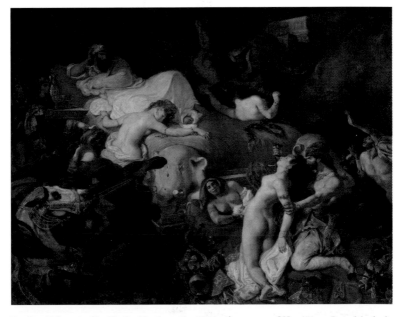

Eugène Delacroix, *The Death of Sardanapalus*, 1827, oil on canvas, 392 x 496cm, Paris, Musée du Louvre.

Japonisme

OR THE DISCOVERY OF DECORATIVE COLOUR

From the 1860s onwards, Japanese art was all the rage. Japanese curios and ceramics were sought by collectors, and numerous exhibitions of prints were held — in Samuel Bing's gallery in Paris, at Liberty's in London and at Tiffany in New York. Hokusai, who gave himself the epithet 'old man mad about drawing', Hiroshige and Utamaro, the great masters of Ukiyo-e, the school of painting whose name means 'pictures of the floating world', served as examples and models to artists thirsty for new forms of expression.

The pure, primitive character of Japanese prints, which were compared by some to the 'Imagerie d'Épinal' French cartoon books, especially interested the younger generation of painters: Monet, Manet (who incorporated a Japanese print into his *PORTRAIT OF ÉMILE ZOLA*), Van Gogh (who gave the title *JAPONAISERIE* to one of his paintings), Degas, Gustave Caillebotte, as well as Paul Gauguin and his friends associated with the Pont-Aven School.

These Japanese works encouraged European artists to experiment with flat composition and unusual perspective effects (see p.92). They rediscovered the decorative character of curves — plant stalks and waves — as well as large diagonals that dominated a whole work. They also borrowed certain themes (rocks in the sea and bridges), a particular way of painting them (Van Gogh's trees, crows and irises) and specific bodily attitudes (men and women stretched out full-length, crouching or curled up — poses that Gauguin later painted during his Polynesian period).

In addition, they discovered in these works the justification for a new type of drawing which involved giving forms a definite outline (Manet and Gauguin made ample use of this technique) or sketching forms with reed pens in a procedure called *trait-point* (literally 'line-point'), which was a source of inspiration to Van Gogh in particular.

Finally, they valued the flat, bright hues of these coloured engravings. The absence of shadow and shading meant that their colours were particularly bright: always saturated and never mixed with black. The contrast with the official art of the period — nicknamed *jus de chique* (tobacco juice) — was stark. Gauguin's *The Vision after the Sermon* (see p.245) and Paul Sérusier's *The Talisman* (see p.247), dating from summer 1888 and autumn 1888 respectively, are examples of paintings executed using pure colour alone.

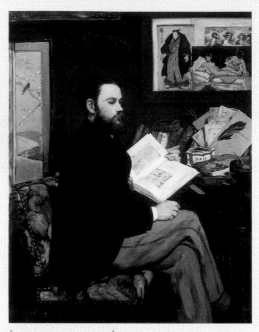

Édouard Manet, *Portrait of Émile Zola*, c.1868, oil on canvas, 146 x 114cm, Paris, Musée du Jeu de Paume.

Vincent Van Gogh, *Japonaiserie, Bridge in the Rain (after Hiroshige)*, 1887, oil on canvas, 73 x 54cm, Amsterdam, Vincent Van Gogh Foundation, Rijksmuseum.

Impressionism and Neo-Impressionism: the precise rendering of light

Painting out of doors (known in France as *pleinairisme*) – in other words, painting pictures from the first to the last brush stroke in the open air in order to recreate the effects of the light – brought with it a return to light colours; indeed, to such an extent that the period between 1870 and 1886 was known in France as *les années-lumière* (the 'years of light').

The methods employed by the Impressionists to satisfy their passion for light did not, however, involve combining different hues or adding white to a colour. Their technique of using separate brush strokes allowed them to apply pure colour to the canvas (rather than mixing different pigments on the palette) and leave the task of optical 'mixing' and the discovery of nature's colours to the onlooker.

This method was taken to its most technically sophisticated level by Georges Seurat. Having read Charles Blanc's *La Grammaire des Arts du Dessin* (*Grammar of the Art of Drawing*), which introduced him to the ideas of Chevreul, and having followed the work of Charles Henry, Seurat not only used the technique of separate brush strokes, he also exploited the principle of exaggerated contrast at the meeting point of two complementaries and at the junction between planes of unequal luminosity. Delacroix had already had an inkling of this phenomenon when studying shadows in bright sunlight. In notes for an abandoned dictionary of fine arts, he wrote: 'From my window I study the shadows of people walking past in the sunshine on the sand of the port. The sand of this area is itself violet, but appears golden in the sun. The shadows cast by these individuals are so violet that the ground appears yellow.' Use of the complementary colours violet and yellow struck him as a means of rendering the maximum intensity of light. In his paintings, Seurat made a law out of this particular insight: 'My means of expression is the optical mixing of tones and colours (of localities and illumination: sunshine, paraffin or gas lamps, etc), in other words of lights and their reactions (shadows) in accordance with the laws of contrast of the gradation of luminosity.' He also adds: 'The border is in contrasting harmony to that of the tones, tints and lines of the picture', a principle he took to its logical conclusion by bordering works with a network of small dots painted in a harmonious combination of complementary colours (as in *Sunday Afternoon on the Island of La Grande Jatte*, see p.107) and then, from 1888, by stippling the frame itself.

The Fauvist revolution: expressive colour

By confining themselves to a subtle reproduction of the effect of the light on the retina, the Impressionists and Neo-Impressionists neglected the idea that a painting is not simply an imitation of nature but should also arouse emotion. Without abandoning the process of experimentation with the light spectrum, the painters referred to as the 'Fauves' ('wild beasts') invented a language that was far less dependent on the slavish reproduction of real colours, but investigated instead the emotive effect that colours can have.

The name 'Fauves' originated in a remark made by critic Louis Vauxcelles – 'Donatello chez les fauves' ('Donatello among the wild beasts') – in response to the strange sight of two small white statues by the Classical-style sculptor Albert Marque in room VII of the Salon d'Automne of 1905, in which a dozen or so painters (Georges Braque, Charles Camoin, André Derain, Raoul Dufy, Othon Friesz, Henri Charles Manguin, Albert Marquet, Jean Puy, Louis Valtat, Kees van Dongen and Maurice de Vlaminck) were showing their 'super bright' (Vauxcelles) paintings featuring colours thought by many to be garish.

Exposed to public mockery, these young artists (most of them under thirty) rejected dots and eventually short, separate brush strokes as well, and used large patches of colour and extensive flat areas of saturated red, yellow, violet and green, whether they were painting a landscape bathed in light or a portrait.

Line and colour

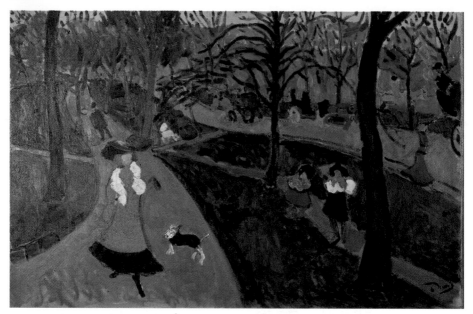

André Derain, *Hyde Park*, 1906, oil on canvas, 65 x 100cm, Troyes, Musée d'Art Moderne.

But their art did not completely reject the imitative use of colour, at least during the early stages. It simply followed to the letter the thoughts of the preceding generation of artists on the way our perception of a colour is modified by the hues that surround it. For example, Gauguin – in a comment made 15 years earlier to another young painter, Sérusier – advocated the use of saturated colours: 'How do you see these trees? They are yellow. This bluish shadow? Paint it in pure ultramarine. These red leaves, use vermilion for them.'

In addition to their interest in the optics of colour, the Fauves were committed above all else to exploring the joy, sensuality and eroticism of colour. From this point of view, their nickname was well chosen: the word 'fauve' comes from *fulgeor*, which in the Middle Ages referred to a yellow bordering on orange, the colour of the coats of certain wild beasts, and in the 19th century to the animals themselves. The Fauves' chromaticism, which accorded an important place to yellow and orange, can be seen as a symphony of bright colours. In London, 'the city of fog' where he spent the winter of 1905–6, Derain produced canvases in which every surface and every form is vibrant with intense, powerful colour. In *HYDE PARK* he makes the paths pink, the trunks of the trees red ochre and the lawns an astonishingly vivid green. In Matisse's *PORTRAIT OF MADAME MATISSE*, also known as *The Green Line*, orange, green, yellow, pink and blue patches are arranged apparently at random across the surface of the painting, but actually give structure to a face that seems to materialize suddenly out of the thick mass of the sitter's shoulders and neck.

Metaphysical painting in the 19th century: colour as a route to the sublime

Although colour as used by the Fauves gradually freed itself from the motif and shone out all its glory, it did so while remaining attached to recognizable forms. In short, it was put to the service of figurative painting, and aspired to a sort of visual celebration by exploding across the canvas like a riotous firework display.

Prior to the emergence of the Fauves, however, a number of painters had been exploring the whole area of colour by freeing it little by little from its subservience to motif. They replaced the pursuit of the pleasure to be derived from the representation of a motif with

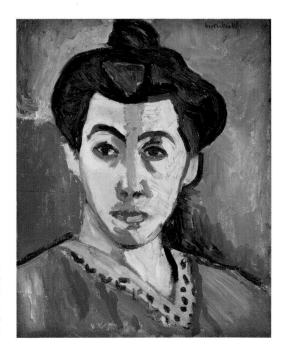

Henri Matisse,
Portrait of Madame Matisse, also
known as *The Green Line,* 1905, oil
on canvas, 40.6 x 32.4cm,
Copenhagen, Statens
Museum for Kunst.

a philosophical-style investigation in which colour became a gateway to the absolute, in other words to the 'sublime'.

This notion of the sublime was introduced into art by the ancient Greek philosopher known as Pseudo-Longinus. It attributed to painting — as well as to literature and music — the function of introducing man to notions of majesty and grandeur by giving him a glimpse of vast cosmic distances where boundaries of self, individuality and uniqueness no longer exist. This tradition, taken up in the 3rd century AD by Plotinus, enjoyed great success during the Enlightenment thanks to Edmund Burke and the German philosopher Immanuel Kant. In the 19th century, Hegel saw painting's mission as painting the infinite, and the idea of the sublime became established at the heart of Romantic thinking.

During this period, optical colour theory came to the assistance of those painters who took up the challenge. In his *Theory of Colours* of 1810, Goethe declared that contemplation of a single expanse of colour could kindle an awareness of universality and put the spectator in harmony with the fundamental unity of things. J M W Turner, between 1840 and 1845, and to an even greater extent the American-born WHISTLER, during the second half of the 19th century, painted works that support these views. The immensity of nature overwhelms the human figure, who slips into the background and disappears almost completely; the line of the horizon all but vanishes too. Almost devoid of motif, these paintings — landscapes and often seascapes — contain few colours. Covered with an expanse of colour taken from a limited portion of the spectrum, they border on complete abstraction.

Towards the end of his long life, Monet also succumbed to the temptation of painting canvases consisting almost of a single colour. Painted in his garden at Giverny, the series of WATER LILIES he produced between 1898 and 1926 features chromatic compositions painted over and over again almost obsessively, resulting in hundreds of canvases in virtually identical colours. In them Monet clearly favours a blue like that of the sky reflected in the water of the pond, or like that of the primeval ocean.

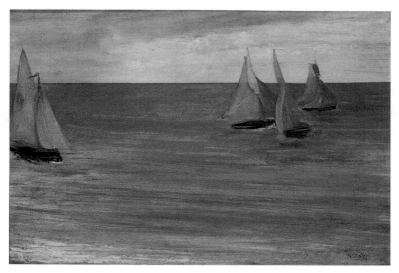

James Abbott McNeill Whistler, *Sea and Rain*, 1865, oil on canvas, 51 x 73.4cm, Ann Arbor, Bequest of Margaret Watson Parker, The University of Michigan Museum of Art.

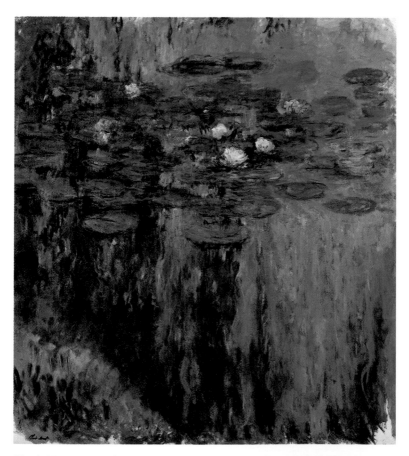

Claude Monet, *Water Lilies*, 1904, oil on canvas, 200 x 200cm, Paris, Musée Marmottan.

The 20th century: the apotheosis of the monochrome

It was not until the end of World War I, however, that the first truly monochrome paintings were created, and these had a very different theoretical or mystical basis.

Inspired by the mathematician and mystic Piotr D Ouspensky, the Russian painter Kasimir Malevich sought to introduce into painting a 'fourth dimension that would allow the mind to enter a time-space continuum'. His 'Suprematist' works, so named because they asserted the supremacy of abstraction, were meant to open up the way to the infinite, to a reality beyond the reality of form. Symbolically, for his WHITE SQUARE ON WHITE of 1918, he chose the hue that embodies the unity of the spectrum. 'I have broken through the colour frontier and emerged into white', he wrote.

The Russian Alexander Rodchenko, a contemporary of Malevich, also painted monochromes between 1918 and 1921, but his aims were far more materialist than metaphysical. He was not remotely interested in introducing spectators to the dimension of the sublime, but in revolutionizing the treatment of the canvas by regarding it not as an illusory field representing three-dimensional space, but as a simple and immediate object not that far removed from sculpture. In short, his intention was to sign the death warrant of the easel-painting tradition.

After nearly 30 years of oblivion, monochrome paint-ing was resumed in the United States in around 1950, and almost immediately afterwards in Europe. As in the 1920s, two different tendencies emerged. While artists such as Mark Rothko in America and Yves Klein in France represented what American critic Harold Rosenberg called the 'theo-logical wing' of painting, others emphasized the 'necessities of painting' to the exclusion of all else, in other words they based their ideas on the flatness of the object that constitutes the pictorial support. This tendency was displayed by Frank Stella, who in 1959 started exhibiting large canvases covered in mechanical fashion with a regular and repetitive pattern of black stripes. These were painted in commercial gloss paint on unprepared canvases using a house painter's brush and were known as 'stripe paintings'.

Kasimir Malevich, *White Square on White,* c.1918, oil on canvas, 79.4 x 79.4cm, New York, Museum of Modern Art.

The function of colour in this type of painting is more formal than existential: it pursues neither emotive ends nor is involved in any metaphysical quest. It is what remains of painting after subject and human figure have been banished and its illusionistic dimension abandoned.

The human figure

Prior to the 20th century and the advent of abstraction, the main job of the painter was to paint men and women. The expression 'figurative art' describes exactly this function: to depict the external form of the human body in portraits or integrated into narrative scenes.

FROM THE SYMBOL TO THE BODY: THE INVENTION OF THE HUMAN FIGURE

In the Western world during the Middle Ages, painters took their subjects from the Bible (the story of the chosen people and the Incarnation of Christ) and from hagiographical works (lives of the saints such as *The Golden Legend* by Jacobus de Voragine). Occasionally they also portrayed prominent figures such as popes, emperors and sovereigns. Frescoes, mosaics, altarpieces, Byzantine icons and illuminated manuscripts were thus peopled with human figures.

The human figure in the Middle Ages: a disembodied symbol

However, these figures were not convincing representations of the human form, nor were they designed to be. Painted in general in a standing position and shown from the front in rigid, solemn (hieratic) poses, they were clothed (during the Romanesque period, for example) in garments whose folds seem to be at variance with the shape of the body beneath. While they were sometimes given a gender, this was often the only individual physical characteristic they possessed.

It would also be futile to try to ascertain whether a particular woman in a painting dating from between the 5th and 8th centuries is beautiful or ugly, and even more so to try to guess the age of a child or determine whether a man is fat or thin. The artists of this period employed a range of established symbols, stereotypes that would be immediately recognizable to the public of the day, in order to indicate those features that were essential to the stories they were telling: short stature for a child, white beard for an old man, dishevelled hair for a prostitute, and so on.

This lack of realism was taken for granted. The object of a painting during the Middle Ages was not to deceive onlookers with an imitation of reality, and even less to provoke astonishment or admiration through naturalistic virtuosity. These pictures represented a catalogue of images in which the public (the overwhelming majority of whom were illiterate) could recognize well-known episodes from Biblical history. The term 'poor-man's bible' is sometimes used to denote this function, meaning that the painted scene was the

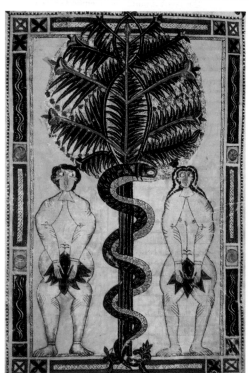

Anonymous (Castille), *The Original Sin* or *Adam and Eve with the Serpent*, end of the 8th century, miniature from the *Commentary on the Apocalypse* by Beatus de Liebana, Madrid, Biblioteca del Monasterio, El Escorial, 11.5, folio 18r.

equivalent of the book for those who couldn't read.

In addition to being an aide-mémoire, the image was designed to encourage religious contemplation on the part of the believer. The visual reminder of the holy stories was only the initial stage: rather than becoming lost in admiration of the work, the Christian soul was supposed to use it as a springboard that would help him or her turn towards God.

Under these conditions, it would be pointless and even harmful for artists to include in their works too many motifs that would steer the thoughts of the viewer back to earth. To depict a body in detail would at best distract the viewer by encouraging them to explore the painted details; at worst it could arouse feelings of lust, for example by presenting them with the beautiful body of the chaste Susanna. When portraying naked bodies in depictions of the Original Sin or the Last Judgement, therefore, painters confined themselves to sketchy stylizations in which the structure of the body bears only an approximate resemblance to its real structure and whose artificial colours are not capable of evoking the sensuality of real flesh (*BEATUS DE LIEBANA*).

The trecento: the emergence of the real body

It was only at the end of the Middle Ages that painters became interested once more in painting real bodies rather than simple signs that symbolized human figures. This change — a true revolution that ushered in the modern age of painting — took place in trecento Italy. Here, the influence of Franciscan spirituality, with its strong interest in celebrating the world and all its creatures, coincided with the rapid rise of the mercantile spirit, in other words the practical mentality of the merchant-bankers who, in their capacity as artistic patrons, were keen to see the real world depicted in the works they financed.

Giotto, the greatest living Florentine painter in the years around 1300, embodied this transformation in the way he portrayed human figures. For his frescoes and altarpieces he invented figures of generous proportions whose heavy forms filled out their clothes and who were painted in a light and shade that highlighted rather than hid their forms. For example, the *Maestà* he painted in 1310 (Florence, Galleria degli Uffizi) allows us to make out the contours of the Madonna's full breasts and powerful thighs beneath her dark blue dress. In his *The Stigmatization of St Francis* (Musée du Louvre), the saint kneels firmly on the ground and his habit, the cloth stretched forward by his bent right knee, covers his body amply, emphasizing its structure (see p.183). In *The Gift of the Mantle* (see p.70), the same saint and the pauper he is helping are wearing habits and, of particular note, white linen bonnets and a hat, allowing them to be assigned to a specific time and social group. Finally, in his fresco *THE VERIFICATION OF THE STIGMATA* in the Bardi Chapel in Santa Croce in Florence, Giotto has taken pains to give the monks gathered around the body of St Francis distinct characteristics: different builds, different ages and even different hair.

In short, for the first time ever, Giotto's figures were individual physical presences with believable bodies, located in a specific period close to the painter's own.

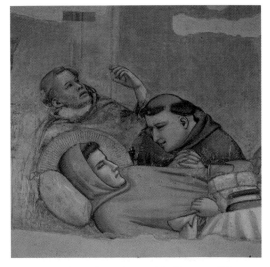

Giotto, detail from *The Verification of the Stigmata*, c.1325, fresco, 280 x 450cm, damaged, Florence, Bardi Chapel, Santa Croce.

THE HUMAN FIGURE FROM THE FRONT AND FROM THE BACK: A REVOLUTION IN THE MODE OF REPRESENTATION

In medieval works, figures were shown in such a way that their faces could be seen. God and the saints, shown either enthroned or standing in isolation, were painted from the front (see p.38). Profiles are more rare, and were used to depict figures who were supposed to be moving. In the Bayeux Tapestry, for example, King Harold and William the Conqueror are seen from the front when sitting in council or banqueting, but in profile (like their men) when going into battle.

The Middle Ages: the first attempts to animate the figure

Painters of the Middle Ages did, occasionally, demonstrate a desire to animate their figures. The Carolingian illuminator who created this image of St Mark the Evangelist has shown him with his feet together or possibly even with his legs crossed (known in Latin as the position of *otium*, in other words 'ease' — or in this case intellectual activity). His head and upper body are seen from the front, but his right shoulder is foreshortened slightly so that his hand can be shown writing in the book on the right, and his head is turned towards the lion dictating to him on the left.

This position is impossible, or at the very least uncomfortable. It is used because the artist wants to depict the figure dynamically while still clearly showing the face.

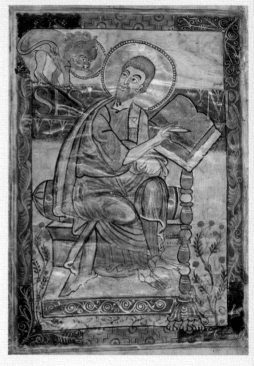

Anonymous, *St Mark the Evangelist*, 781–2, miniature, Paris, Bibliothèque Nationale de France.

Giotto: use of the profile

Painted a little more than five centuries after the miniature of St Mark, this fresco by Giotto is a supreme example of those complex arrangements of figures that painters later strove to perfect. During an era in which painters found it difficult to organize large numbers of figures in a picture (experiments with perspective were still very much in their infancy), Giotto has arranged the crowd of

Giotto, *The Kiss of Judas*, 1304–6, fresco, 200 x 185cm, Padua, Arena Chapel.

Caspar David Friedrich: concealing the face

Whereas in *The Kiss of Judas*, Giotto was concerned to show all the faces with the exception of the man wearing the hood, here Caspar David Friedrich has depicted the one and only human figure in the painting entirely from the back — as a black silhouette against a landscape of clouds and rocks — thereby deliberately depriving us of the opportunity to study his face.

The purpose of this particular viewpoint is to make it easier for viewers to imagine themselves in the shoes of the anonymous individual meditating on the landscape, without being distracted by his facial features.

The painting seeks to create a feeling of the sublime: that impression of magnificence but also of man's insignificance that is experienced when we come face to face with nature. The concealing of the face — the part of the body that is the best indicator of individuality — is a visual metaphor for the idea of the subject becoming one with the vastness of the cosmos as yearned for by this German Romantic painter.

Caspar David Friedrich, *The Wanderer above the Sea of Clouds*, c.1818, oil on canvas, 98.4 x 74.8cm, Hamburg, Kunsthalle.

soldiers in several ranks parallel to the picture plane, with the apostles surrounding Jesus and Judas. At the back, only the soldiers' helmets are visible above the heads of the men in front. To the right, four profiles stand out, staggered diagonally at different levels of depth. At the front of the picture a figure in a heavy cloak points out Jesus with an expansive gesture of his arm.

The left half of the painting is taken up by three figures who are shown either from the back or almost from the back: Judas, in the act of kissing Jesus, a man in a hood and St Peter, whom we see cutting off the ear of the high priest's slave. These back views were new in painting: their inclusion and the systematic use of the profile (not a single figure is seen from the front) were employed to unsettle the eye and increase the impression of agitation and disorder in the scene.

The human figure

Another innovation was that these figures displayed emotions through gesture and expression. In the fragment of THE VERIFICATION OF THE STIGMATA that has been preserved, the three men standing around the body of St Francis display three different psychological approaches when confronted with the miracle of the presence of stigmata on the body of the saint and the drama of death. The only member of the laity, on the right (identifiable as such from his hat and ermine collar), is a sceptic like St Thomas: the first thing he does is to lift the torn habit of the saint in order to check that there really is a wound in his side.

The middle-aged monk with the thickset torso bends over the corpse, grimacing and clasping his hands in an expression of pain that is at the same time an acceptance of death. Finally, the young Franciscan at the head of the bed — a masculine and more restrained equivalent of the female mourners of antiquity — looks towards heaven and raises his hand. He embodies the onset of an anguish that refuses to accept death. We can see that each individual standing around the saint (whose face is shown in profile) is painted in a different position: the layman is shown from behind, the corpulent monk is shown in three-quarter profile, and the young Franciscan in three-quarter profile from the opposite angle.

In their diversity of gesture and expression as well as of physical types, Giotto's paintings reveal an unprecedented richness of invention. His use of complex layouts and a specific attitude for each character mean that his works, which often form part of larger cycles with numerous compartments close together, allow the viewer to understand the mood of each individual and his or her function in the story.

The 15th century: the Flemish interpretation

In the 15th century, painters throughout Europe were preoccupied with painting realistic figures. In Flanders, the body began to be shown in three-quarter view, a more effective means of emphasizing physical volume than the frontal or profile view. The Flemish painters also paid careful attention to drapery, favouring thick textiles that covered the body generously and fell to the floor in heavy folds. In Jan van Eyck's PORTRAIT OF GIOVANNI ARNOLFINI AND HIS WIFE, the young Giovanna Cenami is a good example of a three-quarter figure draped in a voluminous garment (a dress so ample that some people have suggested that the lady, only just married, might be pregnant).

The care they took to emphasize physical density also led the Flemish artists to paint the first cast shadows alongside their figures and to depict details on flesh that evoked an organic, or in other words physiological or pathological, reality. In the *Portrait of a Man with Carnation* (see p.33), *Madonna with Chancellor Rolin* (see p.191) and *Madonna with Canon van der Paele* (Bruges, Groeningenmuseum), the faces of the sitters (men of mature or advanced years) are riddled with wrinkles and scars, bloated with warts and protruding veins and covered with enlarged pores or facial stubble.

Detail from the *Portrait of Giovanni Arnolfini and His Wife* by **van Eyck**: Giovanna Cenami. See also page 4.

134

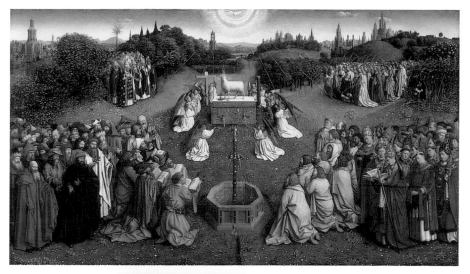

Jan van Eyck, *The Adoration of the Mystic Lamb,* a panel from The Ghent Altarpiece.

Finally, in paintings in which crowds are gathered, the Flemish organized their figures in such a way that no individual ever resembles his neighbour. In *THE ADORATION OF THE MYSTIC LAMB,* for example, van Eyck treats each of the men in the groups that have assembled near the Fountain of Life as an individual in a portrait of mixed types. He places a bald man next to someone with plentiful hair, an old man next to a younger one, juxtaposes smooth faces with bearded faces, a brown-haired man with a redhead, and so on.

The nude: a contribution from quattrocento Italy

After the time of Masaccio, around 1425, Italian painters were well aware of Giotto's contribution to painting and, soon afterwards, of the naturalistic innovations of the Flemish as well. The main contribution made by 15th-century Italy to the history of the representation of the human figure, however, was the introduction of a new subject into painting: the nude, in particular the female nude.

One of the most beautiful nudes to be painted during this period, however, is to be found in a Flemish picture: Eve in van Eyck's *Ghent Altarpiece.* With her bulbous stomach, her small, high breasts (echoed in the roundness of the fruit she is holding), the full curve of her thigh and the darker line running from her navel to the visibly thick hair of her pubis, van Eyck's *Eve* was the most sensual work produced during the closing years of the Middle Ages. She was also an absolute anachronism, an invention of which there was no other example in the north for the rest of the 15th century.

For it was only in Italy that images of the naked body appeared and proliferated. Masaccio's *The Expulsion of Adam and Eve from Eden* was the first convincing example (see p.9). Once the restorers had removed the pair's fig leaves, the fresco emerged in all its stunning forthrightness. These strongly sexualized bodies — each followed by its

shadow — of the first man and woman are painted with astonishing anatomical precision and the play of light and shade makes them appear more like sculptures than paintings. Masaccio has not sought to make them seductive: Adam's beauty is ruined by his posture, his back bowed and his face buried in his hands; Eve, with her heavy, rectangular chest, is also deprived of grace, her face hideously contorted by the grimace with which she expresses her suffering, her eyebrows forming an upside-down 'V' and her mouth wide open in a howl of pain.

Before the body could become seductive, nudity first of all had to move on from religious to mythological subjects. The guilty Eve, discovering herself to be naked after having sinned, was succeeded by Venus, proud of her body and not afraid to turn it into an object of display.

This shift occurred during the second half of the 15th century in Florence, where a Neoplatonism flourished that was infatuated with the notion of beauty. Prior to the Savonarolan revolution in that city, these ideas were embodied in the work of one artist: Sandro Botticelli. In *La Primavera* (also known as *The Allegory of Spring*, Florence, Galleria degli Uffizi) and THE BIRTH OF VENUS — two works painted for a cousin of Lorenzo the Magnificent in the early 1480s — 'an extremely graceful nymph' (in the words of Marsilio

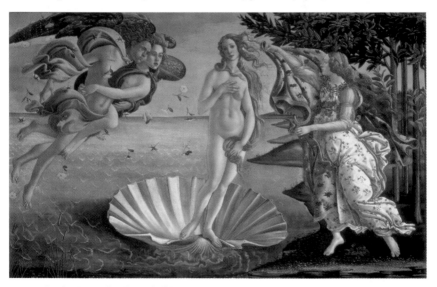

Sandro Botticelli, *The Birth of Venus*, 1484–6, tempera on wood, 172 x 278.5cm, Florence, Galleria degli Uffizi.

Ficino, founder of the Neoplatonist school) appears either alone or in the company of other young women, as naked and delicate as the female figures who adorn the ancient sarcophagi and who were the inspiration for her physical form.

The slender curve of the bodies in *La Primavera* is accompanied by the fluid lines of thin veils that conceal neither breasts nor buttocks and emphasize the triangle of the pubis by catching between the legs. In *The Birth of Venus*, the veil has been removed and Venus's delicate white body stands completely naked on the shell that carries her to shore.

Further contributions of the 15th and 16th centuries: the body in all its states

The gradual discovery of the male and female body from the beginning of the Renaissance onwards, and the right or obligation painters now felt to reveal their beauty and diversity and to paint them in all possible poses, led to profound changes in the pictorial tradition. The move away from a static depiction of figures and towards the depiction of dynamic situations was the first of these changes. Breaking with the rigid postures of medieval painting, the early Renaissance artists gave their figures animated poses in the

THE BODY OF VENUS

A major story in Greek mythology tells of a prince-shepherd named Paris who was asked to name the most beautiful of the three goddesses Aphrodite (Venus), Hera (Juno) and Athena (Minerva). Paris — who was later to abduct Helen, the most beautiful of all mortals — chose Aphrodite, representing sexual love, in preference to marital fidelity and the power of intelligence as represented by the other two. At the end of the 15th century, when he depicted Venus at the centre of a large painting for the first time, Botticelli endeavoured if not actually to desexualize her body, then at least to combine her desirability with an impression of purity. In short, he grafted a 'celestial' (or idealized) Venus onto an 'earthly' (or natural) Venus.

Her narrow shoulders

Unlike Classical statues, whose shoulders form a horizontal, Venus's upper torso is constructed as a triangle with its apex at the top. As a result the viewer's eye moves from her head towards her arms (particularly her left arm, which brushes against her hip) following an unbroken line identical to the lines that convey the movement of her hair.

The whiteness of her skin

Venus's skin is the colour of ivory: a white lightly tinged with yellow, with hints of pink here and there. The immaculate perfection of her body evokes not flesh, but the surface of a statue. The figure we are shown bears no resemblance to a living organism, and its firmness and clearly delineated contours (which gentle shading does not succeed in softening) do nothing to suggest warm and supple flesh.

Her jutting hip

All Venus's weight rests on her left leg; her right foot is held back and raised slightly. This pose inspired by Classical, and more precisely Greek, statuary is known as *contrapposto*.

Unlike her Classical antecedents, however, Botticelli's Venus lacks balance: all her weight has been transferred to one side (the viewer's right) instead of being distributed equally on either side of her body's axis.

The effect of this is to make Venus appear extraordinarily light; indeed she 'floats' above both the water and the shell. Her body forms a curve around an imaginary vertical line that could be drawn upwards from the heel of her one foot that rests 'on the ground', and this curve gives the painting its harmonious rhythm.

Her hair

As an extremely erotic and attractive part of the female body — the only female hair visible outside the more intimate areas — Venus's head of hair unfurls in long arabesques that brush lightly against her body like a passionate caress. The movement of its strands illustrates Alberti's recommendations in *On Painting*: 'I want [...] hair [...] that winds and waves as if it were going to tie itself up in a knot, that flutters in the air like flames, that occasionally slips like snakes beneath other strands, or billows up on one side then the other.'

Her face

Very young-looking, with a closed mouth and pale eyes, Venus's face is similar to the faces of the Virgins that Botticelli painted. Her expression is one of gentle melancholy, an emotion never encountered in female Classical statuary. The delicacy of her features suggests a moral goodness that purifies and in some way Christianizes this pagan goddess.

Her pose

Venus's pose takes its inspiration from a type of Classical statue known as the Venus Pudica ('Venus of Modesty'): one of her hands rests on her bust, the other on the genital area. In reality, these hands hide nothing: one breast remains fully visible, and her long hair, held 'modestly' between her legs, evokes the idea (all the more sensual as its depiction was forbidden at the time) of pubic hair.

spirit of Giotto's depiction of the gesticulations of the Franciscans at the deathbed of St Francis (see p.131). At the end of the 15th century, Leonardo da Vinci devoted a whole notebook to a consideration of human movement: the Codex Huygens. While the original manuscript of this has been lost, texts and drawings from it, with commentary by one of his followers, have been preserved (New York, The Pierpoint Morgan Library).

The question of equilibrium

This new interest in movement forced painters to resolve questions relating to the equilibrium of the body and the coherence of its parts. This applied to the body both when moving and at rest, and also to the foreshortening of the whole anatomy and individual parts of it.

In *On Painting*, Alberti attaches great importance to the problem of equilibrium. He was particularly interested in counterbalancing: 'I have observed that in every position, the whole of the human body is subordinate to the head, which is the heaviest limb of all. If one positions a body so that all its weight rests on one foot, this foot, like the base of a column, will always be positioned perpendicularly below the head, and the face of the person holding this position will almost always be pointing in the same direction as the foot.' This definition of the correct *contrapposto* position, which proves Botticelli wrong (see p.137), was to be understood and reproduced by the large number of artists who read Alberti's book as well as by further generations of painters who copied the works that his principles inspired. His observations concerning the weight of the head and its position relative to the supporting foot can also be found in Leonardo da Vinci's notebook (Codex Huygens). In ADAM AND EVE, painted at the beginning of the 16th century, the Flemish painter Jan Gossaert, known as Jan Mabuse, depicts the first man and woman in a

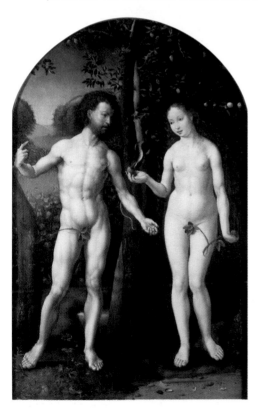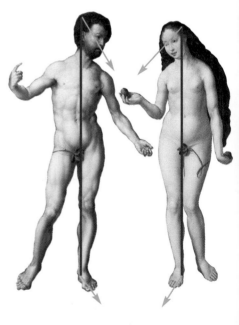

Jan Gossaert, known as **Mabuse**, *Adam and Eve*, 1532, oil on wood, 56 x 37cm, Madrid, Fundación Thyssen-Bornemisza.

contrapposto position. In each case, a plumb line could be dropped from the neck to the heel of the foot supporting their weight, and as prescribed by Alberti, their faces point in the direction of this foot.

The use of foreshortening, violent movements and off-balance poses to increase drama

The ability to depict figures in stable standing positions allowed naked bodies to occupy a prominent position in paintings for the first time. Conversely, the portrayal of dramatic physical situations involving corpses and wounded and tortured bodies often required figures to be either lying on the ground or off-balance in some way.

As early as the 15th century, two painters, Paolo Uccello and Andrea Mantegna, understood the dramatic power of this form of portrayal and exploited it using the technique of foreshortening: the distorted representation of a motif — in this case the body — seen from an extreme perspective. Mantegna's *Dead Christ* (see p.116), for example, is viewed

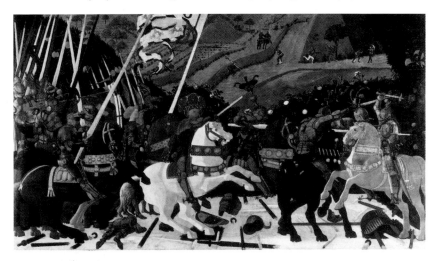

Paolo Uccello, *The Battle of San Romano* (whole and detail), c.1450, tempera on wood, 182 x 320cm, London, National Gallery.

from a position by his feet, which, being closer to the viewer, appear very large compared to the size of his head. The corpse encased in armour in the London version of Uccello's THE BATTLE OF SAN ROMANO lies on the ground in a similar position, this time on its front rather than its back.

In the 16th century, the Venetian painter Jacopo Robusti, known as Tintoretto, also made systematic use of foreshortening, but in particular he increased the number of bodies in unstable positions in each painting. In THE MASSACRE OF THE INNOCENTS, the figures are arranged in groups at different levels of depth. With the exception of the corpses, none of the figures is shown immobile. In the foreground on the right, a soldier holding a young child by the feet has his right arm raised, his chest turned in one direction and his head facing the other. He is taking a large stride and half rests his foot on a body that has

The human figure

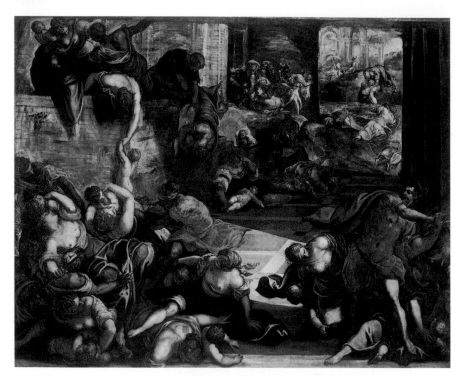

Tintoretto (Jacopo Robusti), *The Massacre of the Innocents*, 1582–7, oil on canvas, 422 x 546cm, Venice, Scuola Grande di San Rocco.

collapsed to the ground. This position, not one that can be held for any length of time, captures a precise instant within a larger movement and is accentuated by the billowing of his cape behind him. All the other participants in the scene, mothers, executioners and newborn babies, have been painted in the same dynamic manner. The bodies lying on the ground have been rendered using foreshortening and figures are shown upside down (for example, mothers bending over the wall to catch hold of or embrace their babies). These positions are precarious and temporary: women and men struggle, topple over, pick themselves up and crawl along the floor.

Whether they feature abduction (*The Stealing of the Dead Body of St Mark*, Venice, Galleria dell'Accademia), torture (*St Mark Freeing a Slave*, same location), the *Crucifixion* (main canvas in the Scuola Grande di San Rocco cycle, Venice) or even scenes of a essentially less tragic character, most of Tintoretto's other paintings depict gestures that are just as extreme, as well as foreshortened figures.

Inevitably, the extremely vivid dramatic effects Tintoretto obtained with these methods had an impact on other artists. It is hard to see how a canvas as impressive as Peter Paul Rubens's *The Erection of the Cross* (Antwerp Cathedral), dating from the beginning of the 17th century (in which the body of Christ extends diagonally across the centre of the composition as workers brace themselves to take the weight of the crucifix) could have been conceived if the Flemish painter had not visited the Scuola Grande di San Rocco and seen Tintoretto's paintings during his stay in Italy (1600–9).

It is equally difficult to imagine Caravaggio's Roman cycles without Tintoretto's earlier experimentation. In San Luigi dei Francesi, where the story of St Matthew is told in three paintings, Caravaggio features numerous 'action shots' (Matthew recoiling and pointing to himself in surprise when Jesus summons him in *The Calling of St Matthew*), precarious poses (the Evangelist resting one knee on a stool that topples over in *St Matthew and the Angel*) and bodies fleeing or shown (foreshortened) throwing themselves onto the ground to avoid danger (*The Martyrdom of St Matthew*). In Santa Maria del Popolo the two canvases dedicated to the lives of St Peter and St Paul each depict a scene involving falling

or being tipped over. *The Conversion of St Paul* (see p.203) shows Saul, as the saint was called before he became a Christian, temporarily blinded by the divine light. Thrown by his horse, he has fallen to the ground and his foreshortened body in the foreground forms a diagonal compositional element.

In *THE CRUCIFIXION OF ST PETER*, we are shown the body of the founder of the Church upside down and slightly foreshortened. He raises his upper body in a painful effort that can last no longer than the workmen's similarly painful and short-lived efforts as they push, heave and hoist the cross up.

It could even be claimed that it was not just Rubens's art and Caravaggio's art that were born out of Tintoretto's vehement style, but the whole of Baroque painting, with its battalions of angels flying through the heavens, its often paroxysmal gestural language and the habitual off-balance poses of its figures.

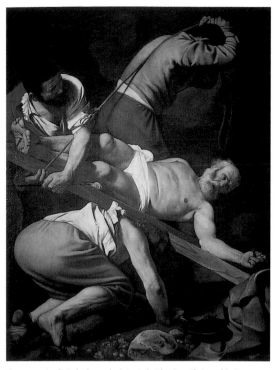

Caravaggio (Michelangelo Merisi), *The Crucifixion of St Peter*, 1601, oil on canvas, 230 x 175cm, Rome, Cerasi Chapel (left side wall), Santa Maria del Popolo.

Artistic licence: variety and gratuitousness of movement

In addition to serving a dramatic purpose, the representation of bodies in unusual positions allowed painters to surprise their public and show off their virtuosity. Ultimately, the use of extreme gestural language can bore the viewer as much as the absence of movement, a risk of which many theoreticians and painters have been aware. Artists therefore varied the movements in their pictures by subjecting them to the overall design of 'variety', another aspect of painting formalized by Leon Battista Alberti. In *On Painting* he distinguishes 'seven directions' of movement that he claims should be present in a work: 'towards the top or bottom, towards the right or left, moving away from us or returning towards us' and 'turning in a circle'.

Other artists, in particular the Venetian Paolo Caliari, known as Veronese, sought to create grand spectacles resembling theatrical productions by painting dozens of characters all performing gestures that tell a story in miniature. His *Banquets*, executed during the years 1560-70 (immense canvases designed to decorate convent refectories, and which have titles such as *The Last Supper*, *Wedding Feast at Cana*, *The Feast in the House of Levi* and *The Feast in the House of Simon*) provided the perfect opportunity for the inclusion of 'details for general admiration' (to quote a contemporary chronicler). These paintings were mime shows designed to be easily interpreted by the viewer.

Thus in *THE FEAST IN THE HOUSE OF LEVI*, originally named *The Last Supper*, nearly 50 figures occupy a large architectural structure in the form of a loggia served by two staircases. On the right-hand flight of stairs, a servant dressed in the manner of a German halberdier raises to his lips a glass he has just cleared away: it is clear that he is finishing off the remaining wine. On the left-hand staircase another servant leans on the balustrade hold-

Veronese (Paolo Caliari),
The Feast in the House of Levi,
(details). See p. 76.

ing a handkerchief: he has a nosebleed.

Of course, none of these gestures is mentioned in the Gospels, and none of them is necessary to our understanding of the scene. Obliged to account for his actions before the Tribunal of the Holy Office, otherwise known as the Inquisition, Veronese defended himself by offering the justification: 'We painters take the same licence as poets and madmen.' The offending characters, he affirmed, were 'ornaments' and 'invented figures'; by painting them, he had not wanted to 'do wrong', but had simply filled the space using his 'imagination'.

The Mannerist interpretation of the figure: style versus imitation

This 'imagination' claimed as his right by Veronese is a quality that was in a sense characteristic of painters during the second half of the 16th century. While artists of other ages took a back seat to the model they were imitating (in other words nature) or confined their ambitions to respecting the stylistic conventions of the day (be they Gothic, Classical, Baroque or whatever) painters between the approximate dates of 1520 and 1600 asserted the right of each and every painter to his own *maniera*, in other words an individual style that allowed his personality to show through in each of his works.

It is probable that the heightened self-awareness typical of the humanist philosophy of the 15th and 16th centuries favoured this tendency of painters to promote their ego. The battle being fought at the time over the dignity of the painter and the idea emerging at the time that the artist was a unique individual, a 'genius' that common mortals could not hope to understand, were without doubt contributory factors in this development.

Whatever the reason, the blossoming of individual styles — or more accurately the deliberate exaggeration of the characteristics that identified different ways of painting — found a perfect outlet for expression in the treatment of the body.

It is impossible to list here all the different solutions found by painters during this period to depict the body in their own individual way; there were as many solutions as there were artists. Suffice it to say that critics, both ancient and modern, have all used terms of astonishment and often disapproval to describe the figures painted by these artists. 'Eccentric, caricatural, angry' are adjectives that have been used for the characters painted by Rosso Fiorentino; 'strange' and 'over-ornate' for those of Pontormo (the second of these from Vasari); 'experimental' to describe the work of the Venetian painter Lorenzo Lotto; 'bizarre' (a term used by Luigi Lanzi in the 18th century) and 'sophisticated and urbane' with reference to the work of Bronzino.

Without examining in detail the human figures in question, it is nevertheless possible to make a number of observations. In their grace and sophistication, or in their violence and severity (the last two being characteristics of Rosso Fiorentino's human forms), Mannerist

142

figures possess a number of common characteristics. Anatomical distortion is common, and the positions adopted by the figures – determined by considerations of overall harmony rather than by any attempt to actually imitate the body – are often impossible in real life.

In Bronzino's AN ALLEGORY WITH VENUS AND CUPID, for example, the white naked body of the goddess and that of the young Cupid, or Eros, are arranged according to an artificial schema. Undulating lines extend from Venus's delicately raised index finger down to her other hand, which holds the golden apple, and from Cupid's face to the toes of his right foot following the small of his back and the counter-curves of his thigh and bent leg.

This melodious line, which might be called 'serpentine' (*linea serpeggiante*), is found not only in Bronzino's work, but also in that of other artists: for example, Parmigianino's *The Vision of St Jerome* (see p.99) and THE MADONNA WITH THE LONG NECK. Undulating and twisting to various degrees, the serpentine line was supposed to give figures an effective and elegant dynamism, causing their bodies to resemble 'the shape of the flame of the fire' (in the words of the 16th-century Venetian theoretician Giovanni Paolo Lomazzo).

In Parmigianino's THE MADONNA WITH THE LONG NECK, the singularity of his style is not just represented by the long line that meanders from the Virgin's head to the extremity of her delicate foot, passing along her arm and the body of the sleeping Infant Jesus. Other elements also give the image an unreal appearance

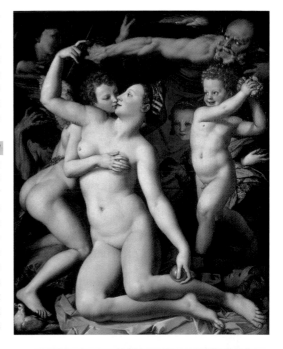

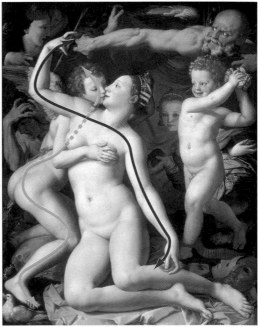

Bronzino (Agnolo di Cosimo), *An Allegory with Venus and Cupid*, 1540–5, oil on wood, 146 X 116cm, London, National Gallery.

that is both fascinating and disquieting: the obvious disproportion in the Madonna's neck from which the panel takes its name; the elongation of her hand and fingers and the torso of the Infant; and the undulations in the fabric, which has swollen out into heavy folds in the cloak and creased up across her stomach as if it had become electrically charged as a result of rubbing against her body.

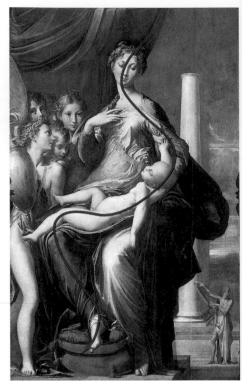

Parmigianino (Francesco Mazzola), *The Madonna with the Long Neck*, 1535–40, oil on wood, 214 x 133cm, Florence, Palazzo Pitti.

THE CLASSICAL PERIOD: PAINTING THE MOVEMENTS OF THE SOUL

Except perhaps in Baroque art, the virtuoso experiments into the representation of the body by artists during the cinquecento gave way in the 17th century to more reasoned and restrained poses. The aim of such poses was no longer to astonish the viewer visually, but to reveal to the viewer's mind the emotions of the characters in the paintings.

Proto-history of the representation of the emotions

Ever since the end of the Middle Ages, gesture has been considered by painters to be a means of expressing states of mind. Alberti put it as follows: 'The viewer will be affected by the story when the human figures depicted in it express the movement of their souls in a highly visible way [...] But these movements of the soul are revealed through the movements of the body'. Leonardo da Vinci went further: 'The good painter must depict two things: the individual and his mind [...] This has to be achieved through gesture and movement of the limbs.'

Gestures then — few in number, but with very clear meanings — are aimed at conveying particular states of mind. In the 1300s the manifestation of grief, in particular, gave rise to codified forms of expression of this kind: the bereaved clasped their hands (Giotto, *The Verification of the Stigmata*), pulled their hair out, rent their garments and tore at their chests. Remarkably, the last of these actions is still being performed by the old woman at the centre of Jacques Louis David's *THE INTERVENTION OF THE SABINE WOMEN* 400 years later.

During the following century, this repertoire of gestures was enlarged. Borrowed from the gestural language of silentiary monks and also from that used by merchants for counting, finger movements came into use to emphasize points being made by speakers in scenes of discussion.

Most importantly, the first theoretical statements on the subject transformed simple gestures understood instinctively by the public into symbols obeying fixed rules that needed to be learned. In this regard, there were significant differences between the beginning and the end of the 15th century. While Alberti confined him self to detailing the different types of behaviour and recommending that they be faithfully rendered ('The movements of old men should be slow and their demeanour weary, they should support themselves not merely with their legs but lean on things with their hands too'), Leonardo da Vinci set out precise, codified instructions: 'Give the person in despair a knife and show him rending his garments with his hands, one hand tearing at his wound. Paint him standing up with legs slightly bent, his body stooping towards the ground and his hair thin and dishevelled.'

Jacques Louis David, old woman rending her clothes, detail from *The Intervention of the Sabine Women* (see p.26).

Painting, the 'passions' and parallels in other branches of the arts

During the Classical period, to paint what were henceforth known as the 'passions' became an important challenge. For the artist this was a means of competing with the poet, replacing words or speech with gesture. The representation of the emotions took place within the framework of the *ut pictura poesis* debate, which went back to the Roman writer Horace. This compared painting and poetry and examined the pretensions of the first to be the equal of the second (*ut pictura poesis* literally means 'as painting, so poetry', in other words, 'poetry is like a painting' — or, as tendentiously interpreted by Classical minds, 'a painting is like a poem').

Modern painters had everything to gain in this debate. During an age in which they were claiming 'liberal status' for their art, in other words the status of an intellectual activity, it was very much to their advantage for paintings to be compared with poetry. Furthermore, artists did not merely claim to be the equal of writers. Certain theoreticians asserted the superiority of their art, stating that that which is seen is more effective at arousing emotion than that which is described.

Another comparison exercised the minds of artists and art lovers and influenced artists' work during the Classical age: the *paragone* (Italian for 'comparison', the term used to describe academic debates of this kind about the relative merits of different artistic disciplines) between sculpture and painting. This debate originated in the 15th century, reaching its peak in the middle of the 16th. Discussion of the two disciplines' relative merits always advanced the same arguments.

Those defending sculpture argued that it was the only art truly capable of creating a real illusion of the body, as it showed figures in three dimensions. Painters responded from time to time by organizing their figures so that they could be seen simultaneously from a number of different angles. They invented the motif of a mirror that shows the hidden part of the sitter's anatomy (as in Velázquez's *The Toilet of Venus*, better known as *The Rokeby Venus*, London, National Gallery) or they depicted from the front, in profile and from the back figures so similar that they could be considered different views of a single model (as in Antonio Pollaiuolo's *Battle of the Nudes*, see p.157, or Rubens's *Three Graces* in the Prado in Madrid). Painters also advanced the arguments that sculpture was a dirty business requiring considerable physical strength (in other words it made demands of the body

but neglected the mind) and that they, the painters, had the advantage of being able to place the figures they depicted in settings that imitated nature.

Charles Le Brun and the painting of the passions

The idea that the body can express the state of a person's soul, and reveal not just passing emotions but character, reflected the success of a practice that flourished throughout Europe from the 13th century until the Enlightenment: physiognomy. In Italy at the end of the 16th century, the most famous figure in this 'magical' rather than scientific discipline was the Neapolitan Giovanni Battista della Porta. In 1586 he published his *Physiognomia Humana* in Latin, and this was translated into many vernacular languages in the 17th century. Illustrated with engravings, the work attempted to compare human and animal faces and discover what tendencies of character might be deduced from any similarities.

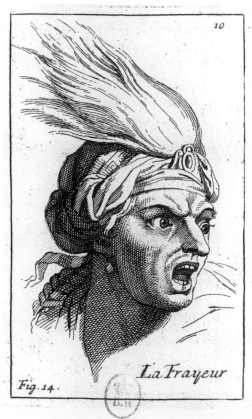

After **Charles Le Brun**, *Fright*, 1727, engraving, Paris, Cabinet des Dessins, Musée du Louvre.

Speculations of this kind were all the rage in 17th-century France. At a time when René Descartes was writing *Passions of the Soul* (1649) and Jean de La Bruyère was writing his *Characters* (1688), when royal absolutism was seeking to institute a form of control over society which was also a control over people's minds, nothing seemed more urgent than to know how to interpret the bearing, body and face of an individual in such a way as to reveal their character. In the spring and autumn of 1668, CHARLES LE BRUN, official painter to the king and director of the recently established Académie Royale de Peinture et de Sculpture, gave two lectures to the Academy on the subject. The first examined how the appearance of a face changed as the emotions changed (described as the 'passions', in keeping with Cartesian vocabulary), and the second, more obviously inspired by Della Porta, established a parallel between the characters of animals and those of humans on the basis of possible facial resemblances.

From the passions to pathology

The idea of the expression of the passions through gesture and facial movement survived well beyond the 17th century. During the 18th century, the Age of Enlightenment, dreams were entertained of a union between man and nature. Even before Rousseau's *Discourse on the Origins of Inequality* and Bernadin de Saint-Pierre's *Études de la Nature* (*Studies of Nature*), the notion of an almost pantheistic utopia of human happiness in harmony with the world gave rise to the paintings of Antoine Watteau and later those of Jean Honoré Fragonard, in which slender figures whose faces and gestures can barely be made out bear witness to the happiness of living in 'natural' gardens that also happen to be beautifully landscaped (see p.76). The Age of Enlightenment was also that of psychological analysis,

POUSSIN: GESTURES OF EMOTION IN THE 17TH CENTURY

Although, like all well-read individuals of his day in Italy, he was probably familiar with the writings of Giovanni Battista della Porta, Poussin never made use in his work of the analogies between humans and animals that Le Brun later took up in his theories. Poussin's paintings — which, in the proper fashion for conveying historical narrative, used figures expressing their emotions through gesture — did also provide support for the arguments of those in late 17th-century France who sought to defend a type of art that used gesticulation freely in order to move the viewer. His canvas entitled *The Israelites Gathering Manna in the Desert* is one such example.

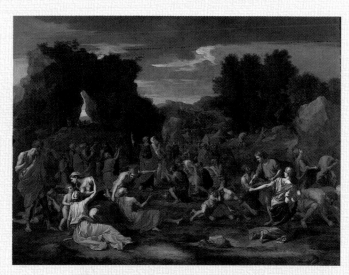

In 1667, this painting by Poussin was the basis of a lecture given by Le Brun to the Academy. Le Brun emphasized the importance of a young woman on the left (in blue), who gives her breast to her aged mother instead of to her hungry child. He judged the heroic generosity of this woman to be remarkable, and, from a formal point of view, he considered the treatment of the man in red, who observes the scene with stunned respect, to be even more extraordinary: 'This man is a fine representation of a person filled with astonishment and admiration. We see that his arms are drawn back and placed by his sides; it is usual during moments of great surprise for all the limbs to be pulled back into themselves [...]. We also observe that, unable to conceive of anything but admiration for such a dignified sight, he opens his eyes as wide as he can in the belief that by looking more intently he will be better able to understand the enormity of this action. Thus he employs the full power of his senses in order to better see what he could not hold in higher esteem.'

'The same is not true of the other parts of his body, which, abandoned by the senses, remain motionless: his mouth is closed as if through fear that he might give away something of what he is thinking and because he cannot find adequate words to express the beauty of the act before him. And as at this moment he is holding his breath, his stomach area is raised higher than it would normally be, as can be observed from various exposed muscles. This man even seems to step back a little: not only in order to show the surprise this unforeseen encounter has caused him, but also to show his respect for the virtuous woman giving her breast.'

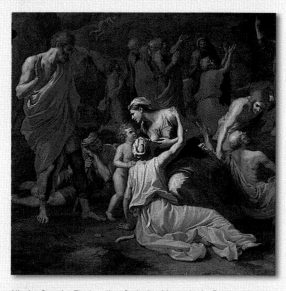

Nicolas Poussin, *The Israelites Gathering Manna in the Desert*, c.1637–9, whole and detail, oil on canvas, 149 x 200cm, Paris, Musée du Louvre.

however, as demonstrated by the comedies of Marivaux. In 1719, in his *Réflexions sur la Poésie et la Peinture* ('Reflections on Poetry and Painting'), the theoretician Charles Du Bos attempted to draw a parallel between the movements of painted figures and mime shows.

In the middle of the 18th century, the Comte de Caylus, a great art lover, inaugurated an 'expressive head competition' at the Académie designed to encourage young painters to study the means of representing the passions, and in his Salons dating from the same peri-

Diagram showing the three expressive faces as described by Charles Blanc.

od (1759 to 1781), Denis Diderot praises Jean-Baptiste Greuze's genre scenes, which use the rhetoric of gesture inherited from Poussin but with added exaggerated pathos (see p.51).

A century later, these 'grimaces' (David) and gestures designed to express emotion can be seen in the work of David and Jean Auguste Dominique Ingres; and in his *Grammar of the Art of Drawing* of 1867, CHARLES BLANC — combining the theory of the symbolic direction of lines (see p.70) with the theory of physiognomical expression — drew three facial 'types', adding the observation that 'the human face has three different appearances' depending on whether the 'double organs' (the eyes, the nostrils and the corners of the mouth) are 'horizontal', 'expansive' (extremities pointing upwards) or 'converging' (extremities pointing downwards). 'The image in the middle, whose lines are horizontal, expresses calm; the image on the left, which has expansive lines, expresses a mood of cheerfulness; and that on the right, whose lines are converging, displays a feeling of sadness.'

However, in a century in which Darwin invented the concept of evolution and which witnessed the development of disciplines dedicated to the study of deviant behaviour (criminology, psychoanalysis, the study of mental illness), painters with a superficial knowledge of these new ideas liked to think of themselves as observers of the physical manifestations of the perceived states of mind with which these disciplines concerned themselves — wickedness, brutishness and insanity.

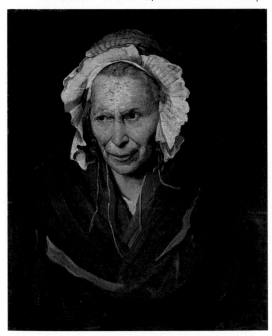

Théodore Géricault, *The Madwoman*, 1822–8, oil on canvas, 72 x 58cm, Lyons, Musée des Beaux-Arts.

THÉODORE GÉRICAULT's *Monomanes* series (1821–4) — painted, it is said, using models who were patients in an asylum directed by the famous mental-illness specialist Dr Jean-Étienne Esquirol — is a collection of studies of the insane that demonstrates this new interest in extreme forms of human behaviour. Twenty years later, Gustave Courbet depicted himself with deranged features and an abnormally intent stare in his self-portrait *The Desperate Man* (1844–5), the model for which he may have found among a collection of contemporary photographs of hysterics (Oslo, Nasjonalgalleriet). Subsequently, in 1865, he painted *The Sleepwalker* (also known as *The Clairvoyant*, Besançon, Musée des Beaux-Arts): the head of a

woman leaning forward slightly, with a prominent forehead and eyes lost in a hypnotic trance.

The interest shown by Edgar Degas in dancers (in both his painting and sculpture) also has a basis that might in his case be called anthropological rather than purely medical. So light when in motion, these girls adopt exhausted poses as soon as they stop dancing. Degas's pencil then lingers on their coarse features: their projecting chins and receding foreheads, so the artist believed, were signs of the degeneracy of the lower social classes whose intelligence had been stifled by generations of poverty and alcoholism. Even more so than in his paintings and pastels, this approach was given concrete expression in his sculpture *Little Dancer Aged Fourteen* (Paris, Musée d'Orsay), which was first exhibited in 1881 in the company of two pastels depicting *Criminal Physiognomies*.

THE CODIFICATION OF BEAUTY

At the same time as establishing the basis for a coherent representation of the body capable of expressing emotion, the painters of the late Middle Ages and the Renaissance also laid down the principles for an idealized form of beauty that existed only in paintings.

Beauty, a constructed ideal

Beauty as a concept has its roots in the philosophy of Plato. For Plato, and for the humanists who rediscovered his thinking in the 15th century, there was no point in seeking beauty in nature. Perfection was an idea, or ideal, that the mind alone was capable of creating.

By claiming that the body had been subject to a long decline ever since the expulsion from the Garden of Eden, Christian theology allowed the idealistic notion of beauty to influence anatomical judgements. Adam — created directly by God in his own image and less guilty of original sin than Eve — and his sons may still be regarded as beautiful. Eve, on the other hand, along with all women descended from her, is necessarily imperfect, as authors from the Middle Ages to the modern era insisted again and again. Thus Cennino Cennini, discussing the dimensions of a man's body, adds: 'As for those of woman, I shall not speak of them, for she has no measurement that is perfect.' And Rubens, in his *Theory of the Human Figure* from around 1600, wrote: 'In terms of the perfection of forms, woman comes second to man, being subject to predestination to a greater extent than he is.'

During the Renaissance, the widespread reading of Classical authors also contributed to the idea that no perfectly beautiful woman could exist on earth. The story of Pygmalion, the sculptor who falls in love with his statue, and that of the painter Apelles, who summoned the most beautiful young girls in Croton so that he could copy parts of their bodies to serve as parts of a model for his composite Venus, showed that no man or artist would be able to find among mortals a woman beautiful enough for him to adore or to serve as his sole model.

Finally, between the 16th and 18th centuries, the revival of archaeology, which uncovered an increasing number of Classical statues with perfect anatomies, transformed negative judgements on the body into commonplaces. Rubens, again in his *Theory of the Human Figure*, and later the scholar Johann Joachim Winckelmann in his *Reflections on the Imitation of Greek Works in Painting and Sculpture* (1755) both asserted that antique and especially Ancient Greek bodies had been more beautiful than modern bodies — on the one hand because they were closer to the origins of humanity (then considered the golden age of mankind), and on the other hand because the ancients lived their lives naked, or nearly naked, with nothing to constrain or distort their figures, and were able to develop well-balanced muscular bodies by taking regular exercise as the Spartans did. This being the case, it is hardly surprising that for a long time painters were reluctant to depict a particular individual when creating a figure of exemplary beauty. Rather than resorting to a 'model' — a man or woman who would pose for them in their studio — they took their inspiration from Classical statuary or placed their trust in their own imagination.

The human figure

The canon of proportions

For painters from the 15th century onwards, the ideal of physical beauty depended first of all on adhering to a set of proportions that was supposed to guarantee the 'symmetry' (in its ancient sense of 'harmony') of the figure. Perfect proportional relationships had to exist between the size of the head and the total height of the figure, its breadth and the different parts of the body. During the Middle Ages and the Renaissance, 'canons' were circulated: these were sets of rules laying down the ideal proportional relationships. The study of the human figure and in particular that of the nude depends on a knowledge of these canons and on comparing them with the measurements that painters of different eras have used.

At the end of the Middle Ages, painters used proportions that were sometimes set down in writing, both in the Byzantine world (in the Painter's *Manual of Mount Athos*, a later text that summarizes older practices) and in the West (Cennino Cennini's *The Craftsman's Handbook*). The canons dating from this time were not based on the observation of real bodies, but devised along moral lines according to a religious mentality.

The seat of spiritual expression, the face — the part of the head extending from the chin to the hairline — served as a means of calibration for the rest of the body. But the face was itself divided into three equal sections (the forehead, the nose and the area between the nose and the chin), which served as secondary units for specifying the dimensions of the body. It is easy to see the influence of Christian symbolism (the Holy Trinity) in this triple division. The full height of a harmonious male body, according to Cennini, should be eight times the length of the face plus two of its subsidiary units — thus eight faces plus twice the height of the forehead, the nose or the bottom part of the face. The width of such a body, from the tips of the fingers of one hand to the tips of the fingers of the other, with the arms extended, should be equal to its height.

These recommended measurements relating to the different parts of the body varied from century to century and could differ slightly from one workshop to another during the same period. However, they did not go unheeded, and many examples of the proportional relationships described by Cennini can be found in paintings dating from his time.

The head of St Francis in THE VERIFICATION OF THE STIGMATA is one such example; this is hardly surprising as Cennini had been taught by a disciple of Giotto. From the top of the cranium covered by the cowl to the chin, it is divided into four parts: from the top of the head to the tonsured hairline, from the hair to the top of the bridge of the nose, the nose itself, and finally the space between the bottom of the nostrils and the tip of the chin.

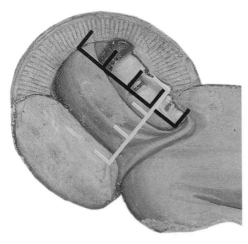

The proportions according to which the head of St Francis is constructed, detail from *The Verification of the Stigmata* by **Giotto** (see p.131).

We can take our checking of Cennini's recommended measurements even further. In his *Craftsman's Handbook* he advises that the distance 'from the edge of the nose to the far corner of the eye' is equal to 'one of these measures'. This is indeed the distance used by Giotto in his head of St Francis, and this measurement in turn is a third of the width of the whole profile, making a small allowance for the sinking of the saint's head into the pillow.

From the middle of the 15th century, the medieval model of proportions started to be replaced by an equally idealized system of measurements inspired by the Roman architect Vitruvius, the 1st-century BC author of *Ten Books on Architecture* (*De Architectura*), a text that was at the time being redis-

covered and eagerly read.

Comparing a beautiful man (*homo bene figuratus*) to a beautiful building, Vitruvius proposed a canon of proportions slightly different to the one used during the Middle Ages. In this the total height of the body is eight times the head measurement (face plus cranium) or ten times the face (from the hairline to the chin), which is divided (as in the Middle Ages) into three equal parts and is the same size as the hand 'from the wrist joint to the tip of the middle finger'. The navel ('umbilicus') is the centre of this body, which is contained within simple geometric shapes much admired

Leonardo da Vinci, *Vitruvian Man*, 1490, pen and ink on paper, 34.4 x 24.5cm, Venice, Galleria dell'Accademia.

by the mathematicians of the ancient world: the circle and the square. Vitruvius in fact claims that if a man extends his arms and his legs, a circle drawn with its centre at his navel 'will meet his fingers and toes'. Similarly, he continues, 'it will be seen that as in a square drawn with a set square, his width will equal his height'.

The system of proportions defined by the Roman architect is illustrated in a very famous drawing by *LEONARDO DA VINCI* accompanying a text (written from right to left as was his custom) in which he ponders its lessons. This drawing shows a single masculine figure in two positions: one with its arms extended horizontally, forming a cross that fits neatly into a square, and another in which arms and legs are spread symmetrically so that their extremities describe a circle.

Masculine beauty: grace or strength?

The Vitruvian man drawn by Leonardo da Vinci is in his prime. He could be thirty years old or a little older — the age of Christ at the time of the Passion, or that of the resurrected souls at the Last Judgement. In paintings, however, the age of *homo bene figuratus* varies considerably.

At the end of the 15th century and during the first few years of the 16th century — the era of Botticelli, Perugino, Giovanni Bellini, Dürer in Germany, Raphael and the Michelangelo of the Sistine Chapel — the body type that predominated was that of an extremely young, often slender male, rather than a mature man. Some decades later, the beautiful male physique was considered to be that of an older, mature, more solidly built man with much better-developed muscles. This change can be explained in part by archaeological discoveries that uncovered male statues with a different physique to that

FEMALE PROPORTIONS: AN EVOLVING HARMONY

Like those canons that were popular during the Middle Ages, the Vitruvian canon of beauty was based on the adult male. Albrecht Dürer was the only author to discuss women's and children's bodies, which he did in his *Vier Bücher von Menschlichen Proportionen* (*The Four Books on Human Proportions*), published in 1528. His aim was not, however, to propose a model of perfect beauty, but rather to examine the real proportions of the human body.

In actual fact, the canons relating to the female body have probably evolved to a greater extent over the centuries than those relating to the male physique. These changes have been determined by the evolution of sensuality — in other words, the pleasure obtained by male viewers from looking at a female figure.

Lucas Cranach the Elder, *Eve Tempted by the Serpent*, 1530, oil on wood, Chicago, The Art Institute.

Cranach's Eve is standing in an impossible position. Her legs, close together, are equally extended, yet her feet do not rest on the same spot. One leg is seen from the front while her torso and face are shown in three-quarter profile. Her navel is out of line with the central axis of her body (the vertical extending from her chin to the heel of her right leg).

Her figure is extremely elongated. Measured from the top of the cranium to the heel of the left leg, she is the equivalent of eight head-heights. She has a very expansive forehead: the fashion was for domed foreheads extending upwards, and women (and sometimes men) plucked the hair from around the edges of their face.

The impression of elongation is increased by the position of her feet and the narrowness of her torso, which has been constructed according to precise proportions: it extends over three head-lengths, the first from the chin to the right breast, the second from the right breast to the navel and the third from the navel to the lower pubis. The distance between her nipples is one head, as is the width of her very slender waist.

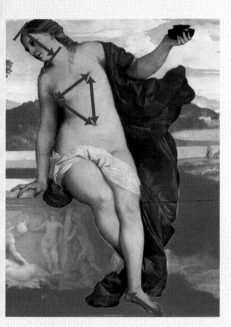

Titian, *Sacred Love*, detail from *Sacred and Profane Love*
(see p.XIV-XV, Introduction)

Parmigianino, *Madonna and Child*, detail from a prelim-
inary drawing for The Vision of St Jerome (see p.99).

Although representing a chaste love dedicated to God, one that spurns profane finery, the female figure sitting on the right of the canvas nonetheless possesses a voluptuous body. Her form was probably inspired by some long-forgotten antique statue. It has been observed that the crimson robe that breaks the line of the arm holding the lamp has been draped over the spot where one such statue had been broken. The retracted right leg, which gives the body an elegant *contrapposto*, is also modelled on Classical statuary.

Compared to Cranach's nude, this figure is much fuller and stockier (the foreshortening of the thighs prevents a precise evaluation of her height).

The length of the torso is less than three heads, which reinforces this impression of shorter overall proportions, but the rules of harmony are applied in those areas of the body where eroticism was allowed (it was out of the question at the time to show the female pudenda). An equilateral triangle can be traced with sides as long as the head that meet at the nipples and navel. The length of the head is the same as the length of the foot and the length of the uncovered part of the left arm, from the elbow to the wrist joint.

Although mathematics is likely to be far from our minds as we contemplate this 'flesh and blood' figure, it was very much in Titian's mind when he was planning the work.

Mary's head is extended vertically by the bun in her hair, but it is extremely narrow, and her tiny face is made even smaller by her downward glance towards the earth. Her head is contained within her body seven times and her face 14 times.

While her waist remains narrow, her hips and thighs flare out like the top of some large amphora, the width of each leg being equal to the height of her head.

The proportions of the body give a strong impression of fertility: Mary is literally a vase, the receptacle for the Incarnation, the Mother par excellence.

Far from being unusual, this method of presenting the body — showing little regard for the models provided by Classical statuary and based on an exaggeration of real physiology — is, as we have seen, one of the characteristics of Mannerist art.

The human figure

previously known in Classical sculpture.

The young male nudes painted by artists at the beginning of the Renaissance conformed to the ancient Greek type of sculpture known as the *kouros* (plural *kouroi*) which was copied by the Romans. These nudes had wide shoulders, narrow hips and triangular torsos with flat abdomens displaying a discreet grid of muscles — known colloquially today as a 'six-pack'. Their *contrapposto* poses give these figures a certain grace and even a rather androgynous softness. Examples of this type of figure include the sculpted nude set in a niche by Raphael in THE SCHOOL OF ATHENS, St Sebastian (although not totally naked) in Bellini's *San Giobbe Altarpiece* (see p.17), the far more athletic *ignudi* from the ceiling of the Sistine Chapel (see p.61), and, above all, Adam coming to life, his limbs still lethargic, in *The Creation of Adam* from the same cycle.

The older nudes that took over towards the middle of the 16th century were inspired by a different type of statue: statues such as the Belvedere Torso, the Farnese Hercules, and LAOCOON, which show male figures bursting with strength. These have extraordinarily powerful torsos, so broad they are nearly square, and thick limbs with sculpted ridges and hollows like those of bodybuilders.

In 1511, MICHELANGELO tried out a pictorial version of the statue of Laocoon, whose discovery he had witnessed only a few years earlier, on 14th January 1506. This painting was *The Punishment on Haman* on the ceiling of the Sistine Chapel. Although treated in foreshortened perspective, the tortured body of Haman, his arms and legs secured to a cross, recalls the posture of Laocoon, the priest of Troy strangled by serpents as he tried in vain to free himself. Just as muscular as the 1st-century BC statue, Haman's physique is that of a younger man, however — a sign of his youth is the fact that he is smooth-shaven rather than bearded. A quarter of a century later, in *The Last Judgement* (see p.67), the same powerful physique is given to obviously more mature men. Christ raising his arms to judge the damned at the centre of the fresco is the youngest male figure in the painting. The other male bodies could be aged anything up to sixty — Michelangelo's age

Raphael, *Apollo,* detail from *The School of Athens* (see p.83)

Laocoon (Laocoon and His Sons Strangled by Serpents), 1st century BC, ensemble sculpted in marble, Rome, Pinacoteca Vaticana.

when he painted the work, a coincidence that invites other interpretations.

The existence of two alternative male stereotypes — one full of grace and the other characterized by power — was interpreted by 16th-century art theoreticians, notably the Venetian critic Lodovico Dolce, as a consequence of opposing personalities. Associated with Raphael's art were 'moderate' or 'temperate' figures (Dolce) corresponding to the gentle young men; associated with Michelangelo's art were the 'fearsome manner' (*terribilatà*) and 'monstrous physiques' (Dolce again) often seen in foreshortened perspective.

Thus, a rift that would last a long time opened up between the kind of sensibility which appreciated moderation in all things, particularly the body, and that which wanted to stun the imagination with nudes of

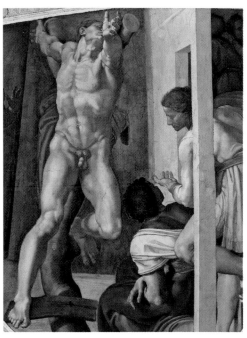

Michelangelo, *The Punishment of Haman* (detail), c. 1511, fresco, Rome, Vatican City, ceiling of the Sistine Chapel.

immense energy. With the start of the Mannerist age, a number of artists favoured the second solution, painting bodies with a musculature that was sometimes taken to excess (by Giulio Romano, for example, in his *The Fall of the Giants* in the Palazzo Te in Mantua). This group of artists also included the Flemish artists of the 17th century. The Farnese Hercules, for example, which Rubens drew on numerous occasions and describes several times in his *Theory of the Human Figure*, was his model of ideal manhood. French Classical painters of the 17th century — and in a wider sense artists painting in an academic style up to the end of the 19th century — preferred physiques showing a rather more discreet musculature and displaying a certain elegance and even insipidness. Examples of these are the Apollo with the large chest and heavy shoulders in Poussin's *The Inspiration of the Poet* (see p.74) and the short-legged men with shapely buttocks fighting one another in David's *The Intervention of the Sabine Women* (see p.26).

Revenge of the real: the sensual female

Corresponding to the slender young men of Classical art is a firm-fleshed female type who reveals herself, in the way she poses, to be a sturdy character with complete freedom of action.

In Poussin's paintings, the immobile women resemble architectural columns — for example, the tall figure of the Muse in *The Inspiration of the Poet* (Louvre, see p.74) and the shepherdess in the Paris version of *The Shepherds of Arcadia* (see p.71) — or, if younger, they dance in a restrained, poised manner, their nudity restricted to a glimpse of breast or leg (as in THE EMPIRE OF FLORA).

In the work of David too, female bodies are neither unrestrained nor languid, nor entirely unclothed. This can be seen in *The Intervention of the Sabine Women* (see p.26). Whereas the male heroes are nude, the women who have become the wives of the Romans are fully clothed. Their young, firm bodies perform vigorous movements that have nothing sensual about them. Their breasts are large only because they are mothers who are suckling their infants. Only one of the women reveals her breasts, and as she is kneeling above children close to a shield bearing the effigy of the Roman she-wolf, her semi-

THE CONTRIBUTION OF ANATOMY
TO THE REPRESENTATION OF THE MALE BODY

In the middle of the 16th century, Lodovico Dolce criticized Michelangelo for the 'similarity' of all his figures. This sin of uniformity was particularly serious in the context of an aesthetic which, ever since the time of Alberti, had stressed the importance of variety in painting. According to Dolce, this similarity originated in Michelangelo's habit of exposing the musculature of his figures regardless of their age, their gender and the circumstances in which they are portrayed.

What might be described as Michelangelo's mania for muscles can be partly explained by the great success enjoyed by the new science of anatomy.

As early as the 13th century, the authorities had begun to authorize human dissections, initially only rarely and in the south of Italy, but later throughout the whole of the peninsula and with greater and greater frequency. The rich complexity of the muscles hidden beneath the body's skin and fat came as a revelation and had an immediate effect on painting.

Cimabue, *Crucifix of Santa Croce*, c.1280?, tempera and gold leaf on wood, 433 x 390cm, Florence, Museo dell'Opera di Santa Croce (photograph taken before the flood of 1966).

Cimabue: the first anatomical approach

The anatomical definition in Cimabue's *Crucifix*, painted in around 1280, is remarkable. The body's extreme thinness allows us to see the collar-bones, sternum and ribs; the *rectus abdominis* muscles have been treated as volumes, as have the muscular insertions at the extremities of the ribs and along the abdominal arch. Cimabue's treatment of the lower limbs, in particular the knees, is also astonishing.

Pollaiuolo: triumph of the écorchés

During the 15th century, painters were encouraged by the theoretician Alberti and the sculptor Lorenzo Ghiberti to familiarize themselves with the human skeleton and the cut-away anatomical models known as 'écorchés'. In his *Battle of the Nudes*, Antonio Pollaiuolo has reproduced the play of muscles in movement in such minute detail that it is likely he depicted the muscles that he knew existed rather than those that he could actually see.

Michelangelo: painting and dissection

In the 16th century, artists picked up the dissecting knife themselves: Leonardo da Vinci first, then Michelangelo. Michelangelo's first biographer wrote that he became 'very skilled and experienced in this study', but that he had to give it up because a long series of dissections had ultimately 'turned his stomach'. The year 1543 saw the publication of a book of anatomy illustrated with magnificent engravings that had been drawn and printed in Titian's workshop: Vesalius' *On the Fabric of the Human Body* (*De Humani Corporis Fabrica*), which became the bible of most European artists. The excessively muscular male nudes produced by certain Mannerist painters and engravers would not have been possible without the opportunity to consult works like this. Such works were the precursors of the 'artists' anatomies' that became obligatory in art schools and academies right up to the 20th century.

Michelangelo, anatomical drawing.

Antonio Pollaiuolo, *Battle of the Nudes*, 1470, copper engraving, 41.8 x 61.1cm, Cleveland, The Cleveland Museum of Art.

The human figure

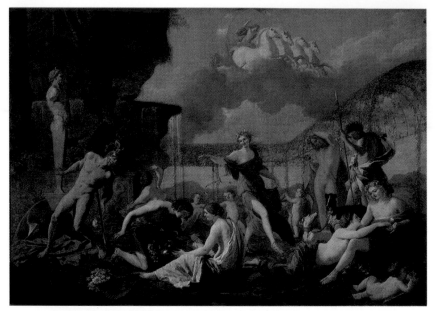

Nicolas Poussin, *The Empire of Flora*, 1631, oil on canvas, 131 x 181cm, Dresden, Staatliche Kunstsammlungen, Gemäldegalerie.

nudity takes on an allegorical character, making her the new wet nurse to the Romans.

The eroticization of the female statue

Although Michelangelo, a lover of men rather than women, may not have created a convincing example of feminine beauty (the Sybils in the Sistine Chapel were drawn from male models), a century later the Flemish artists (RUBENS and later Jacob Jordaens, both from Antwerp), while also creating powerful male bodies, painted women of a fleshiness never before seen in art.

An easy explanation for this would be that these particular painters had a predilection for body types that are no longer considered fashionable, or that this sort of sensuality was related to a social environment in which abundant white flesh was valued as a sign of the indolence associated with wives who stayed safely at home.

In reality, the reason for painting large women was essentially formal. While for a century and a half the idealized beauty of the female type had stifled sensuality, Rubens introduced the reality of the body into painting by depicting figures with large amounts of flesh (which is entirely visible, as he barely took the trouble to clothe them), thereby erasing the memory of marble statues and making any canon of proportions redundant.

In short, Rubens's women are not plump because the Flemish painter liked them like that, but because in the 17th century their outrageous obesity (relative to academic norms) was the only way painting could reclaim the world of reality and voluptuousness.

Making the body erotic: creating tactile sensations

The gestural language of Rubens's women is also very different from that depicted by artists of the Classical tradition. Where Poussin, for example, brought bodies close together while making sure they did not touch or at most only brushed against each other (even if they were the bodies of lovers), Rubens shows women rubbing and caressing their own flesh, allowing it to be touched by others or, if under duress, unable to prevent it being touched by others. The contrast between *The Empire of Flora* and *The Rape of the Daughters of Leucippus* is striking.

In Poussin's picture, which is an allegory inspired by Ovid on the origin of flowers, there is only restrained contact even between couples: Narcissus looks at himself in the water

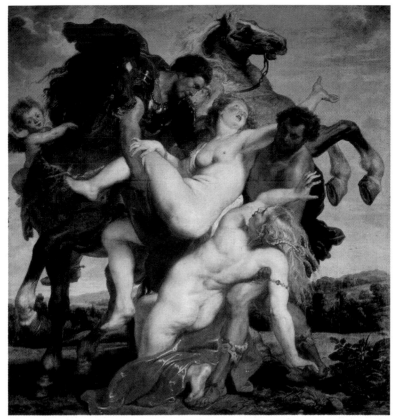

Peter Paul Rubens, *The Rape of the Daughters of Leucippus*, c.1616, oil on canvas, 222 x 209cm, Munich, Alte Pinakotek.

without touching his image or so much as caressing the nymph sitting next to him with the tip of his finger; Clytia (the sunflower or heliotrope behind Narcissus) turns towards Apollo, who is far away in his celestial chariot; in the foreground on the right, Crocus and Smilax (the personification of bindweed) are — theoretically at least — embracing, but her hand does not touch that of her lover as she gives him the flower, and Crocus' right hand rests on his own knee rather than on the shoulder of the one he loves.

In Rubens's canvas, by contrast, the abduction of the fiancées Phoebe and Hilaeira by the spurned lovers Castor and Pollux, the twin sons of Zeus, could literally be described as a grab raid. One of the women is seized under the armpit and forced back over a knee, and the other is lifted up by one of her legs, but the two beauties still manage to caress with their fingertips the arms of those clasping them or to pass an arm around the shoulder of whoever is supporting them. The compact mass formed by the group — the princesses, the twins abducting them, the horses — overlays the actual physical contact between the parties with visual or 'plastic contact', to borrow the term used by Maurice Brock about Titian. Hanging down in front of the hips of the man lifting her up, the blond hair of the princess at the bottom of the picture comes into direct contact, visually at least, with the man's tanned skin, while the white foot of Leucippus' other daughter, raised to the level of the horse's breast ornament, appears to rest on the horse's red coat. These encounters between different surfaces create quasi-tactile sensations of which the painter is aware and on which he plays. He wants the viewer (or 'observer', as Poussin preferred) to feel against his own skin the softness of the girls' hair and the hot flesh glistening with sweat, and to smell the stallions' bodies. These effects were another way of putting desire and pleasure back into painting.

The human figure

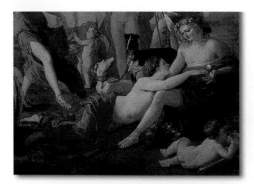

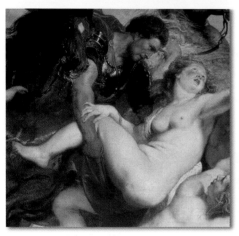

Nicolas Poussin, *The Empire of Flora* (detail: Crocus and Smilax), see p.158;
Peter Paul Rubens, *The Rape of the Daughters of Leucippus* (detail), see p.159.

Venustas **and** *morbidezza*: **the pleasures of flesh tints**

The excitement provoked by these far from innocent juxtapositions of surfaces depended above all on how they were painted. For Rubens — but also for Titian before him and for many painters after him — flesh was the texture best suited to arousing this emotion.

The desire to paint flesh effectively originated at the end of the 15th century with Leonardo da Vinci. The *sfumato* technique he used in the background of his landscapes to convey a sense of distance also served him as a means of shading off the contours of his figures to prevent their outlines cutting across each other too abruptly and making them look like statues.

Several decades later, an evaluation of the varying ability of artists to paint the softness of flesh gave rise to a new word in the critic's vocabulary: *venustas*. According to the Venetian critic Lodovico Dolce, *venustas* (meaning 'graceful beauty') was an 'indefinable quality' that provided 'infinite pleasure', capturing something of the 'tenderness and brightness' with which nature endows flesh. Dolce offers the example of a naked Venus that Titian painted from behind in *Venus and Adonis*. The viewer, presented with the small of the goddess's back and her buttocks, can make out the 'macatura of the flesh caused by the sitting position' — a reference to the hollows created by cellulite where chubby flesh has been compressed by an excessive weight.

The Mannerist painter Giorgio Vasari — who was also a historian and author of the indispensable *Lives of the Most Eminent Painters, Sculptors and Architects* (1550 and 1561) — used another word, *morbidezza*, to describe the ability to paint flesh in a manner so 'similar to nature' (*similissima al naturale*) that it was capable of arousing erotic feelings. *Morbidezza* refers to the particular quality of flesh tones that makes painted flesh seem soft and warm, in other words lifelike. Vasari's vocabulary associates *carnosità morbida* with a choice of colours in which pinks and whites predominate, with a 'combination' (*unione*) of tones or *sfumata maniera* (style based on *sfumato*) in which the different shades merge delicately into one another instead of being juxtaposed in stark effects of light and shade, and finally with a delicacy and general softness (*dolce*) that contrasts with the dryness (*secco*) or stiffness (*tagliente*) of a body based essentially on a drawing.

The 18th century: Boucher's pearly tones

Like Rubens and other Flemish painters during the 17th century, French painters during the 18th century also chose to celebrate the supple, diaphanous quality of flesh rather than painting nudes of perfect firmness and whiteness.

At the beginning of the century (for example in the work of Noël Nicolas Coypel), when northern painting was in vogue and moral values became more relaxed under the Regency (and again later, at the end of Louis XV's reign), pictures began to be populated by pale-bodied but amply proportioned nymphs whose flesh was enlivened with touches of pink and blue.

This style of painting full of feminine grace was embodied by François Boucher. Rather libertine in character, it generally stopped short of overtly erotic connotations (one exception being *Hercules and Omphale*, in the Pushkin Museum in Moscow, which features a highly unambiguous embrace). Enjoying the patronage of Madame de Pompadour, the king's mistress, Boucher used a light, vivid palette to paint scenes in which mythology provided a pretext for the removal of clothing. For example, *The Birth of Venus* (a Classical theme if ever there was one, and which had already inspired Botticelli's painting of the same name) allowed him to bring to life the flesh of women in abandoned, lascivious poses, their long thighs on full display, their backs turned in some cases to the viewer and their pale flesh, contrasting with the bronzed skin of the sea gods, featuring abundant pink highlights.

Less subtly poetic, and painted with a more direct sensuality, Boucher's *Odalisque* (painted around 1745) and *Nude on a Sofa* (*Reclining Girl*) (1752) present a more realistic image (no doubt inspired by specific models) of a very young woman stretched out entirely naked or with raised chemise on a daybed, 'presenting [...] the most beautiful back and the most beautiful buttocks, inviting the viewer to join in her pleasure, and doing so in the most carefree and attractive manner' (Diderot).

The 19th century: sins of the flesh

Even when they strike obviously sensual poses, Boucher's women remain in a certain sense unreal. Their radiant but excessively youthful bodies and their flesh that seems powdered and made-up rather than naked transform them into nymphs, creatures of fantasy rather than real women. These nudes prefigure the ones that came to be hung on the walls of the Salons by painters of a Neoclassical tradition that had become 'academic' or *pompier* (pretentious and over-conventional) during the 19th century. These were

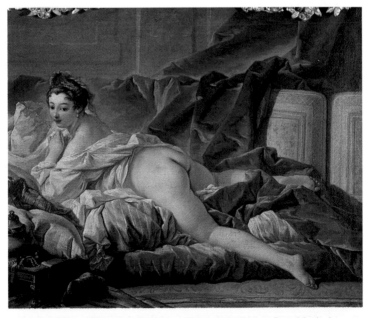

François Boucher, *Odalisque*, c.1745, oil on canvas, 53.5 x 64.5cm, Paris, Musée du Louvre.

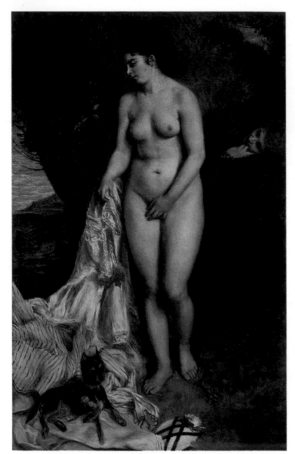

Pierre-Auguste Renoir, *Bather with a Griffon*, 1870, oil on canvas, 184 x 115cm, São Paulo, Museu de arte.

completely white nudes with small heads, hands and feet that avoided any excessive opulence of the flesh, and from which all body hair had been banished. Exponents of this type of nude were Paul Baudry (*Pearl and Sea Wave*, 1862, Madrid, Museo Nacional del Prado), Alexandre Cabanel (*The Birth of Venus*, 1863, Paris, Musée d'Orsay) and Henri Gervex (*Rolla*, 1878, see p.169).

Those 19th-century artists who reacted against this artificial prettiness chose their models from the heavier body types favoured by Rubens, but painted their flesh with a truth that offended against propriety. Renoir's *BATHER WITH A GRIFFON*, for example, does not remotely resemble an imaginary nymph. Her skin, devoid of any pink or blue tinges, displays a naturalism quite unlike the carmine-tinged whiteness of the earlier nudes, prompting some to describe her as 'dirty'. Her doleful, stubborn facial expression, wide hips, divergent breasts, recessed navel set in a bulging stomach and fold of flesh at the point where her upper body bends forward contradict her academic pose in which her weight is on one leg with her left hand covering her pubic area and her right hand holding her clothes. In Courbet's *WOMAN IN THE WAVES*, the erotic, even pornographic, impact is even greater. The pose (a life-size torso emerging from the water) is no longer academic: the woman's raised arms reveal her underarm hair — highly uncommon in paintings of the time and thus all the more disturbing. The red and blue tones have not been added randomly but accentuate the swelling of the breasts and indicate the flow of blood stimulated by the cold, bringing colour to her cheeks and her erect nipples. Towards the end of his life, Cézanne, commenting on either this painting or other Courbet nudes featuring 'abundant flesh', wrote: 'One's mouth is full of colour. One is drooling with it.' Finally the foam, applied or perhaps flung in thick splashes onto the partially submerged stomach, is a metaphor for semen that could not fail to shock.

The knowing look: from Titian's *Venus* to Manet's *Olympia*

Seductive flesh was not, however, the only means painters adopted to give their pictures suggestive force. In addition to specific features such as the small of the Odalisque's back and the raised arms of *The Woman in the Waves*, the poses struck by figures could also be highly eloquent: the arched back of Leucippus's daughter in Rubens's painting (see p.159) and that of the slave in the foreground of Eugène Delacroix's *The Death of Sardanapalus* (see p.123), for example. But, as we shall see, looks can also contain an erotic charge.

Titian's paintings occupy a special place in the history of the nude. *THE VENUS OF URBINO*

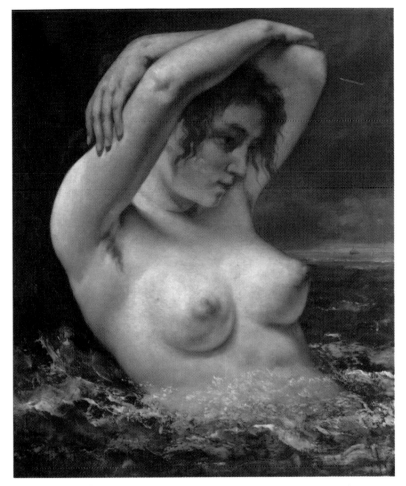

Gustave Courbet, *The Woman in the Waves*, 1868, oil on canvas, 65 x 54cm, New York, Metropolitan Museum of Art.

(see p.166) is a work that started a tradition of a particular type of composition. Stretched out on a crumpled white sheet in the niche of a bedroom in which two maidservants bustle about, this naked young woman with her hair undone, crumpling a posy, is the older sister of the 'recumbent nudes' that would later be painted by Velázquez, Goya, Manet and many others. She in turn has her origins in the eponymous figure in a landscape by Giorgione called *Sleeping Venus* (Dresden, Gemäldegalerie) that was completed by Titian after the death of the young master.

The fundamental difference between Giorgione's and Titian's Venuses lies less in their different settings than in the fact that one is asleep and one is awake. Giorgione's sleeping Venus is unaware that she is being observed. Her nudity is entirely innocent, like that of Eve who does not know herself to be naked before picking the apple. The Venus of Urbino, by contrast, has her eyes open and is facing the viewer. She is a gentle mistress whose face retains a degree of reserve — but she is also, no doubt, a courtesan: a woman who sells her body. The look she directs at the viewer is that of a woman who knows herself to be observed, and the gesture of the hand placed between her legs, far less innocent than that of a Venus Pudica, should be understood as an invitation or prelude to the pleasures of love. Goya's NAKED MAJA, painted two centuries later, seems even more naked, if this is possible, than the Venus of Urbino. This is because far from concealing her genitalia and partially depilated pubis, she has turned her pelvis slightly so that it can be seen from the front and has raised her arms in order to emphasize her breasts. With wide open

SUGGESTIVE POSES AND OTHER EROTIC MOTIFS IN INGRES'S *THE TURKISH BATH*

Although he also uses a smooth finish and pearly tints for his treatment of flesh, Ingres's firm yet supple nudes have a greater erotic charge to modern eyes than those of his academic contemporaries. *The Turkish Bath*, which pleased the sensualist Khalil Bey so much that he decided to buy it, is the most knowingly erotic of Ingres's paintings.

Oriental voluptuousness. The theme of the female bather, so common in antique sculpture and Classical painting, has been stripped of all mythological references and presented in oriental style: the location is a hammam (or Turkish bath) as described, for example, in the accounts of the British traveller Lady Mary Wortley Montagu.

Female homosexuality. Related to the theme of the harem — and thus guaranteed to appeal to Western fantasies — the hammam provided the painter with an opportunity to depict the intimate environment of an all-female universe. Female homosexuality was fashionable in the 19th century, and was depicted, among others, by Courbet in *The Sleepers* (or *Sleep*) of 1866 (see p.235). Renoir also hinted at the subject by including a woman with dishevelled hair behind the main figure in *The Bather with a Griffon* (see p.162). In *The Turkish Bath*, the gesture of the young woman squeezing the breast of the friend pressed up against her leaves the viewer in no doubt as to the relationship between the pair.

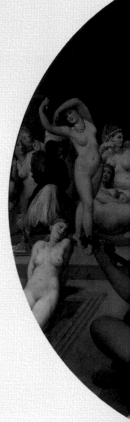

Raised arms. The dancer in the background reproduces the pose of the woman stretched out in the foreground on the right (there is a magnificent study for this woman in the Musée de Montauban). Their raised arms show off their breasts and also reveal their armpits, which (even if shaved, as here) were considered one of the most sensual parts of the body during the 19th century. There is a famous scene at the beginning of Zola's novel *Nana* in which the actress excites her audience by half exposing her bosom and the underneath of her arms. The same pose with raised arms was depicted by Francisco de Goya in his *Naked Maja*, dating from around 1800–3 (see p.166), and can also be seen in canvases by Courbet (*The Woman in the Waves*, see p.163) and Théodore Chassériau (*The Toilette of Esther*, see p.231) as well as in other works by Ingres.

The back. The women in *The Turkish Bath* are, as it were, offering themselves up to be viewed from both sides, allowing male viewers to feast their eyes on their nudity from every angle. The lute player in the foreground recalls other nudes whose backs are presented for the viewer's admiration, including Velázquez's *The Rokeby Venus*, Paul Gauguin's *Vahine No Te Miti*, also known as *Woman of the Sea* (Buenos Aires, Museo Nacional de Bellas Artes), and *Half-Figure of a Bather* (Bayonne, Musée Bonnat) and *The Bather of Valpinçon* (Paris, Musée du Louvre) by Ingres himself. The slight three-quarter orientation of the figure allows us to see the curve of her breast and the bulge of her stomach as well as the fine curve of her back.

164

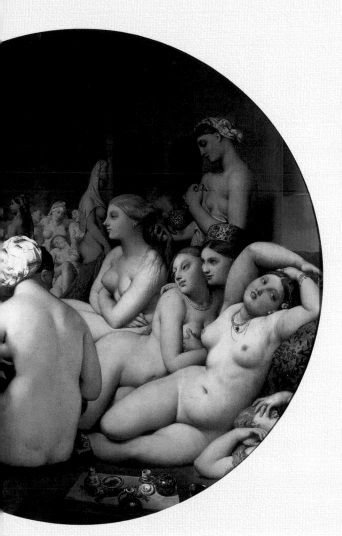

J A D Ingres, *The Turkish Bath*, 1848–63, oil on canvas stuck to wood, diameter 109cm, Paris, Musée du Louvre.

Swallowing Turkish delight. Right at the back of the painting, in the smallest of motifs, a woman swallowing a piece of Turkish delight contrasts with the elegant self-control of the other women and has obvious sexual overtones.

The *tondo* format. The ultimate decision to give the painting a circular (*tondo*) format has allowed Ingres to centre his composition on the nudes and to suppress most of the decorative elements of the picture. The round canvas matches and echoes the roundness of the female bodies. And, because this roundness gives the canvas the shape of an eye or a lorgnette, the viewer is transformed into a voyeur who has stolen an illicit glimpse into this room where women are supposed to remain by themselves.

A tangled mass of nudes. The proliferation of nudes in a space restricted by the painting's circular format accentuates the closeness of the bodies to each other. By touching and fitting closely together, the breasts, stomachs and thighs acquire a maximum of sexual suggestiveness. The painter and writer Jacques-Émile Blanche compared this mass of nudes to 'amorous she-cats whose limbs intermingle like a teeming mass of earthworms.'

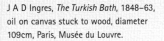

The reclining dancing girl. The bottom part of the picture was cut off in 1862, when it was transformed from a square into a circle, so that we can now see only the face, hands and one arm of the young woman in the extreme bottom right of the painting. She may have been sacrificed because she was too racy: completely recumbent, she revealed the inside of her thigh through the gap between her crossed and folded legs.

The human figure

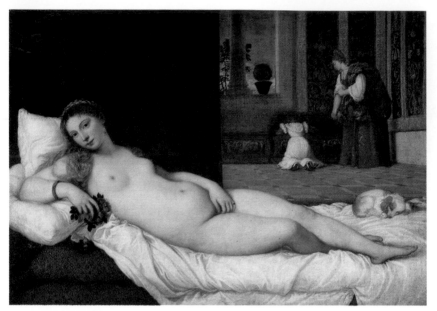

Titian, *The Venus of Urbino*, 1538, oil on canvas, 149 x 165cm, Florence, Galleria degli Uffizi.

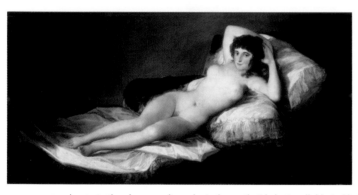

Francesco de Goya, *Naked Maja*, 1800–3, oil on canvas, 97 x 190cm, Madrid, Museo Nacional del Prado.

eyes, she casts the viewer an impudent glance that is just as liable to kindle desire as her naked body, especially since her face, which has been treated in portrait fashion, makes her a far more real person than Titian's Venus.

Manet's OLYMPIA, dating from half a century later, is also wide awake. Naked, she displays the accessories of the kept woman: the velvet ribbon around her neck, the gold bracelet with a little chain that sets off the whiteness of her skin, and the heeled mules that accentuate the arch of her feet. The glance she directs at the viewer, like that of Goya's Maja, is the stare of the unapologetic courtesan. This caused an outrage when the picture was exhibited as it was seen as an expression of sexual defiance by a 'filthy' or 'lewd' woman. In conjunction with the bouquet brought to her by her black servant, this glance clearly transforms the viewer's role from that of a voyeur to that of a client preparing for his visit by sending her a present.

Manet has suggested, if not demonstrated, that men who believe they are looking at a nude for aesthetic pleasure alone are in fact deriving sensual satisfaction from the experience.

This is why he has eliminated any possibility of an allegorical interpretation. The treatment of the body, rendered solidly in broad brush strokes of flat white, is deliberately ordinary; the setting, with its cold light and heavy fabrics, conjures up a rented room; the Negro servant, her thick body engulfed in a mass of pink fabric, is a resolutely down-to-

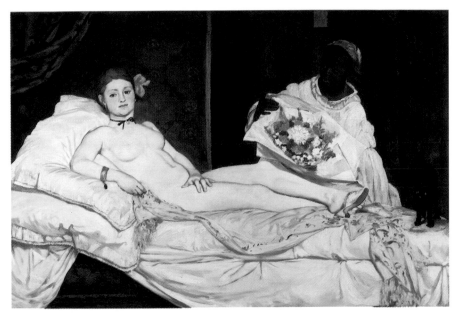

Manet, *Olympia*, 1863–5, oil on canvas, 130 x 190cm, Paris, Musée d'Orsay.

Paul Cézanne,
A Modern Olympia, c.1873–5,
oil on canvas, 46 x 55cm,
Paris, Musée d'Orsay (gift of
Paul Gachet).

earth figure; the black cat stretching with satisfaction is another version of the dog sleeping quietly in *The Venus of Urbino*; and the heavy bouquet in its over-large wrapper has been bought from 'a flower shop on the corner', as one critic of the day suggested.

The person who perhaps best, and first, understood the meaning of Manet's *Olympia* was the young Paul Cézanne. His own painting *A MODERN OLYMPIA* — exhibited at the Salon and given an even worse reception than the picture it was modelled on — is a parody, but a revealing parody. It takes the viewer into the interior of a composition suggested by Manet's: a paunchy bourgeois gentleman dressed in tails, his top hat behind him, is seated at the far end of a sofa watching a black woman uncover a white woman lying on a bed. The picture has been painted in such a way that it is impossible to know whether the scene thus observed is real or if it is actually a picture within a picture.

Eroticism and Social Outrage: Bourgeoisie and Prostitution

In contrast to their predecessors, painters at the end of the 19th century dealt directly with the subjects of women's control over their bodies and their degradation through prostitution. Henri de Toulouse-Lautrec's favourite theme, for example, was the brothel, and Degas painted not only young dancers and their 'protectors' but also female drunks and cabaret singers.

In the 1860s and 1870s, two paintings — both apparently Classical as regards theme yet executed in very different styles — caused sensational scandals: *Le Déjeuner sur l'Herbe* by Manet and *Rolla* by Henri Gervex.

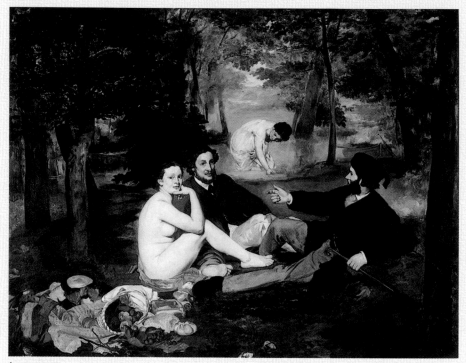

Édouard Manet, *Le Déjeuner sur l'Herbe*, 1863, oil on canvas, 208 x 270cm, Paris, Musée d'Orsay.

A nude among clothed men

This picture of a picnic (a common form of enjoyment among the city dwellers who had packed into the towns and cities during the industrial revolution) is painted in experimental Impressionist fashion in the open air and refers back to a specific tradition of scenes featuring a naked woman in the countryside in the company of clothed men, the main source being Giorgione's *Pastoral Symphony* (Paris, Musée du Louvre).

Manet's scene, however, is imbued with a realism that scandalized the public of the day. The painting was rejected by the jury of the 1863 Salon and received a hostile reception at the Salon des Refusés, where it was finally shown. The woman's nakedness is made particularly shocking by the fact that her companions — who might be young, elegant students or painters — are wearing contemporary clothes. Her fleshy body, her face, which has been treated as a portrait, and even her pose were deliberately provocative departures from the allegorical style of painting nudes.

The viewer is rebuffed by the woman's open stare. As in *Olympia*, it thwarts the expectations of men who wish to gain a sexual hold over her, and the traditional erotic scenario is utterly demolished. A woman who is bold enough to get undressed in the presence of several of her friends is clearly not a nymph; neither does she give the impression of being an abandoned lover

head over heels in love. She is one of those models described by Zola and the Goncourt brothers: women who 'are not afraid to get involved, between poses, with the Raphaels of the future' as an old edition of the Larousse dictionary had it, and who 'have real names, such as Paméla or Thérésa' (here, in fact, Victorine Meurent) 'and very real charms that can, if necessary, be verified' (Charles Blanc).

Henri Gervex, *Rolla*, 1878, oil on canvas, 175 x 220cm, Bordeaux, Musée des Beaux-Arts.

The role of secondary detail

In this painting, Henri Gervex illustrates a poem written by Alfred de Musset in 1833 in which Rolla, a young man of means, ruins himself for the sake of a prostitute named Marion and commits suicide after a final night of passion. The subject was a delicate one. The painter, then aged twenty-six, chose to treat it in an academic style in an attempt to limit the scandal it was bound to provoke. The work was nevertheless refused by the Salon on moral grounds, but went on to achieve great public success.

What was found shocking was not the image of the perfect body of the prostitute stretched out on her back in a deep sleep: her hairless, perfectly white skin, set off by her dishevelled coiffure, respected the norms of the 'acceptable' nude. A potentially more shocking element, the rumpled bed — an explicit evocation of the night that had just ended — was made tolerable by the perfect cleanliness of its sheets and pillowslips.

What was indecent about the painting were the articles that form a still life in the foreground. The lovers had obviously removed and discarded their clothes in haste. In a symbolic representation of the social relationships of the day, the top hat of the dissolute bourgeois sits on top of the red corset, lined with white, of the prostitute, who de Musset tells us is a poor working-class girl. The man's cane — in all likelihood a deliberate sexual metaphor — casts its shadow on the woman's starched petticoat, onto which a pink garter has fallen.

As an image of the lewd side of modern life, these undergarments provoked anger. Critic Paul Sébillot wrote at the time: 'One is used to the nudity of the heroes and heroines of antiquity: the modern nude shocks [...] and paintings pose a threat to public morality in proportion to the nobility of their minor details.' The writer J K Huysmans had summed it up somewhat differently the year before: 'The aristocracy of vice is revealed in the underwear.'

BEYOND THE BEAUTIFUL: OTHER INTERPRETATIONS OF THE BODY

One consequence of the creation of a canon of beauty from the 16th century onwards was the quest for an antithesis to this beauty. Painters had sometimes used bodies that were ugly or unexceptional as a way of holding the viewer's attention or of at least allowing them to break free from the straitjacket of the ideal imposed by the dominant aesthetic. This search became more systematic as artists became interested in reproducing reality and no longer simply obsessed with making their paintings beautiful.

Ugliness: moral symbol or curiosity

In the 16th and 17th centuries, physical beauty was seen as a sign of moral virtue. Prior to the Fall, Adam had been created in the image of God, in other words beautiful. Jesus, as the incarnation of God, was necessarily beautiful. Thus it followed logically that benevolent princes too should be portrayed as beautiful. The theoretician André Félibien (1619–95) spelt this out when he wrote: 'A painter should never fail to make his heroes appear in the best light [...] because beauty has great influence over the mind, and [...] therefore when painting an prominent individual, if he has certain natural defects, these should, as far as possible, be concealed.'

Conversely, painters around the dawn of the modern era who wanted to depict evil characters made them ugly. The caricature did not take off as a genre until the 19th century, but its roots go back to the Renaissance, to artists who helped define the canon of beauty: Leonardo da Vinci, for example, who made countless drawings known as 'grotesques', and Albrecht Dürer, who drew sketches in which he systematically distorted the proportions of the human face. Scenes from this period (and sometimes later) depicting the Passion of Christ and the martyrdom of the saints feature executioners and enemies of Christianity whose bodies are deformed and whose faces have coarse features such as toothless mouths, crooked or hooked noses and murderous eyes. These deformities often have racist or discriminatory overtones, with evil-doers being given Semitic or Negroid profiles, hunchbacks, goitres, or the stature of dwarves.

In the 17th

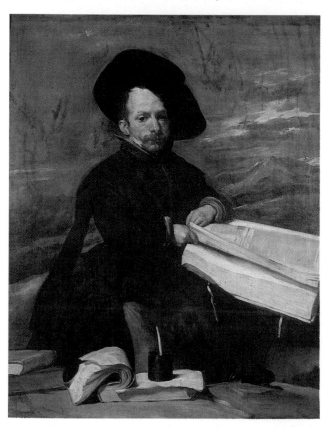

Diego Velázquez, *A Dwarf Holding a Tome on His Lap (Don Diego de Acedo, El Primo)*, 1644, oil on canvas, 106 x 82cm, Madrid, Museo Nacional del Prado.

century, the exploration of ugliness was no longer solely a matter of moral symbolism. Except in Classical France (which remained attached to the pursuit of beauty in painting), a fascination with that which went beyond the familiar order of the world — in other words beyond the norms defined by the canon — led to a pictorial inventory that captured extraordinary bodies for posterity and to picture galleries that resembled those collections of extraordinary artefacts known as 'cabinets of curiosities'. In Spain in particular, bearded women (in the work of Juan Sánchez Cotán and Jusepe de Ribera) rubbed shoulders with monstrously obese figures such as *La Mostrua* by Juan Carreño de Miranda (Madrid, Museo Nacional del Prado) and the male and female dwarves with deformed bodies and often low intelligence painted by Felipe de Llano, Rodrigo de Villandrando and, of course, DIEGO VELÁZQUEZ.

Realism as measured by ugliness

This iconography of deformed bodies was also found in the art of the rest of Europe. In the 17th century it was present in particular in the north, in the work of Anthonis Mor and even in the paintings of the elegant Sir Anthony Van Dyck (that said, the former settled in the southern Netherlands and the latter was a native of that region, which from a cultural point of view belonged at the time to the Spanish sphere of influence).

In northern Europe, however, it was less often a quest for the exceptional than a deliberate cult of the ordinary that was the motivation for depicting bodies which, if not exactly hideous, could hardly be described as beautiful. In his *Lectures on Aesthetics*, delivered around 1830, Georg Wilhelm Friedrich Hegel notes (with regard to versions of the Virgin with Infant) a fascination with the real that — unlike in Italian art — meant the Flemish had no qualms about painting imperfections: 'In paintings of the Infant Christ by Raphael [...] Christ wears a childlike expression of the most exquisite beauty [...]. In images of the Madonna by van Eyck, the children are [...] the least successful of his figures: indeed those he depicts are more often than not quite wooden, with the faces of newborn babes.'

Yet it was in Italy, at the beginning of the 17th century, that one artist in particular began to paint bodies that were unexceptional. By choosing to paint people off the street rather than imaginary figures or imitations of antique statues, CARAVAGGIO introduced an idea of the figure entirely lacking in the grace and perfection to which, thanks to idealization, people had become accustomed over the previous one hundred years. This blatant aesthetic deconstruction brought him accusations from his biographer Bellori of having 'chosen ugliness' over beauty and from Nicolas Poussin of 'having come into the world in order to destroy painting'.

Caravaggio (Michelangleo Merigi), *The Death of the Virgin* (detail). See p.121.

The tired face and unkempt hair of the Mother of Jesus in Caravaggio's *The Death of the Virgin* are those of an ordinary woman, her yellow skin is reminiscent of a real corpse, her swollen ankles and stomach resemble those of a body that has been in water for several days — all this to depict the woman that traditional theology has always celebrated as the most beautiful of women, as an Eve without sin that neither old age nor death can wither.

The same is true of other paintings by Caravaggio: the *Sick Bacchus* (Rome, Galleria Borghese) has the feeble look and sallow complexion of a lower-class boy with some shameful disease; St Matthew the Evangelist in *The Calling of St Matthew* in San Luigi dei Francesci is a 'real' tax collector who has set up office in a tavern and is counting his pennies surrounded by the innkeeper and idle customers; and St Peter, in *The Crucifixion in Santa Maria del Popolo* (see p.141) is an old man with an untidy beard and loose skin around his stomach. In the same painting, the men lifting the cross are ugly characters

THE 19TH CENTURY: WORKERS AND PEASANTS

In France, the true heirs of Caravaggio's realist revolution were the painters active two and a half centuries later who dedicated themselves to the portrayal of 'modern life' (to use Baudelaire's expression), regardless of whether they belonged to the academic, Realist or Impressionist schools.

The preoccupations of these artists were moral or political — as in the case of Courbet, a friend of the socialist theorist Pierre Joseph Proudhon, whose portrait he painted. They were also largely formal: these painters wanted to depict their subjects in terms of their position within the new world resulting from the industrial revolution. Thus, their portrayal of workers, either at work or at leisure, had as its corollary the bourgeois world of elegant apartments, Parisian boulevards, cafés, brothels, theatres and the Opera.

These new subjects needed new styles of painting: the academic idealization of the body was no longer appropriate.

Jules Bastien-Lepage, *Haymaking*, 1877, oil on canvas, 180 x 195cm, Paris, Musée d'Orsay.

The world of the peasant

In the 19th century, France was still a largely agricultural country and many painters came from provincial farming communities. Working the land remained an important theme in painting throughout most of the second half of the century.

It was present in the work of the painters who exhibited at the Salons: Jules Bastien-Lepage from Lorraine, for example, whose picture *Haymaking* became the manifesto of official naturalism despite the 'repulsive' character (in the words of one critic of the day) of the little peasant woman 'sitting, with dangling arms and a red, sweaty face' (as Bastien-Lepage himself described her).

Most importantly, it was present in the more directly realist work, considered scandalous, of painters such as Jean-François Millet, the subjects of whose *Gleaners* (1857, Paris, Musée d'Orsay) were described as 'the Parcae of pauperism' and 'scarecrows in rags', and above all Courbet, who in the early 1850s painted *The Stonebreakers* (now lost) and *The Wheat Sifters* (Nantes, Musée des Beaux-Arts).

The proletariat

The proletariat duly made their entry into painting a little later than the peasants, in 1870–80, and in an area where it was least expected: the work of the Impressionists and Neo-Impressionists rather than that of the Realists. This was because the Impressionists and Neo-Impressionists sought formal answers to the questions posed by a new world. Thus, in paintings by Gustave Caillebotte, notably *The Floor Scrapers* (see p.242) or *Man at His Bath, Drying Himself* (Chicago, Art Institute), the figures are working men with thin, muscular bodies — as different from the well-padded physiques of the bourgeois as they are from the all too perfectly proportioned academic nudes.

The proletariat also feature in the paintings of Seurat. In *Bathers at Asnières*, for example, the young men enjoying their leisure time on the banks of the Seine are clearly young workers who have temporarily fled the working-class districts of Paris.

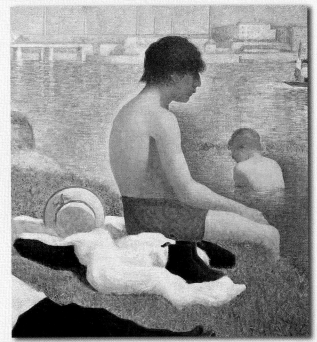

Georges Seurat, bathers sitting on the banks of the Seine, details from *Bathers at Asnières* (see p.64).).

It was not, however, until the beginning of the 20th century — during the interwar years in particular (not only in France, but in the United States and the rest of Europe as well) — that workers were depicted in paintings (and photographs) realistically and in line with a vision of social militancy. They were shown at work (in the factory), at leisure (particularly enjoying sports such as boxing or football — in the paintings of Delaunay or Seurat, for example), involved in disputes (strikes and demonstrations) or enduring poverty (unemployment). Except in the United States, in the paintings of Grant Wood, and for completely different reasons in Nazi art (in which a taste for scenes depicting farm workers was part of a celebration of 'genuine' values and a cult of the land – *der Boden*), the agricultural classes disappeared from painting around this time.

with shabby clothes. Their gestures, those of real workmen, convey the pain of their effort but none of its nobility. The rope which the standing labourer is using to attempt to raise the cross must be cutting into his back through his clothes, and the breeches of the worker underneath the cross are stretched so much that the material seems about to split.

The painters who continued Caravaggio's tradition throughout the 17th century adopted his custom of painting 'real' bodies — in other words those marked by the ravages of time, illness or work — whether they were painting genre scenes featuring ordinary men and women or mythological scenes. The young Velázquez, for example, painted an old woman of unprepossessing appearance and a red-faced boy in *Old Woman Cooking Eggs* (see p.75), but also depicted characters of the same type when painting subjects

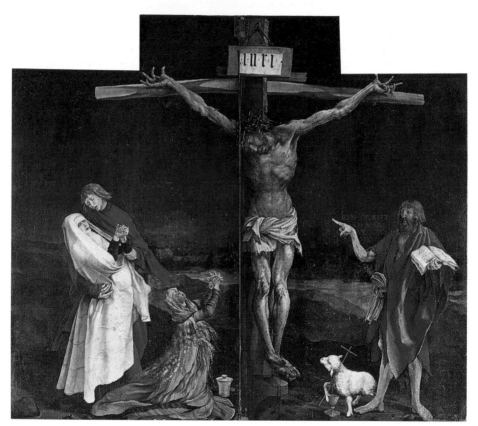

Matthias Grünewald, *Crucifixion*, c.1510–16, central panels (closed) of the Isenheim Altarpiece, tempera and oil on wood, 269 x 307cm, Colmar, Musée d'Unterlinden.

based on Classical legend: rustics affected by wine in *The Drinkers*, an allegory on the theme of Bacchus (Madrid, Museo Nacional del Prado), and men with the bodies of labourers in *The Forge of Vulcan*, inspired by Ovid's *Metamorphoses* (same location).

Painting the unacceptable

By choosing to paint bodies that were ugly or imperfect relative to the norms of beauty, painters were taking up the challenge of 'making beautiful art' without choosing beautiful subjects. The feats achieved might vary according to the painter's degree of virtuosity, but they were always a sign of their self-confidence. This approach to art also indicates that they refused to regard paintings as 'objects of delectation', as 17th-century convention would have it. For most buyers, once the art market had replaced the system of individual commissions (between the 17th and 19th centuries in Europe depending on region),

a canvas was seen as a decorative object: an ornament to be hung on the wall of an apartment. Ideally, paintings would be a source of real pleasure — collectors contemplating their works would find reasons to convince themselves that a better world existed.

But sometimes they were simply used to show off the affluence of the owner and his 'aesthetic sensibility'. In this context, the status of paintings differed from that of wallpaper — or to take a present-day example, the poster — only in terms of market value. They were 'images' that could either appeal to people or leave them cold, but they were not, under any circumstances, allowed to disturb them.

At the beginning of the 20th century, the German philosopher Konrad Fiedler wrote a critique of this system — a system that reduces art to insignificance. According to Fiedler, where aesthetics had gone wrong from the start was in investing art with the sole function of portraying beauty. The aim of a painting or a sculpture is not and should not be simply to satisfy our longing for beauty. They can also convey a message: a warning or a cry of rage when confronted with the ugliness of the world.

In the 15th century, absolute ugliness, the utterly intolerable, was represented by the death of God in the form of the Crucifixion. Between 1493 and 1516, *MATTHIAS GRÜNEWALD* painted an altarpiece for the hospital church of the Anthonite Abbey in Isenheim featuring at its centre the crucified Christ. This Christ was described by J K Huysmans as 'a giant figure, disproportionately large compared to those surrounding him, nailed to a tree poorly stripped of its bark'. His body 'is livid and shiny', continues Huysmans, 'flecked with blood, bristling like a chestnut husk with splinters of wood stuck in the holes of wounds; [...] his knees turn in and knock together and his feet, bolted one on top of the other, are nothing more than a jumbled mass of muscle beneath discoloured, rotting flesh and blue toenails; as for his head, adorned with an enormous crown of thorns, it lolls onto his chest, which has become a loose, swollen sack patterned with the lines of his rib cage [...]. His jaw hangs loose and his lips slaver.'

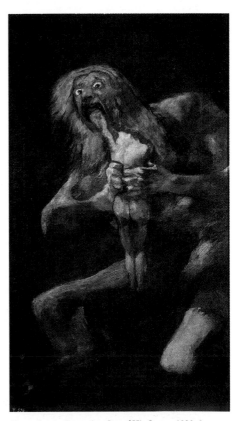

The ugliness of this Christ is one of the most beautiful images in Western art. The alchemy wrought by the artist's brush has transformed the terrible agony suffered by a body into a deeply disturbing image. Our attention is drawn to Jesus's martyred body by the enormous finger of St John the Baptist (St John the Evangelist is Mary's usual companion in crucifixion scenes) — a body which represents quite the opposite of the sublimation we are accustomed to, and which has become a symbol of the 'horror knocking at our door', a sign that 'what is, will be again', to quote the writer Elias Canetti.

Like Grünewald in his *Crucifixion*, Rembrandt, in paintings such as *The Blinding of Samson* (see p.123), and Goya, in his 'Black Paintings' and in canvases such as *The Prison Interior*, *The House of Fools* or *The Cannibals*, depict bodies covered in blood, fearsome-looking executioners and nightmare visions that would repel in real life, but which we are forced to look at here because of the artistry with which they are painted.

Goya, *Saturn Devouring One of His Sons*, c.1820–3, mural (oil on canvas fixed to the wall), 143.5 x 81.4cm, Madrid, Museo Nacional del Prado.

In *SATURN DEVOURING ONE OF HIS SONS,* an allegory of universal chaos, the god devouring his own offspring has been turned by Goya into an ogre who is nothing more than a human caricature. His victim is no baby, as it is in Rubens's painting of the same subject (Madrid, Museo Nacional del Prado), but a mutilated, bleeding adult who could be either a man or a woman.

The violence of the colours and the total incongruity of the forms correspond to the madness of a world in which order and reason cannot make themselves heard. It creates disharmony and gives the canvas a 'convulsive' character (to use André Breton's expression), turning it into the symbol of an era in which it had become impossible to believe in humanism. The 20th century, with its wars, poison gas and genocide, made paintings like this seem distressingly topical. In the experimental work of modern painters, the quest for a harmony they knew to be illusory gave way to the search for images from which the viewer could not turn away unscathed. In a series of watercolours painted in the early 1920s and based on photographs of World War I veterans with severe facial injuries, Otto Dix adopted a Classical style and subdued colours in order to accentuate the horror of disfigured individuals who had lost a part of their humanity. In his triptychs *The Big City* (Stuttgart, Galerie der Stadt) and *War* (Dresden, Stadtmuseum), painted around 1930, he used an altarpiece format to depict the decaying of bodies destroyed by vice and war — subject matter in strong contrast to the nobility of its setting.

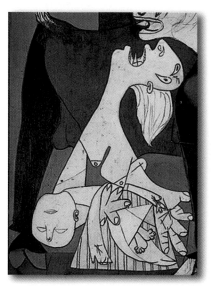

Pablo Picasso, mother with dead child, detail from *Guernica* (see p.18).

In 1937, Picasso used distortion of human forms in order to intensify the emotional effect produced by his painting *GUERNICA.* In the exact opposite of an elegiac style, he expresses the terror and distress of the victims of the bombing of the town of Guernica through the use of exaggerated gesticulation, profiles with howling mouths, eyes out of position, foreshortening and a simplification that eliminates the superfluous and retains only the most emotionally expressive parts of the human body.

Throughout the 20th century, painters have striven to depict the human body in ways that convey the horror of historical events, the pain of existence (Egon Schiele, Antonin Artaud or Francis Bacon) or the power of desire (Picasso). Their aim has been not to create beauty in the Classical sense, but to engender unease. Picasso, quoted here by André Malraux, expressed this forcefully: 'We must wake people up. Turn the way they see things upside down. We have to create unacceptable images. Make people froth with rage. Force them to understand that they live in an absurd world. A world that offers little comfort. A world that is not the way they think it is.' However, this shift in artists' aims does not stop us from finding their work beautiful — proof that beauty should be analysed as a historical phenomenon and that what constitutes the notion of beauty changes radically from age to age.

Paul Cézanne: the body as motif

The painters we have been looking at consider the body as a motif that carries a great emotional impact. They also regard painting as a means of expressing a message. In other words, they subscribe to the principle of *ut pictura poesis,* of comparing painting to text.

For others, however, painting is a matter of form, and this is sufficient in itself. They see the painter's task as filling a flat surface with lines and colours and depicting three-

dimensional motifs on it in the most satisfying way possible. For them, the human body is just another subject, and the painter treats it as any other object, refusing to invest it with specific psychological, erotic or dramatic overtones.

Paul Cézanne strove always to eliminate the emotive power of the body, and to portray the body instead with the same implacable objectivity that he brought to other motifs.

Cézanne displayed his passionate temperament in early canvases depicting nudes, in which he endowed the female body with erotic force — *A Modern Olympia*

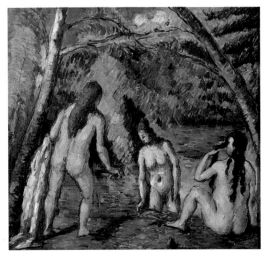

Paul Cézanne, *Three Bathers*, 1879–82, oil on canvas, 53 x 55cm, Paris, Musée du Petit Palais.

(see p.167), *Afternoon in Naples* (Canberra, Australian National Gallery) and *The Eternal Feminine* (Malibu, J Paul Getty Museum) — or with violence — the watercolour after Delacroix of *Medea* (Zurich, Kunsthaus). Cézanne himself described his works dating from this time as belonging to his 'red-blooded' period.

The painter's subsequent work consisted in devising techniques that would enable him to contain this strength of feeling and transform it into objective representation, turning declamation into suggestion. Cézanne's ideal had much in common with the stylistic restraint of Gustave Flaubert, whose *The Temptation of St Anthony*, an account of repressed sexual temptation, provided the subject matter for a number of Cézanne's paintings. The subject of female bathers, which he painted tirelessly from 1874–5 onwards, forced him to consider nudity within a natural setting, in other words to look at problems of morphology, dynamics, perspective depth and the play of light as it modulated flesh tones in an uneven manner.

In pose after pose of naked women beneath foliage, Cézanne rehearsed the entire repertoire of bodily attitudes: seen from the front, from the back, from right or left, in three-quarter profile from behind, standing, leaning, sitting and so on. The trees serve as indicators of scale, and their slanting trunks provide a tight framework, forcing the eye to concentrate on this lexicon of the human body. These methodical exercises do not deprive the canvases of sexual energy: they give them a sharper and more subdued form, making them all the more provocative.

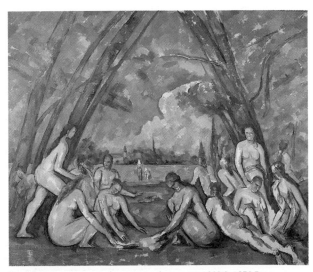

Paul Cézanne, *Large Bathers*, 1906, oil on canvas, 208.3 x 251.5cm, Philadelphia, Philadelphia Museum of Art.

In the THREE BATHERS in the Petit Palais, for example, the disproportions of bodily form, the strange pose of the woman sitting on the ground with her legs spread wide apart, and the faces reduced to their basic features — all these communicate the dangerousness of the bodies while emphasizing their plasticity. Not until one of the painter's last nude compositions, the LARGE BATHERS in the Philadelphia Museum of Art, is there the peace the painter sought for so long to achieve. Under the pointed arch of the trees, the lines of the bodies and tree-trunks form a harmonious ensemble. The figures' hair merges with the foliage and shades of ochre spread across both ground and bodies. Absorbed and blended into the landscape at last, the naked female bodies, now chaste, attain serenity.

Picasso: deconstructing the figure

After completing *Large Bathers*, Cézanne died in October 1906. The following year, Picasso showed what he had learned from the older painter's experimentation. Like Cézanne's bathers, LES DEMOISELLES D'AVIGNON features a group of naked women. They are prostitutes in a brothel, and therefore symbols of dangerous pleasure from which death is not far away (the first version included a still life featuring a skull). Abandoning the erotic 19th-century style of painting nudes, Picasso learned from Cézanne that it was possible to break with the verisimilitude of visual imitation without reducing emotional power. In order to force the eye properly to take in the five nudes that fill the canvas, Picasso broke up their bodies, making them more and more angular as his preliminary studies progressed. Like Cézanne, he simplified their faces, turning their eyes into black ovals. At a time when the Fauves were working with colour to give their figures the appearance of surface decoration, he was treating noses as triangles and — by adding lines to either side of the ridge of the nose and hollowing out the eye sockets — emphasizing the impression of projecting volume. The figures' hard breasts, pointed elbows and thick hands and feet endowed their bodies with even greater power.

This sacrilegious treatment gave *Les Demoiselles d'Avignon* maximum visual impact, which the painter Georges Braque understood immediately. Discovering the painting in Picasso's Bateau-Lavoir studio, he declared that 'this style of painting had the same effect on him as drinking petroleum'. After *Les Demoiselles d'Avignon*, Picasso's successors had

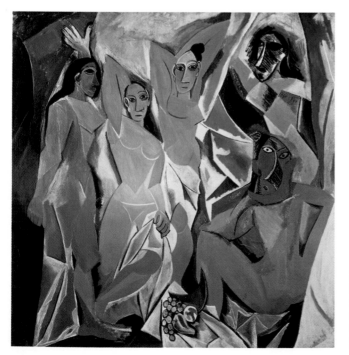

difficulty returning to a conventional manner of depicting the female body — a manner which, both in terms of its assumptions and the feelings it aroused, now seemed to have little left to offer.

Pablo Picasso, *Les Demoiselles d'Avignon*, 1906–7, oil on canvas, 243.9 x 233.7cm, New York, Museum of Modern Art.

TWO NEW VIEWS OF THE BODY: CORPET AND ORLAN

While working on *Les Demoiselles d'Avignon*, Picasso discovered the 'Negro statues' in the Musée du Trocadero and the Iberian sculptures in the Louvre. These 'primitive' models encouraged him to reinvent the code of representation of bodies and faces through a process of distortion.

Very differently from Picasso, but with the same desire to surprise and challenge the eye, there are two artists working at the beginning of the 21st century who treat the nude and face in a way that represents a complete break with Western traditions of depicting the body in art.

Vincent Corpet: the body as object

Vincent Corpet works in a traditional medium on a traditional support: oil and canvas. He refrains from distorting what he sees, but demands that his models stand in front of him with their arms hanging down loosely by their sides: an autopsy position contradicted by their wide open eyes and vertical stances.

The format is made to fit the height of the subjects, who find themselves enclosed by the canvas as if in a coffin. The background is monochrome and of a vivid colour that varies from painting to painting.

The painter objectively reproduces the details of his subjects' bodies, including deformities in terms of height, corpulence, scars, skin defects and body hair. He works in such a way that each zone of the body, as he paints it, is at his eye-level. This 'record' — painted with meticulous naturalism and favouring no single part of the body over any other — conveys a forceful image of his subject's body while creating a strangely non-hierarchical vision of it in which the knees or feet are of no less importance than the sexual organs or the face.

Vincent Corpet, *Nude*, 2467 M VIII 92 h/R, 1992, oil on canvas, 180 x 50cm, private collection.

Orlan: the body metamorphosed

Orlan started her career as an artist around 1968 in an environment strongly influenced by feminism, and is currently working at a time when the subject of globalisation is very much to the fore. In her work she examines the female body, and more specifically the codes of beauty that we have come to regard as absolute.

Working either directly on her own body, by willingly undergoing surgery, or using techniques that combine photography and the virtual manipulation of images, she uses her body as a basis for the construction of a new one — a 'hybrid' body that she chooses as an alternative to the one allocated to her by chance — and integrates into it elements of alternative beauty (rather than ugliness) which are inspired by principles alien to conventional aesthetic norms. Dissymmetry, for example, replaces the symmetry widely regarded as an indispensable element of facial beauty. In a recent series of works, the artist combined models of beauty alien to Europe with her own face through a process of virtual transformation: the long necks of African women, for example, or the sculpted skulls of pre-Columbian civilizations.

Orlan, *Self-portrait*, 1999, private collection.

Styles

The question of style is a tricky one. Before the 20th century it was rare for artists or the critics associated with them to publish manifestos containing the principles governing their work. The grouping together of artists into movements with a precise name and a list of characteristics describing each movement has therefore taken place a posteriori and in certain cases a long time after the artists have completed their work. This time-lag can result in too rigid an analysis of their work, which becomes imprisoned within overly simple or abstruse categories. For those who believe they can define an artistic movement, the analysis of a painting amounts to the identification of signs in the work that might indicate its adherence to a particular trend, whereas a characteristic of great painters is precisely that they avoid those elements that might reduce their art to a codified formula.

However, such is the force of habit and the power of vocabulary that it is impossible to avoid such descriptions altogether. But it would be dangerous to employ the terms commonly used for stylistic trends without seeking to define them precisely. We would run the risk of replacing an over-precise set of markers with an accumulation of vague labels that would be of even less use in understanding works of art. The distinction proposed in the 20th century by Eugenio d'Ors between the two 'eternal sensibilities' of Baroque and Classical art as a way of analysing not just 17th-century paintings but the entire history of Western art seems perfunctory and oversimplified. This distinction describes Classical art as an aesthetic 'of economy and reason' characterized by a love of 'stable, weighty forms', and Baroque art as a style filled with 'music and abundance' that features 'convoluted, soaring forms'.

Instead of resorting to categories so vast that they are meaningless and ineffective, or looking for characteristics which define the dominant psychological type and its counterpart in every era, the most appropriate solution is to examine different styles from a historical perspective.

Gothic

INTERNATIONAL GOTHIC

The Renaissance

Mannerism

Caravaggism

The Baroque

Classicism

Rococo

Ever since man first engaged in artistic activity, the history of art has been a succession of changes in which one style of painting (and sculpture and architecture) has replaced another before being swept aside in its turn. In the past, these changes took place at a far slower pace than they do today, but they have always occurred. They cannot be attributed solely to the influence of strong personalities seeking unique modes of expression. According to 'formalist' historians, there may be an inevitable aging of artistic forms: they become over-exposed, the pleasure of viewing them diminishes and a weariness on the part of both artist and public sets in. In this case the evolution and replacement of styles could be seen as an autonomous development of pictorial effects, an intrinsic part of the artistic process that is unaffected by external influences.

But the opposite could also be true: that, in each era or sometimes each generation, stylistic changes — far from being independent of developments within the society in which the art is produced — reflect a specific vision of the world or change of attitude that influences the artistic forms themselves. The question of style thus needs to be approached very cautiously. It is important to take account of the specific conditions involved in the production of works of art, in other words of the (at least relative) autonomy of the creation of forms — what the French art historian Henri Focillon, at the beginning of the 20th century, called the 'life of forms'. It is also important, however, to remember that artists belong to their times, that the emotions and feelings they put into their works are also those of their contemporaries, that the technical means at their disposal influence the manner in which they work and, conversely, that they also adopt or invent procedures and choose or think up subjects relevant to the world in which they live.

Neoclassicism

Romanticism

Realism

Impressionism

Post-Impressionism

NEO-IMPRESSIONISM

SYNTHETISM

THE NABIS

SYMBOLISM

FAUVISM

EXPRESSIONISM

Gothic

The term 'Gothic' was first used during the Renaissance, with strong pejorative overtones, to denote the art forms that prevailed at the end of the Middle Ages, particularly in northern Europe (the region of the Goths — in contrast to Italy, which was the land of those who had succeeded the Romans). In the middle of the 15th century, the historian Giorgio Vasari defined the 'style invented by the Goths' as 'monstrous and barbaric'. During the 19th century, John Ruskin, a great advocate of the Gothic style, described its main characteristic as 'savageness or roughness'. At the same time (1851) the Romantic movement (Victor Hugo, Prosper Mérimée, Arcisse de Caumont) saw in this same 'roughness' an aesthetic quality, and the proponents of a revival of Catholic piety (such as the British architect and desginer August Pugin) defended Gothic Art as the perfect expression of faith so successfully that artistic movements such as the Nazarenes and the Pre-Raphaelites adopted it as their model.

Gothic art emerged in architecture (the cathedrals of the Île-de-France) and sculpture just before the middle of the 12th century. It reached its peak during the 13th century, but lived on and continued to spread until the end of the 14th and first half of the 15th centuries, taking on the slightly different characteristics of a form known as 'International Gothic'.

Centres and artists

• **In France**, the most active centres were Burgundy, where painters such as Melchior Broederlam (d.1409) and Jean Malouel (d.1415) worked; Provence, specifically Avignon, seat of the popes between 1309 and 1376, where Italian artists such as Simone Martini (c.1284–1344) and Matteo Giovanetti (d.1367) converged during the 14th century and where Enguerrand Quarton (c.1410–66) worked during the 15th century; and later, during the second half of the 15th century, central France (the Master of Moulins).
Paris, a major centre of illumination during the 14th century, when Jehan Pucelle (d.1344) was active, declined as a result of the Hundred Years War (1337–1453). At the end of the 14th and beginning of the 15th centuries, the leading illuminators of the day (Jacquemart de Hesdin and most importantly the brothers Paul, Jean and Herman de Limbourg) were working for the duke Jean de Berry.
The leading painter of the late Gothic period in France was Jean Fouquet (c.1425–c.1480), who was both an illuminator and a painter on wood.
• **In England** the main artist was the illuminator Matthew Paris, who was active in St Albans and London during the middle of the 13th century.
• **Flanders** was under Burgundian rule between 1384 and 1477. Numerous artists born in the region worked in Paris (such as the illuminator Jean Bondol, around 1370) or for the French princes (for example the Limbourg brothers).
• **In Germany and the Germanic lands**, the main artists whose names have survived or whose work has been gathered under a name of convenience were active during the International Gothic period: in the Prague region, Master Theodoric and slightly later, during the second half of the 14th century, the Master of Wittingau; in Germany, Master Bertram von Minden and Konrad von Soest around 1400, followed a little later by Stefan Lochner, the Master of St Veronica and Master Francke.
• **Italy** was unusual during the Gothic period in that its artistic tendencies followed a number of different directions. Its principal centres were Florence and Siena (in Tuscany), Rome and Naples. The Venetian painters had not yet developed a style of their own. During the 14th century, they were still under the influence of so-called 'Greek' (Byzantine) art and remained faithful to the mosaic technique (St Mark's in Venice). In the 15th century they embraced northern influences and cultivated a highly ornate decorative style involving a lavish use of gold.

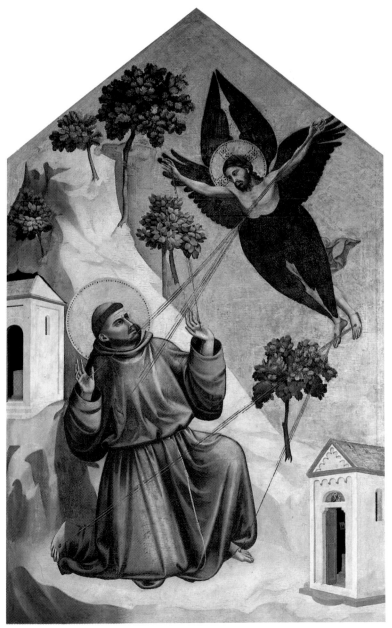

Giotto, *The Stigmatization of St Francis of Assisi*, c.1300, tempera on wood, 314 x 162cm, Paris, Musée du Louvre.

• **Spain** was very much open to Italian influences during the 14th century. Thus the style of Ferrer Bassa, who worked in Barcelona between 1324 and 1348, reflected the pictorial language developed in Tuscany by *GIOTTO*. In the 15th century, Miguel Alcaniz, Pedro Nicolau, Luis Borrassá and Bernado Martorell, active in Valencia and Barcelona, were the main representatives of International Gothic in Spain.

Characteristics

Supports

• In northern Europe, illumination and stained-glass windows had pride of place. During the 14th and 15th centuries, painting on wood began to play a more important role. The

GOTHIC ART OF NORTHERN EUROPE

Melchior Broederlam, *Annunciation and Visitation*, 1395–9, wing of an altarpiece painted for the Carthusian monastery of Champmol, tempera on wood, 167 x 125cm, Dijon, Musée des Beaux-Arts.

This painting is typical of the Gothic art of northern Europe. The irregular form of the panel indicates that it was once part of an altarpiece. The theme is religious, and is taken from the New Testament — more specifically the Gospel According to St Luke (1, 26–45) — and the apocryphal gospels, in other words those not actually recognized by the church but nevertheless very widely read.

It is a painting of hope, as the story of the Incarnation represents a promise of salvation for mankind.

Colour

The abundant use of gold and the use of a precious blue exclusively for the Virgin reflect an aesthetic that valued colours for their brilliance, while also being aware of their intrinsic value. The painting provides clear evidence of an enjoyment of drawing — this can be seen in the coiling phylactery on which the words of the Angel Gabriel are presented to Mary and in the treatment of the cloaks where they touch the ground. No less evident is the painter's love of decorative detail, which can be seen in the delicate motifs of the lily leaves and the sculpted ornamentation in the doorway to Mary's chamber.

Space

A sense of depth has been achieved through the succession of overlapping interiors on the left-hand side of the painting. Here we can see an attempt at geometric perspective in the architecture of the windows and the patterns of the floor tiles. An interest in nature is conveyed, on the right, by the view of mountains (in reverse perspective: those behind are higher). They have been depicted as rocks partially covered by greenery, with trees considerably smaller than the human figures. A bird in flight has been portrayed against the gold background.

Direction for reading the image

Mary is shown twice. The chronological sequence follows the normal reading direction, starting with the earliest episode in the story (the Annunciation) on the left, and continuing on the right with the most recent (the Visitation, in other words the encounter between Mary and her cousin Elizabeth, herself pregnant with St John the Baptist).

oldest preserved panel painting in France is the portrait of *Jean II Le Bon, King of France* (see p.32). Paintings on wood rarely consisted of single panels, belonging more usually to ensembles of varying degrees of complexity known as 'retables' (altarpieces).

• In Italy, stained-glass windows were relatively rare and illumination also less widespread. Painting primarily took the form of decorative murals in churches, as in the Basilica of St Francis in Assisi (see p.8) and elsewhere.

Techniques

• On parchment or wood: tempera.
• On walls: fresco, often with *a secco* retouching (see p.9).

Themes

• The concept of 'genre' did not yet exist as all painting was religious. During the Gothic era there was a tendency to humanize holy figures. The Virgin was often depicted as a humble figure (the Virgin of Humility, sitting on the floor), but also occasionally as the Queen of Heaven (Virgin enthroned). Christ's childhood was a common theme and his moral distress and physical pain were shown in scenes depicting the Passion (*Christus patiens*). Narrative became more important: new saints were introduced into paintings and more scenes from saints' lives were depicted.

• The first portraits appeared during the 14th century, sometimes integrated into larger works. Elements of landscape and still life (see p.32) also emerged at this time.

Composition

• Gothic art conveyed an impression of depth in a manner that was not rigorously geometric.

• The backgrounds of paintings continued to be treated in abstract fashion: gold (on wood), vivid colours such as red or blue or even decorative tiled motifs (in the case of miniatures) were used above architectural or landscape elements. In Italy, blue was the colour most commonly used for the background of frescoes, but before about 1420-30 no clouds were ever shown and so it is inappropriate to talk of a sky as such except in a very small number of nocturnal scenes where the moon and the stars are shining (Pietro Lorenzetti's *Arrest of Christ* in Assisi).

Line, colour, brushwork

• Line remained predominant.
• Colours are vivid and only roughly imitative.
• Colours were chosen for their brightness and sometimes for their market value too. Gold and blue (especially lapis lazuli) were particularly highly prized.
• In stained-glass windows, the quest for luminosity led to an increased use of yellow and white.
• Brush strokes are undetectable and impasto non-existent (see p.12).

Figures

• Figures are elongated and display little detail as regards physical characteristics.
• Except in Italy during the 14th century, their volume was not accentuated and they cast no shadow on the ground.
• Movements were strictly codified and there was little variation in posture.
• Painters ensured that bodies — those of the main figures at least — were visible in their entirety.
• In the main tier of altarpieces, each panel would often be devoted to a single figure. In the narrative compartments, particularly the predella, the same figure might appear several times where a number of different episodes are depicted (see p.184).

ITALIAN GOTHIC : SIENA AND SIMONE MARTINI

The pictorial revolution that took place in Italy during the 14th century (the trecento) is associated above all with the name of Giotto (c.1267–1337). This Florentine architect, sculptor and — most importantly — painter, who worked in Rome, Naples, Assisi and Padua, was the first to attach major importance to the treatment of space (see p.79) and volume, notably that of the human figure (see p.131).

During the first half of the 14th century, however, before the scourge of the Black Death descended and devastated the city in 1348, Siena was an artistic centre fit to rival Florence.

At the end of the 13th century and the beginning of the 14th, Duccio di Buoninsegna (c.1255–1318/19), the greatest Sienese painter of his day, set great store by linear and decorative values. In his *Rucellai Madonna* (Florence, Galleria degli Uffizi), the figure of Mary, far more delicate than Giotto's figures, is given a distinct rhythm by the undulating line of the golden scalloped trimming of her cloak. On either side of her throne, which is still extremely shallow in terms of perspective depth, angels float gracefully one above the other against a golden background, rather than being positioned at various levels of depth as in Giotto's paintings.

From around 1310, Simone Martini (c.1284–1344) — who also worked in Assisi and Avignon, joining the court of Pope Benedict XII in 1340 — occupied an important position in Siena. His *Maestà* in the city's Palazzo Pubblico (town hall) and his ANNUNCIATION in the Uffizi in Florence took the linear style characteristic of Duccio's work a stage further, introducing a far greater degree of spatial density and emotive power.

From the 1320s, and particularly after 1330, the brothers Ambrogio and Pietro Lorenzetti were — along with Simone Martini — the most remarkable of the Sienese painters.

Both fell victim to the plague in 1348. More sensitive to the art of Giotto and his disciples (Ambrogio had worked in Florence before 1332), they took Sienese painting in a new direction. The two brothers accentuated the solidity of the human figure and increased the effectiveness of spatial construction in works such as the *Annunciation* in Florence, Ambrogio's frescoes depicting *Good and Bad Government* in the Palazzo Pubblico in Siena, and Pietro's *Birth of the Virgin* in the Museo dell'Opera del Duomo in Siena. More specifically, following a tradition inspired by Giotto's most important pupil, Taddeo Gaddi, Pietro worked on lighting effects, painting star-studded skies, snowy landscapes and rooms illuminated by a fire burning in a hearth.

The Annunciation by Simone Martini

This *Annunciation* painted by Simone Martini and his brother-in-law Lippo Memmi takes the form of a triptych with saints on either side of the central panel. These are St Ansano, a recently canonized Sienese saint (on the left), and probably St Margaret, patroness of childbirth (on the right), whose presence is justified by the theme of the main compartment.

Delicacy of technique against a gold background

Executed in precise, sinuous outlines, the figures stand out against an almost entirely gilt background. The floor in the picture consists of a strip of marble with polychrome veins arranged in such a way that they converge on the gold vase at the centre. The vase itself has been treated as a volume, producing a perspective effect. The various motifs have been treated in an extremely delicate manner, as can be seen in the draughtsmanship of the olive branch held by Gabriel, the stalks and petals of the lily in the vase, the angel's wings imitating peacock feathers and the check pattern of the angel's cape as it describes arabesques in the air.

Simone Martini and Lippo Memmi, *The Annunciation*, 1333, tempera on wood, 184 x 210cm, Florence, Galleria degli Uffizi.

Style based on specific effects

The psychological intensity of the scene is conveyed by the Virgin, who recoils in alarm at the sudden appearance of God's messenger, and the painting's charm stems from the very human character — something new in art — of this reaction. It stems too from the intense luminosity of the work, which results not only from the profusion of gold, but also from a particular treatment of it that makes the precious metal even more radiant. This treatment involves the use of lacquers and various procedures to produce a grained effect, create indentations in the surface (in the haloes and wings) or else raise the surface slightly (as in the case of the words AVE MARIA GRATIA PLENA DOMINUS TECUM — 'Hail, Mary, the Lord be with you').

Styles

INTERNATIONAL GOTHIC

This movement spread throughout the whole of Europe between 1380 and 1450. Its common characteristics — common enough in spite of regional differences to be considered a distinct artistic language at the heart of the Gothic style — earned it the name 'International Gothic' at the end of the 19th century, along with others that have today become less common: 'courtly art', 'cosmopolitan art', *weicher Stil* (German: 'soft style').

International Gothic emerged at a time when a coherent European society was starting to form as a result of the many contacts that had developed between countries. From an artistic point of view, these contacts took the form of works of art being bought and sold far from their place of production and of extensive travelling on the part of painters. International Gothic was also related to the crisis affecting that period of history which the Dutch historian Johan Huizinga defined at the beginning of the 20th century as the 'autumn of the Middle Ages'. This was a time when feudal society — faced with the expansion of towns and the spreading of the bourgeois mentality — was on the wane, and noble patrons were financing expensive works that celebrated, for the last time, their chivalrous and aristocratic ideals.

Centres

- The main centres of International Gothic art were the courts. Avignon was possibly its main focal point even before the middle of the 14th century.
- Following this the main centres were the Paris of Charles IV and, in the rest of France, the courts of the dukes Jean de Berry and Philip 'the Bold' of Burgundy; the England of Richard III; the principalities of the Rhine, particularly the city of Cologne, but also Munich, Hamburg and Lübeck; and Prague and the Bohemia of King Wenceslas during the second half of the 14th century.
- The main centres in Italy were Lombardy, where Michelino da Besozzo was working for Gian Galeazzo Visconti around 1380, and in the 15th century Verona, where Pisanello was active, Siena (Sassetta, Sano di Pietro, Giovanni di Paolo) and even Florence (Lorenzo Monaco, Gentile da Fabriano).
- In Spain, where foreign artists such as the Florentine Gherardo Starnina and the German Andrés Marzal de Sax had settled, the main exponents of the movement (in Valencia and Barcelona) were Miguel Alcaniz, Pedro Nicolau and Luis Borrassá.

Characteristics

- The works created during this time were frequently costly and extremely refined. Use of gold was common, and a marked preference was shown for brilliant colours. Human figures were elongated, or at the very least delicate, adorned in fine clothes and aristocratic in their gestures and expressions. But painters liked to differentiate between the social classes, and were happy to depict the rags of the poor as well.
- Though predominantly religious, the paintings also often included princes (*The Adoration of the Magi,* for example, in Gentile da Fabriano's *Strozzi Altarpiece*). Artists celebrated the Virgin by depicting her as a queen (the *Coronation of the Virgin*) or by showing her as a frail and delicate virgin shut away in her garden (*hortus conclusus* or 'closed garden', a symbol of her virginity). Chivalrous themes were also widely portrayed — Paolo Uccello's battle scenes, for example (see p.139), or Pisanello's *Tournaments* cycle, now ruined (Mantua, Ducal Palace). Paintings also celebrated life at court (such as the frescoes in the Torre Aquila, Trento).
- These works were often executed naturalistically. Birds, animals and garden plants were reproduced with great attention to detail, as were the actions of everyday life — the interest being shown in the Infant Christ at the moment of birth in nativity scenes, for example.

• Great attention was paid to space. Paintings with raised horizons — Gentile da Fabriano's *Strozzi Altarpiece*, for example, or Uccello's battle scenes (see p.139) — enabled deep landscapes to be painted in which human figures and other motifs grow smaller in the distance without, however, losing their sharpness of outline or brilliance of colour.

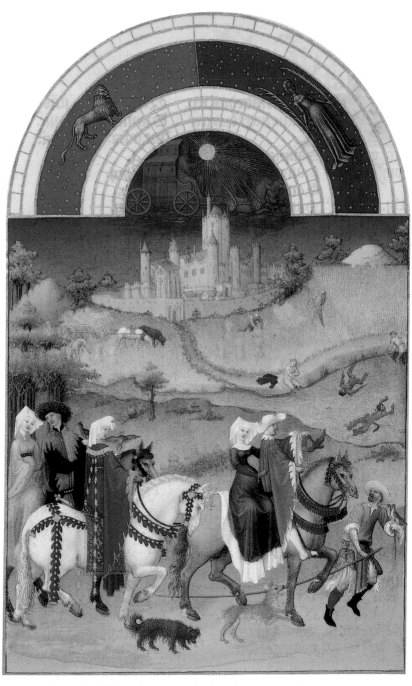

Paul, Jean and Herman Limbourg (The Limbourg Brothers), *August*, 1413–16, illumination from *The Very Rich Hours of the Duc de Berry*, fol. 8v, Chantilly, Musée Condé.

Styles

The Renaissance

In the middle of the 16th century, the term 'renaissance' was used by the art historian Giorgio Vasari in his *Lives of the Most Eminent Painters, Sculptors and Architects* to praise what he saw as a renewal in the arts that had begun with Giotto in Italy in the early 14th century, when painters turned away from their Byzantine models and became interested in the real world and in reviving the art of the ancient Romans.

In the sense in which we use it today — with a capital 'R' — the term was first employed in the 19th century by the French historian Jules Michelet and later by the German cultural historian Jakob Burckhardt in his *Civilization of the Renaissance in Italy* (1867). Burckhardt saw it as resulting from a glorification of the individual by a triumphant bourgeois spirit that was secular, infatuated with reality and thirsty for power.

Contemporary scholarship tends to narrow the chronological definition of the Renaissance and widen its initial geographical horizons.

While not denying the undoubted modernity of Giotto's pictorial revolution, it defines the Renaissance as starting in the 15th century, specifically with the generation of van Eyck in Flanders and that of Masaccio in Italy. Furthermore, it regards the northern centre of activity (Flemish art) as being just as fundamentally innovative in its approach to the real as the Italian centres were. Eschewing any notion of hierarchy, historians identify an initial period that is known as the 'Early Renaissance', and which lasted from 1420 to around 1500. Within this period they examine the different characteristics of the northern and Italian Renaissance (the latter showing the influence in particular of Neoplatonist values on painting) and study the reciprocal influences between the two regions, rather than viewing the new style as spreading in one direction from the Italian peninsula to the rest of Europe.

Specialists also tend to regard the Renaissance as ending at a very early stage in the 1500s rather than viewing the 16th century as a single aesthetic unit. They thus define a period they refer to as the 'High Renaissance', corresponding to the height of Rome's cultural influence, which was encouraged by the patronage of Pope Julius II (1503–13) and Pope Leo X (1513–21). Following this period, what used to be known as the 'Second Renaissance' is now regarded by scholars as 'Mannerism'.

Defined in this way, however, the chronology of the Renaissance corresponds to an Italian viewpoint, as it is based on the primacy of Rome. In certain European regions (such as England), the Gothic era lasted until the beginning of the 16th century and elsewhere, in Spain and the Danube region for example, features of the High Renaissance period were still around long after the 1520s.

Centres and artists

• In Flanders, the pictorial revolution asserted itself in Tournai in the workshop of the little-known Robert Campin (the Master of Flémalle, c.1375–1444) and particularly in Ghent and Bruges, where Hubert van Eyck (d.1426) and his brother JAN VAN EYCK (c.1390–1441) worked. The most important artists of the second half of the 15th century were Rogier van der Weyden (c.1400–64), Petrus Christus (c.1410–72/3), Dierick Bouts (1415–75), Hugo Van der Goes (1435/40–84), Geertgen tot Sint Jans (c.1460–c.1490) and Hans Memling (1435/40–94). After 1500, Gerhard David (c.1460–1523), Quentin Massys (1466–1530) and Joachim Patenier (c.1485–1525) continued the Flemish tradition, bringing to it a greater monumentality (David), a tendency to use anecdote that anticipated the genre scene (Massys) and a growing interest in landscape (Patenier). In 1510, upon his return from a journey to Rome, Jan Gossaert, known as Jan Mabuse (c.1478–1532), who settled in Middelburg in Zealand, began to introduce an Italian influence into the

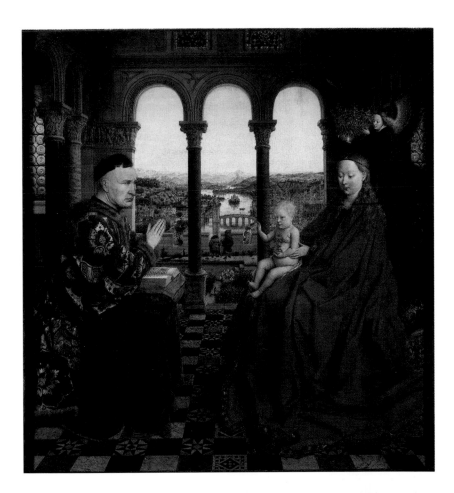

Netherlands. Having become a Habsburg possession in 1477, at the beginning of the 16th century the region produced the first outstanding painter of what would later become the northern Netherlands (or United Provinces). This was Hieronymus Bosch (c.1450–1516), who was born and worked in 's Hertogenbosch.

• In Italy, Florence was the main centre of the Renaissance during the quattrocento, pre-eminent in the fields of architecture (Brunelleschi), sculpture (Donatello) and painting, in which it boasted Masaccio (1401–28), Fra Angelico (c.1395–1455), Paolo Uccello (1397–1475), Sandro Botticelli (1445–1510), Leonardo da Vinci (1452–1519) and many others. At the end of the century, the northern regions made an

Jan van Eyck, *Madonna with Chancellor Rolin*, also known as *The Virgin of Autun*, 1434–6, whole and detail, oil on wood, 81.9 x 59.9cm, Paris, Musée du Louvre.

Styles

active contribution to the definition of a new style with Andrea Mantegna (1431–1506) in Padua and Mantua, Carlo Crivelli (1430/35–1494/1500) and Cosimo Tura (c.1430–95) in Ferrara, and Piero della Francesca (1415/20–92) in Rimini, Arezzo and Urbino. Venetian art started to find a way forward with the Bellini dynasty – Jacopo, its founder (1396?–1470?), his elder son Gentile (1429–1507) and his younger son Giovanni (c.1432–1516) – and with Vittore Carpaccio (c.1460–1526).

Between 1500 and 1520, Rome was Italy's main artistic centre. Raphael (1483–1520, see p.194), at the head of a sizable workshop, and Michelangelo (1475–1564), operating alone, worked concurrently on the Vatican Palace from 1508 – Raphael working on the *Stanze* (the 'chambers' of the papal apartments) and Michelangelo on the Sistine Chapel (whose ceiling was completed in 1512). During the same period, the Venetian school continued to assert itself through Giorgione (1477/8–1510), Palma Vecchio (c.1480–1528) and the early work of Titian (c.1488–1576).

• **In the German-speaking world**, the Swiss painter Konrad Witz (c.1400–before 1446), who worked in Basel, absorbed Flemish influences at a very early stage. Later, also in Switzerland, Hans Leu the Younger (c.1490–1531) painted landscapes featuring jagged mountains and wild vegetation. The Rhineland, with the engraver Martin Schongauer (1453–91) and later the painter Mathias Grünewald (1470/5–1528), was another major centre. In southern Germany the great Renaissance artists were Hans Holbein the Elder in Augsburg (1460/5–1524) and Albrecht Dürer in Nuremberg (1471–1528). To the south, Michael Pacher (1430/5–98) introduced the Italian style into the Tyrol, where a little later Lucas Cranach the Elder (1472–1553), Wolf Huber, Jörg Breu and above all Albrecht Altdorfer developed an original style based on a treatment of landscape (similar to that of Hans Leu) that became known as the 'Danube School'.

• **In Spain**, the Flemish painters influenced the work of Jaime Huguet, Pablo de San Leocadio, Bartolomé Bermejo and later Vicente Masip. Italian models inspired the two Rodrigo de Osonas (father and son) and the Castilian Pedro Berruguete (c.1450–1504), who painted a great deal of his work in northern Italy. North and south merged in the paintings of Jacomart, who made a trip to Naples around 1443. After 1500, aspects of Leonardo da Vinci's style influenced Fernando Yáñez de la Almedina and Fernando de Llanos. Much later on in the 16th century, the work of Raphael inspired Juan de Juanes (before 1523–79) and Juan Correa de Vivar (c.1510–66).

Characteristics

Supports

• Mural painting remained fashionable in Italy. In Venice, the mosaic tradition started to wane and murals began to be painted on canvas (*tele*) for reasons of conservability.

• In spite of the spread of canvas, wood remained the most widely used support for painting. Painters in northern Europe and Spain remained faithful to the more complex style of altarpiece, the polyptych, while in Italy the *pala* or single-panel altarpiece (see p.11) prevailed.

Techniques

• Italian painters continued to use the fresco technique.

• Illumination gradually declined in importance because of the advances made by the printed book.

• From the end of the 15th century, engraving on wood and later (from the early 16th century) copper were developed as important new techniques – either as representational techniques in themselves or as techniques that allowed painted works to be reproduced and disseminated. Schongauer, Dürer and Marcantonio Raimondi (who worked in Raphael's workshop) were among the first great engravers, and Dürer's watercolours are some of the earliest surviving works to have reached us using these techniques.

• Drawing started to acquire a new importance, no longer being regarded merely as a subsidiary technique used for the preparation of painted works.

The influence of Flemish painting on Italian art

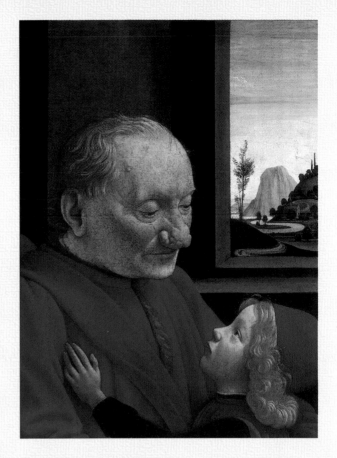

This double portrait, damaged at its centre (on the old man's forehead), was painted by a Florentine artist who never travelled to northern Europe. It nevertheless provides important evidence of the influence exerted by Flemish painting on Italian art during the 15th century.

Typically Flemish elements

This painting was executed in oil (the medium made popular by the paintings of van Eyck) on a wooden support. This allowed extremely detailed effects to be obtained, such as the fur trimming on the sitter's coat.

In terms of composition, Ghirlandaio has favoured a northern style. While the little boy is seen in profile, the old man is presented in three-quarter profile, a Flemish technique that allowed a figure's volume to be emphasized. The two figures are shown in a room in front of a window that looks out onto a landscape. This setting, combining interior and exterior, is similar to those found in northern works during the second half of the 15th century.

The naturalism evident in the man's face is also Flemish: his grey hair is sparse, he has a wart on his temple and above all his bulbous nose has been so meticulously copied from nature that doctors have been able to diagnose a skin disease known as rhinophyma.

A funerary portrait?

Nothing is known of the identity of the sitter or the circumstances in which this picture was painted. A drawing by Ghirlandaio in Stockholm shows the face of a deceased elderly man similar in appearance to the man in the Paris portrait and with the same disfigured nose. It is impossible, however, to tell whether this drawing is a preparatory study for the portrait, which would therefore have been executed after the man's death, or whether it was an independent portrait of a man Ghirlandaio might have been close to during his life, drawn on his deathbed.

Allegorical meaning

Similarly, in the absence of any documentation, viewers are at liberty to work out the meaning of the picture for themselves. This depiction of an old man and a child squeezing up to him may well be the celebration of a close family relationship, but we still do not know whether it was a private image or a commissioned work. It is also possible that the contrast between old age and youth is allegorical in intent, referring to the passage of time or representing an encounter between past and future. Seen in the context of Florentine society, whose structure was based on the supremacy of family bonds, it may symbolize the importance — within a bourgeois framework — of lineage, of dynastic continuity from generation to generation. These various possible meanings are not mutually exclusive.

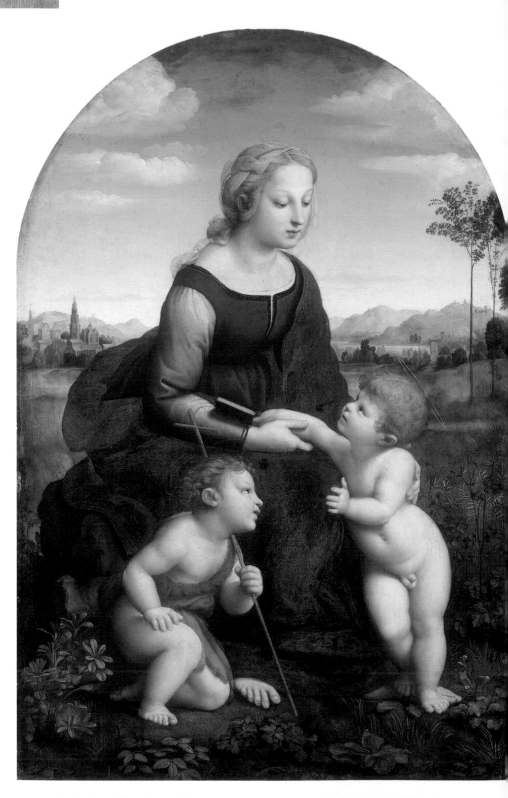

Raphael, *La Belle Jardinière*, also known as *The Virgin and Child with St John the Baptist*, 1507, oil on canvas, 122 x 80cm, Paris, Musée du Louvre.

• The great revolution of the Renaissance was the systematic replacement of tempera by oil. The use of oil (perfected in the north and in particular in the workshop of the van Eyck brothers) spread gradually throughout Europe, starting with Italy, where Flemish works that had been sent to Naples prompted Antonello da Messina to copy the technique. He passed it on to the Venetians when he stayed in Venice in 1475–6 (see p.13).

Themes

• In northern Europe and Spain, religious painting remained extremely important, almost to the exclusion of any other subject matter. New saints and new ways of depicting traditional ones were introduced as a way of reflecting the preoccupations of the day. St Jerome, for instance, was painted in the guise of a humanist at work in his study.
• In Italy, mythological subjects taken from Classical authors (Virgil and Ovid) or contemporary authors (Dante, Petrarch, Boccaccio) gradually became more common. The history of conflicts between cities was a source for battle scenes (*The Battle of Anghiari* and *The Battle of Cascina*, painted by Leonardo da Vinci and Michelangelo respectively for the Palazzo Vecchio in Florence).
• The art of the portrait started to develop. Landscapes, while never painted for their own sake, began to play a more and more important role in paintings, particularly in Venice, Flanders and the Danube region (see p.46).

Composition

• Space began to be rationalized through the use of linear and atmospheric perspective.
• Composition focused on the centre rather than the periphery of paintings, and significant use was made of symmetry. Simple shapes such as the circle and the pyramid were sometimes used to organize the composition of a painting.
• Antique motifs were used for settings (such as the semicircular ceiling vaults in Raphael's *School of Athens*, see p.83, and the sarcophagus in Titian's *Sacred and Profane Love*, see p.XIV of the Introduction), as was architecture inspired by specifically Roman models (which we would call 'Classical' today), such as the centrally planned temple in Raphael's *Marriage of the Virgin* (see p.85) which was reminiscent of the Tempietto being built by Bramante in Rome at that time.

Line, colour, brushwork

• Gold gradually disappeared completely from paintings, and the practice of using expensive colours for strategic parts of a painting also began to disappear. Palettes became more varied. As a general rule they were light, but certain painters attempted unusual lighting effects such as storms (Giorgione's *The Tempest*, see p.6) or night skies broken up by patches of light (Raphael, *The Liberation of St Peter*, see p.58, and *The Transfiguration* in the Vatican Museum in Rome).
• The use of oils allowed more delicate shades of colour to be achieved than had previously been the case, notably in the rendering of landscapes and flesh tones, and also made it possible for painters to obtain a remarkable brilliance, transparency and luminosity.
• The *sfumato* technique, used notably by Leonardo da Vinci, allowed painters to blend figures with their surroundings rather than giving them strong outlines (see p.78).

Figures

• The depiction of faces was inspired by a new realism, particularly in Flemish painting. Artists focused their efforts on the diversification of human figures, which had to be convincing in terms of resemblance to real individuals as well as in terms of their movements.
• At the same time, particularly in Italy, a desire to idealize — which expressed itself above all in the depiction of the nude — inspired painters to observe canons of proportions and to give their figures poses that were judged to be ideally beautiful. The various codes that were proposed took their inspiration from antique models, the writings of Vitruvius and the Roman sculptures that were being excavated at the time.
• The corollary of this 'standardization' of beauty was the emergence of antithetical types. The grotesque, an early form of caricature, came into being at this time (see p.170).

ALTDORFER AND THE DANUBE SCHOOL: ANOTHER RENAISSANCE

Albrecht Altdorfer (c.1480–1538), who worked in Regensburg, was the leading exponent of the so-called 'Danube School' (*Donauschule*). The subject of this large-format painting executed in 1529 for the Duke of Bavaria is the battle of Issus between Alexander the Great and King Darius III of Persia in 333 BC. While it clearly belongs to the Renaissance from the point of view of its theme (taken from ancient history) and technique (oil), it provides a good illustration of the diversity of European painting which is called 'Renaissance', due to the number of features that distinguish it from other works being produced at the time.

A symbolic landscape

This painting presents us with a fascinating landscape. The viewer looks down from a great height on a large expanse of land in the lower half of the picture (executed in brown-red and green-red tones) and water and sky in the top half (executed in blue tones). The two halves of the painting are connected chromatically by the repetition of each set of dominant colours in the opposite half: the blue reflections on the armour of the soldiers in the terrestrial half and the brown and red hues of the sun and the enormous sign decorated with ribbons in the sky area. Faced with this immense panorama, the viewer becomes dizzy. The view of the battlefield, filled with innumerable tiny figures, contributes to this sensation, as does the movement of the improbable sign (swivelling in a strong wind) that is suspended in the void. This panel bears a Latin inscription that relates the circumstances of the battle and tells of the ultimate victory of Alexander. The clouds, torn apart, and the simultaneous presence of the moon, rising on the left, and the sun, disappearing on the right, gives the viewer the feeling that the battle is not just between men, but between the forces of nature as well.

Freeze frame

The painter has captured a precise moment in time. Order has been introduced into the teeming confusion of battle. While in the foreground and background the Persian and Greek armies continue to confront each other, a new situation has developed at the centre of the scene, and the soldiers' upright spears indicate that they are no longer fighting but are on the march. Greek infantry and cavalry are attempting to catch up with Darius' guard, which has turned and fled. Isolated amid the chase are a magnificently dressed horseman on a white mount (Alexander), and the chariot of the Persian king, who will clearly not win the day.

The pre-eminence of colour

The encounter takes place in clouds of dust, which in certain places blur the forms, thus emphasizing the violence of the struggle. In the top part of the painting, the yellow-orange splendour of the sun is reflected in long streaks across the water. This painting gives priority to colour and landscape in a way that no other painting from Flanders, Italy or Spain does. It merges man and his actions with a panorama that dwarfs the individual, reminding him of his true insignificance in the face of God's immensity.

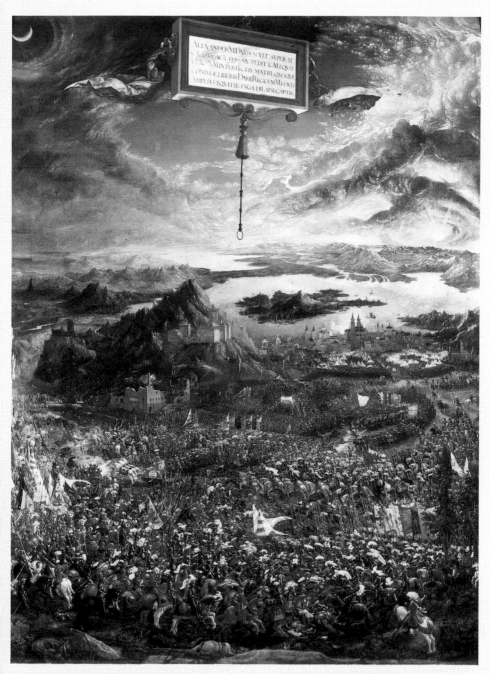

Albrecht Altdorfer, *The Battle of Alexander at Issus*, 1529, oil on wood, 158.4 x 120cm, Munich, Alte Pinakothek.

 Styles

 # Mannerism

The adjective 'manniériste' was first used in 1662 by the Frenchman Fréart de Chambray, a friend of Poussin and a collector of his works. The noun 'manierismo' was used over a century later, in 1792, by the Italian historian Luigi Lanzi. These terms, which derive from the Italian *maniera* (manner, style), were employed around 1400 by Cennino Cennini and in the 16th century by Giorgio Vasari; they were used disparagingly, to castigate a form of stylistic exaggeration that had established itself at the expense of the imitation of nature. It was not until the 19th century and especially the 20th century that Mannerism was rehabilitated.

Mannerism's dates were set by Lanzi at the end of the 18th century. According to his chronology, it started with the Sack of Rome by Imperial troops in 1527, thus with the sudden decline of the pontifical city and the dispersal of the artists who worked in it, and ended with the advent of the Carracci family (and Caravaggio, it must be added) around 1600. However, there is a tendency today to regard the Mannerist aesthetic as being already present in works painted in Rome as early as 1520 (the year of Raphael's death, which left his workshop without a master), if not earlier — notably in works executed in Florence at the beginning of the century by Michelangelo (such as the *Tondo Doni*, 1504–6, Florence, Galleria degli Uffizi). The genesis of Mannerism was therefore characterized by a gradual development of forms rather than an abrupt break initiated by external events. In order to underline this continuity with the period sometimes known as the 'High Renaissance', certain art historians choose to refer to Mannerism as the 'Mannerist Renaissance'.

Whatever name one gives it, the movement's birthplace was Italy, but it spread so widely throughout the rest of Europe that it would not be inappropriate to talk of 'International Mannerism' in the same way that 'International Gothic' has been described above.

Centres and artists

• **Italy.** While it may be possible to find elements of proto-Mannerism in the paintings executed in Rome after 1508, the sacking of the city in 1527 prevented the popes from playing an important role again until Pope Paul III commissioned Michelangelo to paint *The Last Judgement* (1536–41) and the frescoes in the Pauline Chapel (1542–50).

In Tuscany, Florence became the main focus of the new style at the beginning of the 1520s. This style expressed itself in the work of Andrea del Sarto (1486–1530), Jacopo Carucci, known as Pontormo (1494–1556), and Giovanni Battista Rosso, known as Rosso Fiorentino (1494–1540), who had left Florence for Rome in 1523 or 1524 and had a difficult escape from that city a few years later. In the second half of the 16th century, the new generation of Florentine Mannerists included Francesco Salviati (1510–63), Giorgio Vasari (1511–74) and most importantly Agnolo di Cosimo, known as Bronzino (1503–72), the court painter of Grand Duke Cosimo I de' Medici. The other Tuscan centre of Mannerism was Siena, where Domenico Beccafumi (c.1486–1551) was active.

Further north, Parma and Emilia, where Correggio (c.1489–1534) and Parmigianino (1503–40) worked, were also important Mannerist centres, and Giulio Romano (1499–1546), who had been Raphael's main collaborator, worked in Mantua from 1523. Venice's stylistic development was so distinct from the rest of the Italian peninsula that it might not be appropriate to talk of Mannerism there except in the case of Lorenzo Lotto (1480–1556), who spent most of his working life in the province of Venice rather than in Venice itself, and possibly Tintoretto (1518–94).

• In **Spain**, Mannerism was represented by Alonso Berruguete (1489–1561), who had worked in Italy until around 1518 (where he influenced the early careers of Pontormo and Rosso Fiorentino) Pedro Machuca (c.1495–1550) and the Flemish painter Peter de Kempener, known in Spain as Pedro de Campana (1503–80). The strongest artistic

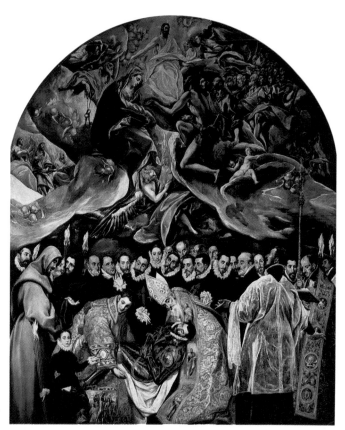

El Greco (Domenikos
Theotokopoulos),
The Burial of Count Orgaz,
1586, oil on canvas, 480 x
360cm, Toledo, Santo Tomé.

personality at the end of the century was EL GRECO (1541–1614), a Greek from Crete who
had spent time in Venice and Rome before settling in Toledo in 1577.

• In northern Europe, where religious and political conflict resulted in the gradual sepa-
ration of the Catholic southern Netherlands (Flanders) from the Protestant northern
Netherlands (United Provinces), painting cannot be described simply in terms of the Italian
influence. Artists such as Jan van Hemessen (c.1500–c.1565), the creator of genre scenes
that anticipated the themes and compositional style of Caravaggio, and particularly Pieter
Bruegel the Elder (c.1525/30–69) defy any attempt to define them as Mannerists.
However, it was becoming more and more common for Flemish painters to undertake
journeys to Italy, where artists such as Pieter de Witte (Pietro Candido) stayed for
extended periods and others, such as Lambert Sustris, settled for good, and this con-
tributed to the development at the end of the century of a trend known as 'Romanist'
which does indeed merit the description 'Mannerist'.

Antwerp was the main focus of Romanism in the southern Netherlands, with Jan de Beer
and Jan Wellens de Cock (Jan van Leyden) active initially, followed by Pieter Coecke van
Aelst (1502–50), Frans Floris (c.1519–70) and, at the end of the century, Maerten de Vos
(1532–1603). These painters are often referred to as the 'Antwerp Mannerists'.

In the north, Mannerism manifested itself initially in Leiden, where the transitional work
of Cornelis Engebrechtsz (c.1465–1527) has been described as 'Gothic Mannerism'. Later,
Utrecht became another centre of Netherlands Mannerism, with the remarkable por-
traitist Jan van Scorel (1495–1562), Dirck Barendsz, Joos de Beer, Joachim Wtewael
(1566–1638) and Abraham Blomaert (1564–1651), who kept the style alive right into the
middle of the 17th century. The last Mannerist centre in northern Europe was Haarlem,
where the Italian influence introduced by Maerten van Heemskerck (1498–1574) came to
the fore in the work of Karel van Mander (1548–1606), author of *The Book of Painters* (*Het
Schilder-Boeck*) – a northern equivalent of Vasari's *Lives*, Hendrick Goltzius (1558–1617)
and Cornelis van Haarlem (1562–1638).

• As for the German-speaking world, it is difficult to link Dürer and painters of the

Styles

Danube School to Mannerism. However, Cranach's nudes — due to their elongated proportions and the erotic power of their pale flesh enveloped in transparent veils — were not uninfluenced by the Mannerist aesthetic. The same is true of a number of canvases by the Swiss painter Manuel Deutsch (1484–1530). A brilliant centre of Mannerism developed at a relatively late stage at the court of Rudolph II in Prague. Rudolph summoned Italian artists such as Giuseppe Arcimboldo (1527–93) and Flemish artists such as Bartholomeus Spranger from Antwerp (1546–1611), Heintz the Elder, Hans von Aachen and the miniaturist Georg Hoefnagel.

• In France, FONTAINEBLEAU became one of the most remarkable centres of Mannerism, thanks to the patronage of François I. In addition to Leonardo da Vinci, the French monarch attracted Italian artists such as Andrea del Sarto (briefly) in 1518, Rosso in 1532, Francesco Primaticcio, known as 'Le Primatice' (1504–70), Luca Penni and Niccolò dell'Abbate. Under Henri IV, the Second Fontainebleau School also consisted of foreigners, this time from Flanders rather than Italy, and included Ambroise Dubois (alias Ambrosius Bosschaert?), although a number of French figures also emerged, such as Toussaint Dubreuil (c.1561–1602) and Martin Fréminet (1567–1619).

• In England, Henry VIII also appealed for foreigners to come and work at his court. Those who responded included the Italians Antonio Toto del Nunziata, Bartolomeo Penni and Nicolas Bellin da Modena, and Flemish artists such as Hans Eworth (Ewoutsz). During the reign of Elizabeth I, many painters dedicated themselves to the portrait, including Nicholas Hilliard (1547–1619) and Isaac Oliver (c.1556/65–1617), who was of French origin.

Characteristics

Techniques and supports

• These were the same as during the Renaissance. Fresco remained common in Italy; oil had spread throughout Europe by this time, and was used on both canvas and wood. Wood was still the most commonly used support in northern Europe.

• While works designed for the decoration of churches and palaces were necessarily large, court culture also favoured more intimate works that were often small in format. These included drawings, prints (which were produced in large numbers around 1540 and contributed to the dissemination of the new style), miniatures now executed in watercolour, such as the *Album of Insects* painted in Prague by Hoefnagel (Brussels, Bibliothèque Royale), and paintings (small portraits such as those executed by Hilliard in England as well as paintings of other subjects). In order to intensify the colours, artists like Spranger sometimes chose copper as the support for these small-format works.

Themes

• Religious themes, the basis of works commissioned for the churches, remained common. A mystical artist like El Greco painted one religious subject after another, although he did also paint a number of Classical subjects (the story of Laocoon), genre scenes — *Boy Lighting a Candle* (Naples, Capodimonte), which is really a meditation on light — and landscapes, notably his *Views of Toledo*.

• Mythology and allegory became more and more common. Artists incorporated erudition and esotericism in their works, which were designed to provide intellectual pleasure in part through the deciphering of often hidden or complex messages. In the gallery of François I at Fontainebleau, and also in other great cycles of paintings, we find cosmological symbols (stars, the seasons of the year, the stages of life), moral symbols (the virtues) and historical symbols (the family, the State) intertwined. Artists used books of symbols (*imprese*) to help them design their allegories. The most widely used of these, Cesare Ripa's *Iconologia*, was published relatively late, however, in 1593.

• The importance of the portrait increased steadily. There are two reasons for this. Firstly, court culture favoured the cultivation of the individual, provided this was carried out within the established hierarchy and according to fixed norms. Secondly, the mistrust of images expressed by Protestant and particularly Calvinist theologians, along with their

censure of all religious painting and condemnation of the nude, did at least leave painters free to paint portraits (see p.41).

Composition, line, colour, brushwork

• The formal treatment of the image was designed to challenge the eye just as much as the subject matter was. Painters employed a range of very different techniques in order to take the viewer by surprise. These included: contrasting a large figure in the foreground with a much smaller one in the background, as in Parmigianino's *The Madonna with the Long Neck* (see p.144), a method also used occasionally by Pontormo and systematically by Spranger; depicting bodies so intertwined that it is difficult to distinguish one from another (Rosso);

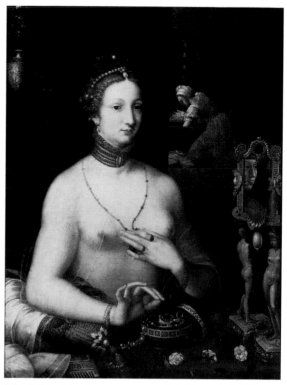

School of Fontainebleau, anonymous artist, *Woman at Her Toilet,* c.1560, oil on wood, 105 x 76cm, Dijon, Musée des Beaux-Arts.

decentralized composition; opening up the picture through the use of forms that continue beyond the frame; violent contrasts of light or colour (Cranach and, in a very different way, Beccafumi); and the use of unfamiliar shades and hues (the vivid palette adopted by Pontormo, for example).

• These techniques are too numerous to be listed here in their entirety. Mannerism could be said to be the art of an era during which images became abundant for the first time. This very abundance provoked an intolerant reaction (the iconoclast crisis linked to the Reformation) but also, due to a process of familiarization, forced painters to look continually for new solutions and to go further in their experimentation. In this respect, Mannerism was perhaps the first of the modern 'movements': it was based on an attitude of mind not very far removed from that of the 20th-century avant-garde.

Figures

• The Mannerists' figures, too, had to astonish the viewer. Distorted proportions; the body treated in terms of a serpentine line on the one hand or repeatedly broken straight lines on the other (Rosso); complex poses (exaggerated *contrapposto* stances, violent movement) — these techniques were combined with an emphasis on the grace and sensuality (*venustas*) or power (*terribilatà*) of the human figure.

• Religious crisis in the form of the Reformation brought gradual change (depending on region), and influenced the type of subjects in which bodies could be shown. Erotic subjects triumphed in the countries that remained Catholic: from Marcantonio Raimondi's engravings of Giulio Romano's illustrations of the poet Aretino's *Modi* (lovemaking positions) to the images of women at their toilet or women bathing of the Second Fontainebleau School via the *poesie* (mythological scenes featuring largely naked goddesses) commissioned from Titian by Philip II of Spain. In Protestant countries on the other hand, nudity was less commonly portrayed and there was no place at all for erotic painting (see p.40).

Styles

Caravaggism

Caravaggism is the name given to the 17th-century trend in painting that derived from the art of Michelangelo Merisi, known as CARAVAGGIO (1570/71–1610).

Strictly speaking, Caravaggism corresponds to Caravaggio's own period of activity: the last eight or ten years of the 16th century and the first ten years of the 17th century. However, many young painters born around 1580–90 who discovered his works in the years 1605–6 imitated his style enthusiastically. The movement survived in Rome until about 1620 when, with the return of artists to their home towns, it spread throughout Italy and the rest of Europe, enjoying enormous success before declining by the middle of the century.

Centres

• **Italy.** Originating in Rome, where Michelangelo Merisi had arrived in 1591 or 1592, Caravaggism developed there within a cosmopolitan artistic community that included the Tuscan Orazio Gentileschi (1583-1639), the Venetian Carlo Saraceni (c.1580-1620), the Roman Orazio Borgianni (c.1578-1616), the Mantuan Bartolomeo Manfredi (1582-1622), the German Adam Elsheimer (1578-1610), the Frenchmen Valentin de Boulogne (1591-1632, see p.205) and, until his return to France, Simon Vouet (1590-1649), and the Dutch painters Gerrit van Honthorst and Hendrick Terbrugghen.
Caravaggio's trip to Naples in 1607 encouraged the early development of his style in that city. The main exponents of Neapolitan Caravaggism were Giovanni Battista Caracciolo (1578-1635), Andrea Vaccaro, Bernardo Cavallino and Massimo Stanzione, and after 1630 Mattia Preti (1613-99), Salvator Rosa (1615-73) and Luca Giordano (1634-1705) in the early part of their careers. Elsewhere, Caravaggio's influence was short-lived. It was felt in Florence between 1612 and 1621 thanks to the presence of Artemisia Gentileschi (1593-1652/3), the daughter of Orazio, who settled in Naples after 1626.
• **Spain** had enjoyed close connections with Italy, especially Naples, for centuries. It was the first country outside Italy to discover Caravaggism, due to works by the master and his disciples being sent there early on and due to journeys undertaken by artists in both directions. Borgianni worked in Spain on several occasions around 1600, while Jusepe de Ribera (1591-1652), nicknamed II Spagnoletto, settled permanently in Naples in 1616. Among the first painters to convert to Caravaggism were Francesco de Ribalta (1565-1628) and his son Juan (1596/7-1628) in Valencia, and to a certain degree the monk Alonso Sánchez Cotán (1560-1627), a still-life painter. Diego Velázquez, during the time he spent in Seville, and Francisco de Zurbarán, around 1630, were also influenced by this aesthetic, which remained the dominant trend in Spanish painting until nearly 1635.
• **Lorraine** was an independent duchy in the 17th century. Jean Le Clerc (1585-1633), who spent the years 1600-10 in Rome, was the main disseminator of the Caravaggesque style, whose realism inspired the picturesque scenes of the engraver Jacques Callot (1592-1635). But the history of Caravaggism in the duchy culminated in the work of Georges de La Tour (1593-1652) in Lunéville.
• **In France,** Caravaggio's influence made itself felt above all in the provinces: in Toulouse, with Nicolas Tournier (1590–after 1657), in Burgundy, where Richard Tassel worked (c.1580–c.1666), in Aix-en-Provence, where the Flemish artist Louis Finson (Finsonius) settled in 1613, and in the Puy, where the monk Guy François was active. The influence of Caravaggism can also been seen in the still lifes of Lubin Baugin, Jacques Linard, Louise Moillon and Sébastien Stoskopff. The art of the Le Nain brothers, Antoine (c.1588-1648), Louis (c.1593-1648) and Mathieu (1607-77), natives of Laon, was also partly rooted in this style.
• **The seven northern provinces of the Netherlands** that had united to form the Union of Utrecht were Protestant. Although Baroque art, being an expression of the Catholic Reformation, did not suit the regional temperament, Caravaggism did take root there. The

Caravaggio (Michelangelo Merisi),
The Conversion of St Paul, 1601, whole and
detail, oil on canvas, 230 x 175cm, Rome,
Cerasi Chapel (right side wall), Santa
Maria del Popolo.

main proponent of Caravaggism in the region was Terbrugghen (1588–1629), who returned from Rome in 1614. Along with Dirck van Baburen (c.1594–1624) and Van Honthorst, nicknamed Gherardo delle Notti (1590–1656), who had both spent time in Rome between 1610 and 1620, he founded the Utrecht School. Later in the century, the work of Frans Hals (1581/5–1666) in Haarlem, Rembrandt (1606–69) in Amsterdam and even (because of his attention to light) Jan Vermeer (1632–75) in Delft was also influenced by Caravaggesque stylistic elements.

Characteristics

Techniques and supports
• Caravaggesque paintings were executed in oil on canvas, in formats that allowed figures to be portrayed life-size.

Subjects
• The art of Caravaggio and his disciples was to a large extent religious. Much of its subject matter was furnished by the Old and New Testaments and stories of the saints. Its themes are easily recognizable: the Caravaggesque painters did not place a particularly high value on subtle or erudite subjects.
• Genre scenes are common. Caravaggio led a disorderly life, and so too did his emulators. Their morals are reflected in the Caravaggesque iconography, in which tavern scenes, card games, drinking bouts, brawls, concerts (musicians often had a bad reputation) and encounters with gypsy women proliferate. During the final period of Caravaggism, this taste for trivial detail and slices of low-life gave rise to colourful genre scenes known as *bambocciate* (singular *bambocciata*, Italian for 'childish action'). Those who painted such scenes were labelled *bamboccianti*.
• Mythological subjects are far rarer, although Caravaggio depicted Bacchus, god of wine (and thus of drinking binges and carnal love) a number of times, as did Velázquez (in deliberately rustic style).
• The Caravaggisti loved subjects rich in dramatic power: Judith murdering Holofernes, Abraham's sacrifice of Isaac and scenes of martyrdom are extremely common.
• Still lifes are not totally absent from the Caravaggesque repertoire. In Spain and France in particular, they consisted of humble objects displayed in a shallow space against a dark background. The term *bodegon* was used in Spain to denote this type of subject (see p.55).

Composition
• The Caravaggisti shunned vast panoramas. They preferred to bring the action up close to the viewer, depicting figures life-size, either full-length or half-length.
• There is no deep space in their pictures. There is usually a dark background – a wall, a curtain (less commonly) or the impenetrable darkness of night – immediately behind the figures, thus forming a visual barrier that forces the viewer to concentrate on the action in the foreground.
• All elements reminiscent of antique decoration or Classical pomp are excluded. Sarcophagus-type motifs (one exception being Valentin de Boulogne's *Concert with Roman Bas-Relief*, Paris, Musée du Louvre), columns, pediments and so on disappear in favour of humble objects such as wicker baskets, earthenware bowls, copper basins and stools.

Line, colour, brushwork
• No drawings by Caravaggio are known and very few by any of his followers.
• The adoption of a dark palette interspersed with areas of intense light and colour represented a radical break with the light palette that had predominated until then. This taste for chiaroscuro and dramatic contrasts of light was taken to its limit by the *tenebrosi*, a group of mainly Neapolitan and Spanish painters who were enthusiasts of tenebrism, the use of dark tonalities in painting.

Valentin de Boulogne, *Gathering in a Tavern*, c.1625, oil on canvas, 96 x 133cm, Paris, Musée du Louvre.

• The Caravaggisti used bright colours, relying heavily on the primaries (particularly red and yellow) to break up the predominant browns of their backgrounds. They avoided the complex combinations of colours favoured by the Mannerists (see p.117).

Figures

• 'The most famous statues by Phidias and Glycon having one day been proposed [to Caravaggio] as subjects for studies, by way of an answer he merely indicated the crowd with a wave of his hand. [...] And to give weight to his words, he called a gypsy woman over [...] and drew her portrait,' claims Bellori, the painter's biographer. This anecdote is probably untrue, but has the virtue of highlighting one of the fundamental characteristics of Caravaggism: the realism of its figures (and therefore in all probability the use of live models) and its tendency to feature protagonists who, far from being idealized, were everyday types — rough boys from the streets of Rome and ordinary workmen and women dressed in old clothes. This characteristic earned Caravaggio the criticism that he lacked nobility. In the 19th and 20th centuries it helped popularize the expression 'painters of reality' (first used by the realist novelist Champfleury in his work *Painters of Reality under Louis XIII. The Le Nain Brothers*) as a way of denoting, among others, Caravaggesque artists.

• The poses given to their figures by Caravaggio and his followers are always dynamic. Their bodies, being those of working people, are never at rest. They are always either in movement (except if dead) or on the verge of moving. However, such movement had nothing in common with the soaring motions of the Baroque style that followed. The figures painted by Caravaggio do not soar — even the rare angels that appear in his work give the impression of being suspended on ropes rather than flying (like *St Matthew and the Angel* in San Luigi dei Francesi). On the contrary, his characters seem to be pulled downwards by the power of gravity, either falling (*The Conversion of St Paul*) or struggling to raise a heavy object (*The Crucifixion of St Peter*, see p.141).

The Baroque

The term 'Baroque' was not used during the 17th century. Its origins are disputed, though it probably derives from the Spanish *barrueco*, which denotes an irregularly shaped stone. In France, the adjective appeared for the first time in the *Dictionnaire de l'Académie* of 1694 to describe a misshapen pearl and was later derogatorily defined in the *Dictionnaire de Trévoux* in 1771 as 'irregular', 'peculiar', 'uneven'.

The word retained its pejorative associations until the 19th century, when the Swiss historian H Wölfflin published — in his first book, *Renaissance and Baroque* (1888) — a positive assessment of the transformations that took place in Italian architecture during the second half of the 16th century. In *Principles of Art History* (1915), he attempted to define the distinctive characteristics of Baroque painting by contrasting them with those of Classical painting in a non-hierarchical manner. The German Alois Riegl (*The Birth of Baroque Art in Rome*, 1908) and the Italian Eugenio d'Ors (*On the Baroque*, 1935) stand out among the other historians who have contributed to the rehabilitation of Baroque art.

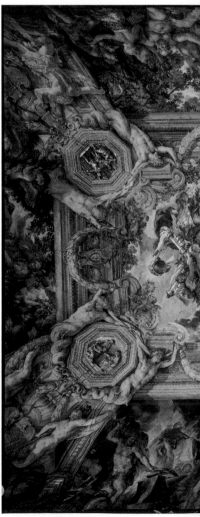

The Baroque was closely linked to the Catholic Counter-Reformation. While its artistic roots lay in the Caravaggism of the beginning of the 17th century, its spiritual basis went back to the desire expressed by the Council of Trent (1545–63) to rehabilitate the image by creating a form of realist art that appealed to the emotions rather than to the mind. Associated in this way with militant Catholicism, and most notably with the programme of the Jesuits, the Baroque developed in countries that remained true to the Roman Catholic faith. From 1600 onwards, the Baroque style established itself in Rome and then throughout Italy, in the Spanish-speaking world, the southern Netherlands (which remained under Spanish control) and, following the Thirty Years War (1618–48), in Austria and Bavaria.

However, care must be taken not to identify the Baroque too precisely with Catholic countries and regions. Even in Rome there was a Classical tradition, represented by the Frenchman Nicolas Poussin, as well as by Domenichino, Guido Reni and Il Guercino. Catholic France resisted the Baroque vigorously, while certain Protestant countries such as Rembrandt's Holland did not remain entirely immune to its influence. It could be claimed that the Baroque, indissolubly linked in this respect with the Catholic Reformation, was implementing a rhetoric of action similar to that of the great expansionist monarchies: the Holy Roman Empire, the Spanish monarchy and its colonies in the New World, and the Italy of the popes and the duchies. From a sociological point of view, as the historian Victor Louis Tapié has shown in *Baroque and Classicism* (1957), the Baroque style established itself in Europe's agricultural regions, which were characterized by a system of private land ownership and a strict hierarchy, while it spread less successfully in urbanized countries with a powerful bourgeoisie.

What is certain is that the Baroque affected the whole of the 17th century, changing gradually through the first half of the 18th century as it evolved towards Rococo.

Centres and artists

• Italy was the cradle of the Baroque. The style expressed itself in Rome in the decoration of cupolas that seemed to open up architectural interiors and provide a view of the heavens. The principal exponents of this style were Giovanni Lanfranco (1582–1647) and most importantly PIETRO DA CORTONA (1596–1669) for his work at the Palazzo Barberini, then Giovanni Battista Gaulli, known as Il Baciccio or Baciccia (1639–1709), for his decoration of the Gesù, and finally Father Andrea Pozzo (1642–1709) for his ceiling fresco in St Ignatius. Outside Rome, the Baroque style had great success in Genoa, with Giovanni Benedetto Castiglione (who was also active in Rome and Mantua and whose work did not always follow the Baroque pattern), Bernado Strozzi (1581–1644), Gregorio de Ferrari (1647–1726) and Alessandro Magnasco (1667–1749). In Naples it informed the work of followers of Caravaggio such as the Spaniard José de Ribera (see p.208) and younger painters such as Mattia Preti (1613–1699). In Milan, the Baroque manner established

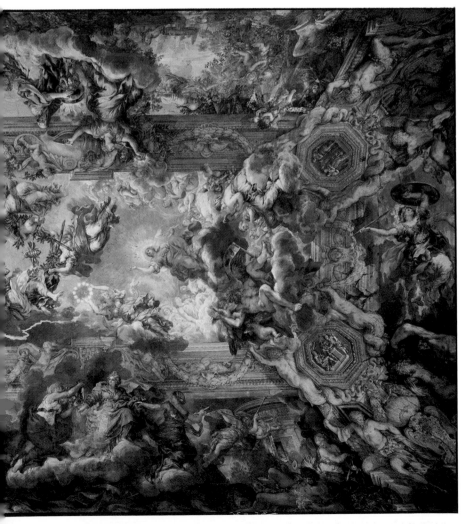

Pietro da Cortone, *The Glorification of the Reign of Urban VIII*, 1633–9, fresco, Rome, Palazzo Barberini.

itself early on through the work of Pier Francesco Mazzuchelli, known as Morazzone, and Giovanni Battista Crespi, known as Il Cerano.

• **In the Spanish Netherlands,** the first and most important representative of the Baroque was the Antwerp painter Sir Peter Paul Rubens (1577–1640). Jacob Jordaens (1593–1678, see p.210), whose studio was also in Antwerp, adopted a similar style in paintings that often displayed a more lurid and mystical streak.

• **In England,** Sir Anthony Van Dyck (1599–1641) — likewise a native of Antwerp, who worked in Rubens's studio before spending time in Italy, notably Genoa, and settling in England in 1632 — showed in his portraits of aristocrats an interest in the paint medium itself, using visible brushwork in accordance with the Baroque aesthetic. Following in the footsteps of the Italian artists who had introduced the fashion for illusionist decoration to England, James Thornhill (1675– 1734) decorated the cupola of Wren's St Paul's Cathedral in the Baroque style.

• **In Spain,** Francisco de Zurbarán (1598–1664), Bartolomé Esteban Murillo (1618–82) and most importantly Diego Velázquez (1599–1660) — who was court painter to Philip IV, met Rubens in 1628 and made two journeys to Italy — embodied an aesthetic that preserved a strong national character and counterbalanced the most extreme aspects of the Baroque with elements of Classical composition. Later, in the reign of Charles II, Francisco Herrera the Younger (1627–

José de Ribera, *The Martyrdom of Saint Philip,* 1639, oil on canvas, 234 x 234cm, Madrid, Museo Nacional del Prado.

85), Juan Carreño de Miranda (1614–85), Juan de Valdés Leal (1622–90) and Claudio Coello (1642–93) adhered more closely to the Baroque style used by Italian artists working in Spain, notably the Neapolitan Luca Giordano (1634–1705), who was nicknamed 'Luca fa presto' because of the speed at which he painted.

• **In central Europe,** the Baroque blossomed in Vienna thanks to Father Andrea Pozzo, who worked there from 1703 to his death in 1709. After him, the leading painter of ceiling decorations was Johann Michael Rottmayr (1654–1730), who decorated the buildings of the architect Fischer von Erlach. In Munich, the brothers Cosmas Damian Asam and Egid Quirin Asam executed large decorative pieces that combined sculpture, stucco and fresco, notably in the choir of St John Nepomuk (1733).

• **In France,** Simon Vouet, whose earlier work had been much influenced by Caravaggio, was one of the few artists in Paris who attempted to combine Baroque dynamism with Classical rigour. During the 1620s, Rubens's cycle of paintings devoted to the life of Marie de Médicis, painted for the Palais du Luxembourg, aroused little interest. At the end of the century, however, a number of painters with a strong interest in colour rediscovered Rubens's art, and the work of Charles de La Fosse (1636–1716), Jean Jouvenet (1644–1717) and Antoine Coypel (1661–1722) took on discreet Baroque overtones.

Characteristics

Techniques and supports

• The Baroque style was dominated by mural decoration, in particular ceilings painted using the fresco technique. Works were generally large, taking their dimensions from ceiling vaults and domes that were no longer divided up into compartments. The painted works were generally set within ornate moulded frameworks featuring a combination of stucco (a mixture of powdered marble and chalk) and sculpture.

• Canvas predominated in the south, but wood remained popular in northern Europe, where artists remained faithful to the triptych or adopted the format of the single-compartment altar picture. These were usually enclosed within a heavy wooden frame decorated with gilt sculptures. Works were executed in oil, and dimensions were almost always large: paintings were decorative, destined mainly for churches, and needed to be visible from a distance by large congregations.

Themes

• Baroque painting was primarily devotional. The art historian Émile Mâle described its subjects in his book *Religious Art of the 17th Century. A Study of Iconography After the Council of Trent*, written in the middle of the 20th century: the Virgin (in Spain the themes of the Assumption and the Immaculate Conception in particular), the angels and the lives of the saints, including the lives of recent heroes of the Catholic church (for example, Saint Ignatius of Loyola, founder of the Jesuit order). The images were intended to be triumphal: painters depicted apotheoses (holy figures borne up into the clouds by angels) or religious ecstasy (the rapture of saints experiencing visions of heaven). A tendency towards theatricality and the desire to surprise and move the viewer also led painters to depict scenes of martyrdom and visions of death. This trend culminated in the cult of the macabre — in Spain in the work of Valdés Leal, who devoted large canvases to the triumph of death (*Finis Gloriae Mundi* and *In Ictu Oculi*, Seville, Hospital de la Caridad).

• Baroque painting was not entirely religious, however, and mythological scenes and allegories which legitimized the depiction of the nude (as in the work of Rubens and Jordaens) also formed part of its iconography.

• Subjects of a trivial nature were depicted in genre scenes, although these were relatively rare and were more a feature of painting in the north, where they continued a tradition that went back as far as Bruegel. There are a few isolated examples in the work of Rubens (*The Village Fair*, Paris, Musée du Louvre, for example), but they are more common in the work of Jordaens, who painted domestic concerts and Twelfth-Night feasts (*The King Drinks*, Vienna, Kunstmuseum, see p.210) as well as various other subjects.

Composition, line, colour, brushwork

In his *Principles of Art History*, Heinrich Wölfflin defined the characteristics of the Baroque style with regard to composition, line, surface finish and colour by contrasting them with the characteristics of Classicism. The distinctions he made should be approached with caution, as they are not all present at the same time and to the same extent in every Baroque work, and certain characteristics that are supposed to be Baroque can be found in paintings that are generally regarded as Classical. Nevertheless, Wölfflin's five definitions cannot be ignored:

• Baroque painters played down the linear in favour of the 'pictorial'. In other words, drawing was not, for them, the essential element in their works. Figures and objects do not have the same sharp outlines that they have in Classical painting: forms interlink and the eye is no longer guided by a rational system of linear perspective. Instead the viewer's attention is held by the tactile and chromatic elements that structure the painting: the brushwork, varied and dramatic light effects, and the manner in which surfaces, particularly flesh tones and drapery, are rendered.

• However, Baroque painters did not reject the notion of depth. On the contrary, the eye is still led from the foreground into the background, but not by a near-exclusive use of perspective lines as previously. In order to be convinced of this, we merely have to think

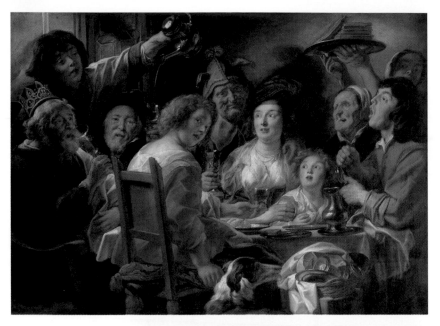

Jacob Jordaens,
The King Drinks,
1638–40, whole and
detail, oil on canvas,
152 x 204cm, Paris,
Musée du Louvre.

of the large vistas presented by ceilings painted in this style, in which the eye plunges along vertiginous diagonals.

• Another Baroque characteristic is the opening up of the composition ('open form'). This does not mean that painters cut off their works in mid-composition or devised viewpoints as subjective as those of 19th-century painters such as Degas. However, through their distribution of forms within the interior of the work, they refrained from highlighting the proximity of either the edges or corners of the painting. This approach had important consequences: as the composition of these works was no longer thought out in terms of their borders, it could be decentralized and did not have to be based on top–bottom or right–left symmetry. Another consequence was that painters could emphasize lines that ran counter to the horizontals or verticals of the frame, and arrange their forms along diagonals, creating a sense of movement rather than stability. Many scenes are presented as if the spectator is an actual participant, very close to the main action. Partially seen figures at the edges of the canvas enhance the effect of immediacy and involvement.

• Baroque works were planned as single units: 'Individual parts are subordinate to the whole, without, however, ceasing to exist in their own right' (Wölfflin). And in fact forms intermingle to such an extent in Baroque paintings that it is difficult to isolate individu-

al motifs. They are not shown in such a way that their full outlines can be traced, as they often are in Classical compositions.

• With forms merging with one another in this way and outlines more or less deliberately softened, Baroque painting is frequently less 'legible' than Classical painting: 'It is no longer necessary to reveal a form to the viewer in its entirety, but simply to give its salient features' (Wölfflin, see also p.73).

Figures

• In accordance with the principle of propriety demanded by the Council of Trent ('the Holy

Peter Paul Rubens, *The Arrival of Marie de Médicis at Marseilles*, 1622–3, oil on canvas, Paris, Musée du Louvre.

Council desires that all impurity be avoided and that artists refrain from giving images provocative charms'), figures in Baroque art are rarely completely naked other than in the work of the Flemish painters Rubens and Jordaens. The desire not to set human figures within a narrow period of time (with the exception of portraits) meant that they were rarely depicted in 17th-century dress either. As a rule, Baroque painters combined nudes with elements of drapery, which gave them the opportunity to paint flesh and fabric together. In the work of Rubens, female nudes are set off by fragments of veil (*The Three Graces*, Madrid, Museo Nacional del Prado) or furs that caress the skin and seem to communicate their warmth to it (*The Fur Cloak*, Vienna, Kunsthistorisches Museum), while male nudes are set off by the inclusion of pieces of armour whose metallic lustre creates a remarkable contrast with the richness of flesh flushed with blood (*The Rape of the Daughters of Leucippus*, see p.159). Rubens was never afraid to combine historical figures entirely or partially clothed in contemporary dress with naked allegorical figures (*THE ARRIVAL OF MARIE DE MÉDICIS AT MARSEILLES*).

• The desire to create a sense of drama inherited from Caravaggio — and Tintoretto and Michelangelo before him — meant that Baroque painters favoured dynamism over static poses. The figures in these works perform violent or extreme movements that are frozen in time by the artist. Were it not anachronistic to do so, it would be tempting to borrow the metaphor of the snapshot from photography and the freeze frame from film-making to describe these gestures, for which no models would be able to pose for any length of time. The artificiality of these frozen physical attitudes can sometimes be irritating. When repeated, the overall effect tends towards grandiloquence. But it also arouses emotion in the viewer, which was the aim of Baroque painters.

Styles

Classicism

In Latin, *classicus* denotes that which is high-ranking or first-class. The word therefore has positive connotations. The adjective 'Classical' was used for the first time during the Renaissance. Vasari uses it in his *Lives* to describe an art in its mature phase, one that has reached its culmination. It is associated with what (in the eyes of the theoreticians of the Renaissance and later) was the unsurpassable pinnacle of the history of artistic creation: the ancient Roman model — the only one known during the 16th century — and later that of ancient Greece, about whose history more was learnt during the 18th century.

The word 'Classical' and its derivatives can therefore be used whenever we want to describe a work modelled on Greek art of the 5th century BC or its later imitations. It is employed to describe both Roman art and the art of the Renaissance. It is the obvious term to use when discussing 17th-century paintings of the French School, but serves too as a description of the 'Neoclassical' works painted from the second half of the 18th century onwards. It can also be used to characterize 19th-century works that are 'academic' or *pompier* (overly conventional, grandiloquent) in style — it is interesting to note that these two adjectives have pejorative overtones in this context which the word 'Classical' never does — and even 20th-century works of the 'return to order' tendency of the interwar period or those produced by artistic movements associated with dictatorships (fascist art, Nazi art, Socialist Realism).

In the historical sense in which we are using it here, 'Classicism' is a pictorial movement which developed during the 17th century, providing an alternative to Baroque art. It originated in Italy during the first third of the century and had its roots in the work of the painter Annibale Carracci, who, looking back to the period before Mannerism and in complete contrast to Caravaggio, sought to reconnect with the style of Raphael. Classicism blossomed in the art of the French painter Nicolas Poussin, who — except for a brief stay in Paris at the request of Louis XIII (from the end of 1640 to the end of 1642) — spent his working life in Rome. During the second half of the century, at the time of Louis XIV, his minister Colbert and the painter CHARLES LE BRUN, Classicism came to be identified in France with the 'grand manner', whose iconographical and stylistic characteristics were defined by the Academy (L'Académie Royale de Peinture et de Sculpture, founded in 1648).

Centres and artists

• In Italy, the work of Annibale Carracci (1560–1609) reconnected with the style of ancient Rome and revived the study of Raphael (particularly during his Roman period, when, from 1596, he painted the ceiling of the gallery in the Palazzo Farnese). Carracci's pupils Guido Reni (1575–1642), Francesco Albani (or Albano, 1578–1660), Domenico Zampieri, known as Domenichino (1581–1641) and, at a later stage in his career, Giovanni Barbieri, known as Il Guercino (1591–1666), were the main exponents of the Classical style in Rome, Bologna and Naples after the death of Carracci. Andrea Sacchi (1599–1661), Carlo Maratta (1625–1713) in his early work and Giovanni Romanelli (1610–62) kept this strand of Classicism alive until well after the middle of the 17th century, despite the fact that it was under fierce attack from the Baroque aesthetic by this time.

• Among French painters, Nicolas Poussin (1594–1665) was the first to make a major contribution to Classicism. His works, painted in Rome, were collected by French art lovers, notably Louis XIII's minister Cardinal Richelieu, his political heir Mazarin and the Duc de Richelieu, nephew of the Cardinal, for whom *The Four Seasons* (Paris, Musée du Louvre) was painted. Gaspard Dughet (1615–75), Poussin's brother-in-law and disciple, and Claude Gelleé, usually known as Claude Lorraine or simply Claude (c.1602–82), also spent their working lives in Rome (the first was born there). They

were also known in France, where there were many collectors of their work.

In Paris, Laurent de La Hyre (1606–56), whose work was still steeped in Mannerism, Philippe de Champaigne (1602–74), a native of Brabant, and Jacques Stella from Lyons (1596–1657), who had returned in 1635 from a long stay in Italy, were representatives of the first generation of Classical painters.

Around 1650, the Atticist movement, named after a rhetorical style defined by the ancient Roman orator Quintilian, introduced 'precious' refinements into French Classicism. The exponents of this style were Eustache Le Sueur (1616–55, see p.217), nicknamed 'the French Raphael', Sébastien Bourdon (1616–71), Le Brun in his youthful works, Nicolas Chaperon (1612–51) and Nicolas Loir (1624–79).

During the second half of the 17th century, Classicism, which started to take on more and more sumptuous forms (notably in the decoration of the Palace of Versailles), was personified by Charles Le Brun (1619–90), Louis XIV's *premier peintre* and Director of the Academy, and later by Pierre Mignard (1612–95), who succeeded him in his various public positions. A few years later, Nicolas de Largillière (1656–1746) introduced into his still lifes and portraits of aristocrats the final flourishes of a Classicism that – in his work as in that of his contemporary, the severe Jean Jouvenet (1644–1717) – displayed a sensitive use of colour and a strong Flemish influence.

• **In the southern Netherlands**, painters in Liège developed a form of art during the 17th century that (in contrast to the Antwerp School) inclined towards Classicism. Representatives of this trend included its leading exponent Gérard de Lairesse (1640–1711) as well as Berthollet Flémalle (1614–75), who spent part of his working life in France, and his pupils Jean-Guillaume Carlier, Englebert Fisen and Lambert Blendeff.

Characteristics

Techniques and supports

• Fresco remained popular in Italy (the ceiling of the Farnese Gallery) and was widely used for domes in France (that of the Val-de-Grâce church in Paris, painted by Mignard in 1663), but the system of compartmentalizing or dividing up ceilings, in contrast to their Baroque treatment as single units, allowed for the incorporation of oil paintings on

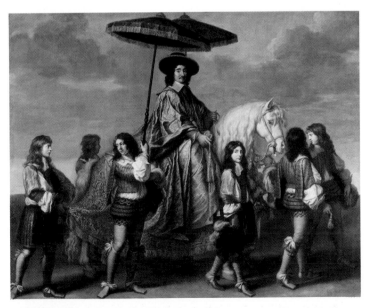

Charles Le Brun, *Portrait of Chancellor Séguier,* 1655, oil on canvas, 295 x 351cm, Paris, Musée du Louvre.

THE CEILING OF THE FARNESE GALLERY:
BETWEEN RENAISSANCE AND BAROQUE

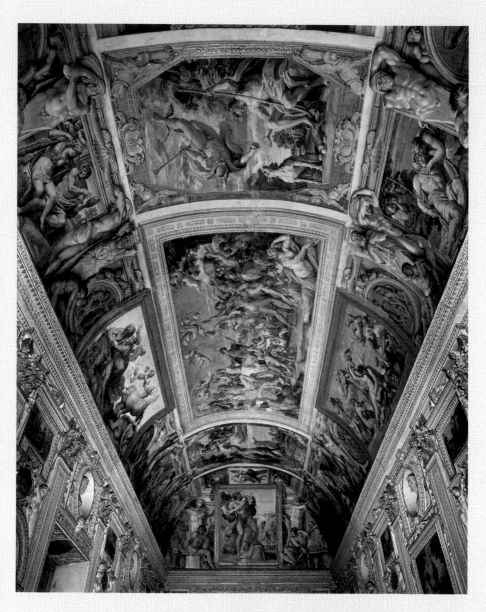

Annibale Carrache, the ceiling of the Farnese Gallery and *The Triumph of Bacchus*, 1596–1600, fresco, Rome, Palazzo Farnese.

Annibale Carracci, who trained as a painter in northern Italy (mainly Bologna, but also Parma and Venice), was initially interested in the direct representation of reality. However, he turned back to Renaissance models and — influenced by ancient Roman art — towards an idealization of natural forms.

A compartmentalized ceiling

The organization of the ceiling of the Farnese Gallery stands out as being different from the Renaissance style without altogether ushering in the grand Baroque manner. As in the ceiling of Michelangelo's Sistine Chapel (see p.60), the surface is compartmentalized following the *quadratura* method rather than

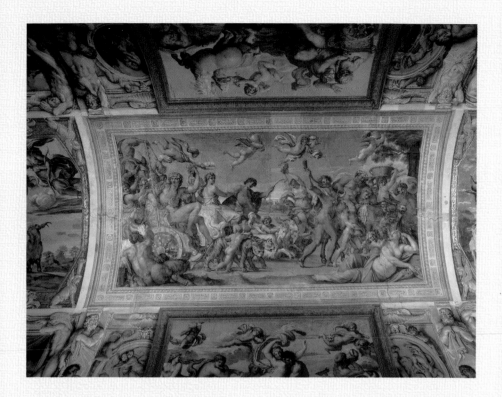

being treated as a whole, as it later was by Baroque artists. The painted, framed compartments obey their own spatial logic, in other words they present their figures in normal frontal perspective rather than foreshortened. This technique is known as *quadro riportato* (transferred picture). In the corners of the gallery behind the *quadri*, painted trompe-l'oeil architecture opens onto illusionistic skies. Space is therefore starting to be opened up, albeit still tentatively.

Mythology and a light palette

The subject chosen for the decoration of the gallery is the story of the love lives of the gods as related by the Roman poet Ovid.

This choice of mythological theme, combined with the artistic decision to employ a light palette, contrasts strongly with the style of painting adopted by Caravaggio at the same time. It was a deliberate aesthetic decision that was later to inspire Classical painters, but it was also entirely appropriate to the circumstances of the commission, whose purpose was to celebrate the marriage of Ranuccio Farnese to Margherita Aldobrino.

The Triumph of Bacchus

At the centre of the ceiling the largest of the paintings depicts the triumph of the god of wine. Its very simple organization contrasts with the complexity of Mannerist images. The figures,

quite distinct from each other, are arranged in a frieze with their heads and feet positioned at the same (or nearly the same) level. The corners of the picture are accentuated by seated figures who are variations on the Classical motif of the river gods, and the right-hand edge is emphasized by a standing nude and a tree.

Nudes predominate and are athletic; they do not have the elongated or angular proportions of which painters of the second half of the 16th century were so fond. The colours are bright and fresh, with yellows and blues that do not mutate into other shades under the effect of the transition from light to shade.

canvas separated or bordered by lavish gilt moulded frames and coving.

• Except for those produced specifically for mansions, palaces and churches, Classical works were far more modest in size than their Baroque counterparts. They were 'easel paintings', oils on canvas that collectors hung in tightly packed rows in the rooms where they displayed their collections, in other words in their 'galleries'. Very small paintings are rare, however, as the Classical painters' preoccupation with nobility of style was incompatible with tiny dimensions (see p.214).

Themes

• Religious themes remained common, whether paintings were commissioned for churches or convents or bought by individuals — Poussin's two series of *Sacraments*, for example, were painted for the Italian collector Cassiano dal Pozzo and the French collector Paul Fréart de Chantelou. Subjects were taken from the Old Testament as well as the New Testament, and also from the lives of the saints. Philippe de Champaigne, a Jansenist, and Jean Jouvenet had a preference for themes relating to the crucifixion (*Descents from the Cross*, *Pietàs*, and so on).

• A significant number of commissions were for historical and allegorical pictures. During the first half of the century, ancient history was the most popular subject matter for paintings (Poussin's *The Rape of the Sabine Women*, for example). When teams of painters in Louis XIV's France were commissioned to decorate the Louvre, the Tuileries and Versailles, subjects from ancient history were supplemented by images from the country's own history and scenes glorifying the 'Sun King'.

• Fable also provided the theme for numerous works, with subjects taken from recent Italian literature (such as Ariosto's *Orlando Furioso* and Tasso's *Jerusalem Delivered*) and more traditionally from the ancient Roman and Greek authors.

• As it became more centralized and absolutist, the French monarchy increased the importance it attached to the king's image, requiring it to be displayed throughout the kingdom. Following the example of the sovereign, the aristocracy — and on a more modest scale the bourgeoisie — also had their portraits painted. The ceremonial portrait was generally full-length, and included accessories that helped to create a sense of pomp (a brightly coloured, often red, curtain; columns or a portico). Champaigne on the other hand preferred simple compositions and shades of brown for his Jansenist paintings (his *Ex-Voto* of 1662, Paris, Musée du Louvre, for example). At the end of the century, Mignard sought a more graceful elegance allied to animated poses and an attempt to capture psychological realism, and Nicolas de Largillière came to the fore with strongly composed works in which the personality of his models shone through and which featured a sensuous, warm palette that paid careful attention to textures while not neglecting landscape (*La Belle Strasbourgeoise*, Strasbourg, Musée des Beaux-Arts).

• Ranked bottom of the hierarchy of Classical genres, landscape was also highly prized. In 17th-century France it accounted for as many as a third of all pictures painted. Nature was never completely devoid of a human presence, however. This often took the form of architectural structures (commonly of a fantastical kind) or tiny figures. The landscape itself was generally imaginary, and only rarely topographical (in the case of battle scenes, for example, or in certain paintings by the Le Nain brothers depicting peasants in an outdoor setting). The great model was the 'Italianate' landscape: a deep view accentuated by buildings drawn in perspective in which light plays an essential role (in the work of Claude Lorraine), or a series of planes — known as the 'composed' landscape — successively featuring vegetation, buildings and mountains beneath clear skies (Poussin).

Nearly all the genres were practised during this period, the only exceptions being those that were too far down in the Academy's hierarchy: genre painting and still life (see p.53).

Composition, line, colour, brushwork

The following are the contrasts between Classical and Baroque art as described by Wölfflin (see p.206):

• Classicism is linear, favouring drawing (and therefore distinct contours) over interlink-

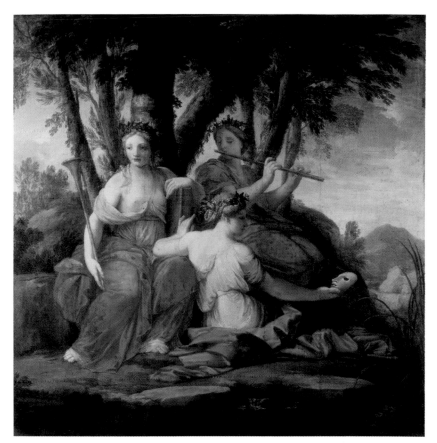

Eustache Le Sueur, *Clio, Euterpe and Thalia*, 1647–9, oil on canvas, 130 x 130cm, Paris, Musée du Louvre.

ing forms (in other words the 'pictorial' vision), prominent surface textures, effects of colour and light and the play of brush strokes, which are generally eliminated in a smooth finish.

• Classical painters attached great importance to the ordering of space on successive planes. They arranged architectural elements according to the rules of linear perspective (Claude Lorraine, for example, in *Seaport at Sunset*, see p.218) or accentuated space through the use of successive planes parallel to the surface of the painting, with the motifs growing progressively smaller (Poussin's *The Ashes of Phocion Collected by His Widow*, see p.48). In doing so, they avoided the severe diagonals of Baroque works that 'lead the eye from the foreground into the background'.

• Unlike Baroque paintings, Classical works adopt closed rather than open forms. A centralized spatial design positions the main motifs at the heart of the composition, either leaving an empty space around the edges of the painting (Le Brun's *Portrait of Chancellor Séguier*, see p.213) or placing various motifs against the edges in order to emphasize their presence. These motifs can be figures, as in Carracci's *The Triumph of Bacchus* (see p.215) or architectural forms, for example columns or other details borrowed from the ancient Greek or Roman language of architecture and sculpture whose purpose was to ennoble Classical art.

• Forms do not intersect, or at least only to a limited extent: each one is immediately recognizable as an individual form and has a degree of independence, rather than being subordinated to the whole as in Baroque works.

• As the art of an era that regarded itself as an age of reason (Descartes) and that was characterized by the control of minds and individuals (by a Catholic absolute monarchy in

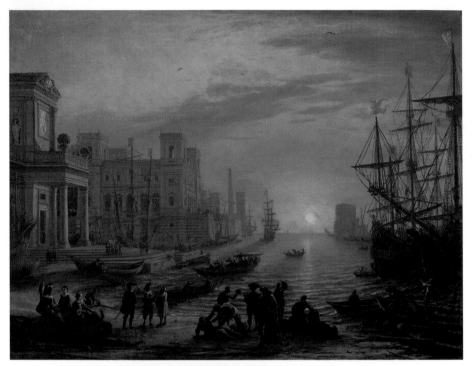

Claude Lorraine, *Seaport at Sunset*, 1639, oil on canvas, 103 x 136cm, Paris, Musée du Louvre.

France), Classical painting had clarity as its ideal. As much as composition, it was brilliant light and colour, strictly defined for each motif or figure, and the absence of violent contrasts that emphasized the forms. The aim was summed up by Poussin: 'It is in my nature to seek out and admire the well ordered, and to shun confusion, which is as alien and hostile to me as light is to gloom and darkness.' (See p.103.)

Figures

• Classical art aimed at re-establishing a connection with antiquity. It also regarded itself as art of an eternal kind, and its figures, if not exactly dressed in the style of Classical antiquity, are nevertheless clothed in garments that are not tied to any specific period. Classical artists undressed their figures to a far lesser extent than Baroque painters did. Only in portraiture does contemporary dress resurface, though not always even there. To the clothes of the day — which had the advantage of setting figures in the correct period and social class (and thus indicating their 'distinctiveness', according to Roger de Piles) — portraitists sometimes preferred 'garments indicative of some virtue, of some particular attribute or of some pagan divinity' (Piles) or timeless drapery that would not go out of fashion quickly and 'be found ridiculous'.

• Human figures are idealized, displaying neither the triviality of Caravaggesque figures nor the carnality of Rubens's. Their firmly drawn contours, the paleness of the flesh tones (in the case of the women) and their solidity and three-dimensionality make them resemble antique statues, whose proportions and sometimes postures provided the artists with their ideal, and indeed occasionally were used as their actual models.

• Classical painters eschewed extravagant poses and poses that evoked excessive movement. The nobility of their figures is conveyed through static poses or visibly slow movements. Classical artists disliked the 'large, awesome or frightening' figures (*spaventose*, as they were described by Pietro Aretino in the 16th century) of the pictorial tradition from Michelangelo to the Baroque. They preferred a range of gestures that at all times conveyed the emotions (*affetti*, see p.217) soberly, in other words with discretion (*discrezione*).

Rococo

The term *rocaille* (literally 'rockwork') had been used in France since the 17th century to denote a type of decoration featuring shells and small stones used in grottos and garden pavilions. It was used after 1730 as an alternative name for the movement also referred to as 'new style', 'modern taste' or 'new manner', which was born in the closing years of the 17th century. The word 'Rococo', which in all likelihood derives from *rocaille*, came into use in Parisian artistic circles at the end of the 18th century and had pejorative connotations: Rococo was seen as a late, degenerate addition to an already devalued Baroque style.

Nowadays free of negative connotations, the term 'Rococo' is used by art historians to refer to the international (and particularly Germanic) stylistic trend corresponding to the French *rocaille*. In central Europe 'late Baroque' (German: *Spätbarock*) is also sometimes used to describe the style.

Above all, Rococo is a decorative art. An examination of the paintings executed in this style (often intended as decoration for private houses) should always take into account the locations for which they were designed. Hanging in rooms that were smaller than those in palaces, the majestic forms of Classicism gradually gave way to ornamental paintings of a graceful and delicate nature. In France, this transformation began during the last few years of Louis XIV's reign (he died in 1715), and became established during the regency of Philippe d'Orléans (1715–23) and the reign of Louis XV (who died in 1774). The final phase of French Rococo is also known as 'Pompadour style' after the name of the king's influential mistress. The style subsequently spread throughout the rest of Europe, firstly to Italy, and then through the Italians to the courts of central Europe, where the powerful, dynamic volumes of the Baroque style were abandoned in favour of a lighter style of surface decoration. This process of dissemination was encouraged by artists who travelled: Giambattista Tiepolo, assisted by his son Giandomenico, worked in Würzburg (the Italians played a significant role in introducing Rococo into central Europe) and Boucher journeyed to Sweden, Denmark and Poland.

From a social point of view, Rococo was the art of an era whose main patrons were no longer the monarchy or the church. Wealthy individuals — in Paris the financier Pierre Crozat and the Comte de Tessin, the Swedish ambassador, for example — became the patrons and sponsors of artists. Intellectually, Rococo is linked to the Enlightenment and to the keen, nimble intelligence of the Salons, which formed a great contrast to the rationalist, moralistic rigour of Classicism and the ponderous dramatizations of the Baroque.

However, beginning in France in the middle of the century, Neoclassicism developed initially in reaction to the Rococo style and gradually established itself. Rococo's dominance came to an end during the years 1760–70.

Centres and artists

- In France, Antoine Watteau (1684–1721), born in Valenciennes (a French town but Flemish from a cultural point of view), was the first major exponent of the new art; indeed, his poetical, individual style helped to define it. The prolific François Boucher (1703–70), Jean-Marc Nattier (1685–1766), essentially a portraitist, François Hubert Drouais, his disciple in this genre, and Jean-Honoré Fragonard (1732–1806, see pp.220 and 221) were later painters in the Rococo style.
- In central Europe, where he worked from 1710 to 1735, the Italian Carlo Innocenzo Carloni (1686–1775), who trained in Venice and Rome, was the main proponent, along with Tiepolo, of the Rococo style. The main local representatives of the movement included the German Johann Evangelist Holzer (1709–40) and the Austrians Paul Troger (1698–1762), who made a long trip to Italy, and Franz Anton Maulbertsch (1724–96), who continued working in this style until the 1760s.

Jean Honoré Fragonard, *Swarm of Cherubs*, c. 1767, oil on
canvas, 65 x 56cm, Paris, Musée du Louvre.

• **In Italy**, Genoa, where Gregorio de Ferrari (1647–1726) worked, was an important early
centre of the Rococo style. The movement was represented at the court of Savoy by
Giovanni Battista Crosato (1686–1758), a native of Venice, and in Naples by Giacomo del
Po (1652–1725). Venice, however, was the most productive centre of the new style and
the one in which it became most firmly established thanks to the decorative genius of
Giambattista Tiepolo (1696–1770). In Venice the Rococo style also influenced Marco Ricci,
Bernardo Bellotto (who spent the second half of his career in central Europe) and most
importantly Antonio Canaletto (1697–1768) and Francesco Guardi (1712–92). Their views
of Venice and imaginary places also influenced Giovanni Paolo Pannini and Piranesi (dur-
ing the early stages of his career) in Rome.
• **In England**, the Frenchman Philippe Mercier (1689–1760), Bartholomew Dandridge
(1691–after 1754), both greatly influenced by Watteau, and most importantly William
Hogarth (1697–1764) were responsible for introducing the decorative principles of the
Rococo style. Hogarth's satirical cycles, which show an entirely original imagination that
cannot be defined simply in terms of Rococo, are nevertheless related to it by the painter's
style and by his advocacy of the 'serpentine line' (otherwise known as the arabesque) in
his theoretical treatise *The Analysis of Beauty* of 1753. Thomas Gainsborough (1727–88)
— a painter of charming portraits, which he often set in landscapes — was very much a
part of the Rococo aesthetic.

Techniques and supports

• Rococo is a decorative style. Commissioned work included pieces for window piers, ceiling paintings, mural panels, chimney pieces, over-door panels and so on. Artists produced canvases in oil whose formats varied according to where they were to be hung, but which were generally smaller than the decorative paintings of the 17th century and fitted the (often curved) spaces that needed to be filled.

• Fresco remained in use for large ceiling decorations.

• Rococo is a colourful style. It was strongly influenced by the Flemish school championed in France by Roger de Piles and the 'colourists'. Pastel, a medium for drawing in colour on paper, was one of its means of expression (see p.100).

Themes

• The serious allegories of the preceding period (Baroque or Classical) were replaced by mischievous and frivolous themes: amorous mythological scenes involving Venus and Pan, or pastoral subjects with stock shepherds and shepherdesses. Certain painters who specialized in this genre sometimes painted even more risqué scenes such as Boucher's *Odalisque* or *Nude on a Sofa (Reclining Girl)*, see p.161, or THE BOLT by Jean Honoré Fragonard.

• Boucher in particular was inspired by the craze for chinoiserie evident in the fashion for Chinese lacquerware and porcelain (see p.122).

• Landscape was reinvigorated by the introduction of panoramas of urban or countryside scenes — the latter featuring ruins. First produced in Italy, these landscapes were known as *vedute* (views) or *capricci* depending on whether they were real or imaginary, and the artists who painted them were known as *vedutisti*. It is debatable whether Watteau's parkland scenes with beautifully dressed figures should be included in the category of landscape or not, and indeed the Academy failed to assign these 'fêtes galantes' to any particular genre.

• The portrait remained extremely popular. In France, its exponents were Nattier, who painted his sitters as antique gods and goddesses, Fragonard, Roslin, Drouais and of course

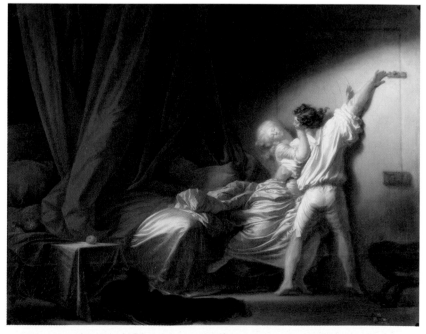

Jean Honoré Fragonard, *The Bolt*, c.1774, oil on canvas, 98 x 122cm, Paris, Musée du Louvre.

François Boucher, *The Chinese Fair*, c.1742, oil on canvas, 41.5 x 64.5cm, Besançon, Musée des Beaux-Arts.

Chardin, who took an 'intimist' approach to his models, not all of whom have been identified. In England a new type of portrait developed through the work of Mercier, Dandridge and most importantly Gainsborough and Hogarth (*Assembly at Wanstead House*, Philadelphia Museum of Art). This became known as the 'conversation piece' and depicted identifiable individuals engaged in conversation in their mansions or gardens.

Composition, line, colour, brushwork

• Ornament was at the heart of everything. The arabesque and the *coquille* (or shell motif) with undulating, asymmetrical contours formed the basis of the decorative schemes into which paintings were required to fit and so influenced their composition. Artists could consult catalogues of ornamentation compiled for their benefit (*Livre d'Ornements* drawn by J A Meissonnier and engraved by G Huquier, 1734; *Livre de Cartouches* by Lajoue, 1734). Painters sought a lightness of touch, a surface effect rather than an effect of depth. The desire to create graceful pictures resulted in the disappearance of the heavy architecture that formed the settings of works painted during the previous century. The new taste — as demonstrated by the fashion for the 'English garden' and literary eulogies to nature (Rousseau, for example) — was for the countryside. In England, the success of Gainsborough's paintings bore witness to this taste.

• In general, painters favoured a smooth finish (although Watteau's and Fragonard's brush strokes are visible to the eye). Draughtsmanship is clearly in evidence despite the relatively rich subject matter of the picture. The colours are light, with pastel shades often featuring in amorous scenes — as, for example, in Boucher's works, in which pinks and blues predominate.

Figures

• Figures are idealized, always young and display a charm that owes more to prettiness than beauty. The language of gesture is less important than in Classical art since the aim is not to communicate a message. Poses ceased to be dramatic: Rococo art did not seek to arouse strong emotions as Baroque art did.

• Clothing is conventional — except in portraiture, where painters paid particular attention to the cut of their sitters' garments (which had to be fashionable), the fabrics and the elements of decoration (feathers, ribbons, flowers and so on).

Neoclassicism

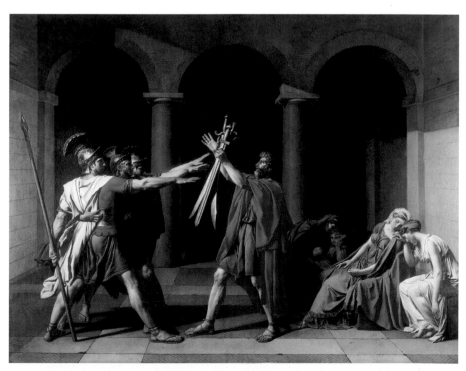

Neoclassicism blossomed in Europe between 1760 and the beginning of the 19th century. Though under fire from Romanticism, it remained influential until around 1830. Neoclassicism was characterized by a desire to 'return to antiquity', a taste for serious subjects, a simple and sober style and the dream of creating an 'ideal beauty'.

Historically, Neoclassicism was connected to the archaeological discoveries made at Herculaneum from 1738 and at Pompeii from 1748. It was boosted by a number of illustrated works on the art of ancient Greece that were published around this time (*Les Ruines des Plus Beaux Monuments de Grèce* by Le Roy, 1758 and *The Antiquities of Athens* by Stuart and Revett, 1762) and by the series of engraved *Views of Rome* made by Giovanni Battista Piranesi (1720–78) between 1748 and 1775.

In social terms, Neoclassicism summed up the taste of a new class of collector: the bourgeoisie who had grown wealthy from the Industrial Revolution in Great Britain or who had profited from the Revolution in France. From a philosophical point of view, it had links with Utopian systems of thought and therefore followed in the Enlightenment tradition. Neoclassical theoreticians cultivated a sense of nostalgia for a period of antique splendour they regarded as ideal: 5th-century BC Greece for the German art historian Johann Joachim Winckelmann, republican Rome for revolutionary France, and imperial Rome for Napoleonic France (the First Empire coincided with the high point of the Neoclassical movement in France). They saw these periods as providing not only formal but also ethical models and they hoped to regenerate their own society by reviving these supposed virtues. In this way, Neoclassical art subscribed to the mission that Diderot gave to art around 1760: to educate and to make virtue 'attractive'.

Jacques Louis David, *The Oath of the Horatii*, 1794, oil on canvas, 330 x 425cm, Paris, Musée du Louvre.

Styles

Centres and artists

• **In France**, Joseph Marie Vien (1716–1809), who spent a number of years in Rome, was one of the founders of the Neoclassical movement and Jacques Louis David (1748–1825, see p.223), official painter of the Revolution and the Empire, was its chief exponent. In their early work, Pierre Paul Prud'hon (1758–1823), Germain Jean Drouais (1763–88), Pierre Narcisse Guérin (1744–1833) and Anne Louis Girodet-Trioson (1767–1824) all displayed an affiliation with Neoclassicism. The work of Jean Auguste Dominique Ingres (1780–1860), from Montauban, which combined coolness with sensuality, extended this aesthetic beyond the middle of the 19th century. Ultimately, Neoclassicism joined forces with neo-Rococo tendencies (erotic nudes and widespread use of blues and pinks) and resulted in the 'academic' or *pompier* (grandiloquent) art of painters such as Eugène-Emmanuel Amaury-Duval (1808–85), Jean Léon Gérôme (1803–60), William Bouguereau (1825–1905) and Paul Baudry (1828–86).
• **In Italy**, Andrea Appiani from Milan (1754–1817) and Vincenzo Camuccini from Rome (1771–1844) worked in the style of David.
• **In Germany**, Anton Raphael Mengs (1728–79), who worked in Dresden, Rome and Spain, produced a number of early works in the Baroque style. He then came under the influence of Winckelmann to such an extent that, like Winckelmann, he became a theoretician and one of Neoclassicism's earliest exponents. Gottlieb Schick (1776–1812), who worked for a while in Paris alongside David and then Ingres before spending time in Rome, was the main representative of the Neoclassical aesthetic in Stuttgart.
• **In Spain**, despite the presence of Mengs in Madrid, where he had been summoned by King Charles III, Neoclassicism did not attract any major followers, and indeed it would be impossible to describe the work of Goya, for example, in terms of this movement. Francisco Bayeu (1734–95) and later Vincenzo López (1772–1850), José Aparicio Anglada (1793–1838) and José de Madrazo (1781–1859) all painted in this style, however, which was championed by the new Royal Academy of San Fernando.
• **Great Britain** was introduced to Neoclassicism early on thanks to the work of the Scotsman Gavin Hamilton (1723–98), who divided his time between Rome and Britain. The London painter Nathaniel Dance (1735–1811), who likewise lived for a time in Rome, was also an adherent of Neoclassicism, as was the American Benjamin West (1738–1820), the first great painter from across the Atlantic, who settled permanently in London in 1763 after living for three years in Rome.
• **In Denmark**, the main Neoclassical painter was Christoffer Wilhelm Eckersberg (1783–1853), a pupil of David who spent time in Rome.
• **In Russia**, Vassily Kouzmich Shebujev (1777–1855) was the main practitioner of this aesthetic, which was supported by the Academy of Fine Arts in St Petersburg.
• **The Swiss** painter Angelica Kauffmann (1741–1807), who knew Winckelmann and West in Rome, divided her time between London and Italy. Her style tends towards the emotional and sentimental.

Characteristics

Techniques and supports
• Neoclassical works were either frescoes or, more commonly, oil paintings on canvas.

Composition, line, colour and brushwork
• The very name of the movement indicates that painters had accepted the principles that had inspired French art during the 17th century. Drawing prevails over colour. Space tends to be shallow, with the background parallel to the surface of the painting and not especially distant. Interior scenes were often painted in dark colours, thereby highlighting the foreground. Forms reflect the shape of the frame (generally rectangular) so the composition is closed. The light is bright and often cold — a golden light would be regarded as too sensual. Motifs are coloured in rather than painted in colour: colour has an informative rather than aesthetic function, adding relief in order to define fully the object whose out-

INGRES: A CLASSICAL REALIST?

J A D Ingres, *Portrait of Monsieur Bertin*, 1832, oil on canvas, 116 x 95cm, Paris, Musée du Louvre.

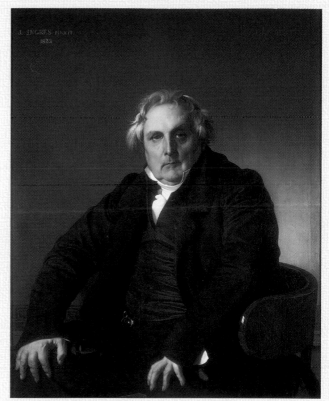

Neoclassical in terms of his smooth finish and preference for line, Jean Auguste Dominique Ingres is nevertheless one of those artists whose work cannot be reduced to a single style or movement — surely the sign of a great painter.

Diversity of style

Showing an affiliation with Romanticism in *The Dream of Ossian* (Montauban, Musée Ingres) and in his troubadour-style paintings (*Don Pedro of Toledo Kissing the Sword of Henry IV, Paolo Malatesta and Francesca da Rimini*) or his orientalist paintings (*La Grande Odalisque*, Paris, Musée du Louvre; *The Turkish Bath*, see p.164) — whose exoticism underlines the sensuality of the subject — Ingres revealed himself to be a proto-Realist, too, in his *Portrait of Monsieur Bertin*, completed before Courbet had even begun painting. In work of this type he anticipated photographic portraits, which became fashionable among the middle classes during the 1840s. Photography had been invented by the physicist Nicéphore Niepce in 1826 and its popularization by Daguerre in the form of the daguerreotype dated from 1838.

A 'modern' subject

After a number of less striking studies depicting him standing, the subject — Louis François Bertin Snr — has been shown seated in the final version. The founder of the *Journal des Débats*, one of France's first press barons and one of the chief supporters of the newly installed July Monarchy (the reign of Louis-Philippe), Bertin is dressed in clothes appropriate to a member of the bourgeoisie. His posture, with legs apart and hands resting on his knees, is one of impatience rather than repose, and indicates a desire to get up — either to stop wasting time with posing, or else to pounce on the painter or viewer.

Unbearably 'vulgar'

The uniformly dark palette (a range of blacks and browns) makes Bertin's shadowy figure stand out strongly against an almost abstract background lit artificially by a source of light situated towards the bottom right of the picture. His head rests on a white cravat and is encircled by a halo of grey hair. His hands resemble powerful claws. Contemporaries were struck by the size of the figure and the brutality of the pose, but also by the nobility, or rather the sense of assurance, of the face, which is shown from the front while the body is shown in three-quarter profile. They considered the image to be unbearably vulgar, while to our eyes it has become the icon of an era or, as the engraver Mane (who reproduced the picture) wrote: 'the Buddha of the sated, triumphant bourgeoisie'.

Styles

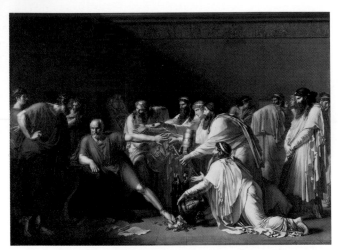

Anne Louis Girodet-Trioson, *Hippocrates Rejecting Artaxerxes's Gifts*, 1792, oil on canvas, 99 x 135cm, Paris, Musée d'Histoire de la Médicine.

line has been created by drawing.

• The profession of painter is an impersonal one. The smooth finish makes it impossible for the viewer to detect any emotion in the artist's treatment of his subjects.

• In acknowledgement of the interest in archaeology, Neoclassicism displayed a fondness for ancient Greek and Roman motifs. Research enabled painters to introduce into their pictures objects that had been copied from shapes on reliefs and paintings or that had been found buried in the ground.

• The preoccupation with grandeur and reason meant that architecture played a leading role: the action in a painting unfolds in a setting dominated by buildings with pilasters, cornices and so on (see p.59).

Themes

By defining the new aesthetic as an ideal of 'noble simplicity' and 'serene grandeur', Winckelmann provided painters with a framework for their art.

• Nobility is expressed through allegorical subjects, edifying themes or themes with a moral message, such as the death of the hero or self-sacrifice. Painters portrayed instructive, rather than licentious, episodes from mythology and also dealt with themes from ancient history based on Homer's epics or Livy's accounts of Roman history.

• The demands of simplicity meant that when dealing with one main narrative, artists refrained from depicting multiple secondary episodes (anecdotes or 'vignettes') that would risk diverting the viewer's attention from the main 'lesson' of the painting.

Figures

• The language of gesture allowed figures to be made eloquent without sacrificing their beauty. Great suffering is expressed through restrained movement, rather than ugly gesticulation or faces deformed by crying or shouting.

• Figures are generally few in number. They are large relative to the size of the painting, well spaced and positioned primarily in the foreground, all of which is designed to achieve maximum clarity.

• Figures are idealized. Painters understood themselves to be imitating 'nature in its beauty', a perfect model of man and woman that was supposed to have existed during the early days of the human race and that had since become corrupted. After Winckelmann, the idea gained currency that Classical statues preserved the memory of this lost perfection in stone, and this was used as an argument for copying them rather than taking models from real life.

• Except in portraits — in which contemporary costume was marked by a sobriety that contrasted with the fanciful excesses of the previous era — clothes were replaced by robes, which were regarded as majestic and valued for their Classical appearance. Nudity, which is possibly even more timeless, was used in connection with heroic themes. However, only men were naked, not women, as the nudity did not serve any sensual purpose. Genitalia were hidden by objects which just happened to be in a convenient position, such as the sheath of Tatius' sword in *The Intervention of the Sabine Women* by David (see p.26).

Romanticism

The word *romantic*, or *romantick*, was first used in England in the 17th century to denote romance in literature. At the beginning of the 19th century this term assumed an aesthetic dimension, and was used to denote works of literature and visual artworks that opposed the Classical and particularly the Neoclassical tradition. In the context of the 1846 Paris Salon, Charles Baudelaire made the following assessment: 'Romanticism [...] resides in the way one feels. For me, Romanticism is the most recent, the most up-to-date expression of beauty. To utter the word Romanticism is to utter the words modern art, denoting intimacy, spirituality, colour and a yearning for the infinite, expressed through all the means art has at its disposal.'

Romanticism was a French, German and British movement that developed throughout Europe at the end of the 18th century, reaching its peak at the beginning of the 19th century. It influenced not only painting and sculpture (Antoine-Louis Barye, Emmanuel Frémiet, François Rude), but also literature (James Macpherson and his *Ossian* poems in Great Britain during the years 1760–70; the Schlegel brothers, Friedrich von Schelling, Kleist, Novalis, etc in Germany; Madame de Staël, Chateaubriand, Hugo, Nerval, etc in France) and music (Beethoven, Chopin, Mendelssohn, Berlioz, etc). It was characterized by a sensibility that glorified the individual, or more precisely 'the free manifestation of one's personal impressions' (Delacroix), and was influenced to a considerable extent by the concept of the irrational.

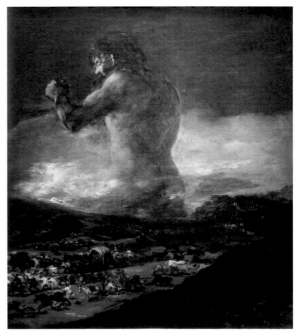

Goya, *The Colossus*, 1812, oil on canvas, 116 x 105cm, Madrid, Museo Nacional del Prado.

Broadly speaking, Romanticism can be said to have extended from 1770 to 1840. The first period (1770–1800) can be seen as a pre-Romantic phase during which themes began to reflect the Romantic sensibility while still being steeped stylistically in Neoclassicism. From a pictorial point of view, the movement's mature period, essentially a French phenomenon, lasted from 1800 to 1824, the year of Géricault's death. After this date, Romanticism was represented primarily by Delacroix and the late work of Turner.

Centres and artists

• In Great Britain, the artists of the pre-Romantic generation included the Swiss-born Henry Fuseli (Johann Heinrich Füssli, 1741–1825) and William Blake (1757–1827), who was first and foremost a poet. John Constable (1776–1837), Joseph Mallord William Turner (1775–1851), John Martin (1789–1854), who achieved considerable success

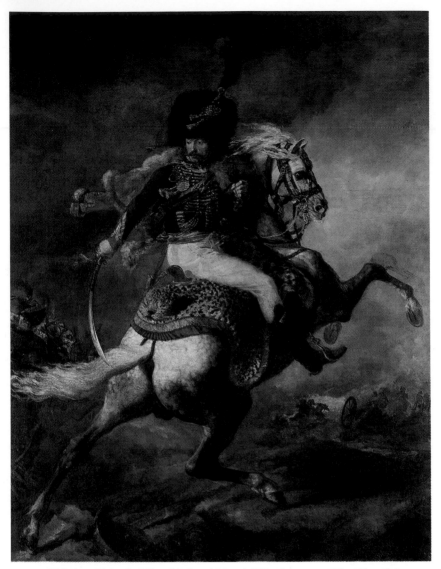

Théodore Géricault, *Officer of the Imperial Guard*, 1812, oil on canvas, 349 x 266cm, Paris, Musée du Louvre.

during his lifetime, and David Roberts (1796–1864), who excelled as a landscape painter and travelled to the Orient, were exponents of Romanticism at its peak.

• **In Germany**, Philipp Otto Runge (1777–1810), the author of a theoretical work on light and colour, was the precursor of the Nazarene movement, whose genesis coincided with the founding of the Brotherhood of St Luke in Vienna in 1809. The Nazarenes sought to restore Christian art to the way it was in the Middle Ages. Friedrich Overbeck, Franz Pforr, Josef Anton Koch, Peter von Cornelius, Julius Schnorr von Carolsfeld and Johann Anton Ramboux were the main painters belonging to this group. Caspar David Friedrich (1774–1840) was a more authentic and original exponent of Romanticism.

• **In France**, Anne Louis Girodet-Trioson, Pierre Narcisse Guérin and Pierre Paul Prud'hon, all of them adherents of Neoclassicism during their youth, were, with François Gérard (1770–1837), the first representatives of Romanticism in their later years. The movement's mature period was represented by Antoine Jean Gros (1771–1835), *THÉODORE GÉRICAULT* (1791–1824), *EUGÈNE DELACROIX* (1798–1863), who also revealed himself in his *Journal* to be a remarkable writer, and the more conventional Eugène Devéria (1805–65).

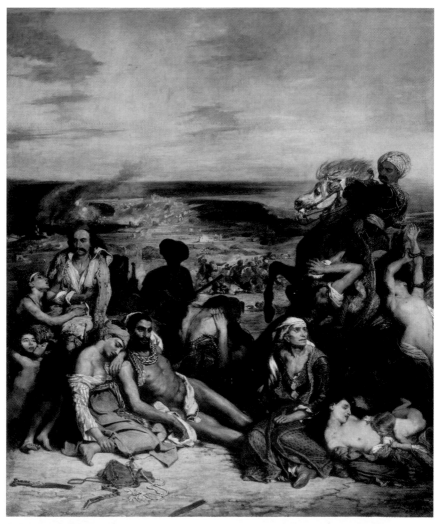

The Romantic sensibility found a more academic form of expression in the work of Paul Delaroche (1797–1856) and Horace Vernet (1789–1863), both representatives of the style referred to as 'eclectic' or *pompier*. Romanticism survived in the work of Théodore Chassériau (1819–56, see p.230), Gustave Doré (1832–83), Gustave Moreau (1826–98) and to some extent Odilon Redon (1840–1916), as well as in the work of Orientalists such as Eugène Fromentin (1820–60), Alexandre Gabriel Decamps (1803–60) and later Félix Ziem (1821–1911).

• **In Spain** during the 1790s and particularly during the bloody Peninsular War, Francisco de Goya y Lucientes (1746–1828, see p.227) abandoned the bright colours and light-hearted subjects of his youth in favour of dramatic themes that combined the fantastic with the real, employing a dark palette illuminated by intense localized flashes of light.

• **In Poland**, Alexander Orlowski (1777–1832) was the country's main Romantic painter.

• **In Russia**, Alexander Andreyevich Ivanov (1806–58), who associated with the painters of the Nazarene group in Rome around 1830, is worthy of note.

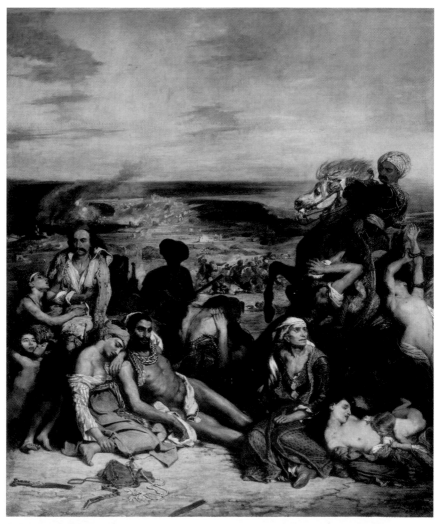

Eugène Delacroix, *The Massacre at Scio: Greek Families Awaiting Death*, 1822, oil on canvas, 419 x 354cm, Paris, Musée du Louvre.

Styles

Characteristics

Techniques and supports

• The main medium, oil, was used in conjunction with a range of formats that were sometimes quite large.

• Watercolour, which had been widely used in Britain since the 18th century, became fashionable. It proved a useful technique for painters who travelled, particularly the Orientalists: the wonderful illustrations in Delacroix' travel diaries,for example, are in watercolour. It was also used by landscape painters such as Constable and Roberts.

• Etching, of which Goya was a brilliant practitioner, also influenced Delacroix's work.

• Drawing was eminently suitable for the immediate expression of an artist's inner thoughts and feelings, and enjoyed considerable popularity. Victor Hugo, for example, executed his graphic works in charcoal and ink.

• Certain painters, such as the Nazarenes in Germany and the Flandrin brothers in France (exponents of the Lyon or 'Quattrocento' School, whose style was closer to that of the Neoclassicists than the Romantics), sought to reintroduce the fresco and the pictorial techniques of the 'primitive' (pre-16th-century) painters in general. Friedrich, for example, sometimes used an altarpiece format and employed gold in his work.

Themes

• Literature provided artists with a range of subjects. Painters took their inspiration both from rediscovered authors (Froissart, Tasso, Dante, Shakespeare) and from modern, Romantic authors such as Byron, Goethe and Walter Scott. Nordic mythology replaced Greco-Roman legends of gods and goddesses.

• For the Romantics, the Middle Ages assumed the same importance that Classical antiquity had had for the Neoclassicists. Painters valued the medieval period for its exoticism and the different settings and props from those used in Classical paintings. This was the 'Neo-Gothic' or 'troubadour' tendency that could be observed from the 1770s onwards, associated in France with the work of Jean-Louis Ducis, Pierre Révoil, Fleury-Richard, Pierre Nolasque Bergeret and a number of paintings by Ingres. Taking their lead from Chateaubriand's *Genius of Christianity*, others — such as the Nazarenes in Germany and the Pre-Raphaelite Brotherhood in Britain — saw in the Middle Ages an era of great piety to which they hoped to return.

• While hitherto artists had travelled almost exclusively to Italy, they now started to discover new horizons, particularly Morocco, Algeria and Spain. The Orient, which Napoleon Bonaparte's campaigns had helped to bring to notice, was like some unknown Mediterranean land: it exerted a great fascination with its unfamiliar landscapes, its different light, its veiled women and the mystery of its Arab and Jewish civilizations. A powerful source of inspiration for Delacroix (who travelled to Morocco, Algeria and Spain in 1832) it provided subject matter for 'Orientalist' artists such as Eugène Fromentin, who was also a writer, and Alexandre Decamps. The Orient also influenced CHASSÉRIAU, and even the Neoclassical Ingres (*The Turkish Bath*, see p.164).

• Mystery, imagination and fantasy occupied an important place in Romantic paintings, and were treated in a stirring manner that favoured the depiction of drama, madness, extreme melancholy or nightmare. Death was often combined with eroticism (*The Death of Sardanapalus*, see p.123).

• The Romantic painters were not oblivious to reality, and contemporary political events are reflected in their works in the form of war (the Napoleonic campaigns, wars of national liberation, particularly in Spain and Greece) and revolution. They always portray such events dramatically, featuring images of the wounded and dying in paintings such as *The Battle of Eylau* by Antoine Jean Gros, *The Raft of the 'Medusa'* by Géricault (see p.72), *The Massacre at Scio* by Delacroix and the execution scenes painted by Goya (see p.28).

• Landscape painting was not widely practised on the Continent. In Britain, however, it saw its conventions turned upside down. In the work of Constable (see p.232), the Dutch landscape tradition inspired scenes of the Suffolk countryside and wonderful studies of

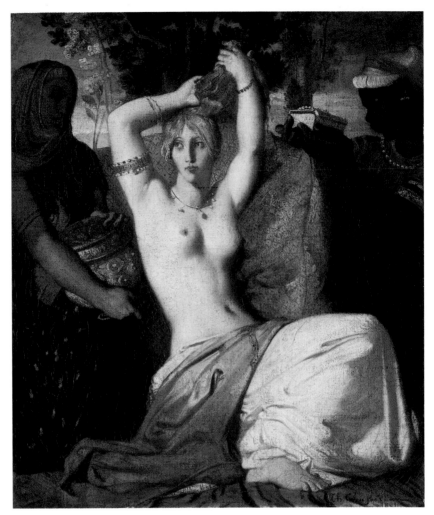

Théodore Chassériau, *The Toilette of Esther*, 1841, oil on canvas, 45.5 x 35.5cm, Paris, Musée du Louvre.

clouds, and in the work of Turner, a watercolourist by training, that same tradition inspired monumental works whose real subject is the celebration of the forces of nature, the harmonies of the sky, the sea, the light of dawn, the vibration of the atmosphere, snowstorms, and fire. In Germany, meanwhile, Caspar David Friedrich dreamed up sublime and harrowing landscapes, frozen vistas, cemeteries and black nights in which gnarled trees loom out of the darkness.

• Animal painting was also very successful during this period. Paintings were invaded by beasts both wild and domesticated (although proud), by animals that evoked distant lands and by those that evoked noble passions such as the hunt — for example, the lion, which had been the subject of much study in menageries, and the horse, which became Géricault's favourite animal and the creature through which he expressed himself (see p.228).

Composition, line, colour, brushwork

• Whereas Neoclassicism sought its models among the painters of the Italian Renaissance (Raphael) and 17th-century France (Poussin), the Romantic artists' frame of reference was much wider. The Nazarenes and the Pre-Raphaelites, who had much in common with the Romantic sensibility but were on the fringes of the movement, wanted to return to pre-16th-century painting and saw in Fra Angelico an unsurpassable model. The Romantics

John Constable, *Cloud Study*, 1822, oil on paper laid on board, 47.6 x 57.5cm, London, Tate Gallery.

themselves, however, favoured a darker style of painting featuring strong contrasts: Prud'hon looked to the work of Correggio, Gérard looked to the work of Leonardo, Géricault developed a passion for Caravaggio, and both Gros and Delacroix were influenced by Rubens.

These tendencies resulted in a style of painting that was markedly different to that of the Neoclassicists. From 1800 if not earlier, the expansive, powerful construction of Romantic works, with thickly textured paint and visible brush strokes, made them seem at times like sketches. Their dazzling colour and violent contrasts of light and shade relegated drawing to a supporting role.

• Rigorously organized architectural layouts did not sit happily with the Romantic painters' desire to elevate subjectivity above reason. In their history paintings, grand architectural perspectives were replaced by views of nature in which order was deliberately lacking and by clouds in skies that were rarely full of light. In their landscapes, buildings were often given a historical character (Gothic cathedrals) or painted as ruins.

Figures

• Romantic painters were interested in history rather than the ideal. They did not, therefore, paint timeless characters, but instead dressed their figures in clothes that reflected the fashions of a particular era or a particular place, whether the Middle Ages or the Orient of the day. The effect of this local colour or exoticism is to hold the viewer's attention, but the profusion of 'interesting details' risks diverting it from the main subject.

• The same concern with truth and a desire to appeal to their public on an emotional level meant that these painters were less interested in seeking beauty than in creating a sense of reality. They were not afraid of scandal and were not repelled by sallow complexions, corpses, wounded, sick, or mangled bodies or bodies disfigured by pain, and even sometimes resorted to the morgue for their models, as Géricault did when working on *The Raft of the 'Medusa'* (see p.72).

Realism

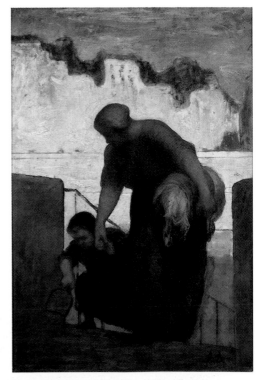

The words 'realism', 'realist' and 'reality' describe a style of painting that aims to reproduce nature exactly, without seeking to embellish it. In a certain sense, van Eyck, in the 15th century, could be called a realist. However, the terms are more applicable to the painters of the 17th century, from Caravaggio to the Le Nain brothers, who were devoted to painting humble themes and who chose their models from among the common people. The expression 'painters of reality' was used for the first time in 1857, at the height of the Realist movement, by the French novelist and critic Jules Champfleury, a great champion of this aesthetic. The term 'Realism' had been used in 1836 in the *Chronique de Paris* by another critic, Gustave Planche, to denote the contemporary artistic reaction that — in the face of a dying Neoclassicism and a triumphant Romanticism — advocated a return to the study of nature and humble subjects. In 1855, the term was used by the painter Gustave Courbet, the leading figure of the movement, in the catalogue he wrote for his 'Exhibition of Forty Paintings', an exhibition of his recent work held in a purpose-built venue on the avenue Montaigne on the fringes of the World Fair.

Welcomed at first by critics weary of 'grimaces in the antique manner' (journalist Théophile Sylvestre) and the grandiloquence of the Romantics' paintings, Realism was condemned in the 1840s as the triumph of the 'ugly' and was a cause for concern under the Second Empire because of the ideology of protest it seemed to support. The art of Courbet — who was a close acquaintance of the socialist Pierre Joseph Proud'hon and was imprisoned in 1873 for his role in the Paris Commune two years earlier — was a prime example of a deliberately provocative style of painting that could set alarm bells ringing in official circles.

Historically, Realism was a literary and artistic movement — essentially French — that originated in the years 1820 to 1830 and survived in various official forms until the end of the 19th century. The artists who adhered to this aesthetic not only desired to imitate nature exactly, they also had social and political concerns that led them to take an interest in the humblest members of contemporary society.

Initially a movement of ideological as much as aesthetic dissent, Realism saw itself hijacked by academic art at the beginning of the Third Republic (about 1870), when painters exhibiting at the Salon produced socially relevant subjects in the tradition of Courbet. They did this not in order to pursue any political goal, but with the aim of 'harnessing the trivial in order to express the sublime' (Millet). When certain painters (Thomas Couture, Fernand Cormon) adopted a Realist style for archaeological or prehistoric subjects, they stripped it of any political agenda whatsoever.

Honoré Daumier, *The Laundress*, 1861, oil on canvas, 49 x 33.5cm, Paris, Musée d'Orsay.

 Styles

Centres and artists

Realism was essentially a French movement. However, its influence was also felt in various other European countries.

• **In France**, the first Realist artists were illustrators rather than painters. The greatest of these was Honoré Daumier (1808–78, see p.233), a first-rate political caricaturist who drew politicians and made busts of them. He was also a great observer of ordinary people. The real founder of the Realist movement, however, was GUSTAVE COURBET (1819–77). Jean-François Millet (1814–75), Jules Bastien-Lepage (1848–84) and Rosa Bonheur (1822–99) represented its academic strand, also referred to as 'official naturalism'. Jean-Louis Ernest Meissonier (1815–91), who painted subjects closer to Romanticism, Thomas Couture (1815–79), who was more of a Neoclassicist, and Fernand Cormon (1845–1924), who specialized in prehistoric themes, were also influenced by Realism, as was Édouard Manet (1832–83), a pupil of Couture, albeit in a very different way. Between 1830 and 1860, the landscape tendency of the Realist school was represented by painters who gathered in the hamlet of Barbizon on the outskirts of the Forest of Fontainebleau. These included Narcisse Virgile Diaz de La Peña (1807–76), Théodore Rousseau (1812–67, see p.236), Charles Daubigny (1817–78), Constant Troyon (1810–65) and, again, Jean-François Millet. Jules Dupré (1811–89) came to Barbizon only infrequently, but painted bucolic landscapes in a similar style.

• **In Spain**, Costumbrismo was the name given to a type of painting and literature concerned with the local customs of different regions. This movement, which initially took its essential character from the Romantic style and later, to a greater and greater extent, from Realism, lasted from 1830 to the end of the century and was based primarily in Seville. Its main exponents were José Domínguez Bequer (1810–41), his son Valeriano Bequer (1834–70), Manuel Rodríguez de Guzmán (1818–67) and José Roldán.

• **In the Netherlands**, the closest local equivalent to French Realism was the Hague School, of which Jozef Israëls (1824–1911) and the landscape painter Jacob Maris (1837–99) were members.

• **In Italy**, the Macchiaioli advocated an anti-academic style of painting that would create 'an impression of the real'. The group's name comes from the word *macchia*, which means 'mark' and denotes a style that places greater emphasis on brushwork and the relationships between colours than on drawing. Based in Florence, its leading members were Giovanni Fattori (1825–1908), Silvestro Lega (1826–95) and Telemaco Signorini (1835–1901).

• **In Germany**, Wilhelm Leibl (1844–1900), who met Gustave Courbet in Paris, and Adolf Menzel (1815–1905), who spent his entire working life in Berlin, are the best-known representatives of Realism.

• **In Russia** around 1870, the group known as the Peredvizhniky, the 'itinerants' – so named because they organized itinerant exhibitions – adopted the themes and style of the French Realists. Ilya Efimovich Repin (1844–1930) was the leading exponent of this group.

Characteristics

Techniques and supports

• The Realist painters remained faithful to traditional techniques, painting in oil on canvases that were sometimes very large.

Themes

• The Realists wanted to create works that would be accessible to all, in other words immediately comprehensible and capable of touching a public who were not terribly well informed. The themes they chose were never erudite, therefore, and were taken not from literature, history or mythology, but were contemporary and often based on everyday life, in particular work.

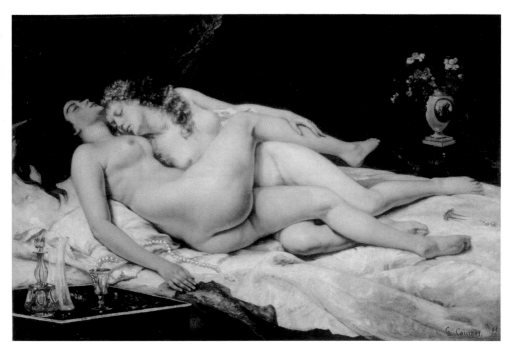

Gustave Courbet, *The Sleepers*, also known as *Sleep*, 1866, oil on canvas, 135 x 200cm, Paris, Musée du Petit Palais.

This aesthetic decision overturned the hierarchy of genres. Finding their models in old masters such as the Le Nain brothers or Chardin, or in Spanish art (Ribera), the Realist painters endowed depictions of everyday life and poverty with the dignity hitherto reserved for history subjects.

• Although still lifes and portraits occupied a less important place in the Realist iconography, they were not regarded as inferior genres. The landscape was particularly well represented — by the painters of the Barbizon School and the Dutch painter Jacob Maris.

Composition, line, colour, brushwork

• Although not worshipping line for its own sake, Realist painters rejected a loose style that promoted the subjectivity of the artist at the expense of clarity of form. Their compositions are often notable for being uncomplicated: figures arranged in friezes or diagonals, groups in which each individual is clearly distinguished, the separation of individual motifs and so on.

• Realist painters had little time for the brilliant experiments with colour indulged in by the Romantics, preferring earthy tones instead. Outdoor scenes are set in daylight, sometimes capturing the special light of dawn or dusk, and commonly recreate the humid atmosphere of the woods. Interiors use lighting effects of greater contrast.

• Classical architectural settings, such a prominent feature of Neoclassical works, were as alien to the Realists as were the backgrounds filled in with secondary detail painted by the Romantics. The Realists favoured settings that were both precise and ordinary: views of the French countryside (Franche-Comté in the case of Courbet), fields with distant haystacks (Millet), sections of road in an unidentified, unremarkable location (Courbet's *Stonebreakers*, now lost) and so forth. Among the painters of the 'official Realism' tendency who treated archaeological subjects, attention to detail once again became important. Thus Cormon painted with great precision the primitive clothes and tools of the first human beings, which contemporary prehistorical research had documented.

Styles

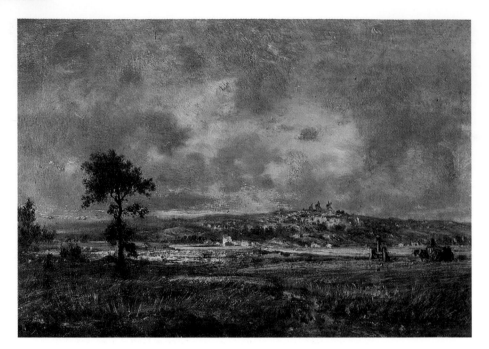

Théodore Rousseau, *View of the Plain of Montmartre (with Storm Clouds)*, c.1850, oil on canvas, 23 x 35cm, Paris, Musée du Louvre.

Figures

• In their concern to remain true to nature, the Realists chose models from among the ordinary people and depicted them — without idealization — dressed in clothes appropriate to their class and profession. These physical types were often not only lacking in beauty; the desire to achieve a sense of realism, sometimes combined with committed social and political views, led these painters to portray characters who might be seen as exemplars of human decay, with the facial features of 'brutes' made ugly or stupid by work, alcohol or hereditary disease. From this point of view, artists like Degas or Toulouse-Lautrec could be said still to belong to the Realist movement, on account of the attention they paid to the bodies and faces of ordinary people.

• The language of gesture changed radically. The Realist painters considered the movements and gesticulations favoured by the Classical artists, and which the Romantics also adopted, to be artificial and crudely sentimental. The gestures the Realists used were those of everyday life: raising one's hat in greeting in Courbet's *The Meeting*, also known as *Bonjour, Monsieur Courbet* (Montpeller, Musée Fabre), and praying in Millet's *The Angelus* (Paris, Musée du Livre). They also frequently depict manual work, such as breaking stones (Courbet), and sowing or gleaning (Millet).

• Eroticism and the nude are still present in Realist paintings, or at least in the work of Courbet. The manner in which he treated naked bodies, rendering thick forms in thick paint, gave them a materiality that was scandalous at the time — all the more so if these bodies were touching or indulging in activities judged by society to be shameful (*The Sleepers*), or focusing, in the style of pornographic photographs of the day, on the sexual organs (*The Origin of the World*, Paris, Musée d'Orsay).

Impressionism

The word 'Impressionism' was coined by the critic Louis Leroy when writing about Monet's painting *Impression: Sunrise* (see p.106) in *Le Charivari*. The picture was shown between 15 April and 15 May 1874 in the group exhibition organized by Degas and held in the studio of the photographer Félix Nadar at 35 boulevard des Capucines in Paris.

Rejected by the Salons and criticized as 'daubers' by the periodicals that championed official art, the Impressionists were supported by the writers Émile Zola, Joris Karl Huysmans and Louis Edmond Duranty, the critic Théodore Duret and the dealer Paul Durand-Ruel, who for a long time was their only financial backer. Collectors started to appear around 1870 (the financiers Ernest Hoschedé and Gustave Arosa, Count Armand Doria, the baritone Jean-Baptiste Faure, the painter Gustave Caillebotte and Doctor Paul Gachet, the future friend of Vincent Van Gogh) and became far more numerous from the end of the 19th century onwards.

The term 'Impressionism' is used to describe the pictorial style that gradually developed in France between the beginning of the 1860s and the end of the 19th century — and indeed a lot later if we take into account the work Monet produced towards the end of his life: he remained faithful to the Impressionist style right up to his death in 1926. Officially, the birth of the movement is considered to date from 1874, the year of the exhibition at Nadar's studio that brought together works by Cézanne, Degas, Monet, Morisot, Pissarro, Renoir and Sisley. This was followed by six further exhibitions, up to 1882, and then by an eighth in 1886. In actual fact, the group started to form from 1862 onwards, based on friendships among members of Claude Monet's circle. The movement reached its peak in the 1870s. Degas and Cézanne defected in the same decade, and it started to disband gradually from the middle of the 1880s. During the 1890s the movement started to expand beyond the borders of France.

The Impressionist movement is associated with two technical innovations in particular: photography (Niepce's process dates from 1826), which the Impressionists considered to be an extraordinary means of exploring the world, and the packaging of industrially prepared oil pigment in tubes, which allowed painters to go off and paint complete pictures outdoors instead of having to make do with sketches that would then have to be worked up in the studio. They also exhibited a scientific curiosity very much in the 19th-century spirit. Keen readers of Chevreul — the chemist whose 1839 treatise *De la Loi du Contraste Simultané Des Couleurs* (The Law of the Simultaneous Contrast of Colours) codified the laws governing colour — the Impressionists and in particular the Neo-Impressionists Seurat and Signac observed a rigorous division of colours on the canvas, requiring the process of mixing to be carried out by the eye of the viewer ('optical mixing'). Finally, following in the tradition of the Realist movement, which had influenced its gestation, Impressionism was very much a child of its time. Its adherents were trapped in a sprawling urban world. They painted either the city that surrounded them or the beauty and leisure spots made accessible by the new means of transport that was the railway. These included riverbanks in the Parisian suburbs and the Normandy coast, the first coast to be reached by train from Paris.

While Impressionism was essentially a French phenomenon, its genesis cannot properly be understood without knowing about the foreign trips the Impressionists made and the influences they came under during these trips. In 1870, during the Franco-Prussian War, Monet and Pissarro took refuge in Britain, discovering Constable and his studies of the sky and Turner and his radiant landscapes. The following year, Monet travelled to the Netherlands, where the light came as a revelation to him and inspired his *Windmills*, the first of a number of series paintings. Already filled with enthusiasm by the experimental landscape painting of the Frenchman Eugène Boudin (1824–98) and the Dutchman Johan Barthold Jongkind (1819–91), Monet and Pissarro turned to outdoor painting.

Styles

Centres and artists

• **France** was the cradle of Impressionism and the country in which it blossomed. While the Impressionists admired the paintings of the Realists, they valued even more highly the work of Édouard Manet (1832–83), whose *Le Déjeuner sur l'Herbe* and *Music in the Tuileries*, both exhibited at the Salon of 1863, caused a scandal. Manet became close to the group for a while, painting, like Monet, in the open air (*Monet Painting in his Studio Boat*, 1874, Munich, Neue Pinakothek). But it was really CLAUDE MONET (1840–1926) and Camille Pissarro (1830–1903) who were at the group's heart. These two, along with Pierre Auguste Renoir (1841–1919), painted in the open air between 1867 and 1869, seeking to capture the effect of light on water in Normandy or on the banks of the Seine or the Oise. Alfred Sisley (1839–99), of English parentage, Frédéric Bazille (1841–70), Berthe Morisot (1841–95), Mary Cassatt (1844–1926), an American national, and Armand Guillemin (1841–1927) belonged to this first generation of Impressionists and were to remain true to its principles throughout their careers. Edgar Degas (1834–1917) had a more fleeting encounter with Impressionism, as did Paul Cézanne (1839–1906), who turned away from it in order to develop a style emphasizing the solidity of form. The Dutchman Vincent Van Gogh (1853–90) created a unique style of his own which derived from Impressionism.
• **In Germany**, Max Liebermann (1847–1935) and Lovis Corinth (1858–1925) were exponents of a style influenced only partly by French Impressionism.
• **In Great Britain**, the early work of Philip Wilson Steer (1860–1942) comprised landscapes painted outdoors in the tradition of Monet.

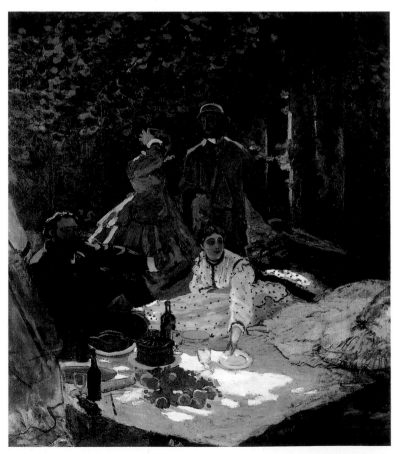

Claude Monet, *Le Déjeuner sur l'Herbe*, 1865–6, oil on canvas, 248 x 217cm (fragment of a damaged painting), private collection.

• **America** subscribed to Impressionism through the group known as Ten American Painters, founded in 1898. Its main members were John Twachtman (1853–1902) and Childe Hassam (1859–1938), who both spent time in France and exhibited their Normandy landscapes at the Durand-Ruel gallery and in New York.

• **In Poland**, the movement known as 'Kapism' or 'Polish Colourism' — and in particular the painter Jan Cybis (1897–1972) — adopted a late version of Impressionism in the 1920s.

Characteristics

Techniques and supports

• Impressionist paintings were executed in oil on canvas. Small formats were generally preferred, as canvases were bought ready stretched from the dealer and had to be of a size that could be easily transported to the place where the painting was to be done.

• The Impressionists liked to draw in colour and were thus enthusiastic users of pastel, particularly Renoir and Degas.

Themes

• The Impressionist style was based on a desire to convey fleeting impressions of motifs exposed to variable light. The subject was not the most important element: the Impressionists painted landscapes not for the picturesque character of the specific location, which was generally unexceptional, but for its atmospheric effects. In order to convey the very varied appearance that motifs could have depending on the light and time of day, the Impressionists occasionally produced series of paintings of the same motif, such as Monet's *Cathedrals* and *Haystacks*. They explored extreme conditions with enthusiasm and portrayed motifs whose contours were blurred by the prevailing lighting conditions. This resulted in numerous snow scenes, scenes of flooding and water scenes in general — water (or more precisely the reflection of light on the moving surface of the water) was important in their works.

• Much influenced in their early stages by the work of the Realists (notably Courbet) and Manet, the Impressionists were especially responsive to subjects of everyday life. The city, and in particular Paris (then in the throes of reconstruction), occupied them to a great extent. Paris's main boulevards, the new district around Saint-Lazare station (including the Pont de l'Europe) and the Haussmann-style apartment blocks and interiors formed as much a part of the iconography of Manet, Monet, Renoir and Caillebotte as landscapes and seascapes did. The subjects of numerous paintings were provided by the leisure pursuits of the city's inhabitants: strolls in the park (Manet's *Music in the Tuileries*, London, National Gallery), conversations on café terraces, swimming and boating trips, and public dances on the outskirts of the capital (Argenteuil, Bougival, Chatou). Toulouse-Lautrec depicted in an unidealized way the most dissolute forms of public merrymaking (brothels, cabarets, alcohol), whereas Degas was attracted by more conventional pleasures (the theatre, the opera, the races). Enthralled by light, the Impressionists took an interest in new forms of lighting, and the artificial light of the gas lamp is the real subject of Manet's *A Bar at the Folies-Bergère* (London, Courtauld Institute).

• Although Manet was a great portraitist (*Portrait of Émile Zola*, see p.124), and painter of still lifes — as were Van Gogh and particularly Cézanne later on — the Impressionists paid little attention to these two genres (and even less to history painting) when the movement was at its height between 1874 and 1880.

Composition, line, colour and brushwork

• Their brushwork, which was free and visible in the work of Monet, Pissarro, Sisley and Morisot during the peak years of the movement in the 1870s, brought the Impressionists the accusation that they did not take their paintings beyond sketch stage. An artist like Manet, even at the time when he was closest to the movement, favoured a technique based on flat areas of colour.

The brush stroke also assumed a less important role in the work of Degas and Toulouse-

MONET AND CÉZANNE : TWO SEA VIEWS, TWO STYLES

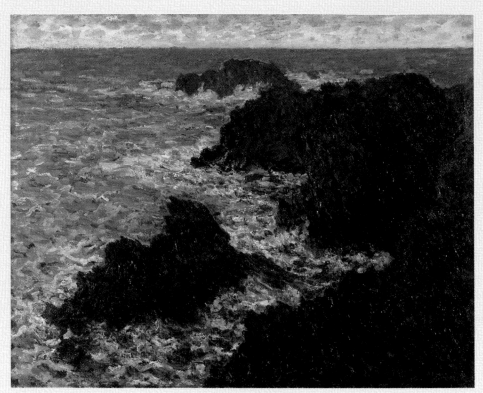

Claude Monet, *Rocks at Belle-Île on the Côte Sauvage*, 1886, oil on canvas, 65 x 81cm, Paris, Musée d'Orsay.

These two paintings, oils on canvases of similar dimensions, were painted in the open air in the same year. A comparison between the two reveals the differences between Monet's style (and that of the Impressionists generally) and Cézanne's, who distanced himself from his former friends as early as 1876 — the year of the second collective Impressionist exhibition, in which he refused to participate — when he moved to L'Estaque, near Marseilles.

Two regions

The subject of both paintings is the sea, or to be more precise the meeting of shore and water. Monet's picture was painted at Belle-Île, off the Brittany coast, and depicts the Atlantic south of Normandy, which was the favourite haunt of the Impressionists, who lived for the most part in Paris. Cézanne's picture is of L'Estaque and the Mediterranean Sea in Provence, where the painter (who was originally from there and who hated city life) made his main home.

Two kinds of light

The difference in light in the two paintings is a result of the difference in location. In order to emphasize the luminosity of the south, Cézanne has chosen a light palette, and has positioned the horizon fairly low down in order to leave plenty of space for a

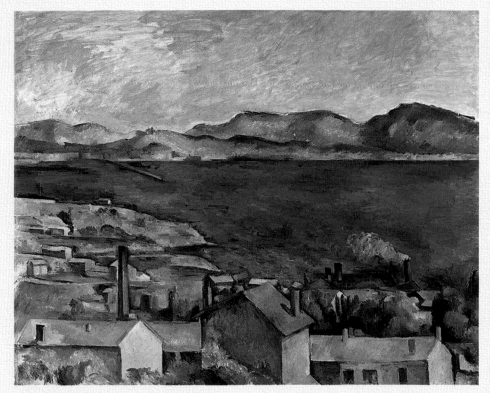

Paul Cézanne, *The Gulf of Marseilles Seen From L'Estaque*, c.1886, oil on canvas, 76 x 97cm, Chicago, The Art Institute, Mr and Mrs Martin A Reyerson Collection.

sky made up of various shades of pale blue (it is winter) and mountains that are also rendered blue by the distance. Monet uses darker tones: browns for the rocks of Belle-Île and intense blues. He raises the horizon, leaving visible only a very small rectangle of sky heavy with clouds.

Two types of brush stroke

The main difference between the paintings, however, lies elsewhere. Monet uses white to convey the turbulence of the ocean, applying it in short brush strokes to represent waves and foam. Cézanne renders the intense calm of the bay (viewed from further back) with a flat area of barely modulated blue. A single plume of smoke, rising from the chimney of one of the local houses, stands out against it.

Monet has employed a technique based on visible brush strokes for the rocks in the foreground too. These brush strokes build up the rock little by little and convey the impression — a physical sensation almost — of the dampness of these outcrops lashed by the surf. Cézanne, on the other hand, fills his foreground with houses and the verticals of chimneys, including even a factory chimney. Man (or more precisely the environment he creates) and modern life are fully integrated into his vision of nature, but above all these buildings impose on the picture a rigorous geometry of forms, volumes, angles and solid objects that Monet's vision, focusing on the changing light of the water, ignores completely.

Styles

Lautrec, becoming more or less invisible. In Van Gogh's paintings, however, the reverse was true, and his brushwork gradually acquired a strong expressivity based on swirling movements.

• Except in the work of Degas, drawing was secondary to colour and pigment, which was often applied thickly.

• The most obvious characteristic shared by the Impressionists is their use of light colours in reaction to the dark paintings often produced by the Realists. The separation of the different colours of the spectrum, applied next to each other on the canvas rather than being mixed on the palette, was far less systematic among the first generation of Impressionists than it would later be among the Divisionists (see p.106).

Figures

• The Impressionists did not seek to tell stories and did not, therefore, concern themselves with the invention of gestures designed to communicate emotion. Neither did they have any social agenda, and were not interested in showing people at work for its own sake, as the Realists were. However, the Impressionists were fond of everyday subjects, and artists from Manet to Caillebotte depicted everyday actions: simple leisure activities — walking, dancing, rowing (Édouard Manet's *Boating*, New York, Metropolitan Museum, for example) — but also occasionally work (*THE FLOOR SCRAPERS*, by Gustave Caillebotte).

• The Impressionists painted the world around them: bourgeois gentlemen in their tail coats and ladies in their fine dresses, as well as workers in their work or leisure clothes. The clothes interested the painters less than the fall of the light on the fabrics, especially when they were seen — as was usually the case — outdoors.

• The Impressionists were also attracted to the nude, again especially in the open air. What interested them most here was the play of sunlight and shadow on completely naked flesh. Except in the work of Degas, however, for whom the nude (particularly women bathing) was a favourite subject, and Renoir, especially his late work, it was often the case that the female nude lost her sensuality and became a motif like any other (see p.162).

Gustave Caillebotte, *The Floor Scrapers*, 1875, oil on canvas, 102 x 146.5cm, Paris, Musée d'Orsay.

Post-Impressionism

'Post-Impressionism' is the term used to denote a set of artistic trends that originated with artists who were on the fringes of Impressionism and who used their knowledge and experience to develop a range of distinct and sometimes conflicting aesthetic systems. These different tendencies need to be identified.

NEO-IMPRESSIONISM

This term was first used by the critic Arsène Alexandre in 1886 to refer to the works of Seurat. The words 'Divisionism' and 'pointillism' are often preferred as they accurately describe the technique advocated by Seurat based on small touches designed to break colour up into spots of pure colour. In this he was following — to a far stricter degree than the Impressionists — the optical theories of Chevreul (see p.109) and other physicists such as Hermann von Helmholtz (1878) and Ogden N Rood (1881). The work that marked the birth of the movement was Seurat's *Sunday Afternoon on the Island of La Grande Jatte* (1884–6, see p.107), a genuine pictorial manifesto. Among the writers and critics who supported Neo-Impressionism were Félix Fénéon, Charles Henry and Émile Verhaeren.

Centres and artists

• In France, Georges Pierre Seurat (1859–91) was the leader of the new style, followed by Paul Signac (1863–1935), Camille Pissarro and his son Lucien Pissarro (1863–1944) between 1885 and 1890, and then Albert Dubois-Pillet (1846–90), Henri Edmond CROSS (1856–1910), Maximilien Luce (1858–1941), who took his subjects from the lives of working people, and Charles Angrand (1854–1926). Van Gogh and Toulouse-Lautrec experimented occasionally with this system of separate touches of colour, as did Matisse, Derain, Braque and Delaunay in Fauvism's formative period around 1905.

Henri Cross, *Les Îles d'Or*, 1892, oil on canvas, 59 x 54cm, Paris, Musée d'Orsay.

• In Belgium, Divisionism spread thanks to the group known as *Les Vingt* ('The Twenty' or 'The XX'), formed in 1883, whose main exponents were Théo van Rysselberghe (1862–1926), who introduced the technique into portrait painting, Georges Lemmen (1865–1916), who looked to Renoir as a model as much as to Seurat, Willy Finch (1854–1930), who was of British origin, and Henri van de Velde (1863–1957), who was better known as an architect.

• In Italy, the main representative of this style of painting was Giuseppe Pellizza da Volpedo (1868–1907). Others included Angelo Morbelli (1853–1919) and Gino Severini (1883–1966) in his earlier years.

• In Germany, Christian Rohlfs (1843–1938) was the movement's leading member.

Styles

Characteristics

Techniques and supports
• The Neo-Impressionists painted in oil on canvases of sometimes fairly large dimensions. The frames, covered with tiny dots in a colour complementary to the dominant tonality, form an integral part of the works.
• The Neo-Impressionists were great draughtsmen, and Seurat made countless studies and sketches for his pictures. Signac, Dubois-Pillet and Camille Pissarro also drew copiously, applying the pointillist technique to their drawings.

Themes
• Their themes were the same as those of the Impressionists: landscapes, especially views of the Channel and the North Sea, suburban leisure activities by the banks of the river (*La Grande Jatte* and *Bathers at Asnières* by Seurat, see p.64), the nude (in the sunshine but also posing indoors), and subjects that enabled the Neo-Impressionists to study artificial light (the gaslights in Seurat's *Circus Parade*, New York, Metropolitan Museum of Art).

Composition, line, colour and brushwork
• Line again assumed an important role, helping to define contours. It is often made up of very small touches arranged in an outline.
• While the term 'Divisionism' is accurate, as it describes the separation of the touches (which are always composed of pure colour), the term 'pointillism' is misleading. Far from being consistently reduced to small points, brush technique varied from period to period and from artist to artist, and even within the same picture. For example, between 1882 and the time he completed *La Grande Jatte*, Seurat gradually reduced the size of his brush marks, moving from a style based on intersecting patches of colour to one featuring a mottled effect (see p.107).

Figures
• In Neo-Impressionist paintings the figures are flat and the separation of brush marks makes them almost transparent.

SYNTHETISM

Synthetism was the response of those artists associated with Impressionism who refused to embrace the new Divisionist movement. It was an aesthetic theory defined in August 1888 by Émile Bernard and Paul Gauguin. The movement is rightly associated with the Brittany village of Pont-Aven (the 'Pont-Aven School'), where Bernard and Gauguin were painting when they defined the style. Synthetism is also associated with Cloisonnism, a term invented by the critic Édouard Dujardin to describe paintings executed by Louis Anquetin and Bernard the previous May. These were painted in a style based on 'compartments, similar to the *cloisonné* technique [...] drawing accentuating colour and colour accentuating drawing'.

The adherents of Synthetism refused to accept the reduction of painting to a scientific system, in this instance the laws of optics. At the same time that Puvis de Chavannes was painting his first Symbolist works, Bernard, Gauguin and their followers were dreaming of a style of painting rich in poetic and 'sacred' meaning rather than simply Realist. They wanted to return to a simple, solid construction of form. The way had been prepared for Synthetism by the discovery of Japanese prints, the popular, cartoon-like French illustrations known as 'images d'Epinal', and Western primitive art — all of which revealed the possibility of purifying painting by ridding it of unnecessary detail and constructing works in a different manner. Japanese prints also demonstrated a non-imitative use of colour and a new expressive intensity. Synthetism had a decisive influence on later movements, but it barely survived Gauguin's first trip to Tahiti in 1891 (although when he returned the group did go back to Pont-Aven to paint in 1894).

THE VISION AFTER THE SERMON : REDISCOVERING A SENSE OF THE SACRED

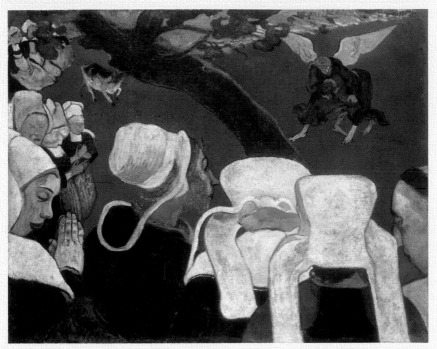

Paul Gauguin, *The Vision After the Sermon*, also known as *Jacob Wrestling the Angel*, 1888, oil on canvas, 73 x 92cm, Edinburgh, National Gallery of Scotland.

The subject of Jacob wrestling with the angel was not a new one. Delacroix had already painted a version of it in the church of Saint-Sulpice in 1861. Gauguin reinterpreted the theme, treating it as a 'vision'.

Power of the imagination

Their minds still alive with the sermon that has just been delivered by the priest (identifiable on the right), the devout Breton women 'see' the struggle told of in the Bible as they leave church. Gauguin explains this in a letter to Van Gogh written at the end of September 1888 when he finished the painting: 'For me, the landscape and the struggle in this painting only exist in the imagination of the people praying after the sermon'.

A new form of construction

Divided in two by the diagonal trunk of a tree (a layout inspired by Japanese prints) the painting contrasts the frieze of Breton women in the foreground, the domain of the real, with the imaginary realm of the background, in which the two figures, painted smaller as if some distance away, are wrestling.

The triumph of pure colour

The intensity of the colours and the rejection of verisimilitude and imitative colour are the main characteristics of this work. Gauguin has contrasted the realistic black and white of the clothes of the women and their spiritual leader with the expanse of vermilion that defines the dream sphere and that at the same time endows the image with an intensity that is in keeping with the fierceness of the battle. The yellow of the angel's wings, the blue of his tunic and the green of the foliage accentuate the contrast between the coloured, heightened world of the vision and the black and white of reality. In his eccentrically punctuated letter to Van Gogh, Gauguin emphasizes his choice of colours: 'Group of Breton women praying, costumes a very intense black. Bonnets a radiant yellow. [...] A dark violet apple tree cuts across the picture diagonally its foliage formed by emerald green area like clouds with chinks of yellow-green sun. The ground pure vermilion [...] The angel is dressed in ultramarine and Jacob in bottle green. The angel's wings pure chrome yellow 1 The angel's hair chrome yellow 2 and the feet flesh-orange [...]'.

Styles

Centres and artists

- **France** was the country in which Synthetism originated. Its leaders were Paul Gauguin (1848–1903) and Émile Bernard (1868–1941). Bernard evolved towards a mystical figurative style during the 1890s. The movement also numbered various artists working in Paris who exhibited either at the Café Volpini or with the others in Finistère: at Pont-Aven at first, then at Pouldu. These included Paul Sérusier (1863–1927), Armand Seguin (1869–1903), Charles Laval (1862–94), Henry Moret (1856–1913) and Claude Émile Schuffenecker (1851–1934). Louis Anquetin (1861–1932) was the inventor of Cloisonnism.
- A number of artists from other European countries also joined the movement, painting with Gauguin at Pont-Aven and Pouldu. The most important of these were the Dutchman Jacob Meyer de Haan (1852–95), Charles Filiger (1863–1928) from Alsace (which was then German), the Irishman Roderick O'Conor (1860–1940), the Pole Wladyslaw Slewinski (c.1854–1918), the Dane Jens Ferdinand Willumsen (1863–1958) and the Swiss Cuno Amiet (1868–1961) during his trip to Pont-Aven in 1892.

Characteristics

Techniques and supports

- The Synthetists painted in oil on canvas.

Themes

- Portraits, genre scenes featuring peasants, and religious themes were all painted by the Synthetists.

Composition, line, colour, brushwork

- Innovations based on Japanese prints (the splitting of images into two by means of a diagonal line or a pillar, and the adoption of motifs such as the bridge and rain) influenced the Synthetists' work, which was stripped of all superfluous detail and reduced to essentials.
- Forms were solidly drawn and figures were frequently given a strong outline or set against a contrasting background colour to make them stand out.
- The Synthetist painters rejected distinct brush strokes, favouring large areas of flat colour instead.
- Their colours are intense: yellows, blues, reds (the primary colours) not substantially modified by chiaroscuro.

Figures

- The figures of the Synthetists represent ordinary people. They are reduced to their essential forms, simplified and solidly constructed.
- The Synthetists were fond of traditional costumes (the black dresses and white headdresses of the Breton women, for example), not so much for their folkloric aspect but because the contrast of colours and simplicity of form of these costumes allowed them to construct effective figures.

THE NABIS

The word 'Nabi' comes from the Hebrew *nabim*, meaning 'prophets'. The Nabis were a group of French painters born between 1860 and 1870, in many cases former pupils of the Académie Julian in Paris. Following Gauguin's lead, in 1888 the Nabis sought an alternative to Impressionism, with the intention of restoring to art a sense of the sacred. Their leader was Paul Sérusier. In 1888, under Gauguin's supervision, he painted the bottom of a cigar box in patches of pure colour, giving it the title *The Talisman* (Paris, Musée d'Orsay). With Maurice Denis (author of the famous phrase: 'a painting, before becoming a battle horse, a naked woman or an anecdote of some sort, is essentially a flat surface covered with colours assembled in a certain order'), the movement — which was also called 'Neo-Traditionalism' (a term invented by Denis) — gradually took on a more pronounced religious character.

Championed primarily by the critic Albert Aurier, the group held exhibitions at Ambroise Vollard's gallery from 1896. Made up of disparate personalities, but represented by the periodical *La Revue Blanche*, the movement survived for a dozen years or so before finally disbanding in 1903, the year the last issue of its review was published.

Centres and artists

• The Nabi movement was predominantly French. Its initiators were PAUL SÉRUSIER (1863–1927), Maurice Denis (1870–1943), Henri Gabriel Ibels (1867–1936), Paul Ranson (1864–1909) and Pierre Bonnard (1867–1947), who were all pupils of the Académie Julian. They were later joined by Édouard Vuillard (1868–1940), Ker Xavier Roussel (1867–1944), Aristide Maillol (1861–1944), better known as a sculptor, and Georges Lacombe (1868–1916), who was also primarily a sculptor.

• A number of European artists living in France also joined the movement: the Dutchman Jan Verkade (1868–1946) and the Dane Mogens Ballin (1871–1914) in 1891; the Hungarian József Rippl-Rónai (1861–1927) in 1892; and finally the Swiss painter Félix Vallotton (1865–1925) in 1897.

Characteristics

Techniques and supports

• The Nabis continued to paint in oils, but no longer confined themselves to canvas, as *The Talisman*, painted on wood, demonstrates.

• Like other groups who were active in Europe at the same time, the Nabis had a vision of an all-inclusive art. They created stamps, playing cards, puppets, fans, posters, screens and wallpaper.

• They were also great illustrators, practising lithography and wood engraving.

Themes

From the movement's earliest days, two distinct types of subject were painted.

• The 'religious' Nabis painted allegorical works in which mystery and a sense of the sacred prevailed. Historical and mythological allusions were common in this type of painting, notably in the work of Denis and Ranson.

• The 'modern' Nabis preferred interiors or scenes of Parisian life featuring a deliberately modest, even 'intimist', atmosphere (Bonnard and Vuillard).

Composition, line, colour and brushwork

• Taking their inspiration from the spiritualist phase of the Symbolist movement (Puvis de Chavannes) and tendencies (such as

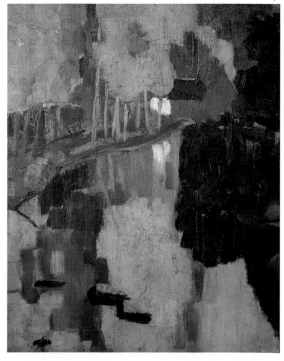

Paul Sérusier, *The Talisman* (*Landscape at the Bois d'Amour at Pont-Aven*), 1888, oil on wood, 28 x 22cm, Paris, Musée d'Orsay.

 Styles

Pre-Raphaelitism in Britain) that championed a return to pre-16th-century painting, the Nabis were loath to employ scientific perspective — which they thought would ruin 'the sense of primitive feeling' — and emphasized the surface of the picture rather than its depth.
• Line, considered to possess strong emotive power, was rehabilitated, and the arabesque was especially highly valued. In this sense the Nabi style prepared the way for Art Nouveau.
• Inspired by Japanese prints (Bonnard in particular), the Nabis employed bright — non-imitative and often pure — colours.

Figures
• The figures are flat. Relief, like perspective, was regarded by the Nabis as undesirable as it emphasized the material side of painting.
• The characters are idealized.

SYMBOLISM

The term 'Symbolism' appeared sometime after 1886, when the French poet Jean Moréas, in a manifesto published in the supplement to the daily newspaper *Le Figaro*, invented 'poetic Symbolism' or the art of 'clothing ideas in a perceptible form'. The epithet was applied to painting by the magazine *Le Mercure de France* in 1890 (with reference to Van Gogh) and again in 1891 (with reference to Gauguin). But Symbolist art, which flourished in the last twenty years of the 19th century, predated its naming by a considerable length of time.

Rather than a precise style, Symbolism was a wide international trend that — counter to Realism and that other form of imitative painting, Impressionism (see p.237) — proposed an idealist (or as Aurier preferred, *idéiste* — 'idea-ist') art in which what counted was not the definition of a unique form, but the subject. An essentially Nordic phenomenon that became more and more influential during the second half of the century, particularly from the 1870s onwards, this movement followed in the tradition of Romanticism, having connections to literature (Oscar Wilde, Poe, Baudelaire, Huysmans, Maeterlinck) and music (Wagner).

Centres and artists
• In Great Britain, the creation of the Pre-Raphaelite Brotherhood in 1848 by Dante Gabriel Rossetti (1828–82), of Italian parentage, and John Everett Millais (1829–96) can be regarded as the first real manifestation of Symbolism. Spurred on by the theoretician John Ruskin, the Pre-Raphaelites, like the Nazarenes before them, used Gothic art and the painting of the quattrocento as their reference points as they attempted to reinstate an idealist, sacred form of art. In addition to Rossetti and Millais, William Holman Hunt (1827–1910) and then, somewhat more loosely, Ford Madox Brown (1821–93) and Edward Burne-Jones (1833–98) were also involved with the Pre-Raphaelite movement. At the end of the century, Symbolism was represented in Britain by Aubrey Beardsley (1872–98), who was essentially a graphic artist, and the Scottish architect and designer Charles Rennie Mackintosh (1868–1928), who also worked on paper.
• In Germany, the precursors of Symbolism (C D Friedrich, Ludwig Richter, Moritz von Schwind) retained their links with Romanticism. Hans von Marées (1837–87) was the principal exponent of the movement at the end of the century.
• In Austria, Symbolism was represented by Koloman (known as Kolo) Moser (1868–1918) and the early works of Alfred Kubin (1877–1959). Despite its individuality, the art of Gustav Klimt (1862–1918) was also inspired by Symbolism.
• In central Europe, the main exponents of Symbolism were the Hungarian József Rippl-Rónai (1861–1927), the Poles Jacek Malczewski (1854–1929) and Jozef Mehoffer (1869–1946), who was also an engraver, and the Czechs Jan Preisler

(1872–1918) and Frantisek Kupka (1871–1957) in his early work.

• **In Switzerland**, Symbolism's leading exponents were Arnold Böcklin (1827–1901) and later Ferdinand Hodler (1853–1918). Albert Servaes (1883–1966), of Belgian origin, also belonged to the movement.

• **In France**, the art of the Pre-Raphaelites came as a revelation at the World Fair of 1855 and led to the birth of a similar movement, the Lyon School or the French Nazarenes, whose exponents Paul Chenavard (1807–95), Louis Janmot (1814–92) and Hippolyte Flandrin (1809–64) painted in a style similar to that of their precursor Victor Orsel (1795–1850). The second generation of Symbolists was made up of Pierre Puvis de Chavannes (1824–98), who painted large allegorical works in light colours, *GUSTAVE MOREAU* (1826–98), whose art was more visionary, and Odilon Redon

Gustave Moreau, *Mystic Flower,* c.1890, oil on canvas, 253 x 137cm, Paris, Musée Gustave Moreau.

(1840–1916), a graphic artist as much as a painter, whose works depict a fantastic and disturbing world. In the 1890s, Symbolism was given a new lease of life by the Synthetists (see p.93), who found a natural leader in Paul Gauguin during both his Pont-Aven and Tahitian periods. At the same time, the writer and Rosicrucian theoretician the Sâr Péladan had an influence on painters such as Edmond Aman-Jean, Louis Anquetin, Filiger, Louis Weiden Hawkins, who was of British origin, and others. Lucien Lévy-Dhurmer (1865–1953) and Henri Le Sidaner (1862–1939) were also associated with the Symbolist movement.

• **In Belgium**, Symbolism became the dominant artistic movement, exhibiting after 1893 in the 'Pour l'art' and 'Art idéaliste' salons founded by the painter and writer Jean Delville (1867–1953). Its main exponents were Félicien Rops (1833–98), who was associated with the Sâr Péladan, Fernand Khnopff (1858–1921), James Ensor (1860–1949), whose work prefigured Surrealism, and Léon Spilliaert (1881–1946) in his early work. William Degouve de Nuncques, of French origin, and Léon Frédéric (between 1890 and 1900) also painted in the Symbolist style.

• **In the Netherlands**, Symbolism came to the fore with Richard Nicolaus Roland-Holst (1868–1938) and Jan Toorop (1858–1928). Around 1890, Johann Thorn-Prikker (1868–1932) joined the movement.

• **In Scandinavia**, Symbolism inspired the work of the Danes Jens Ferdinand Willumsen (1863–1958) and Vilhelm Hammershoi (1864–1916), the Finn Aksel (known as Akseli)

Styles

Gallén-Kallela (1865–1931), the Swede Richard Bergh, and most importantly the Norwegian Edvard Munch (1863–1944), in whose work the evolution from Symbolism to Expressionism is apparent.

• **Southern Europe** was also influenced by Symbolism. In Italy, Giovanni Segantini (1858–99) and the painters Giuseppe Pellizza da Volpedo and Gaetano Previati, who both employed a pointillist technique (see p.243), belonged very much to the movement in terms of their choice of subject. In Spain, representatives of Symbolism included the Catalan Juan Brull y Viñolas and Adriá Gual-Queralt (1872–1944).

Characteristics

Techniques and supports
• Like the Nazarenes, the Pre-Raphaelites and the painters of the Lyon School before them, the Symbolists sought to reintroduce ancient techniques, including fresco, encaustic painting, the use of wood as a support instead of canvas, and the replacement of easel paintings with retables with a gold background.
• Otherwise, most Symbolist paintings were executed in oil on canvas.
• Symbolist artists were often skilled draughtsmen and engravers too.

Themes
• The subject plays an essential role in Symbolist painting. Themes were taken from universal mythology — including Classical, Germanic, Celtic, Scandinavian, the Bible, and fairy stories. Painters favoured dreams, mystery and scenes of anguish, and were sensitive towards Christian spiritual values. They were interested in exploring the meaning of life, figuring out man's destiny and sounding the depths of the human soul. The title of a painting painted by Paul Gauguin in 1897, *Whence Do We Come? What Are We? Where Are We Going?*, is indicative of these ambitions.

Composition, line, colour, brushwork
• Symbolist painting was never characterized by one individual style. Varying according to period, painter and region, it employed the techniques of Romanticism, Impressionism, pointillism, the Nabis and even Expressionism.
• Many of the motifs used by the Symbolist painters are used again and again, however: poppies, lilies and other flowers (symbols of good and evil), swans (Wagnerian in origin) and other creatures that readily metamorphose. At the end of the century, femmes fatales and fallen angels can be found in their paintings.

The figure
• Women play an essential role in Symbolist painting. As virtuous, idealized virgins they lead men to salvation; or as fatal beauties they lead them to ruin.

FAUVISM

Originating between 1894 and 1897 as a result of the meeting between young artists in the Symbolist Gustave Moreau's studio at the École des Beaux-Arts in Paris, the group was given the pejorative name 'Les Fauves' by the critic Louis Vauxcelles at the Autumn Salon in 1905, and broke up around 1907. Championed by the dealers Ambroise Vollard and Berthe Weill, the works of the Fauves were slated by the critics and mocked by the public. Influenced by Gauguin, by the vivid pointillist works of Signac and Cross and by the paintings of Van Gogh they discovered during a retrospective of the artist's work at the Bernheim–Jeune gallery in 1901, the Fauves also took their inspiration from the brightly coloured work of Louis Valtat (1869–1952), likewise a pupil of Moreau, who seems to have been both a precursor and an active sympathizer of the movement.

Centres and artists

• Fauvism was an exclusively French phenomenon. Henri Matisse (1869–1954) and André Derain (1880–1954) were the leaders of the movement, and other members included Maurice de VLAMINCK (1876–1958), Albert Marquet (1875–1947), Othon Friesz (1879–1949) and, more loosely, Jean Puy (1876–1960) and Henri Charles Manguin (1874–1958). Georges Braque, who a few years later invented Cubism with Picasso, painted in a Fauvist style in 1906, and Raoul Dufy (1877–1953) also worked in the style after 1900. Kees van Dongen (1877–1970), who later became a fashionable portrait painter, was also closely associated with the movement between 1905 and 1910.

Characteristics

Techniques and supports

• Fauve paintings tend to be small-format oils on canvas.

Themes

• In particular, the Fauves painted landscapes — in the south of France, Normandy (Le Havre), London (Derain's visit of 1905 was apparently in response to Monet's London canvases of 1870) and in the vicinity of Paris, notably Chatou.

• The portrait also had an important position in Fauvist iconography. Portraits were often reduced to just a face or at most head and shoulders and were painted in non-imitative colours.

Composition, line, colour and brushwork

• The Fauves rejected Classical perspective. They preferred a style that concentrated on the surface qualities of the canvas rather than on depth, and at least some of them, including Matisse, attached primary importance to line and even to the arabesque.

• They painted in pure colour in a non-imitative or relatively non-imitative manner, using the contrast between colours to differentiate between planes. Their rejection of chiaroscuro allowed them to create consistently vibrant works of great emotional intensity.

Maurice de Vlaminck, *The Bridge at Chatou*, 1906, oil on canvas, 54 x 73cm, Saint-Tropez, Musée de L'Annonciade.

Styles

• The Fauves' often large, square brush strokes are always visible, and their execution has clearly been rapid.

Figures

• Except in portraits, figures play only a minor role in Fauvist paintings.

EXPRESSIONISM

Symbolism and Fauvism were as important for the influence they exerted over later movements as they were for the actual works they produced. Expressionism, a style that lasted from the end of the 19th century to the middle of the 1920s, was the result of the combined influence of these two movements. A lyrical, mystical and violent art, it had its beginnings in the reaction against Impressionism and Realism.

Centres and artists

Expressionism was essentially a German phenomenon.

• In Dresden, the group known as Die Brücke ('The Bridge') was formed in 1905 by Erich Heckel (1883–1970), Karl Schmidt-Rottluff (1884–1976) and Ernst Ludwig KIRCHNER (1880–1938). They were soon joined by Emil Nolde (1867–1956), Max Pechstein (1881–1955) and Otto Müller (1874–1930). The movement disseminated its ideas through its review *Der Sturm*, first published in 1910.

• In Munich, the group Der Blaue Reiter ('The Blue Rider') was founded in 1911 by Wassily Kandinsky, whose work evolved almost immediately towards full abstraction (see p.259), Gabriele Münter (1877–1962), Franz Marc (1880–1916), August Macke (1887–1914) and Alexei von Jawlensky (1864–1941).

After World War I, the movement became international, spreading to Austria with Egon Schiele (1890–1918) and Oskar Kokoschka (1886–1980); to Belgium, where Constant Permeke (1886–1952) was its principal exponent and where its ideas were disseminated through the review *Sélection*; to the Netherlands with Jan Wiegers (1893–1959); and to France with Chaim Soutine (1893–1943), who was born in Lithuania.

Characteristics

Techniques and supports

• The Expressionists continued to paint in oil on canvas, often leaving patches of canvas exposed.

• They were also keen engravers, practising wood engraving in particular — a 'primitive' form of engraving whose necessarily crude lines produced a simplification of forms and strong contrasts between black and white.

Themes

• The Expressionists condemned the modern world, particularly the harshness of urban life. They were fond of painting landscapes, or rather nature, which took the place of any real mythology in their work.

• During the tense interwar period, their themes became violent: allegories of nature were replaced by even more forceful denunciations of the contemporary world with its violence and horror.

Composition, line, colour and brushwork

• The Expressionists' compositional style, which right from the early days of the movement avoided superfluous detail, became even more simplified, particularly in their engravings (often in colour), which were inspired by popular wood engravings from earlier periods. It could also sometimes be deliberately complex, for example in the work of Kokoschka, in which a certain confusion forms part of the artist's criticism of the modern world.

• Close to Fauvism at the beginning of the century, Expressionism employed vibrant colours that became extreme — used in deliberately harsh combinations — or, after World

War I, 'muddied' and dominated by blacks and reds.

• In their engravings in particular, but also in their paintings, line assumed an extremely important role. The Expressionists frequently gave their motifs a strong outline.

• Their brush strokes, already visible before 1914, became more forceful after the war, leaving clear marks in uneven, impasted paint.

Figures

• The Expressionists' figures are schematic, often reduced to silhouettes. The nature-loving nudes present in their pre-war works took on misshapen, jagged contours in the years after the war, with faces that were either no longer visible or rendered ugly by twisted expressions or excessive make-up. We are shown inadequate human beings whose physical and spiritual poverty goes hand in hand with the omnipresence of sex, suffering and death.

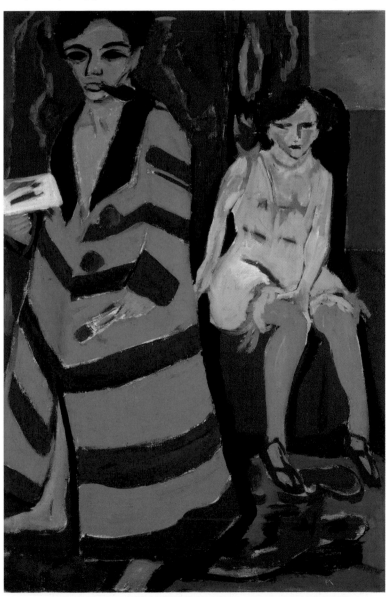

Ernst Ludwig Kirchner, *The Artist and His Model*, 1910–26, oil on canvas, 150 x 100cm, Hamburg, Kunsthalle.

Epilogue

The challenge to figurative art in the 20th century

The notion of style and such concepts as 'movement' and 'trend' need to be used with even greater care (if possible) with respect to 20th-century art than when referring to earlier periods. During the 20th century, artistic forms evolved towards an essentially reductive globalization. The moment the United States, and to a far lesser extent Brazil, Argentina, Japan and China, became significant creative forces, and physical and media communications became even more rapid than before, it became difficult for a sense of national identity or a regional style or character to exist and survive on a long-term basis. Art, like the planet as a whole, identifies with the West and its prosperous and imperialist industrial society.

The speed with which information could be transmitted increased considerably. Newspapers and journals, used by artists until the 1930s to publicize their 'manifestos'; photography, which revealed the appearance of artists' works to the readers of these same publications; radio, cinema and television — all of these allowed artistic (and other) trends to become accessible, and thus susceptible to instantaneous, almost 'real-time' imitation. This accelerated dissemination brought about a surfeit of innovation: a sense of over-familiarization and weariness, the feeling of having 'seen too much and experienced too much' started to affect artistic and other developments during the 20th century with the result that the life expectancy of individual styles was greatly reduced. There has been an increasingly rapid succession of artistic movements since the end of the 19th century. The duration of Impressionism can be measured in decades: a quarter of a century elapsed from the year of the group's first exhibition in 1874 to the success enjoyed by Monet and Renoir around 1900. Surrealism's lifespan was shorter. André Breton wrote the first Surrealist manifesto in 1924 and by 1938 the international Surrealist exhibition already seemed, if not like a form of taking stock, then at least like the crowning moment of a episode that was already largely over. Surrealism's ultimate demise was precipitated by World War II, which was disruptive in terms of both creation and communication. It was above all after 1945, however, that the pace at which different trends appeared and disappeared reached a truly alarming rate. New York-based Abstract Expressionism, which had emerged in 1947–8, was called into question as early as the beginning of the 1950s by the direction taken by two of its main protagonists, Jackson Pollock, who reintroduced the human figure into his drip paintings, which until that point had been non-figurative, and Willem de Kooning, who embarked upon a series of caricatural allegories entitled *Women*. Exactly contemporaneous with Abstract Expressionism, the movement known as Cobra lasted from its creation in Paris in November 1948 only until its self-proclaimed dissolution and the winding up of its publications and group exhibitions in November 1951.

There are many other examples of this same phenomenon: the New York-based abstract style of the early 1960s known as Hard Edge painting and the conceptual movement that originated in that city at the end of the same decade; in France the Supports-Surfaces movement, which lasted from 1971 to 1973, and Figuration Libre

('Free Figuration') in the mid–1980s. Another movement, the trans-avant-garde invented in Italy by the critic Achille Bonito-Oliva and including the painters Sandro Chia, Francesco Clemente and Enzo Cucchi, fell victim to the same general law, disappearing in less than a decade.

Given this trend, it would be rash to attempt to list all the different individual styles that have developed during the 20th century and to define their characteristics, particularly when space is limited. At the risk of drastic simplification, however, it is possible to view the 20th century as having been dominated by two main styles. One is the modern style: its main principles are abstraction and geometric order. The other is the opposite, characterized by freedom and disorder – an anti-style, which by definition excludes the formulation of any dogma or constraint.

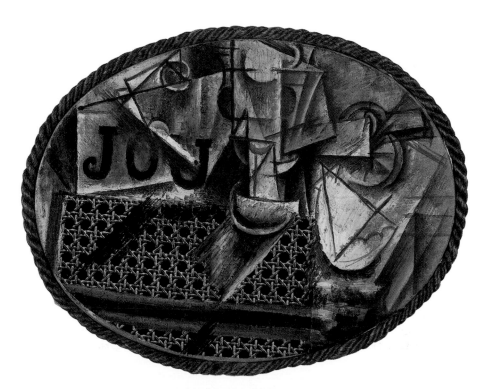

Pablo Picasso, *Still Life with Cane Chair*, 1912, oil and oilcloth on canvas with rope frame, 27 x 35cm, Paris, Musée Picasso.

Epilogue

THE BEGINNINGS OF ABSTRACTION

The claim that abstraction is 'the' modern style is justified first and foremost by its dates. At the beginning of the decade 1910–20, works that contained no imitation of nature — whether literal (in a realist style, for example) or more allusive — were produced in a number of different countries.

A revolutionary break with imitative art

1909–16: figurative painting at the limits of identifiability

This phenomenon was made possible by artists who, in the years around 1910, worked towards the non-identifiability of the subject.

Cubism

Between 1907 and 1912, Cubism — originated by Pablo Picasso (1881–1972, see p.255), a Spaniard living in Paris, and the Frenchman Georges Braque (1882–1963) — suppressed detail and imitative colour, fragmented lines and surfaces, and adopted a multi-perspective approach that viewed the motif simultaneously from a number of angles. Even if figuration was reintroduced after 1912 (the beginning of the phase known as 'Synthetic Cubism') through collages made up of disparate elements, through the use of words, through a return to imitative colour and even, ironically, through trompe l'oeil, these experiments nevertheless opened up the way to a non-figurative type of art.

Italian Futurism

This movement was officially created in 1909 with the publication by the painter and poet Filippo Tommaso Marinetti (1876–1944) of a manifesto in the daily paper *Le Figaro*. Anti-traditionalist ('a racing car is more beautiful than the Nike of Samothrace'), the movement — whose members included GIACOMO BALLA, Carlo Carrà, Luigi Russolo and Luigi Severini as well as the Frenchman Marcel Duchamp, who was soon to become one of the founders of Dadaism (see p.8 and p.261) — survived until 1916. Following the lead of Analytical Cubism, it suggested movement by means of a rhythmic breaking up of form, which made the identification of motifs more difficult.

1912–15: the end of the figure

Delaunay and Orphism

The first attempts to create abstract works occurred in France. In Paris from 1912 onwards, Robert Delaunay (1885–1941), the creator of Orphism (the name he gave to his style after it was suggested by Apollinaire) painted compositions based exclusively on complete or fragmented discs and rings and on the juxtaposition of primary and secondary colours.

Kupka

At the same time, the Czech painter Frantisek Kupka (1871–1957), also working in Paris, carried out similar experiments involving circular or straight rhythms.

Kandinsky and Lyrical Abstraction

In Munich around 1912, the Russian Wassily Kandinsky (1866–1944) — who later took French nationality — created, in his *Compositions and Variations*, a style based on coloured patches and lines in 'musical arrangements', as he considered shapes and colours to be analogous to musical notes.

Malevich and Suprematism

In Moscow three years later, experimentation with abstraction attained what could be seen as its ultimate expression: another Russian, Kasimir Malevich (1878–1935), painted a uniformly white square on a uniformly white background (see p.129).

Giacomo Balla, *Young Girl Running on a Balcony*, 1912, oil on canvas, 125 x 125cm, Milan, Civica Galleria d'Arte Moderna.

Mondrian and Neo-Plasticism

That same year, 1915, the Dutchman Piet Mondrian (1872–1944), working in the Netherlands, was already working exclusively with squares of pure colour and black lines arranged at right angles, laying the foundations for what was to become the language of Neo-Plasticism during the interwar period: grids of black verticals and horizontals dividing the canvas into rectangles and squares, some left white, the others filled with one of the three primary colours (blue, yellow or red).

THE TRIUMPH OF GEOMETRY

The inventors of abstraction regarded their new style as best suited to the age they lived in. Its radical modernity reflected the emergence of an industrial and technological society which, like the art style, was fundamentally different from what had preceded it. Abstract painters deliberately looked for means of expression that were universal, not subjective.

The strand of abstraction known as 'geometric abstraction' was for certain artists the style most representative of the order that had been or was about to be established in a changing world. This style (its name came into use only after 1945, and is used retrospectively) was based on simple shapes, straight lines, the square, the circle and the use of pure colour. The very term 'Neo-Plasticism' — invented by Mondrian (see p.258), whose pictorial methods consisted of straight vertical and horizontal lines and primary colours — proclaimed the conviction that painting in the 20th century needed to employ a language that was entirely new.

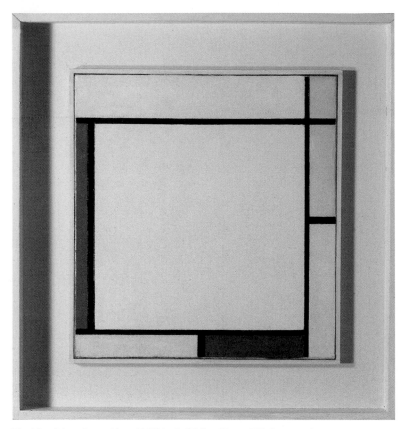

Piet Mondrian, *Composition with White, Red, Yellow, Blue and Black*, 1927, oil on canvas, 37.8 x 34.9cm, Houston, Menil Collection.

1919–37/38: the example of the Bauhaus

Painters working in the style of geometric abstraction did not consider their work to be isolated from other forms of art. As with the Arts and Crafts movement during the second half of the 19th century and with Art Nouveau between 1895 and 1905, their aesthetic was part of a global project whose aim was the remodelling of society. While this was true of Mondrian and Malevich, it was through the Bauhaus in particular that geometric abstraction most powerfully expressed its aim of becoming an all-embracing art form.

Founded in Weimar in 1919, the Bauhaus was a new kind of teaching institution that brought together many avant-garde abstract artists. Its purpose was to train not only painters, but also designers, architects and specialists in the applied arts, so that they in turn would disseminate and popularize the lessons learned from their experiments. Although Mondrian did not teach at the Bauhaus, his influence nevertheless made itself felt there through the review *De Stijl*. KANDINSKY and the Swiss painters Paul Klee (1879–1940) and Johannes Itten (1888–1967) were, however, on the staff.

The architect Walter Gropius, who also taught there, designed the Bauhaus building — based, of course, on a perfect geometrical plan. He and Mies van der Rohe cultivated this type of design in their subsequent work, thereby laying the foundations for an international architectural style — based on the use of right angles, steel, concrete slabs and glass walls — of which there are numerous examples in modern cities throughout the world: New York, Hong Kong, Chicago and the La Défense district of Paris, to name but a few. In many respects these are the most important manifestations of this modern style — a style which began in painting, but which eventually flourished in architecture.

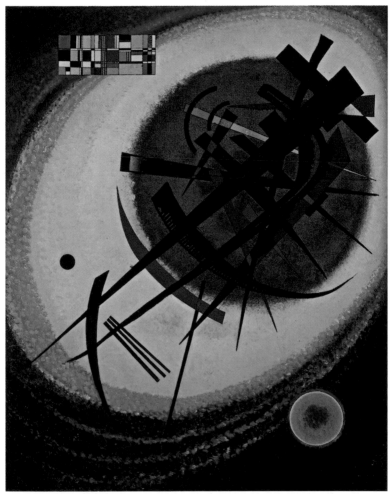

Wassily Kandinsky, *In the Bright Oval,* 1925, oil on board, 73 x 59cm, Madrid, Fondación Thyssen-Bornemisza.

1945–71: American glory, European reaction

Mondrian's emigration to New York during World War II, the earlier emigration of Bauhaus pupils fleeing Nazi Germany, Malevich's return to figuration under pressure from the Soviet regime and even more importantly the affinity between abstraction and an American society infatuated with technology – all of these resulted in the United States becoming the adoptive home of this movement after 1945. Artists influenced by Surrealism initially brought about the success of Abstract Expressionism, which was more in the tradition of Kandinsky's Lyrical Abstraction than the geometric style of Mondrian, Malevich and the Bauhaus. However, the principles championed by the latter returned with a vengeance in the 1960s.

Minimalism

Used for the first time by the American critic Richard Wallheim, the term 'Minimalism' denotes a range of different trends that developed within American geometric abstraction after 1960. Championing the right angle and the use of pure colour, Minimalism was represented by Sol LeWitt (b.1928), Robert Ryman (b.1930), Donald Judd (1928–94) and the Canadian Agnes Martin (b.1912) as well as other artists whose styles were given individual labels: Hard Edge painting, associated with Ellsworth Kelly (b.1923); *Colour Field* paint-

Barnett Newman, *Jericho*, 1968–9, acrylic on canvas, 268.5 x 286cm, Paris, Musée d'Art Moderne.

ing, associated mainly with BARNETT NEWMAN (1905–1970); and *Shaped Canvas*, associated with Frank Stella (b.1936).

Op Art and kinetic art

In America Op Art (an abbreviation of 'optical art'), initiated by Josef Albers, and in Europe the trend known as 'kinetic art' (from the Greek *kinesis*, meaning 'movement'), represented principally by the Frenchman Victor Vasarely (1908–1997), the Venezuelan Jesús-Raphael Soto and the Argentinian Julio Le Parc, expressed an interest in movement through the creation of works that – in stark contrast to traditional painting – either actually moved (kinetic art) or else featured screens and grids and the interplay of colour contrasts in order to create the optical illusion of movement (Op Art).

Supports-Surfaces

Christened thus in 1970 by the painter Vincent Bioulès (b.1938), from 1966 onwards this French movement brought together Louis Cane (b.1943), Marc Devade (1943–83), Daniel Dezeuze (b.1942), Patrick Saytour (b.1935), André Valensi (b.1947), Claude Viallat (b.1936), Jean-Pierre Pincemin (b.1944), François Rouan (b.1943) and Pierre Buraglio (b.1939). Connected during its early stages to Maoist protest, the group liberated its canvases from the stretcher, highlighted the opposition between the painted and the non-painted, favoured the deconstruction of the painting and called for artworks in which front and reverse were of equal importance. After 1971, each of the group's members followed his own individual path.

European monochrome

Those artists such as Yves Klein (1928–62) in France and after him Piero Manzoni (1933–63) in Italy who – independently of any movement – revived monochrome painting in the middle of the 1950s can also perhaps be seen as continuing the aesthetic of geometric abstraction.

ANTI-STYLES: FIGURATIVE ART FIGHTS BACK

Geometric abstraction dominated so much that it appeared to be 'the style of the 20th century' — so great was its influence, mainly in the Western world, but also in a number of Asian countries, particularly Japan and Korea, that it seems the only one worthy of the name — and other artistic movements defined themselves in relation to it. Those who did not share in its creation, in its development or (as early as the 1960s) in defending it against the ravages of time, saw themselves as opposed to its ideals of order, balance, purity and rational control. They acted as a reminder that the world can mean disorder, madness, impurity and sometimes absurdity.

Extremely diverse in character, these movements did not reject abstraction per se — some of them were actually abstract themselves — but they opposed the dogma and specific programmes championed by Mondrian, Malevich or the Bauhaus painters and their emulators. Rather than trying to identify formal principles that unify them, it is more appropriate to recognize that what these aesthetically very different trends had in common was their very negation of the idea of a system. This is what is meant by the concept of 'anti-style'. It seems to be the only possible way of defining all of these expressions of revolt and individuality.

The following are just a few of the most noteworthy of these movements from before and after World War II.

The interwar years

Dada

Created on 8 February 1916 in Zurich, Dada — a name chosen at random from the dictionary — took root in Switzerland, Germany, France and New York and survived until 1924.

Dada broke with traditional forms of art (particularly painting) just as emphatically as abstraction had broken with the imitation of the visible world. It used random chance and adopted invented techniques such as Merz (the creation of assemblages out of rubbish) or the 'ready-made' (elevating industrially manufactured everyday objects into art), a technique associated in particular with Marcel Duchamp (1887–1968). In addition to Duchamp, a Frenchman who adopted American nationality, other Dadaists included Francis Picabia (1879–1953), of Cuban extraction; the American photographer and painter Man Ray (1890–1976); Jean Arp (1887–1966), who was also a poet; MAX ERNST, during his time in Cologne; and the Germans George

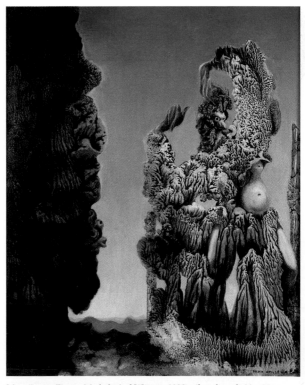

Max Ernst, *Figure, Mythological Woman*, 1939, oil on board, 44 x 33cm, Menil Collection, Houston.

Epilogue

Grosz (1893–1959), later an American national, and (around 1920) Otto Dix (1891–1969).

Surrealism

Succeeding Dada in 1924, Surrealism incorporated many of the artists and poets from the earlier movement, such as Arp, Man Ray and Max Ernst (1891–1976), a German by birth who had become naturalized French. These were joined by the Frenchman André Masson (1896–1987), the Belgian René Magritte (1898–1967), Yves Tanguy (1900–55), an American of French extraction, the Romanian Victor Brauner (1903–66), the Spaniard Joan Miró (1893–1983), the Catalan Salvador Dali (1904–89), Hans Bellmer (1902–75), of German extraction, and later the Chilean Roberto Matta (b.1911). Closely linked to literature (through the poet and essayist André Breton) and also encompassing sculpture and the cinema (Luis Buñuel), Surrealism sought in the depths of the subconscious the material for another reality — one in which the imagination and the world of dreams rubbed shoulders with the bizarre, the comic and the tragic. Experiments involving the immediacy of gesture and 'automatic drawing' went hand in hand with the expression of fantasy, sexual metaphor and a more or less veiled eroticism.

After World War II

Abstract Expressionism and Action Painting

In the United States, Abstract Expressionism (given its name by the American critic Robert Coats, but also known as the 'New York School') was a movement at the heart of abstraction that brought together artists who rejected the absolute primacy of geometry, science and technology. During the 1940s and 1950s, painters belonging to this trend, employing large formats, either brought figurative signs back into their work or continued to use them as before. The main exponents of Abstract Expressionism were Arshile Gorky (1904–48), Willem de Kooning (1904–97), Mark Rothko (1903–70) and Robert Motherwell (1915–91). Joan Mitchell (1926–92) extended the lifespan of Abstract Expressionism beyond 1965.

At the core of the movement, the work of JACKSON POLLOCK (1912–56) was named Action Painting by the critic Harold Rosenberg in 1952. Pollock's technique involved laying a very large canvas on the floor and dripping paint onto it or spreading paint in an irregular flow from a pierced can held out at arm's length. This technique completely transformed the painter's gestures, engaging not only the hand but the whole body, whose vigorous movements were transferred to the painted surface.

Art Informel

With close affinities to Abstract Expressionism, Art Informel (sometimes also called Tachisme) was championed in the 1950s and 1960s by the French critic Michel Tapié. Its chief members were the German Wols (1913–51), the Frenchman Jean Fautrier (1898–1954), Hans Hartung (1904–89), Georges

Jackson Pollock at work, photograph by Hans Namuth, 1950, Paris, Musée National d'Art Moderne.

Mathieu (b.1921), PIERRE SOULAGES (b.1919), Olivier Debré (1920–99), the poet and painter

262

Henri Michaux (1899–1984), Jean Degottex (1918–88), the Canadian Jean-Paul Riopelle (b.1923), the American Sam Francis (1923–94) and the Spaniards Antoni Tàpies (b.1923) and Antonio Saura (1930–98).

Cobra

The name of this group, which was active between 1948 and 1951, is made up of the initials of the capital cities from which its members came: Copenhagen, Brussels and Amsterdam. Its members included the Dane Asger Jorn (1914–73), the Dutchmen Karel Appel (b.1921), Constant (b.1920) and Corneille (b.1922), and Belgian poets such as Christian Dotrement (1922–79). Close to Surrealism, the artists of Cobra refused to distinguish between figuration and abstraction, painting large primitive, mystical figures in pure colours, often allowing their paint to run.

Pop Art

First used by the British critic Lawrence Alloway in 1955, this term denotes work produced between 1955 and 1970 that was heavily influenced by popular culture. Pop Art was a figurative style that took its inspiration from the world of advertising, magazines, television and cartoons. Initially British, represented by Richard Hamilton (b.1922) and Peter Blake (b.1931), it became American with Roy Lichtenstein (1923–97), Andy Warhol (1928–87), Tom Wesselmann (b.1931) and James Albert Rosenquist (b.1933). At the heart of the 1960s French movement known as Neorealism, Martial Raysse (b.1936) also produced work displaying a strong affinity with Pop Art.

To these groups one could add others: Neorealism, which included assembleurs such as Arman and poster artists such as Jacques de La Villeglé and Raymond Hains; Fluxus, also during the 1960s, with Joseph Beuys, Ben, and Robert Filliou; Arte Povera in Italy (c.1970), with Mario Merz, Jannis Kounellis, Luciano Fabro, Giuseppe Penone and Giulio Paolini; the trans-avant-garde that followed around 1980, and so on. In addition to these groups a special mention should be given to Picasso – a one-man movement who belonged to all and none of Symbolism, Cubism, Surrealism and Expressionism – and to painters unattached to any school or movement: prime examples are Max Beckmann (1884–1950) in Germany, Francis Bacon (1909–92) in Great Britain, and Jean Dubuffet (1901–85) in France (despite his name being associated with Art Brut and Art Informel).

Despite making a comeback over the past ten years, painting is now generally seen – rightly or wrongly – as a legacy of the past. It is being challenged by other forms of visual expression, including installations, performance art and video, each of which claims to be the one and only form in which innovation can be achieved.

Pierre Soulages, *Peinture 63cm x 102cm*, 1990, oil on canvas, private collection.

Index

Index

Index

Bibliography

General

Turner, J (ed), *The Grove Dictionary of Art*, Macmillan/Grove, London, 1996
Carr, D W, and Leonard, M, *Looking at Paintings: A Guide to Technical Terms*, Getty Trust Publications, Los Angeles, 1992
Chadwick, W, *Women, Art and Society*, revised edition, Thames and Hudson, New York, 1997
Gombrich, E H, *The Story of Art*, Phaidon, London, 2001
Murray, P, and Murray, L, *The Penguin Dictionary of Art and Artists*, Penguin Books, 1997
Osborne, H (ed), *The Oxford Companion to Art*, Oxford University Press, Oxford, 1970
Nelson, R, and Shiff, R, *Critical Terms for Art History*, University of Chicago Press, Chicago, 1996
Penny, N, *The Materials of Sculpture*, Yale University Press, New Haven, 1995

Iconography, iconology

Kaftal, G, *Saints in Italian Art*, (4 vols), Sansoni, Florence, 1952-85
Ferguson, G W, *Signs and Symbols in Christian Art*, Oxford University Press, New York, 1961
Grabar, A, *Christian Iconography: A Study of Its Origins*, Routledge and Kegan Paul, London, 1969
Jameson, Mrs A B, *Sacred and Legendary Art*, Longman, Green, Longman, Roberts, & Green, London, 1863
Jameson, Mrs A B, *Legends of the Madonna: As Represented in the Fine Arts*, forming the third series of *Sacred and Legendary Art*, Longman, Green, Longman, Roberts, & Green, London, 1864
Mâle, E, *The Gothic Image: Religious Art in France of the Thirteenth Century*, Westview Press, Boulder, 1973
Mâle, E, *Religious Art From the Twelfth to the Eighteenth Century*, Princeton University Press, Princeton, 1982
Mâle, E, *Religious Art in France: The Late Middle Ages; A Study of Medieval Iconography and Its Sources*, Princeton University Press, Princeton, 1986
Panofsky, E, *Meaning in the Visual Arts*, Penguin Books, London, 1993
Panofsky, E, *Studies in Iconology: Humanistic Themes in the Art of the Renaissance*, Westview Press, Boulder, 1972
Panofsky, E, and Panofsky, D, *Pandora's Box: The Changing Aspects of a Mythical Symbol*, Princeton University Press, Princeton, 1992
Réau, L, *Iconographie de l'art chrétien*, (6 vols), Presses universitaires de France, Paris, 1955-59
Seznec, J, *The Survival of the Pagan Gods: The Mythological Tradition and Its Place in Renaissance Humanism and Art*, translated by Barbara F Sessions, Princeton University Press, Princeton, 1972
de Tervarent, G, *Attributs et symboles dans l'art profane: dictionnaire d'un langage perdu (1450-1600)*, 2nd edn, Librairie Droz, Geneva, 1997

The artist's workshop

Bomford, D, et al, *Art in the Making: Italian*

Painting before 1400, National Gallery, London, 1989
Bomford, D, et al, *Art in the Making: Rembrandt*, National Gallery, London, 1988
Bomford, D, et al, *Art in the Making: Impressionism*, National Gallery in association with Yale University Press, London, 1990
Bomford, D (ed), *Art in the Making: Underdrawings in Renaissance Painting*, National Gallery, London, 2002
Watson, D, *The Technique of Painting*, Van Nostrand-Reinhold, New York, 1970
Wittkower, R, and Wittkower, M, *Born under Saturn: The Character and Conduct of Artists; A Documented History from Antiquity to the French Revolution*, Weidenfeld and Nicolson, London, 1963

Genres

Brilliant, R, *Portraiture*, Reaktion, London, 1991
Campbell, L, *Renaissance portraits. European portrait-painting in the 14th, 15th, and 16th centuries*, Yale University Press, New Haven, 1990
Clark, K, *Landscape into Art*, J Murray, London, 1976
Clark, K, *The Nude: A Study of Ideal Art*, Penguin Books, Harmondsworth, 1960
Jordanova, L, *Defining Features: Scientific and Medical Portraits, 1660-2000*, Reaktion in association with the National Portrait Gallery, London, 2000
Pointon, M, *Hanging the Head: Portraiture and Social Formation in Eighteenth-Century England*, Yale University Press, New Haven, 1993
Woodall, J, *Portraiture: Facing the Subject*, Manchester University Press, Manchester, 1997

Philosophy and theory of art

Aristotle, *Aristotle's Art of Poetry: Translated from the original Greek, according to Mr Theodore Goulston's edition. Together with Mr D'Acier's notes translated from the French*, Browne and Turner, London, 1705
Baxandall, M, *Giotto and the Orators: Humanist Observers of Painting in Italy and the Discovery of Pictorial Composition 1350-1450*, Clarendon Press, Oxford, 1986
Blunt, A, *Artistic Theory in Italy 1450-1600*, Oxford University Press, Oxford, 1962
Cicero, Marcus Tullius, *The De oratore of Cicero*, translated by F B Calvert, Edmonston, and Douglas, Edinburgh, 1870
Gombrich, E H, *Art and Illusion: A Study in the Psychology of Pictorial Representation*, 5th edn, Phaidon, London, 1977
Harrison, C, Wood, P, and Gaiger, J (eds), *Art in Theory 1648-1815: An Anthology of Changing Ideas*, Blackwell, Malden, 2001
Harrison, C, Wood, P, and Gaiger, J (eds), *Art in Theory 1815-1900: An Anthology of Changing Ideas*, Blackwell, Oxford, 1998
Harrison, C and Wood, P (eds), *Art in Theory 1900-1990: An Anthology of Changing Ideas*, Blackwell, Oxford, 1992
Hegel, G W F, *Aesthetics: Lectures on Fine Art*, translated by T M Knox, Clarendon

Press, Oxford, 1975
Kant, I, *Critique of the Power of Judgement*, translated by Paul Guyer and Eric Matthews, Cambridge University Press, Cambridge, 2002
Panofsky, E, *Idea. A Concept in Art History*, 2nd corrected edition, translated by Joseph J S Peake, Harper and Row, New York, 1968
Panofsky, E, *Meaning in the Visual Arts*, Penguin Books, London, 1993
Plato, *Republic*, edited by I A Richards, Cambridge University Press, Cambridge, 1966
Plato, *Sophist*, translated and with a commentary by Seth Benardete, University of Chicago Press, Chicago, 1986
Wolfflin, H, *Classic Art: An Introduction to the Italian Renaissance*, translated by Peter and Linda Murray, Phaidon, London, 1994
Wolfflin, H, *Principles of Art History: The Problem of the Development of Style in Later Art*, translated by M D Hottinger, Dover, London, 1950

Sources

Alberti, L B, *The Complete Works*, edited by Franco Borsi, Faber, London, 1989
Apollinaire, G, *Apollinaire On Art: Essays and Reviews 1902-1918*, translated by Susan Suleiman, Thames and Hudson, London, 1972
Battock, G, *Minimal Art: A Critical Anthology*, University of California Press, Berkeley, 1995
Baudelaire, C, *Art in Paris 1845-1862: Salons and Other Exhibitions Reviewed by Charles Baudelaire*, translated and edited by Jonathan Mayne, Phaidon, Oxford, 1965
Bellori, G P, *The Lives of Annibale and Agostino Carraci*, Pennsylvania State University Press, University Park & London, 1968
Cennini, C, *Libro dell'arte: the craftsman's handbook*, translated by D V Thompson, Dover Press, New York, 1954
Cézanne, P, *Letters of Paul Cézanne*, edited by John Rewald, 4th edition, Cassirer, Oxford [London] [Distributed by Faber], 1976
Cézanne, P, *Conversations with Cézanne*, translated by Julie Lawrence Cochran, University of California Press, Berkeley, 2001
Delacroix, E, *The Journal of Eugene Delacroix: A Selection*, 3rd edn, translated by Lucy Norton, Phaidon, London, 1995
Delacroix, E, *Selected letters, 1813-1863*, translated by Jean Stewart, Eyre and Spottiswoode, London, 1971

Medieval, Byzantine, Carolingian, Romanesque and Gothic art

Beckwith, J, *Early Christian and Byzantine Art*, 2nd edn, Penguin, Harmondsworth, 1979
Dodwell, C, *The Pictorial Arts of the West, 800-1200*, Yale University Press, New Haven, London, 1993
Grabar, A, *Byzantine Painting: A Historical and Critical Study*, translated by Stuart Gilbert, Macmillan, London, 1979

269

Bibliography

Lasko, P, *Ars Sacra, 800-1200,* Yale University Press, New Haven, London, 1994

Scott, M, *The History of Dress Series: Late Gothic Europe, 1400-1500,* Mills & Boon, London, 1980

14th- and 15th-century art

Alberti, L B, *On Painting,* translated by Cecil Grayson, Penguin, London, 1991

Baxandall, M, *Painting and Experience in 15th-Century Italy,* 2nd edn, Oxford University Press, Oxford, 1988

Beck, J H, *Italian Renaissance Painting,* Konemann, Cologne, 1999

Brown, A, *Medici in Florence: The Exercise and Language of Power,* Olschki, Florence, and the University of Western Australia, Perth, 1992

Cole, B, *Masaccio and the Art of Early Renaissance Florence,* Indiana University Press, Bloomington, London, 1980

Hills, P, *Venetian colour: marble, mosaic, and glass, 1250-1550,* Yale University Press, New Haven, 1999

Gombrich, E H, *Norm and Form: Studies in the Art of the Renaissance 1,* Phaidon, Oxford, 1985

Gombrich, E H, *Symbolic Images: Studies in the Art of the Renaissance 2,* Phaidon, Oxford, 1985

Lotz, W, *Art and Architecture in Italy 1500-1600,* Yale University Press, New Haven, 1995

Panofsky, E, *Renaissance and Renascences in Western Art,* Westview Press, Boulder, 1972

Monographs

Barbera, G, *Antonello da Messina,* Electa, Milano, 1998

Bellosi, L, *Cimabue,* translated by Alexandra Bonfante-Warren, Frank Dabell and Jay Hyams, Abbeville Press, New York, London, 1998

Kemp, M, *Leonardo da Vinci: the marvellous works of nature and man,* Dent, London, 1981

Rinaldi, S M, *Carpaccio: the major pictorial cycles,* translated by Andrew Ellis, Thames and Hudson, London, 2000

Michael, M, *Piero della Francesca,* Thames and Hudson, London, 1996

Landau, D, and Parshall, P, *The Renaissance Print, 1470-1550,* Yale University Press, New Haven, 1995

Lightbown, R W, *Piero della Francesca,* Abbeville Press, New York, London, 1992

Lightbown, R W, *Sandro Botticelli: Life and Work,* Thames and Hudson, London, 1989

Lightbown, R W, *Mantegna, with a complete catalogue of the paintings, drawings and prints,* Phaidon, Oxford, 1986

Pope-Hennessy, J, *Fra Angelico,* 2nd edn, Phaidon, London, 1974

Seymour, C Jnr, *Italian Sculpture 1400-1500,* Penguin, Harmondsworth, 1966

Spike, J T, *Masaccio,* Abbeville Press, New York, London, 1996

Early Netherlandish art

Alexander, J J G, *Medieval Illuminators and their Methods of Work,* Yale University

Press, New Haven, 1992

Avril, F, *Manuscript Painting at the Court of France, the Fourteenth Century (1310-1380),* translated by Ursule Molinaro, Chatto and Windus, London, 1978

Borchert, T-H, *The Age of Van Eyck, The Mediterranean World and Early Netherlandish Painting 1430-1530,* Thames and Hudson, London, 2002

Evans, J, *Art in Mediaeval France,* Clarendon Press, Oxford, 1969

Hamel, C de, *A History of Illuminated Manuscripts,* 2nd edn, Phaidon, London, 1994

Pächt, O, *Van Eyck and the Founders of Early Netherlandish Painting,* translated by David Britt, Harvey Miller, London, 1994

Panofsky, E, *Early Netherlandish Painting: Its Origins and Character,* (2 vols), Harvard University Press, Cambridge, MA, 1953

Snyder, J, *Northern Renaissance Art: Painting, Sculpture, The Graphic Arts from 1350 to 1575,* Prentice-Hall, Abrams, New York, 1985

Wieck, R S, *The Book of Hours in Medieval Art and Life,* Sotheby's, London, 1988

Monographs

Chatel, A, *Roger van der Weyden,* Gallimard, Paris, 1999

Dhanens, E, *Hubert and Jan van Eyck,* Alpine Fine Arts, New York, 1980

Harbison, C, *Jan van Eyck: The Play of Realism,* Reaktion, London, 1991

Panofsky, E, *The Life and Art of Albrecht Dürer,* Princeton University Press, Princeton, 1971

Thürlemann, F, *Robert Campin, A Monographic Study with Critical Catalogue,* Prestel, Munich, London, 2002

Vos, D de, *Hans Memling: The Complete Works,* Thames and Hudson, London, 1994

The 16th century

Avery, C, *Florentine Renaissance Sculpture,* J Murray, London, 1970

Blunt, A, *Art and Architecture in France 1500-1700,* 5th edn, revised by Richard Beresford, Yale University Press, New Haven, 1999

Brown, J, *Painting in Spain 1500-1700,* Yale University Press, New Haven, 1998

Brown, P F, *The Renaissance in Venice: A World Apart,* Weidenfeld & Nicolson, London, 1997

Humfrey, P, and Kemp, M (eds) *The Altarpiece in the Renaissance,* Cambridge University Press, Cambridge, 1990

Kempers, B, *Painting, Power and Patronage: The Rise of the Professional Artist in the Italian Renaissance,* translated by Beverley Jackson, Allen Lane, Penguin Press, London, 1992

Levey, M, *The High Renaissance,* Penguin, Harmondsworth, 1977

Osten, G von der, and Vey, H, *Painting and Sculpture in Germany and the Netherlands 1500-1600,* Penguin, Harmondsworth, 1969

Partridge, L, *The Art of Renaissance Rome 1400-1600,* Harry N Abrams, New York, 1996

Pope-Hennessy, J, *Italian High Renaissance and Baroque Sculpture,* 4th edn, Phaidon, London, 1996

Shearman, J, *Mannerism,* Penguin, Harmondsworth, 1967

Vasari, G, *Lives of the Artists,* translated by G Bull, (2 vols), Penguin, Harmondsworth, 1996

Monographs

Anzelewsky, F, *Dürer, His Art and Life,* translated by Heide Grieve, Gordon Fraser, London, 1982

Hibbard, H, *Michelangelo,* 2nd edn, Penguin, Harmondsworth, 1985

Hope, C, *Titian,* Jupiter Books, London, 1980

Jones, R, and Penny, N, *Raphael,* Yale University Press, New Haven, 1983

Kemp, M, *Leonardo da Vinci: The Marvellous Works of Nature and Man,* Dent, London, 1981

Rosand, D (ed), *Titian: His World and His Legacy,* Columbia University Press, New York, 1982

Wilde, J, *Michelangelo: Six Lectures,* Clarendon Press, Oxford, 1978

The 17th century

Alpers, S, *The Art of Describing: Dutch Art in the 17th Century,* Penguin, London, 1989

Brown, C, *Dutch Painting,* 2nd edn, revised and enlarged, Phaidon, London, 1994

Minor, V H, *Baroque and Rococo: Art and Culture,* Laurence King, London, 1999

Schama, S, *The Embarrassment of Riches, an Interpretation of Dutch Culture in the Golden Age,* Collins, London, 1987

Slive, S, *Dutch Painting 1600-1800,* Yale University Press, New Haven, 1995

Vlieghe, H, *Flemish Art and Architecture, 1585-1700,* Yale University Press, New Haven, 1998

Waterhouse, E, *Painting in Britain 1530 to 1790,* Yale University Press, New Haven, 1994

Wittkower, R, *Art and Architecture in Italy 1600-1750,* 6th edn, revised by Joseph Connors and Jennifer Montagu, Yale University Press, 1999

Monographs

Alpers, S, *Rembrandt's Enterprise: The Studio and the Market,* University of Chicago Press, Chicago, 1988

Alpers, S, *The Making of Rubens,* Yale University Press, New Haven, 1995

Blunt, A, *Nicolas Poussin,* Pallas Athene, London, 1995

Brown, J, *Francisco de Zurbarán,* Thames and Hudson, London, 1991

Brown, J, *Velázquez: Painter and Courtier,* Yale University Press, New Haven, 1986

Langdon, H, *Caravaggio: A Life,* Chatto and Windus, London, 1998

Lawson, J, *Van Dyck: Paintings and Drawings,* Prestel, Munich, 1999

Nicholson, B, and Wright, C (eds), *Georges de La Tour,* Phaidon, London, 1974

Orso, S N, *Velázquez, Los Borrachos, and Painting at the Court of Philip IV,* Cambridge University Press, Cambridge, 1993

Pace, C, *Félibien's Life of Poussin,* Zwemmer, London, 1981

Perez Sanchez, J, and Spinosa, N, *Jusepe de Ribera 1591-1652,* Metropolitan

Museum of Art, New York, 1992
Thuillier, J, *Georges de La Tour*, Paris, Flammarion, 1992
Thuillier, J (dir), *Simon Vouet*, Réunion des musées nationaux, Paris, 1990
White, C, *Rembrandt*, Thames and Hudson, London, 1984

The 18th century

Barrell, J, *The Dark Side of the Landscape: The Rural Poor in English Painting, 1730-1840*, Cambridge University Press, Cambridge, 1983
Brookner, A, *The Genius of the Future: Studies in French Art Criticism: Diderot, Stendhal, Baudelaire, Zola, the brothers Goncourt, Huysmans*, Cornell University Press, Ithaca, 1988
Bryson, N, *Word and Image: French Painting of the Ancien Régime*, Cambridge University Press, Cambridge, 1981
Conisbee, P, *Painting in Eighteenth-Century France*, Phaidon, Oxford, 1981
Craske, M, *Art in Europe, 1700-1830*, Oxford University Press, Oxford, 1997
Crow, T, *Emulation: Making Artists for Revolutionary France*, Yale University Press, New Haven, 1995
Daniels, S, *Fields of Vision: Landscape Imagery and National Identity in England and the United States*, Polity Press, Cambridge, 1992
Eitner, L, *Neoclassicism and Romanticism 1750-1850, Volume 1, Enlightenment/Revolution*, Open University, London, 1971
Fried, M, *Absorption and Theatricality: Painting and Beholder in the Age of Diderot*, University of California Press, Berkeley, 1980
Haskell, F, and Penny, N, *Taste and the Antique: The Lure of Classical Sculpture, 1500-1900*, Yale University Press, New Haven, 1981
Honour, H, *Neo-classicism*, Penguin, London, 1991
Levey, M, *Painting and Sculpture in France 1700-1789*, Yale University Press, New Haven, 1993
Naughton, G, *Chardin*, Phaidon, London, 1996
Potts, A, *Flesh and the Ideal: Winckelmann and the Origins of Art History*, Yale University Press, New Haven, 1994
Rosenblum, R, *Transformations in Late Eighteenth-Century Art*, Princeton University Press, Princeton, 1967

Monographs

Brookner, A, *Greuze: The Rise and Fall of an Eighteenth-Century Phenomenon*, Elek, London, 1972
Brookner, A, *Jacques Louis David*, Chatto and Windus, London, 1980
Dowd, D L, *Pageant-Master of the Republic: Jacques-Louis David and the French Revolution*, University of Nebraska, Lincoln, 1948
Goncourt, E de, *French Eighteenth-Century Painters: Watteau, Boucher, Chardin, La Tour, Greuze, Fragonard*, translated and edited by Robin Ironside, Phaidon, Oxford, 1981
Posner, D, *Antoine Watteau*, Weidenfeld and Nicolson, London, 1984

Scott, J, *Piranesi*, London, 1975
Wilton-Ely, J, *The Mind and Art of Giovanni Battista Piranesi*, Thames and Hudson, London, 1978

The 19th century

Andrews, K, *The Nazarenes*, Clarendon Press, Oxford, 1964
Baudelaire, C, *Art in Paris 1845-1862: Salons and Other Exhibitions Reviewed by Charles Baudelaire*, translated and edited by Jonathan Mayne, Phaidon, Oxford, 1965
Clark, T J, *The Painting of Modern Life: Paris in the Art of Manet and His Followers*, revised edition, Princeton University Press, Princeton, 1999
Eisenman, S F, et al, *Nineteenth-Century Art: A Critical History*, Thames and Hudson, London, 2002
Hilton, T, *The Pre-Raphaelites*, Thames & Hudson, London, 1970
Nochlin, L, *The Politics of Vision: Essays on Nineteenth-Century Art and Society*, Thames and Hudson, London, 1991
Novotny, F, *Painting and Sculpture in Europe: 1780-1880*, Yale University Press, New Haven, 1992
Thomson, B, *The Post-Impressionists*, Phaidon, Oxford, 1983
Victorian High Renaissance, Manchester City Art Gallery, 1978
Wood, C, *Victorian Panorama: Paintings of Victorian Life*, Faber, London, 1990

Monographs

Adler, K, and Garb, T, *Berthe Morisot*, Phaidon, Oxford, 1987
Camille Pissarro, 1830-1903 (published to accompany exhibitions at the Hayward Gallery, London, Grand Palais, Paris and Museum of Fine Arts, Boston), Arts Council of Great Britain, London, 1980
Parris, L, and Fleming-Williams, I, *Constable*, Tate Gallery, London, 1991
Clarke, M, and Thomson, R, *Monet: The Seine and the Sea*, National Galleries of Scotland, Edinburgh, 2003
Gage, J, *J M W Turner: 'A Wonderful Range of Mind'*, Yale University Press, New Haven, 1987
House, J, *Monet, Nature into Art*, Yale University Press, New Haven, 1986
Pollock, G, *Mary Cassatt*, Jupiter Books, 1980
Reff, T, *Manet: Olympia*, Allen Lane, London, 1976
Renoir, Arts Council of Great Britain, London, 1985
Sutton, D, *Degas*, Rizzoli, New York, 1986
Thomson, B, *Gauguin*, Thames and Hudson, London, 1987
Thomson, R, *Degas: The Nudes*, Thames and Hudson, London, 1988
Thomson, R, *Seurat*, Phaidon, Oxford, 1985
Turner, 1775-1851, Tate Gallery Publications, 1974

The 20th century

General

Barr, A H, *Cubism and Abstract Art*, facsimile of 1936 edn, Secker and Warburg, London, 1975

Brettell, R R, *Modern Art 1851-1929, capitalism and representation*, Oxford University Press, Oxford, 1999
Clark, T J, *The Painting of Modern Life*, Thames and Hudson, London, 1999
Gooding, M, *Abstract Art*, Tate Publishing, London, 2001
Hamilton, G H, *Painting and Sculpture in Europe: 1880-1940*, 4th edn, Yale University Press, New Haven, 1989
Harrison, C and Wood, P (eds), *Art in Theory 1900-1990: An Anthology of Changing Ideas*, Blackwell, Oxford, 1992
Frascina, F, and Harrison, C (eds), *Modern Art and Modernism*, Paul Chapman Publishing, 1988
Moszynska, A, *Abstract Art*, Thames and Hudson, London, 1990
Stangos, N, *Concepts of Modern Art*, Thames and Hudson, London, 1994

Early Modern Art

Rhodes, C, *Primitivism and Modern Art*, Thames and Hudson, London, 2001
Antcliff, M, and Leighton, P, *Cubism and Culture*, Thames and Hudson, London, 2001

Post-World War 1

Willett, J, *Art and Politics in the Weimar Period 1917-33*, Thames and Hudson, London, 1978
Elliott, D, *New Worlds: Russian Art and Society 1900-1937*, Thames and Hudson, London, 1986
Rubin, W, *Dada, Surrealism and Their Heritage*, Museum of Modern Art, New York, 1968
Osborne, H, *Abstraction and Artifice in 20th-century art*, Oxford University Press, Oxford, 1979
Elliott, D et al, *Art and Power: Europe Under the Dictators 1930-45*, exhibition catalogue, Hayward Gallery, London, 1995

Post-World War II

Frascina, F (ed), *Pollock and After: The Critical Debate*, Routledge, London, 2000
Sandler, I, *The Triumph of American Painting*, Harper and Row, New York, 1970
Kuh, K, *The Artist's Voice*, Harper and Row, New York, 1963
Lippard, L, *Pop Art*, Thames and Hudson, London, 1966

Postmodernism

Archer, M, *Art Since 1960*, Thames and Hudson, London, 1987
Chipp, H B, *Theories of Modern Art, A Source Book by Artists and Critics*, University of California Press, Berkeley, 1968
Colpitt, F, *Abstract Art in the Late Twentieth Century*, 2002
Taylor, Brandon, *The Art of Today*, Everyman, London, 1997
Foster, H (ed), *Postmodern Culture*, Pluto Press, 1985

Theories of art and culture

Harris, J, *The New Art History: A Critical Introduction*, Routledge, London, 2001
Adorno, T, et al, *Aesthetics and Politics*,

Bibliography

Verso, London, 1980

Jameson, F, *Postmodernism, or the Cultural Logic of Late Capitalism*, Verso, London, 1991

Crow, T, *Modern Art in the Common Culture*, Yale University Press, New Haven, 1996

Burgin, V, *The End of Art Theory: Criticism and Postmodernity*, Macmillan, London, 1986

Monographs

Sylvester, D, *Interviews with Francis Bacon*, Thames and Hudson, London, 1995

Stooss, T and Elliott, P, *Alberto Giacometti, 1901-66*, National Galleries of Scotland, Edinburgh, 1996

Hope, H R, *Georges Braque*, Museum of Modern Art, New York, 1949

Duchamp, M, *The Bride Stripped Bare by Her Batchelors, Even*, Wittenborn, New York, 1960

Lebel, R, *Marcel Duchamp*, translated by George H Hamilton, Trianon, London, 1959

Barr, A H Jnr, *Picasso: Fifty Years of His Art*, Museum of Modern Art, New York, 1946

Penrose, R, *Portrait of Picasso*, Museum

of Modern Art, New York, 1957

Gilot, F and Lake, C, *Life with Picasso*, McGraw-Hill, New York, 1964

Naubert-Riser, C, *Klee*, Bracket Books, London, 1988

Golding, J, *Fauvism and the School of Chatou: Postimpressionism in Crisis*, British Academy, London, 1982

Barr, A H Jnr, *Matisse, His Art and His Public*, Museum of Modern Art, New York, 1951

Radcliffe, C, *Andy Warhol*, Abbeville Press, New York, 1983

Photo Credits